Praise for *Art in the A*

"Ben Davis understands that you can't truly understand art without an analysis of the economic system that created the artist. He understands that movements create change and that artists only create change if they are involved with that movement in other ways than being the expert observer. Here's to art criticism with an axe to grind." **—Boots Riley**

"Ben Davis is the only art critic I read. These erudite and entertaining essays take the reader on a mind-bending tour through our fragmented, confounding, and commodified cultural landscape, providing welcome historical and political context to many of the high-profile controversies and existential challenges that define our age. Ever attuned to questions of power and profit, Davis never yields to cynicism or forecloses the possibility of creativity's role in our collective liberation. This kaleidoscopic collection will help you see and comprehend the world anew—which is, in my book, what good art should do." **—Astra Taylor**

"Amid the cultural sandstorm of infinite memes and ravenous engagement algorithms, rare sneakers and mythic NFTs, made-for-Instagram immersive installations and the relentless firehose of TikTok clips, Ben Davis asks a simple question: 'What about art?' What follows is an indispensable series of provocations on the future of culture, politics, and society that speak to some of the most urgent issues facing societies where culture, capitalism, and identity have become nearly indistinguishable from one another. Following in the footsteps of theorists like John Berger, Stuart Hall, and Lucy Lippard, Ben Davis is an essential guide to the politics of culture in the twenty-first century." **—Trevor Paglen**

Art in the After-Culture

Capitalist Crisis and Cultural Strategy

Ben Davis

Haymarket Books
Chicago, Illinois

For Chloe

Published in 2022 by
Haymarket Books
P.O. Box 180165
Chicago, IL 60618
773-583-7884
www.haymarketbooks.org
info@haymarketbooks.org

ISBN: 978-1-64259-462-1

Distributed to the trade in the US through Consortium Book Sales
and Distribution (www.cbsd.com) and internationally through Ingram
Publisher Services International (www.ingramcontent.com).

This book was published with the generous support of Lannan Founda-
tion and Wallace Action Fund.

Special discounts are available for bulk purchases by organizations and
institutions. Please email info@haymarketbooks.org for more information.

Cover artwork © Sara Cwynar, *Men in Suits* (Darkroom Manual), 2013.
Courtesy the artist. Cover design by Josh On.

Printed in Canada by union labor.

Library of Congress Cataloging-in-Publication data is available.

10 9 8 7 6 5 4 3 2 1

Contents

PROLOGUE

Art in the After-Culture

The following is excerpted from a 2037 report of the Future Arts Alliance, originally entitled "Three Mind-Melting Facts You NEED to Know about Contemporary Art."

Recent scholarship has come to speak of the "after-culture," the mode of cultural production and consumption related to the new pattern of political and economic power that has consolidated in the wake of the last decade's turbulence. Despite its continued contradictions, this new mode is now stable enough to analyze, and it seems clear that what used to be called "visual art" has today split into three distinct tendencies.

What media theorists and sociologists in the 2020s referred to as the "aestheticization of capitalism" is complete. Cultural life has largely migrated into various virtual platforms, all controlled by the Big Two technology corporations.

The market for new and singular art objects has cratered as interior decorating trends favor the ultra-minimalism that best serves as a background for various forms of customizable augmented reality experiences. Examples of old-fashioned object-based art created in artisanal traditions have been relegated to specialist historical research societies rather than public-facing institutions. "Art" in the Romantic sense of the expression of heroic individuality is largely understood to be anachronistic, a subject appreciated much the way ancient ruins or historical sites continue to be appreciated.

This artistic tradition is considered historically important, with the pathos of representing the life form of a superseded age of culture—but it is without a connection to continuing vernacular forms of creative expression.

Recent decades saw the attempt at self-transformation by museums to meet the demands of a presentist society. This has gradually come apart on the rocks of its contradictions. Art institutions oriented toward middle-class leisure consumption had a good run as purveyors of contemporary adult theme-park attractions, integrated into an increasingly fluid and mobile world of "experience"-based technological leisure. Practically, that meant sidelining questions of authorship in favor of the demands of interactivity from the second decade of the twenty-first century on. Deemphasizing *who* did something or the importance of *personal* or *social symbolism* expanded the audience for the museums with the resources to adapt, allowing institutions to focus directly on the demand for big-budget entertainment environments. The latest feat of maximalist installation by an artist became conceptually indistinguishable, in the eyes of the cultural consumer, from a pop-up environment wholly sponsored by a corporation as an advertisement. The result, however, was that there was little reason to think of the "art" experience as connecting with any historically special type of knowledge that was worth preserving.

This has left art institutions vulnerable to being seen as entirely irrelevant with the widespread introduction of neural aesthetic response production (NARP) technology, in its first years already close to universally embraced. Once the biological interface with artificial intelligence (AI) made it easy to directly plug into and stimulate the brain with personally tailored aesthetic experiences at low cost, there was no credible reason for most cultural consumers to want anything else. By eliminating the friction points to aesthetic delivery involved in an actually existing physical art space as a venue (which limits when and where art is available for experience), the direct stimulation of mental senses of "beauty" and "meaningfulness" made aesthetic experiences available to the widest possible audience. Such technology also minimizes the amount of unprofitable dead time: not only

does mental customization of art experience avoid the problem of cultural consumers having to learn to assimilate an alien set of symbols from another person or culture before deciding whether they appreciate it or not, it also avoids the interruption of aesthetic experience involved in forcing consumers to reflect on what they would like to see or experience before they actually see or experience it. Outsourcing that decision to well-calibrated AI allows for maximum potential profitable aesthetic appreciation, a closed loop of pleasurable reward.

This is Tendency A.

We note, however, two additional tendencies, though all the strands of what used to be called visual or contemporary art define themselves against Tendency A, since the latter represents the fully capitalist, profit-oriented cultural mainstream of a capitalist, profit-oriented world.

Spatial segregation has become almost complete after the failures of recent uprisings, and the purges and urban clearance that followed. NARP-style aesthetic experience provides more than enough on the entertainment level for both the tiny ruling class and its proximate servant class. But exactly because NARP has been so efficient at satisfying the creative demands of so many people on such a wide scale, this experience of art does not fulfill the classical art object's remaining purpose: symbolizing, through its uniqueness, a ruling class's status atop the social pyramid of society. The individual contemporary artist, therefore, lives on, but more in the mode of aesthetic lifestyle coaching and bespoke mythmaking. A small number of artists have assumed a new place, woven into the private life of the upper echelon of a mainly self-isolated ruling class. For a certain set, having a personal artist has become a service similar to having a personal trainer or chef.

For these art patrons, artists' meaning-making services function as a balm for lingering self-doubt about the fragmented form society has taken. The practice of collecting old-fashioned artisanal status-objects even lives on, alongside various forms of meditation and spiritual practice, as a curious hobby and a way to preserve a dignified, if impractical, tradition—very similar to the well-documented recent fad among the

ultra-wealthy of keeping menageries of genetically preserved species otherwise lost to environmental cataclysm. (Cynics are quick to note that these same animal lovers all too often made their money from resource extraction or the land clearance and speculation triggered by the recent super-migrations.) In its cloistered preservation among the very wealthy, art reminds the ultrarich of their unique centeredness and humanity in the decentered and inhumane world that they have secured for themselves. Having a person create an object or an experience may seem antique, given the mass availability and superior responsiveness of ultra-customized entertainment—but the very gratuitousness of the expenditure associates it with those who have gratuitous amounts of time and capital to spare. Through its shared esoteric codes, this type of art provides the basis for status networks to cement a common ruling-class sense of identity and destiny.

Exclusivity itself has increasingly become the medium. Occasionally, images of this clandestine cultural network leak out, either unintentionally in an exposé of its excesses or intentionally as PR, flickering across the greater public consciousness. But given the combination of the highly exhausting work demands and the ready alternative of NARP, it can seem an all but irrelevant tradition for the ordinary person. It endures principally as the province of an impenetrable leisure class. Secret rituals and private emblems, deliberately inaccessible to a broad public, reanimating the sense of personal mission for the entitled—art lives on in this way.

This is Tendency B.

There remain, finally, reports of the role of the artist beyond the privileged zones, where the context remains civil war and intercommunal violence, social dysfunction, and ecosystem collapse. Some of the artists rendered obsolete by the fragmentation of the aesthetic tradition, who are either unable or unwilling to embrace a role as jesters and entertainment-for-hire to the private clubs and speakeasies of Tendency B, have found their destiny in the restive outlands.

The cultural discourse of the first quarter of the twenty-first century had already prepared the way for this, with a vogue for various forms of "politically engaged art" (PEA). However, with the

wealthy in uncontested command of power, the social basis of PEA as a mainstream style eroded. Having been forced to take a side amid the social breakdown of the last decade of ultra violence, the titans of capital have felt no further need to patronize, through direct or indirect funding, art that pretends to heal the divides of society outside their heavily policed enclaves.

Thus, the last frontier for artists is what is sometimes jokingly called "politically disengaged art" (PDA)—"disengaged," that is, from the pretense of healing society's divides. Instead, art frankly acknowledges those divides. The professional artist has a role here, as the cultural officer of the various pockets of revolutionary organization, coalescing in the neglected underground of the polluted hinterlands.

For those large portions of the population written off in this period as disposable, various forms of subculture and messianic belief have surged up in specific opposition to Tendencies A and B. Propaganda from the center projects the power of the elite as fearsome and unassailable. Clearly, large sects in the shantytowns view Tendency B as decadent, demonic. As for the NARP-based art of Tendency A, it put cultural life at the mercy of technology from the same super-corporations that played such a dramatically repressive role in the recent uprisings. It became clear that any artwork that involved AI's scanning of mental life for the purposes of fantasy customization also made it impossible to even fantasize about changing the system without being flagged. Revelations of the abuse of this technology by the security apparatus has pragmatically forced the construction of forms of cultural practice outside it.

PDA artists focus on the task of building the totems of oppositional culture that can draw people closer to their respective political factions, to provide the dissident cultural foci that symbolize actual social dissidence. This is a culture of closely guarded passwords and underground concerts. A ghostly mirror of the private spectacles of privilege within Tendency B, the culture engineered by this cadre of artists is by nature militantly opposed to wider visibility, inseparable from the guerrilla world that gave it birth.

For the "mainstream" public, this art rises into view only at moments of insurgency, when the entire subterranean world of pageantry that has fused together would-be revolutionaries into a like-minded movement shoots to the surface, like lava.

Given their low technical level, these insurgencies have been thus far easy to put down. With each new appearance of revolutionary activity, however, the secret art forms of PDA have been an exciting source of new energies for the cultural worlds of custom-engineered fantasizing and private luxury art alike. Indeed, it has been noted that without these revolutionary interruptions and infusions to replenish the cultural imaginary, the other two tendencies tend to freeze up: AI-powered customization tends to cause people who use it to isolate themselves in symbolic systems that are more and more difficult to communicate to anyone outside of their bubble, causing sociopathy; similarly, elite luxury art tends to become shallowly repetitive and self-referential, given its very small and self-isolated social base, without a socially significant cultural antagonist either to mock or incorporate.

Individual dissident art-makers, seen as more pliable than actual dissident political leaders, have sometimes become hot commodities in this period. They are lavished with promises of amnesty and personal gain if they abandon their comrades. Some go down with their movements, executed for sticking to the foundational principles of oppositional art; some cash in.

Culture can only re-form once again in secret, in coalition with a fresh cadre of the oppressed, keeping the memory of the broken struggles alive. Artists begin to invent anew, despite the unsparing spectacle of repression.

This is Tendency C.

Introduction

It's been an extraordinarily disorienting past few years to write about art. The only thing that has grown faster than the demands on art has been doubt that art can respond adequately to those demands. In some ways, art feels more visible and important than ever; in others, more embattled, small, and peripheral. This book's title, *Art in the After-Culture*, comes from the two short, fictional texts about possible futures that frame it. To state the obvious, these are extrapolations of the possibilities I see gathering in the present, discussed from different angles in the other eight essays here. The idea of an "after-culture"—of a culture whose forms and functions are reshaped by cataclysmic events—resonated with me partly because the recent past has seen such destabilizing changes for art, but also because these changes seem to be accumulating, concatenating into the outline of something bigger coming into view.

My last book, *9.5 Theses on Art and Class*, was published in 2013.[1] In retrospect, this seems like the exact moment when what Marxist literary theorist Raymond Williams would describe as a new "structure of feeling" was emerging in culture: "a particular quality of social experience and relationship . . . which gives the sense of a generation or of a period."[2] Obviously, you can pick any given year and it will have some "particular quality." But some chunks of time feel more particular than others. Usually this happens when simultaneous shifts in multiple areas of life play off of one another to create the sense of a new whole, a new overall context.

Thus, the 1930s stand out as particularly distinctive in US culture because of the background of the Great Depression—but also

1

because of the emergence of photojournalism, the golden age of radio, the advent of sound film, and the excitement around public murals, alongside the explosion of industrial unionism, antifascism, and mass politics rooted in Marxism. The 1960s were defined by the postwar boom and the Cold War but also by the rise of color TV, color photography, pop and conceptual art, the Black Arts Movement, and mass youth culture as new poles of attraction, alongside the galvanizing influence of New Left social movements.

Williams used the term "structure of feeling" to describe changes in sensibility that precede clearly defined ideology. Certainly, the way the larger culture *feels* has shifted more rapidly than the institutions of art have kept up, as the field has been pressured along multiple fronts simultaneously by giant, ambient shifts in the infrastructure of society.

Economically, the extremes of the New Gilded Age set the tone of the 2010s. In *New Left Review*, Susan Watkins went so far as to write that "a new regime of accumulation emerged from the solutions to the financial crisis," dedicated to a single-minded focus on keeping asset prices high, leading to "wildly divergent class outcomes."[3] The fortunes of the investor class recovered spectacularly, while everyone else more or less suffered a lost decade even amid what was technically the US's longest period of economic expansion. This divergence meant that the spectacle of wealth took up ever more mental and physical space, increasing the popular sense of being both dependent on its whims and oppressed by them. By 2017, the three wealthiest US families (the Walton, Koch, and Mars dynasties) had more wealth than the bottom half of the population, busting all-time records. Ultra-low interest rates and low global profit margins pushed mountains of money into speculative investments, including art, but also bid up the prices of whole new areas of luxury consumption detached from old ideas of sophistication: cars, fossils, memorabilia, sneakers, toys, trading cards, and various new digital assets. Luxury real estate ate up huge space in major cities, detonating fights over gentrification. Museums, with limited support from an attenuated state and dependence on the super-wealthy, were slammed by protests over awful patrons, revolts over racism and sex-

ism, and unionization drives. The self-image of art as a social good was collapsing under the weight of capitalism's dysfunction.

Meanwhile, in media, the 2010s saw the takeover of digital culture. *9.5 Theses on Art and Class* only briefly mentioned the web or technology as elements shaping the audience for art, but the topic has since become all-devouring. A decade ago, any show in a major art gallery—and definitely any show in a museum—had an easier claim to importance, because those were the necessary platforms for art to find an audience and be taken seriously. But the accessibility of digital culture created new platforms for showcasing creativity and new pathways to visibility, eroding the assumed authority of existing institutions.

I worked at various art news websites during this entire time. Part of my sense of the changed attention space comes from the grind of working in digital media. The online attention economy is very crowded and therefore very "spiky"—its highs are much higher than ever before, but the average level of interest much lower, so that a minor controversy over a botched art restoration halfway around the world can occupy huge amounts of bandwidth even as coverage of what's going on in local gallery scenes languishes. As a 2017 study of changing audience expectations that I quote in chapter 3 put it: "The definition of culture has democratized, nearly to the point of extinction. It's no longer about high versus low or culture versus entertainment; it's about relevance or irrelevance."[4]

The idea of "context collapse," credited to researcher Danah Boyd, has been used particularly in studies of social media, where you're unable to control the meaning of images or utterances as they circulate among dispersed and unpredictable audiences.[5] "Context Determines Meaning" is an idea so important to post-1960s art that it is number thirty-two in the book of *101 Things to Learn in Art School*.[6] The fact that so much of art is now experienced first as an image via networked media, where context tends to be mercurial, poses a serious challenge to deeply ingrained assumptions about how art makes meaning in the world.

The changed media environment interacts, finally, with a third factor: the new kinds of social movements that erupted onto the

scene in this period. I first had the sense of a new "structure of feel-ing" during the 2014 Black Lives Matter protests in Ferguson, Mis-souri.[7] Seeing the call and response of grassroots political memes from on-the-ground protesters and distant supporters sharing im-ages of solidarity actions and finding creative ways to attack biased media coverage, it seemed clear that this was important culture, both building immediate struggle and leaving a larger, lasting imprint. Because of its openness, immediacy, and urgency, such digital activ-ist culture raised the bar for what felt culturally important in general, even in traditional cultural spaces.

9.5 Theses on Art and Class was published in the still unfolding fallout of the Great Recession. Occupy Wall Street had caught fire in 2011 as a fresh kind of networked movement responding to eco-nomic injustice. Its embers were still throwing off sparks when my book was published—but the decade to come would be defined by one explosive political crisis after another. The alarms of scientists, the agitation of young activists, and escalating natural disasters made it clear that climate change was not a thing of the future but was defining the present. The shocking election of Donald Trump in 2016 led to a sustained sense of daily outrage that irradiated the cultural conversation. The global pandemic in 2020 threw society into an extraordinary period of confusion and despair. The immense Black Lives Matter demonstrations of that same year amounted to the largest burst of protest in US history.

In 1970, the art critic Lucy Lippard had reflected on how the crises of the late '60s had thrown the social value of art into relief. She referenced the big media events of her moment:

> Abbie Hoffman . . . , the Weatherman bombings, Charles Manson, and the storming of the Pentagon are far more effec-tive as radical art than anything artists have yet concocted. The event structure of such works gives them a tremendous advan-tage over the most graphic of the graphic arts. If the theatre was the deadest art form of all during the '60s . . . , the visual arts may be scheduled for the same fate in the '70s. . . . The only sure thing is that artists will go on making art and that some of

that art will not always be recognized as "art"; some of it may even be called "politics."[8]

A similar sense of aesthetic experience being both overshadowed by the spectacle of current events and pressed into new connection with them marks the recent past.

This is a book of essays on distinct debates from the recent past. They can be read individually, but there are overarching themes. The first is the attempt to theorize how inexorably intensifying pressures in the larger society have placed new types of demands on art and pushed it into more and more anxious configurations (the "capitalist crisis" part of my subtitle). The second is the argument for the need to think concretely about the role that the cultural sphere plays in either building or blocking the kinds of social movements needed to turn the tide (the "cultural strategy" part.)

Chapter 1, "Connoisseurship and Critique," is the least pegged to the recent past. It's meant as an accessible history of how the idea of "art" as we know it, as cultural experience that is treated as a special area of prestige, is related to the history of capitalism. This is fascinating historical terrain to explore on its own, but it also contributes to the attempt to critically approach the collapse of formerly distinct types of culture in the present, as museums are treated more and more like theme parks while previously disposable forms of pop culture build up new cults of distinction around themselves.

Politics has completely saturated recent cultural discussion, to the extent that, a few years ago, *New York* magazine asked, "Is Political Art the Only Art That Matters Now?"[9] With everyone from serious organizers to artists to celebrities to corporations invoking activist iconography and radical rhetoric, the meaning of "political culture" is muddied. Chapter 2, "Elite Capture and Radical Chic," looks at what it means to treat the spaces of art as an ideological battleground strategically, given the balance of political forces. As in a number of essays here, this chapter looks to the end of the '60s— the last major moment of sustained left-wing advance in society as

a whole—as a way to get some perspective on how struggle aimed at culture can represent a cul-de-sac when viewed from the point of view of building popular social movements.

It was in theorizing, promoting, and canonizing the experimental art of the 1960s that a lot of the language by which contemporary art continues to be presented to the public was formed—in ways that have been scrambled and challenged as media dramatically shifted in the last ten years. Chapter 3, "The Art World and the Culture Network," looks at how the "smartphone society" has created new categories of aesthetic experience that are crowding into the way we imagine art's mission. Chapter 4, "AI Aesthetics and Capitalism," looks at how artificial intelligence–based art is altering definitions of creativity, pushing art to justify itself in new and defensive ways, much as photography forced painting to redefine its purpose in an earlier era.

Chapters 5, 6, and 7 look at bigger issues about how culture, politics, and activism fit together. "The Anarchist in the Network" is specifically about online political organizing. An argument of *9.5 Theses on Art and Class* was that because artists' position in the economy led them to have an individual relation to their own creative product, they tended to be drawn to an individualistic politics, oriented to ideas, images, or small, like-minded vanguards as the agents of social change rather than mass action. Even as social media has radicalized new layers of people and dramatically expanded the reach of creative expression, it has created a new population of cultural entrepreneurs and online pundits welded into a similar individualistic position of solo media producer—with consequences for the forms of politics that dominate, both in and out of art.

Chapter 6, "Cultural Appropriation and Cultural Materialism," tries to unpack the factors that have led discussions of cultural appropriation to become so explosive in recent years. Indeed, the research into this heated issue was, for me, what clarified how shifts in economics, politics, and culture were interacting to make this period feel like such a distinctly new one. Chapter 7, "The Mirror of Conspiracy," looks at the penetration of conspiracy theories into

the heart of political life as another symptom of the collapse of old cultural boundaries and how aesthetic theory can help explain their currency.

The shadow that climate disaster casts over everything now is one of the surest reasons to believe that we are in a qualitatively new intellectual era. The challenges brought by climate change are so overwhelming that they put pressure on art's sense of assumed importance at the most fundamental level. In the last chapter, "Art and Ecotopia," I look at some attempts by professional artists to live up to these challenges, what their limits are, and what art might offer to a radicalizing environmental movement—or, maybe more to the point, what the environmental movement might offer to art, in terms of a sense of rooted mission.

I've written this book for an audience located somewhere between creaking cultural institutions and volatile leftist cultural debates. A final clear shift from when I wrote *9.5 Theses on Art and Class* is that, at the time, the term "socialism" remained on the far margins of acceptable mainstream discussion. Now it is part of the conversation, beyond the tide pools of the academy and lefty cultural circles—even if it is not always clear what it signifies, with a vaguely progressive economic policy, social democracy, bureaucratic totalitarianism, Chinese-style capitalism, and what I would call actual socialism all mixed up in the hurly-burly of media debate. For myself its important pillars remain: democratic power for the masses of people over the political and the economic institutions that rule their lives, and the redistribution of wealth. You can probably safely add eco-socialism to any contemporary socialist program, centering an effective plan for human survival in the face of capitalism's ecologically suicidal course, focusing on best outcomes for the majority of people and not simply the wealthiest and most privileged.

But even for those who don't completely share my political sense of the world, I hope the book offers something. Specifically, I hope it offers a sense of the excitement, for me, of its subject. It is a scary and disorienting time for art, as it is a scary and disorienting time in general. But it is also an exciting time. New energies are emerging.

The shifts in how culture functions might also mean that it can find new audiences and be put to work in new ways.

As in the end-of-'60s moment Lippard described, a real loss of faith that art might mean anything except as luxury or privilege pervades recent commentary. I do hold out hope, in this book, that the questions that emerge around contemporary art can have serious importance amid the super-storms of the present: in the "Elite Capture" chapter, that the compromised spaces of art can play a part in nurturing genuinely mass politics, however difficult the required balancing act; in the "AI Aesthetics" chapter, that a theory of how meaning is made in art is more vital than ever, as capitalism automates the imagination; in the "Art and Ecotopia" chapter, that the historic project of making tangible the image of a better future might have new relevance.

The stakes are high for art, in terms of the need to make the case for itself in a collapsing cultural space—even as honest assessment of art's capacities also demands some modesty about what it can achieve on its own. A shifting landscape has opened new pathways to relevance but also thrown up new obstacles, and there's not a lot of time to figure out the way through. Williams said that by the time a "structure of feeling" was dominant enough to be analyzed, something new was probably on the way. In whatever small way, I hope that this book can help think through what we want that something new to be.

Chapter 1

Connoisseurship and Critique

What are we actually talking about when we talk about art? What kind of social energies does it encode? What are its capacities and what are its limits? These are basic questions, and yet strangely difficult to answer in a straightforward way. It is almost as if "art," as a field, is committed to not yielding up simple answers.

At a minimum, a fan of contemporary art will be someone who enjoys spotting the telltale signs and styles of artists and accumulating and exercising knowledge about them. Without knowing anything else, such a disposition suggests a way of looking that is deliberately defined by setting itself off against others as more informed and more invested—a fact that connects it to a whole range of implicit questions about status, education, and class. The investment in educated looking can lead equally to an open-hearted curiosity about the many unexpected ways that creativity manifests or to a close-minded cultivation of arbitrary cultural distinctions.

Trying to navigate this terrain, I've gone back to questions of taste and distinction, and how they have been enmeshed with the development of our unequal and rapaciously alienating capitalist society. I realize that writing an essay on Marxism and connoisseurship probably seems something like writing a Marxist theory of dressage. Yet when it comes to the posturing around art, discussions about claiming its apparatus of prestige, on the one hand, or rejecting its culture of entitlement, on the other, still take up a lot of bandwidth. These questions even have a political (or at least proto-political) dimension,

9

in terms of what energies writing about art seeks to connect with—
the gestures of rejecting snobbishness and obscurantism versus those
of rejecting commercialization and anti-intellectualism speak to dif-
ferent kinds of grievances and connect with different senses of what
is wrong with the world.

In art today, "connoisseurship" immediately evokes a kind of
old-guard gatekeeping that is unfashionable—deep looking, an eye
for subtle markers of historical merit, a commitment to fine-grained
distinctions of quality, and an obsession with the signature traces of
the unique artist. "No moment of the discipline's history has been
more reviled," one scholarly article puts it. "Connoisseurship has be-
come a byword for snobbery, greed, and professional mystification."[1]
Speaking at a conference on "The Educated Eye," one British Mu-
seum curator put the matter even more starkly: "[I would] rather
gouge my eyes out with a rusty penknife than describe myself as a
connoisseur."[2]

Yet the interesting thing is that, as art has fled from its historical
association with connoisseurship, the very same virtues have expe-
rienced a boom in the culture beyond the gallery and the museum.
Everywhere people have been encouraged to style themselves as dis-
criminating consumers, possessed of obscure and specific knowledge
about the objects they acquire. As if by magic, the recent past has
conjured up entire new fields of connoisseurship.

One hundred years ago, when the classic connoisseurs of art like
Bernard Berenson and Max Friedländer were at the height of their
prestige, Henry Ford's Model T had just introduced the automobile
as the prototypical mass industrial product. In the new millennium,
interest in collectible cars among moneyed baby boomers has been as
fierce or fiercer than investment in traditional status symbols like art
or wines. Symposia with titles like "Connoisseurship and the Collect-
ible Car" promise the knowledge necessary to navigate this new ter-
rain. "The car is always an assemblage," advised one sage, "not just an
object, but a bundle of stories, paperwork, contexts, as well as parts."[3]

"I always call my cars 'moveable' art," one collector said in 2019,
"and I call sneakers 'wearable' or 'walkable' art."[4]

The first Nike "Moon Shoe" was made in 1971, when Bill Bowerman had the inspiration to use a waffle iron to mold the sole. Turbocharging the market for sport shoes in the 1980s on the back of the jogging and aerobics craze and the nascent cool of hip-hop streetwear, Nike was the vanguard of outsourcing production to low-cost labor markets. The flip side of this was investing in branding and celebrity, starting with the success of Air Jordans and ultimately flowering into what has now become an intricate ecosystem of limited-edition shoe drops, along with a secondary market for shoes and streetwear that was worth more than $2 billion in 2020.[5]

Sneakerheads sustain an entire apparatus of occult knowledge, with its own hierarchies of discernment. As one sneaker expert explained (in an article actually arguing that the sneaker world had become too snobbish):

> It's not just enough to go out and buy the latest and coolest Nikes, Adidas, or Jordans, you have to know every single historical nugget about them, too. Who designed the shoe? When was it first released? How many pairs were made? Which celebrity wore them in an advertisement that was printed before you were born? All of that is viewed as requisite knowledge for anyone who wants to consider themselves a sneaker connoisseur or, better yet, label themselves with the dubious title of being a "sneakerhead."[6]

As one "Sneaker Authenticator," versed in the subtle signs of authenticity—from shoe smell to minute variations in stitching, labels, and dyes—told *GQ*: "Am I surprised [this is a job]? No. Maybe because I'm just into shoes, I've always known how deep the culture was."[7]

Meanwhile, confusingly, as fine art labored mightily to distance itself from the elitist, gatekeeping connotations of connoisseurship, popular critics of art and academic theorists alike were united in disdain for what the post-connoisseur museum became in the 2010s. The *New York Times* critic Holland Cotter lamented that the crowds attracted to spectacular contemporary art exhibitions masked the

withering audience for anything that is not of the now.[8] Critic and theorist Hal Foster attacked contemporary museums for becoming little more than props for callow "cultural tourism" and caving to "a mega-programme so obvious that it goes unstated: entertainment."[9]

The rejection of "connoisseurship" in recent art discourse may be seen simply as the pragmatic outcome of a much-changed contemporary art system. Eclecticism and pluralism are the chief features of the post-1960s art scene; the notion, associated with connoisseurship, of establishing a single firm set of rules for evaluation seems dated at best in a context when almost anything presented within the walls of an art gallery might be considered art. Yet the airy avowal that "anything can be art" masks the deeper, unexamined ways that, in diffused, disguised form, the ideology of "fine art" still structures how art is viewed and valued, even within the polyglot international art world.

The Invention of "Art"

If this question forces us to start from a consideration of traditional European history, this is partly because European industrialization helped forge the contemporary world and European colonialism spread its cultural dilemmas far and wide. We still live in the cage of assumptions formed by this process, so the subject is still worth unpacking.

Among art historians, it is a commonplace that the idea of "fine art" is a relatively recent construction. Its roots lie in the humanism of the Italian Renaissance, the high status accorded to court painters in absolutist societies, and the rationalism of the Enlightenment. It was given further impetus by the formalization of Galilean science, which shook up old tables of knowledge. As Larry Shiner writes in *The Invention of Art*:

> By joining the experimental and mathematical methods, sev-
> enteenth-century scientists not only laid the basis for the sci-
> ences to achieve an autonomous identity but also drove a wedge
> into the liberal arts, pushing geometry and astronomy towards
> disciplines like mechanics and physiology that seemed more

appropriate company than music, which was itself moving towards rhetoric and poetry.[10]

As for painting and sculpture, they could not have existed as art objects in the modern sense before the birth of the museum, which gave the necessary institutional context to view them outside of decoration and patronage. The founding of the Musée du Louvre in 1792 was one of the more unexpected by-products of the French Revolution. It was specifically meant to extract treasures associated with the royal family from their context—and to prevent them from being destroyed by angry sans-culottes. It then became the repository for imperial booty, extracted from conquered cultures and appreciated as trophies.

Yet the truly modern form of capital-A Art is a creation of the Romantic period in Europe (roughly the first half of the nineteenth century), which birthed the ideal of the artist as an independent, "autonomous" visionary. This cult of art emerged opposite the intensifying upheaval of the Industrial Revolution: small workshop production and small farms were being replaced by increasingly industrialized, urban forms of production and consumption. Laborers became anonymous and no longer had creative input into their work; consumers knew less and less about where or by whom goods had been produced.

Here's Shiner again:

> Whereas the eighteenth century split the older idea of art into fine art versus craft, the nineteenth century transformed fine art itself into a reified "Art," an independent and privileged realm of spirit, truth, and creativity. Similarly, the concept of the artist, which had been definitively separated from that of the artisan in the eighteenth century, was now sanctified as one of humanity's highest spiritual callings. The status and image of the artisan, by contrast, continued to decline, as many small workshops were forced out of business by industrialization and many skilled craftspeople entered the factories as operatives performing prescribed routines.[11]

In Europe, the most influential writers to give voice to the age's intensified artistic sensibility were Charles Baudelaire in France and John Ruskin in England. These writers would have been in the same high school class with Karl Marx and Friedrich Engels, the theorists of socialism, which is no coincidence. The same factors that led to increasing awareness of the degrading contradictions of European society also led to an increasing hunger for alternative paths of aesthetic salvation. "There is no understanding the arts in the later nineteenth century," writes the Marxist historian Eric Hobsbawm, "without a sense of this social demand that they should act as all-purpose suppliers of spiritual contents to the most materialist of civilizations."[12]

This position, in turn, gives art a troubling double status. Dave Beech sees art's "exceptional status" as an alternative to alienated labor within capitalist society as containing the germs of meaningful rebellion: "Art's historical hostility to handicraft specifically and work generally has operated according to a utopian logic of securing an island of worklessness within seven seas of drudgery."[13] Simon Gikandi, in contrast, emphasizes that, at the same time European cultures were building up a "culture of taste" that redeemed the grubby business of commerce and politics, they were submitting other peoples around the world to enslavement and colonization, in the name of Europe's civilizing mission. "There has been an intimate connection between a sense of cultural achievement and superiority and the practice of domination."[14]

The process by which cultural objects from non-European cultures were, as art historian Elaine O'Brien put it, "reimagined as 'art' in the modern sense of a product of individual expression meant for individual secular contemplation," has been extensively critiqued and studied.[15] Such values of art have sometimes been imposed on non-European cultures by the most sordid of imperialisms, displacing indigenous art forms. Yet the status invested in the "autonomous" artwork as a kind of alternative to modern pressures can't be seen purely as one-sided imposition either, at least not without overlooking the ways this status has been appropriated critically.

For example, following the Meiji Restoration of 1868, a formerly cloistered Japan decided to industrialize on its own terms in reaction to the expansion of the empires of Europe and the United States. Art historian Dōshin Satō shows in his important book *Modern Japanese Art and the Meiji State* that the Japanese equivalent term for "fine art," *bijutsu*, was consciously constructed by the modernizing Japanese government in this period of social transformation.[16] The field of *bijutsu*, Satō argues, elevated genres including painting and sculpture, which became associated with individual vision and the modification of tradition for the present, attracting members of the former samurai gentry who were looking to hold on to prestige as new economic relations eroded their old privileges. Meanwhile, another term, *kōgei*, approximating the idea of "craft," absorbed the remaining artisanal handicrafts and became associated with the new export economy servicing the West's hunger for *Japonisme*—and therefore with alienated labor and a lower status.[17] A self-conscious ideology of "art" is, it seems, as characteristic a symptom of the implantation of capitalism as wage labor or the commodity form itself.

If European colonial plunder offers the gravest examples of cultural forms being stripped of links to traditional community by domination and commodification, anticolonial thought offers some of the strongest counterexamples of how the figure of the independent artist could be claimed critically. In *Postcolonial Modernism*, art historian Chika Okeke-Agulu firmly rebukes the convention of seeing Nigerian artists who adopted easel painting and European-derived styles of art as victims of cultural imperialism.

Indeed, he argues, it was British colonial administrators like the educator and archeologist Kenneth Murray who advocated that Nigerians should focus on learning traditional handicrafts. In contrast, figures such as the painter Aina Onabolu, one of the progenitors of Nigerian modernism, self-consciously claimed the status of artist as a way to assert "an African modern subjectivity defined primarily by their own need for self-assertion and their visions of political and cultural autonomy."[18] The independent artist was seen as a modern figure. Seizing its status was felt to be part of Nigerian intellectuals'

claiming modernization and independence against an empire that wanted to keep them underdeveloped and dependent.

A very similar drama played out in India, according to Osman Jamal. At the end of the nineteenth century, it was a colonial administrator, E. B. Havell, who insisted on teaching the traditional craft practices to the empire's Indian subjects instead of European academic art practice. He believed that this would be a way to stanch unrest, taking the edge off the spiritual alienation caused by the cultural disruptions associated with British rule. Havell was inspired by the Arts and Crafts movement in England, which believed that a return to the communal style of European medieval art was the antidote to both industrial squalor and the dandyish affectations of Victorian culture. From Havell's curriculum at Calcutta School of Art, the renewal of the teaching of Indian traditional practices spread widely to become a major cultural movement in the early part of the twentieth century. Ironically, this artistic ideology, meant to stabilize British rule, informed Gandhi's independence movement, which looked to village craft production and tradition as the source of an alternative identity opposed to Britain's industrial empire.[19]

Even so, Bengali writer and artist Rabindranath Tagore, who also played a notable role in the independence movement,[20] rejected this romanticization of craft as patronizing in his 1926 lecture "Art and Tradition." He argued that associating "Indianness" with tradition amounted to denying Indians status as modern subjects. "I strongly urge our artists vehemently to deny their obligations to produce something that can be labelled as Indian Art, according to some old world mannerism." Artists should claim their status as individuals. "Art," Tagore wrote, "is personal."[21]

A final, intermediate case might further clarify the stakes of art's shifting relation to labor, prestige, and individual personality: the career of Edmonia Lewis. Born in the United States in 1844 to a free African American father and a Native American mother, she became an internationally celebrated artist in the nineteenth century, eventually moving to Rome with the hope of pursuing an independent career as a sculptor, working in a neoclassical style. "I was prac-

tically driven to Rome, in order to obtain the opportunities for art culture, and to find a social atmosphere where I was not constantly reminded of my color," she told the *New York Times* in 1878. "The land of liberty had no room for a colored sculptor."[22]

She became famous for sculptures celebrating Emancipation and exploring narratives about Native peoples, mostly done as commissions. Reviewers were fascinated and obsessed with highlighting her racial identity; she, in turn, labored to be appreciated for the excellence of her craft rather than for the novelty of who she was, insisting on maintaining a careful barrier between the subjects of her sculptural work and any explicit connection to her personal story. Art historian Kirsten P. Buick writes that Lewis's self-conscious desire to forestall autobiographical associations accounts for the troubling fact that her female figures uniformly have European features, even when they are meant to represent Black or Native women: "Lewis remains a presence that is absent in her work: she is present as an 'artist,' as the creator of art, but she is absent as the 'subject' or 'object' of her art."[23]

In a curious way, the pronounced obsession of Edmonia Lewis's reviewers with reading her works through the lens of her personal biography rather than evaluating them as technically skilled pieces of neoclassical sculpture made her a very modern type of artist indeed, in a period when Romantic ideas about art as heroic self-expression were still congealing in the United States. At the same time, Lewis was barred from fully claiming this position, both by nineteenth-century racism and the conventions of her chosen type of art practice.

Destructive Criticism

The modern connoisseur is also a historical product, born from the same intellectual ferment that produced the modern artist. The two figures are entwined. The formalization of the ideals of connoisseurship legitimated art as a prestige area of production.

The same nineteenth century that gave rise to the cult of the autonomous artist witnessed, within theories of connoisseurship, a

parallel development: an increasingly monomaniacal focus on questions of authorship. In Europe, the key figure is the Italian physician, statesman, and theorist Giovanni Morelli—like Baudelaire and Ruskin, the near-exact contemporary of Marx and Engels.

For earlier proponents of "scientific connoisseurship," attribution of the work to a particular artist was one task among others. For Morelli, attribution became the main obsession—to the point of paradox. All that was most obvious in a painting was liable to be copied by lesser hands. The true personality of the artist, therefore, would reveal itself in overlooked, almost unconscious details, such as the uniquely characteristic way that a hand or an earlobe was rendered. True art appreciation could only mean looking past the "general impression" and seeking out these minute traces of creative individuality.

It bears noting that Morelli's connoisseurship dovetailed with a nationalist political project. He fought in the uprisings of 1848 that would eventually lead to Italian unification, and in 1861 was elected as senator to the first national Italian Parliament. National unity meant creating the idea of an agreed-upon culture, which, in turn, meant ordering the national collections, separating treasures from fakes and copies. Because of Morelli's spectacular success in using his aesthetic forensics to challenge and reattribute famous paintings, he gained great renown in the late nineteenth century. Yet despite the seemingly technical nature of his endeavor, it is worth emphasizing the degree to which Morelli's obsession with authorship was not just a method of attribution but a particularly modern form of taste.

In his treatise *Italian Painters* (1890), Morelli's "Principles and Method" are outlined in the form of a parable: an imagined encounter between a Russian visitor to Florence and a wise older Italian connoisseur. After hearing the Italian hold forth on authentication issues, the Russian departs, thinking him "dry, uninteresting, and even pedantic," and concluding that his theories "might even be of service to dealers and experts, but in the end must prove detrimental to the truer and more elevated conception of art."[24] Returning to Russia, however, the narrator finds himself haunted by the encoun-

ter. He attends a showcase of a prince's Italian pictures before they are sold off at auction. "I could hardly believe my eyes and felt as if scales had suddenly fallen from them," our narrator tells the reader. "In short, these pictures, which only a few years before had appeared to me admirable works by Raphael himself, did not satisfy me now, and on closer inspection I felt convinced that these much-vaunted productions were nothing but copies, or perhaps even counterfeits."[25]

Morelli suggests the term "destructive criticism" for his method. The superficial appreciation of art is destroyed; in its place, a new, ultra-refined appreciation is recovered at a higher level.

Undergirding this aesthetics is a subtle politics of looking. On the one hand, the traditional elitism of connoisseurship is on full view in Morelli's text, with his proxy stating that "the full enjoyment of art is reserved only for a select few, and that the many cannot be expected to enter into all the subtleties."[26] On the other hand, this aristocratic temperament is not just rooted in the past but could very well represent a reaction to a quite modern phenomenon: the commercialization of culture. Indeed, the evils Morelli associates with the "general impression" are conveyed in part by a metaphorical figure who will be familiar within contemporary debates about the transformation of museum culture: the tourist. "The modern tourist's first object is to arrive at a certain point; once there, he disposes of the allotted sights as quickly as possible, and hurries on resignedly to fresh fields, where the same programme is repeated," remarks Morelli's Italian connoisseur, almost as his opening statement. "In the way we live nowadays, a man has scarcely time to collect his thoughts. The events of each day glide past like dissolving views, effacing one another in turn. There is thus a total absence of repose, without which enjoyment of art is an impossibility."[27]

Consequently, the "destructive" aspects of Morelli's criticism can be read as a defensive operation, as old rhythms of culture were being subordinated to the demands of modern commerce. If the cult of art was developed as a reaction to intensifying alienation of labor and life, the *connoisseur of images* was constructed as the counterpoint to the mere *consumer of images*.

The Connoisseur Paradox

The intellectual implications of such "scientific connoisseurship" become clearer still when we come to Morelli's most celebrated follower, Bernard Berenson, who formalized the "Morellian Method" into a legitimating philosophy for the art market of the Gilded Age.

Berenson systematized Morelli's approach and further established the new idea of recognizing "artistic personality" as the highest aim of aesthetic intelligence. Art historian Carol Gibson-Wood explains the method: "The complete description of an artistic personality amounts to identifying an artist's characteristic habits of execution and visualization, noting their changes, deducing from them the ways in which other masters influenced this artist, and finally commenting upon his qualities of mind and temperament, as evidenced by his paintings."[28]

The near-religious charge of this strain of art connoisseurship took on a particular meaning at the time. Notably, this description of the highest duty of art appreciation stands out as a celebration of qualities—a sense of the specific conditions of production and the aura of the humanity behind the object—that were being lost in the transition to alienated consumption, as the latter nineteenth century made the urban department store, the mail order catalog, and an explosion of "new and improved" goods central features of modern life.

At the same time, what also becomes clear from reviewing Berenson's methodological treatise, *Rudiments of Connoisseurship* (1898), is just how oddly the nineteenth- and early twentieth-century obsession with authorship fit its particular privileged object: Italian Renaissance art. Renaissance painting and sculpture had emerged out of the transition from Europe's medieval world, with its workshops and guilds, well before the actuation of Romanticism's ideal of the independent artist. "The artist often left most of the work, if not the whole, to be executed by assistants, unless a special agreement was made that it was entirely or in its most important features, to be from his own hand, although even then he did not always adhere to the terms of his contract," cautioned Berenson, explaining

the difficulty of arriving at true knowledge of authorship. Referring to a Raphael that had been downgraded to "Workshop of Raphael," he writes: "Often there could have been no pretense at execution on the great master's part. Everything painted in his shop was regarded as his work, even when wholly executed and even when designed by his assistants."[29] The idea of sorting the real Raphaels, expressing the master's distinct personality, from the derivative ones essentially involved constructing an idea of artistic authenticity that Raphael himself did not have, creating a layer of appreciation that had little to do with the kinds of visual pleasures and symbolic tasks that originally governed the creation of these objects.[30]

The projective character of Berenson's hunt for the signs of "artistic personality" within and between works may recall what sociologist Michel Foucault says about how the "author function" in literature operates. In his 1969 lecture "What Is an Author?" Foucault argued that authorship was not a given but merely one historical mode of reception:

> Such a name permits one to group together a certain number of texts, define them, differentiate them from and contrast them to others. In addition, it establishes a relationship among the texts. . . . The author's name serves to characterize a certain mode of being of discourse: the fact that the discourse has an author's name, that one can say "this was written by so-and-so" or "so-and-so is its author," shows that this discourse is not ordinary everyday speech that merely comes and goes, not something that is immediately consumable. On the contrary, it is a speech that must be received in a certain mode and that, in a given culture, must receive a certain status.[31]

Foucault's interest in the author function is principally epistemological. Yet even in this passage, the French philosopher hints at how it fulfills an aesthetic function: it serves to differentiate its objects from the "immediately consumable," granting them a "certain status," and setting them off from the oblivion of anonymous "everyday" production. The form of artistic consciousness propounded by

Morelli and Berenson might, finally, be thought of as "the delecta-
tion of the author function": the pleasure one gets from putting one's
knowledge of an "artistic personality" to work.

The Ready-Made Eye

If there is one artwork of the twentieth century that would make the
connoisseur's obsession with the "hand of the master" appear an-
tique, it is Marcel Duchamp's *Fountain* of 1917 (the same year, it so
happens, that Berenson's *Study and Criticism of Italian Art* appeared
in the United States). The lasting provocation of this appropriated
urinal, presented as sculpture, stands at the foundation of contem-
porary art's post-medium pluralism. Yet it is a much remarked upon
irony that the original *Fountain*, which was lost, was replicated in
1950 and 1963 with Duchamp's supervision of all the details. This
quintessential celebration of the industrial object in art became, es-
sentially, a precious trophy, carefully constructed to display, if not
the "hand of the master," then definitely evidence of a unique artis-
tic vision.

The Fordist assembly line had only kicked off in 1913, the same
year Duchamp's *Nude Descending a Staircase* appeared in New York.
An industrial and consumerist world would make new kinds of ob-
jects available for repurposing as artistic expression, via collage or
mining the pathos of the found object. Such emergent strategies
would throw into question many assumptions about what fine art
looked like.

Yet in some ways, rather than representing a break, the changes
Fountain signaled actually consummated the internal logic already
put in play by "scientific connoisseurship." Duchamp famously pro-
fessed himself indifferent to "retinal art"—works whose appeal was
visual. Meanwhile, Morelli's "destructive criticism" had already op-
posed itself to "superficial impression" and turned art appreciation
into a cerebral guessing game, centered on questions of authorship.

In its day, Duchamp's *Fountain* remained a novelty, if not an
outrage. Its influence would not be truly ascendant until the 1960s in

the United States, when rising pop and conceptual artists discovered in the "ready-made" a legitimating tradition. It is yet another historical irony that, just as industrial materials were entering into the mainstream of fine art, conventions of fine art were accumulating around the quintessential industrialized art form: Hollywood film.

Directed at a mass audience and subject to Taylorized production procedures, individual authorship was so little important to Hollywood's Golden Age from the 1920s to the 1940s that the term "genius of the system" has come into currency to indicate how the corporation itself, through the studio system, fulfilled the role of author. Yet by the 1960s, film would become recuperated under "auteur theory" in the writings of figures like André Bazin, establishing the medium as an object for serious intellectual attention rather than a disposable novelty. Critic-turned-filmmaker François Truffaut's book of interviews with Alfred Hitchcock reoriented public perception of the British director from a flashy hired gun to an artist whose oeuvre displayed a unified personal vision.

"Over a group of films, a director must exhibit certain recurrent characteristics of style, which serve as his signature," another proponent of auteur theory, Andrew Sarris, would write in 1962, sounding for all the world like Berenson holding forth on "artistic personality" in painting. "The way a film looks and moves should have some relationship to the way a director thinks and feels."[32] The same conceptual apparatus that could reach back in time to transform Raphael in his Renaissance workshop into an autonomous visionary could transform Hitchcock, working for Paramount, into his distant cousin: Hitchcock the Auteur.[33]

No Quarter

In the final paragraphs of "What Is an Author?" Foucault offers what amounts to a literary prophecy. Associating the author function with "our era of industrial and bourgeois society, of individualism and private property," he hypothesizes that "as our society changes, at the very moment when it is in the process of changing, the author func-

tion will disappear."[34] Written amid the aftershocks of the political earthquake of May '68, the French theorist seemed to be implying that true social revolution would correspond with the toppling of the "author function." What is puzzling about the formulation is that, outside the boutique world of the fine arts and the academy, plenty of texts already fulfilled this post-authorial condition—indeed, the ones that most natively reflected the ideology of "industrial and bourgeois society."

"The words which dominated Western consumer societies were no longer the words of holy books, let alone of secular writers, but the brand-names of goods or whatever else could be bought," wrote historian Eric Hobsbawm of the cultural transformations of the 1960s and after. The same could be said of the world of images, of which museum and gallery art, with its byzantine intellectual concerns, could only form a subordinate part. "From the 1960s on the images which accompanied human beings in the Western world—and increasingly in the urbanized Third World—from birth to death were those advertising or embodying consumption or dedicated to commercial mass entertainment," Hobsbawm continued. "Compared to these the impact of the 'high arts' on even the most 'cultured' was occasional at best."[35] For its target audience, neither advertising nor the average episode of TV is meant to be appreciated, except in rare cases, as the product of a particular subjectivity or as part of an authored body of work.

On balance, locating "bourgeois" values with either authored or unauthored work is futile. Both tendencies exist within capital, which on the one hand transforms everything into equally exchangeable units, but on the other reintroduces distinction in the hunt for the kinds of "monopoly rents" that only unique status symbols can provide. As Marxist theorist David Harvey has written, this restless dynamic of capital "leads to the valuation of uniqueness, authenticity, particularity, originality, and all manner of other dimensions to social life that are inconsistent with the homogeneity presupposed by commodity production."[36]

If connoisseurship seems to have an unsettled status within contemporary culture, it is because it is caught in these crosswinds.

Since production and reception assume one another but are distinct, we can create a matrix of the possible intersection of our terms:

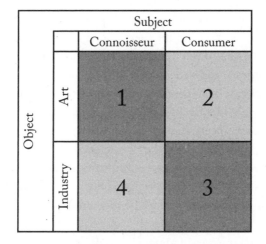

Quadrant 1 represents the situation in which aesthetic objects designed to be read according to the conventions of fine art meet an audience primed to receive them. The best image here is the art lover happily nested in the art museum.

Quadrant 2 represents these same types of fine art objects read in a non-connoisseurly way. The image that comes to mind is tourists flowing through the Uffizi in Morelli's nightmares or multitudes lining up to snap a picture of the *Mona Lisa* in the Louvre because of its media-icon status.[37]

Quadrant 3 takes us into the world of commodity culture as it meets its target consumer. For the casual viewer looking for something suitably distracting while grazing on Netflix, no less than the car buyer looking to balance design with gas mileage, what the cultural object says about its maker or context of production are not the most important factors at play.

Quadrant 4, at last, stands for the situation in which products originally meant to be received outside of any special apparatus of connoisseurship are recuperated: Hollywood film sublimated via auteur theory; sneakers transfigured via sneaker appreciation.

The argument I'm making is that the divisions that form this matrix reflect the way that culture refracts the alienation and class stratification characteristic of a capitalist, divided society. Given these roots in political economy, it should be no surprise that at different times and places, pressing the merits of any of these four quadrants over the others has taken the appearance of political critique.

Thus, in what can be described as a kind of Marxist connoisseurship, appreciation of individually invested artistic labor has sometimes stood as a symbol for the possibilities of unalienated work (Quadrant 1).[38] At other moments, unmasking fine art's pretentions as the product of class privilege has been the key vector of critique (Quadrant 2).[39] In the early twentieth century, subordinating the individual, bourgeois values of art to industry with the idea of producing "art for all" rather than luxury goods for an elite took on a socialist cast in Soviet productivism and the Bauhaus (Quadrant 3). At other times, recovering the humanity and individual creativity hidden behind objects viewed as work for hire, as design, or as "mere commodities" might well have its own polemical charge (Quadrant 4).[40]

Referring to the poles of fine and mass art, the philosopher Theodor Adorno wrote, "Both bear the elements of capitalism, both bear the elements of change. . . . Both are the torn halves of an integral freedom, to which however they do not add up."[41] Extending the thought, you could say that all four quadrants of this matrix are torn parts of an integral freedom, to which they, nevertheless, do not add up.

What seems characteristic of the recent moment is the intensification of the confusion between the different positions. A rapacious contemporary capitalism relentlessly seeks to build up spaces of nouveau-snobbery and privilege while also despoiling and profaning old spaces of solace. And it's important to represent that this happens simultaneously. One of the operations of power is to deflect the critique of capitalism onto the terrain of a more limited cultural critique. Condemnations of arrogant elitism or dumbed-down consumerism, of the detached art object or the degraded commodity form, have value. Each has in its own way been a significant channel

for frustration. But being partial, such critiques are always in danger of redirecting political questions into questions of taste. In the end, you have to keep your sights on transforming the system that produced such contradictions in the first place.

Chapter 2

Elite Capture and Radical Chic

Anyone even a little acquainted with contemporary art will be familiar with the endless number of panel discussions, art shows, and think pieces addressing the urgent subject of "art and politics." What often strikes me is how the distance between the two fields reappears, even as they are being brought together, in the vagueness of the terms "art" and "politics." Hip-hop and quilting are both "arts," but they relate to different audiences, institutions, and types of aesthetic expectations. Presumably thinking about them *politically* somehow involves thinking about what types of arguments need to be won within the different scenes and what the specific stakes are. "Politics," meanwhile, comes in any number of flavors, and the distinctions between them matter a lot to those who take them seriously: does "politics" mean getting out the vote at election time, liberal nonprofit advocacy, anarchist countercultural agitation, workplace struggle, or the building of cadre organizations?

On the art front, the specific set of problems I want to talk about here mainly relate to the terrain of museums, galleries, and other institutions of visual arts and the communities oriented to them. As for politics, I'm most excited by the extraordinary new interest in socialism that has flowered in recent years, as young people look for alternatives to a palpably senescent capitalism. From my perspective, what we need most are broad mass organizations rooted in the idea of organizing working people and fighting to redistribute the wealth and power of our grotesquely unequal and failing society. Also from

my perspective, that goal remains a ways off, and it's important to be strategic about where public consciousness stands and how fragile this renaissance remains in a very hostile time.

Curiously, both these terrains present permutations of the same dilemma. The present-day art industry is notoriously demographically narrow, as protests both inside and outside the museum in recent years have thrown into relief. In terms of audience, research shows that education best determines who is interested in museums or galleries, with each level attained making you that much more likely to be interested in these institutions.[1] While anyone, technically, can claim the idealized identity of "artist," the economic precariousness of the profession means that those with resources coming from somewhere else—stable employment of some kind, a supportive spouse, a family fortune, a stipend from an elite institution or patron—are going to be overrepresented, both among those who make it and those who can even see themselves in a position to roll the dice and aspire to making it in the first place.

Similarly, the fresh political radicalization of recent years, while broad, is overrepresented among downwardly mobile college graduates. Thus, mainstream pundits fret about "elite overproduction"— the idea that institutions of higher education are pumping out more would-be professionals than there are opportunities, destabilizing society.[2] Portions of the left have looked to theories of the professional managerial class to explain the strategic weakness and intellectualist biases of the current left radicalization—the idea of a layer of professionals who exist between the ruling and working classes as buffers, as professors, social workers, and managers.[3] Broad consensus exists that, to realize its potential, the new interest in "socialism" has to escape the places where it has found itself concentrated, becoming more representative and more strategically rooted in terms of racial demographics, economic background, and educational formation.

This is a big problem for the contemporary left, still coming off of decades of retreat. But it is hardly a novel problem, historically. *Every* wave of radicalization, from the 1930s upsurge during the Depression to the movements of the 1960s, has incorporated disaffected but

relatively privileged layers of intellectuals and professionals, creating both opportunities, in terms of the resources and attention they bring, and problems, in terms of an individualist orientation and a tendency to construct intellectual barriers to entry around left politics. From my point of view, the major task right now is to take advantage of the present moment's radicalization where it has happened, but also to break out of its self-marginalizing practices and its confusion of radicalization at the level of culture, where it is overrepresented, with the demands of building more broadly. The goal of this essay is to provide some historical perspective on this complex problem.

The Brazilian Example

What to do, in the face of a world in political crisis? The most obvious answer, for people in and around cultural institutions, is to look to where they already have most power and influence, and to *politicize art practice.* History, however, puts a question mark beside this option.

I think, as a cautionary tale, of Brazilian literary critic Roberto Schwarz's magisterial essay about culture and politics in Brazil, written at the end of the 1960s. In 1964, a US-sanctioned coup put the military in power. Slamming the door on a general left turn in the South American nation, the resulting junta emphasized a populist return to "traditional" values. "Simple homespun thinking suddenly rose to historical preeminence—a crushing experience for the intellectuals, who had become unaccustomed to such things," Schwarz wrote. But that wasn't the end of the story:

> To everyone's surprise, the cultural presence of the left was not suppressed during this period, rather it has continued to flourish and grow to this day. The works produced by the left dominate the cultural scene, and in certain areas their quality is outstanding. Despite the existence of a right-wing dictatorship, the cultural hegemony of the left is virtually complete. This can be seen in the bookshops of São Paulo and Rio, which are full of Marxist literature; in incredibly festive and feverish

theatrical premieres, threatened by the occasional police raid; in the activities of the student movement or the declarations of progressive priests. In other words, at the very altars of bourgeois culture, it is the left which dictates the tone.[4]

In these first years, the regime focused mainly on putting down workers and peasants, leaving the students and artists to stew in radicalism. Some of the glories of modern Brazilian culture flowered in this period, fertilized in this hothouse atmosphere: in art, Hélio Oiticica's and Lygia Clark's advances with participatory sculpture; in theater, Augusto Boal's people-focused experimental Forum theater; in education, Paulo Freire's landmark manual for emancipatory education, *Pedagogy of the Oppressed*; in music, the mind-altering pageantry of the countercultural Tropicália movement.

Schwarz recounts the wild acclaim that greeted left-wing theatrical satires of conservatism. Yet there was a sense of "unreality" to it all, he adds, of willfully looking away from the gathering political storm on the horizon:

> The real drama was not what was going on on stage. No elements of the critique of populism had been absorbed. Mutual confirmation and enthusiasm might have been important then, but it was also true that the left had just been defeated, which gave a rather inappropriate air of complacency to the wild applause. If the people are intelligent and courageous, why were they defeated? And if it had been defeated, why so much congratulation?[5]

Brazil's anti-dictatorship intelligentsia was isolated and growing more so. Four culturally fertile years after the original coup, in 1968, the dictatorship decided it had had enough of fun and games. It dispensed with the pretenses of free speech and liberal norms. Cultural expressions of protest were suppressed or neutralized. A fresh convulsion of brutality seized society. The bubble had proved fragile, as bubbles are.

This is a concrete example, from modern art history, of the profound and potentially tragic consequences of what theorist Sinéad Murphy has called the "art kettle," referring to the police practice of

"kettling" protesters, boxing them in to halt their momentum. "What we call 'art' operates to physically and psychologically contain a growing population of allegedly 'free' thinkers, speakers, movers and livers," Murphy writes.[6] The question now is what the conditions are to break out of the art kettle, which seems to constantly re-form, with each previous attempt to politicize art appearing as the new form of capture, as if you were waking from a dream into another dream.

The US Kettle

The US case is less dramatic than that of Brazil's in the '60s. But to get a grasp on the stakes of the art-and-politics conversation in the present, we must wrestle with the historical paradox that, in recent decades, the mainstream art terrain became more captured by progressive political sentiment during the very decades of conservative and neoliberal ascendancy in economy and politics.

The Great Depression of the 1930s brought a vogue for social realist art in the United States, some of it aligned with the Communist Party or other Marxist formations. Public murals and state-funded community art centers produced a spirit of art "for the masses," directed outside the art market, and a huge movement of artists and intellectuals looked toward socialist politics. But that wave passed with World War II and the bludgeoning by McCarthyism, which destroyed leftist influence of any kind, in both labor and in culture. Former radicals like Clement Greenberg and Harold Rosenberg moved on, from dissident socialist backgrounds, to arguments between formalism and existentialism in painting; indeed, noting their backgrounds in fractious, polemically inclined Trotskyism, in 1968, Barbara Rose wrote of such overheated debates about painting that "a disappointed political idealism, without hope for outlet in action, has been displaced to the sphere of esthetics, with the result that for some, art has become the surrogate for the revolution."[7]

As the critic Lucy Lippard once argued, during the 1950s and 1960s, it didn't even occur to most professional US artists "that their art could be used not only for esthetic pleasure or decoration or status

symbols, but also as an educational weapon."[8] When it came to political art, the common sense would be that it was inherently *movement art*, directed at a political community and seen in alternative institutions attached to the organized left. Charles White, the great social realist painter affiliated (until 1956) with the Communist Party, made widely circulated portfolios of images conveying the dignity of Black workers for the party's journal *Masses & Mainstream*; he showed at American Fine Arts, a leftist-affiliated gallery. Andrew Zermeño is credited with creating the earliest Chicano posters in the mid-'60s working with Cesar Chavez's United Farm Workers. His most famous creation, "Don Sotaco," was an exuberantly unruly worker character used to communicate solidarity via graphics, cartoons, and posters. In the late 1960s, Emory Douglas, who had emerged from the Black Arts Movement in California, created the visual iconography of the Black Panthers in the pages of the group's newspaper, serving as the organization's minister of culture; he originated the iconography of the cop as "pig." And the artist Martha Rosler's most famous series of works—the brutally effective collages called *House Beautiful: Bringing the War Home*, which inserted images of horrors in Vietnam into pictures of beautiful interiors from lifestyle magazines—were produced between 1967 and 1972 and were *not* originally for gallery display. At the outset, they were distributed as photocopies at anti–Vietnam War demonstrations and in underground magazines and newspapers.

Roxanne Dunbar-Ortiz's memoir of life as a revolutionary organizer speaks of a debate, around 1967, "beginning to be played out on campuses, on the streets, and in homes all over the country—the cultural versus the political."[9] The era's political struggles, such as the antiwar and civil rights movements, were hardening their anti-imperialism and anti-capitalism while facing intensifying persecution. At the same time, the demands for alternative lifestyles and forms of culture liberated from suburban conformism that had percolated alongside them offered more promising material for mainstream reabsorption. In 1975, the inaugural text of cultural studies, *Resistance through Rituals* by John Clark, Stuart Hall, Tony Jefferson, and Brian

Roberts, already looked back and viewed the revolutionary hopes for
societal change once invested in '60s counterculture as having been a
kind of optical illusion:

> The counter-cultures performed an important task on behalf of
> the system by pioneering and experimenting with new social
> forms which ultimately gave it greater flexibility. In many as-
> pects, the revolutions in "life-style" were a pure, simple, raging,
> commercial success. In clothes, and styles, the counter-culture
> explored, in its small scale "artisan" and vanguard capitalist
> forms of production and distribution, shifts in taste which the
> mass consumption chain-stores were too cumbersome, inflex-
> ible and over-capitalised to exploit. When the trends settled
> down, the big commercial battalions moved in and mopped up.
> Much the same could be said of the music and leisure business,
> despite the efforts here to create real, alternative, networks of
> distribution. "Planned permissiveness" and organised outrage,
> on which sections of the alternative press survived for years,
> though outrageous to the moral guardians, did not bring the
> system to its knees. Instead, over-ground publications and
> movies became more permissive—*Playgirl* moved in where
> *OZ* feared to tread. The mystical-Utopian and quasi-religious
> revivals were more double edged: but the former tended to
> make the counter-culture anti-scientific in a mindless way, and
> over-ideological—the idea that "revolution is in the mind," for
> example; or that "youth is a class"; or that Woodstock is "a na-
> tion": or, in Jerry Rubin's immortal words, that "people should
> do whatever the fuck they want"—and the quasi-religious re-
> vivals gave to religion a lease of life which nothing else seemed
> capable of doing. The new individualism of "Do Your Own
> thing," when taken to its logical extremes, seemed like nothing
> so much as a looney caricature of petit-bourgeois individualism
> of the most residual and traditional kind.[10]

This cultural pivot was part of how the entrenched interests of
the capitalist system responded to the social crisis of the late '60s and
early '70s. Previously alternative or marginal cultural practices could
be embraced as symbols of progress and accommodation, downplay-

ing any connection to street-level politics. Sometimes this kettling operation was cynically commercial, as Jeff Chang has shown in the case of Coca-Cola, which reinvented itself with a multiracial Flower Power aesthetic in 1971 with its spot "I'd Like to Teach the World to Sing (in Perfect Harmony)," specifically to undercut rival Pepsi, which had been making inroads with Black communities and youth generally.[11] Other times reshaping the political conversation was more consciously the point, as argued by Karen Ferguson's analysis of the Ford Foundation's targeted patronage of experimental Black theater in the late '60s. Theater artists like Douglas Turner Ward and Robert Macbeth sincerely believed in a Black nationalist agenda and in art as an instrument of community uplift that could do direct good among the people in terms of providing a model of Black cultural autonomy. Yet Ford's backers, for their part, viewed the funding as a counterweight to more disruptive popular forms of activism. As Ferguson writes, "Foundation officials hoped to channel social conflict into its dramatization, allowing at least some of the challenge and turmoil of the 1960s to be diverted into the safe waters of cultural expression."[12]

Politics in and out of the Museum

In the visual arts, it has to be said, matters took a less calculated route. In the mainstream museum world, the idea that art institutions themselves could become a primary platform for left-wing causes came late in the United States—not until the tail end of the 1960s. Museums of the time still had a relatively small and self-consciously highbrow audience. It was only the explosion of social activism and counterculture that finally transformed the mainstream conversation and shifted expectations about art, giving rise to the twin phenomena of institutionalized social critique and, later, the role of the artist-as-social-problem-solver (what has lately been called "social practice").

The German-born New York artist Hans Haacke had throughout the early and mid 1960s pioneered styles of minimalist interac-

tive sculpture; his idea was that just stimulating viewers to active participation in the galleries was a radical project, given the priestly atmosphere of passive, church-like contemplation that had ruled the arts. But the 1968 assassination of Martin Luther King Jr. and the immense nationwide uprisings in Black communities in response threw the need for a more engaged art into focus. "No cop will be kept from shooting a black by all the light-environments in the world," Haacke wrote in a self-critical letter the same month.[13]

His phrase makes clear how the increasing political intensity of current events had forced a crisis of relevance for art's understanding of itself as an activity of intrinsic social value. Haacke's turn to a more openly political art at first set out exactly to illustrate the demographic bubble in which it existed and therefore how unmerited art's sense of itself as a universal good might be. For *Gallery-Goers' Birthplace and Residence Profile* (1968–71), he asked visitors to the Howard Wise Gallery to mark where they lived on a map. Haacke then photographed their homes and displayed the results, clustering the photos by the specific streets where they lived, thus showing the audience's confinement to certain enclaves. Art, Haacke would write, drew from "an extremely select audience which recruits from the ranks of the college-educated middle and upper-middle classes. The professionally uncommitted public of the gallery can hardly be suspected of representing 'the proletariat' or the mythical 'man in the street.'"[14]

Famously, in 1971, he attempted to show *Shapolsky et al. Manhattan Real Estate Holdings, a Real Time Social System as of May 1, 1971*, a work consisting of extensive documentation of the real-estate holdings of a notorious slumlord, at the Guggenheim. The museum refused to show it, a curator was fired for expressing solidarity, and artists rallied and protested the museum. It has passed into legend that Haacke's citizen journalism was censored because its target was on the board of the Guggenheim. This is not so; the museum's management simply found that the proposed work was too much like muckraking and not art-like enough to belong in the museum—showing how novel the act of using the museum as an openly didactic platform for progressive aims remained at that moment.

Inspired by the dustup, three years later Haacke created *Solomon R. Guggenheim Museum Board of Trustees*, a series of fake museum donor plaques outlining the ties of members of the museum board to the copper industry, and thus to the US government's support of the bloody Pinochet coup in Chile the year before to protect its mining interests. The work was shown at a commercial gallery, not in the Guggenheim itself, but from examples of these sorts of works about art's financial and political entanglements came the notion of "institutional critique"—essentially a genre of artworks taking as their subject matter the context of the museum itself and the art audience, sometimes in explicitly political ways involving art's connection to structures of oppression, sometimes in more oblique ways involving its unspoken assumptions.

What is worth stressing is that Haacke's influential evolution toward injecting politics into the museum conversation came not as a parallel to the ascent of social movements but in the period of the left's impasse, crisis, and splintering. By the time mainstream art began to take its critical turn, Students for a Democratic Society, the flagship organization of the New Left that had once had tens of thousands of supporters, had already spectacularly imploded, with erstwhile members, frustrated with unwieldy mass politics, turning to direct action and then terrorism as the Weather Underground. The late '60s brought Richard Nixon to power on the program of speaking for the "silent majority," painting the era's social movement as the concern of eggheads, dilettantes, clueless radicals, and degenerate hippies. Among artists and intellectuals alike, as Julia Bryan-Wilson documents, the 1970 Hard Hat Riots—when a group of construction workers brutally beat antiwar students protesting Kent State and Nixon's invasion of Cambodia—would provoke widespread disillusion with the working class in general.[15]

Shapolsky et al.'s title said it was "A Real Time Social System as of May 1, 1971"—which dates this type of art's origins to the final big explosion of the antiwar movement, to the day: the May Day protests that shut down Washington, DC, led to record-breaking arrests, and would come to be seen as the climax of a decade of mass anti–Vietnam

War organizing. Later, Haacke would reflect that the Guggenheim censorship of *Shapolsky et al.* wouldn't have received the solidarity it did if it had happened just a few years later, in 1975 instead of 1971: "As soon as the Vietnam War was over and the draft abolished, everyone relaxed and thought, 'Well, now we can go home, the fight is over.' People withdrew into their private worlds. This is the political vacuum which was then filled by the Right. We have to live with it today."[16]

Claiming the museum for political self-examination was only one direction to go. Another was to apply art's powers of symbol-making outside the galleries. Consider another New York artist, Mierle Laderman Ukeles, whose "Maintenance Art Manifesto" arrived in 1969, almost simultaneous with Haacke's turn to politicized art. Amid the feminist agitation of the late 1960s, Ukeles had been furious when her pregnancy caused her peers to joke that her career was over. She wrote her manifesto in an afternoon of "cold fury." As an artist, she had been working on large-scale inflatable sculptures but realized that such ambitious works were going to be possible to make but impossible to maintain—leading her to ponder how different forms of labor were coded: how creation, coded as male, was highly valued, but maintenance, coded as female, was devalued. "The sourball of every revolution: after the revolution, who's going to pick up the garbage on Monday?"[17]

From that point on, Ukeles declared that her mission would be to celebrate the processes of maintenance—both her own domestic work of childcare and housework and the low-wage labor that kept the whole economic system running. This yielded art projects like *Hartford Wash* (1973), a performance, documented in black-and-white photos, in which the artist washed the floors of the Wadsworth Atheneum in Hartford, Connecticut, focusing attention on the value of the hard work that makes the museum function by reframing it as performance art.

The concerns of the "Maintenance Art Manifesto" were very much of a piece with the era's larger reexamination of values inspired by the women's liberation movement. To take one example, at the same time that Ukeles was scrubbing the floors of the Ath-

eneum, another radical demand for recognition of domestic labor, the Wages for Housework movement, was just beginning to fire the imagination of activists with its argument that uncompensated labor in the home was the foundation of the economy and therefore ought to be materially rewarded. But Wages for Housework emerged out of debates about "reproductive labor" within Marxism and feminism, whereas Ukeles's Maintenance Art emerged out of her own devout Judaism as an application of the belief of the sacredness of the everyday (she was the daughter of an Orthodox rabbi). Thus, while one Wages for Housework provocation was the proposal that housewives perform the necessary work of the home but treat it as if it were alienated wage labor—to make visible what was taken for granted ("More smiles? More money!")[18]—Ukeles's move was in the other direction, bestowing the sacral aura of art on domestic chores.

This evolution of valuing the common would lead to Ukeles's most celebrated initiative, her yearlong project with the New York Department of Sanitation, *Touch Sanitation* (July 1979–June 1980). Ukeles vowed to shake hands with and thank all 8,500 "sanmen" (sanitation workers, all men at that time) in the city as a work of performance art. In the document outlining her pitch, Ukeles wrote that she wanted to bring a bit of "Artmagic" to the city bureaucracy. Scholar Kaegan Sparks, describing the artist's stated mission to honor the workers for "keeping the city alive," writes that

> this phase had particular gravity in the wake of the city's 1975 fiscal crisis, when social services were beleaguered by deep budget cuts. That summer, after Mayor Abraham Beame announced the anticipated layoffs of tens of thousands of city workers, garbage collectors staged a two-day wildcat strike that left 48,000 tons of trash on the streets. And this was no isolated incident: Without adequate state resources for maintaining them, roads, subways, and other infrastructures were crumbling. Between 1976 and 1978, the City University of New York abandoned free tuition; an arson epidemic, exacerbated by defunded fire departments, decimated the Bronx; and

a mass electric blackout left most of the city powerless for 25 hours at the peak of summer.[19]

At the time of *Touch Sanitation*, conditions were so degraded for the sanitation workers that the furniture in their headquarters was scavenged from the street. Ukeles's project provided a feel-good story for a traumatizing time in New York's civic life and received lots of bemused media coverage (as well as some of the more hostile "you call this art?" kind). Ukeles would go on to embed herself in the Department of Sanitation in a multidecade unpaid residency. With its direct avowal of solidarity and act of focusing on the less glamorous but essential processes of life, her work is considered one of the progenitors of what in the 2010s came to be called "social practice," a genre that blurs the line between art-making and community engagement. It showed how the feminist reconsideration of the "personal as the political" opened up new ways of valuing parts of society previously overlooked as valueless. Ukeles's work has also become the template for government agencies everywhere looking for a symbolic boost, explicitly inspiring New York City's Public Artists in Residency (PAIR) program, launched in 2015.

If *Shapolsky et al.* was a gesture of inserting political struggle into the museum, *Touch Sanitation* was a gesture of escaping the museum bubble, away from its elite audience and engaging with working-class issues. At the same time, as with Haacke, the larger social background suggests that this advance of art politics arrived at exactly the moment of disarray in movement politics. New York's 1975 bankruptcy is widely considered to be the starting gun for neoliberalism's gradual evisceration of the public sector and the era of rule by finance. Coming at a decisive point in time, *Touch Sanitation* pointed to how symbolic gestures could be drafted to fill the space left by actual material compensation, an early example of how, as George Yúdice would note of the vast complex of international NGO initiatives that would arise in the coming decades, "culture is invoked to solve problems that previously were the province of economics and politics."[20]

This is not to deny the sense of recognition and good cheer that Ukeles's presence brought to literally thousands of city workers. It's only to note that art gained a new identity as symbolically celebrating labor in this form at exactly the moment that organized labor was beginning its long, painful retreat. Even New York mayor Ed Koch, whose main historic task upon taking office in '77 was bringing the city's unions to heel, took time out to salute Ukeles's celebration of workers. "Seriously, who's to deny that friendly exchange and contact between human beings is not the greatest of all arts?" the pugnacious mayor stated in a 1980 letter. "Accordingly, may you continue to 'shake up' our City for many years to come."[21]

Emerging from the late 1960s activist surge, both "institutional critique" and "social practice" afterward represented dissident modes of art that in subsequent decades became, gradually, more and more mainstream at art biennials, in the museum, and beyond. Their tendencies represent a lasting infusion of the mainstream art discourse with social criticism and community engagement that would have been unthinkable, right up until the very end of the 1960s.

Nevertheless, Lucy Lippard, for one, saw early that the outwardly more radical forms of art-making could delude the art audience into thinking it had broken out of the "art kettle":

> From around 1967 to 1971, many of us involved in Conceptual Art saw that content as pretty revolutionary and thought of ourselves as rebels against the cool, hostile artifacts of the prevailing formalist and Minimal art. But we were so totally enveloped in the middle-class approach to everything we did and saw, we couldn't perceive how that pseudoacademic narrative piece or that artworld oriented action in the streets was deprived of any revolutionary content by the fact that it was usually incomprehensible and alienating to the people "out there," no matter how fashionably downwardly mobile it might be in the art world.[22]

In their own ways, Haacke and Ukeles attempted solutions to this conundrum. Still, the advance of progressive politics into the center

of official art discourse over the coming decades can't simply be rendered as a heroic narrative of cultural advance, as it often has been; it has to be put in perspective of a much larger defeat of left politics everywhere else. An insurgent labor movement was brought to heel; radical political groups faced intense centrifugal pressures and merciless government attack; economic policy turned decisively against the heritage of the New Deal; the gains of the civil rights era were punished with a dog-whistle politics of "law and order" that mutated into mass incarceration, ravaging Black communities. The combative heroism of ACT-UP in the 1980s, for one, preserved the visibility of forms of direct action. But it was impelled exactly by the desperation of queer communities abandoned by the government, a protest against marginalization, silence, and public indifference—against the generally conservative post-Reagan tide in official politics and life.

The big picture was that left-wing sentiment increasingly retreated to academia and, to a lesser extent, to cultural institutions, or was professionalized into the world of single-issue nonprofit advocacy, away from ideas of system change. In the early 1990s, Lippard finally left New York for good. Her "activist community in New York had wilted," she explained. She "didn't want to be dragged into academia."[23]

Radical Chic as Wedge

In the last few years, there has been a remarkable reversal in the common sense of how institutionalized political art is received. "Critical art practice," for decades, was considered a cause to champion and the obvious position to stake out as an alternative to the mainstream art market. But the episodic series of struggles, political crises, and fresh radicalization of the 2010s has battered against the art space in very much the same way as it did in the late 1960s, revealing the limitations of art's "critical" productions and high-minded nonprofit centers—their whiteness, relative privilege, and dependence on the One Percent. "People Are Calling for Museums to Be Abolished," CNN reported in 2020. The headline's summary is not much of an

exaggeration in terms of the general tone of commentary when it comes to the new "art and politics" conversation.[24]

For some historical guidance on how to view this pendulum swing, I think it is illuminating to return to the end of the 1960s again. Because it is in that same context that a criticism of "art politics" was formulated, one so effective and now so widely diffused that most people today don't realize its conservative provenance: the idea of "radical chic."[25]

The central incident of Tom Wolfe's 1970 *New York* magazine essay "Radical Chic: That Party at Lenny's" is a fundraiser at the Park Avenue penthouse duplex of maestro and *West Side Story* composer Leonard Bernstein (it was not actually thrown by him; his wife, Felicia, a long-time supporter of free speech causes, put it together). The essay focuses on the ridiculous incongruity of Black Panther Party spokesman Don Cox's attempts to win his tony audience over to supporting the cause of the Panther 21, a group charged with conspiracy to attack police and bomb the Bronx Botanical Gardens and other sites. They'd be acquitted of all charges one year later in what was then the longest and most expensive prosecution in New York history.

New York's art scene, in fact, has a starring role in "Radical Chic." A key character in Wolfe's account of the evening, which he tells as a comedic parable of limousine liberalism, is tuxedo-clad young art dealer Richard Feigen, who swings by the get-together on his way to a MoMA opening. Feigen's interruption of Cox's presentation to demand info on how to throw his very own Panther fundraiser is the central symbolic moment in Wolfe's depiction of elite shallowness: "I won't be able to stay for everything you have to say," Feigen exclaims from the back of the room at one point, "but who do you call to give a party?" As Wolfe puts it, "There you had a trend, a fashion, in its moment of naked triumph."[26]

"Radical Chic" needled its way into the collective consciousness because it packaged contempt for leftist activism with celebrity gossip, two great American middlebrow pastimes. But Wolfe, as he himself explains, wasn't the first to make a gag out of the Bernsteins'

Panther party. The event was ridiculed by tabloids around the world as soon as it first was reported in the *New York Times* society pages. The *Times*'s own editorial board quickly published a scathing broadside in response, decrying the "emergence of the Black Panthers as the romanticized darlings of the politico-cultural jet set."[27] Essentially, the image of "That Party at Lenny's" seems to have provided a tool that the mainstream universe of liberal opinion, wearied by the disruptions of the 1960s, very much wanted to have on hand so they could begin dismissing all that upheaval as just a trend, like go-go boots or tie-dye.

Michael E. Staub has argued that Wolfe's New Journalism (and that of other literary luminaries, including Joan Didion's depiction of the Panthers as robotic child soldiers in *The White Album*), with its combination of creative writing and current-affairs reporting, was a particularly effective instrument in reshaping the public profile of the Panthers for a liberal readership that had mostly felt constrained to be at least superficially sympathetic to the Black struggle up through the end of the decade.[28] By giving himself the license to invent mortifying inner monologues, Wolfe recoded sympathies for Black radicals as icky and unseemly. When, for instance, the Panther spokesman, Cox, talks about the right to self-defense against violence, saying "I don't think there's anybody in here who wouldn't defend themselves if somebody came in and attacked them or their families," Wolfe inserts, "and every woman in the room thinks of her husband . . . with his cocoa-butter jowls and Dior Men's Boutique pajamas . . . ducking into the bathroom and locking the door and turning the shower on, so he can say later that he didn't hear a thing."[29]

While he is relatively restrained in his depiction of the Panthers, limiting himself to insinuating their anti-Semitism, Wolfe's rhetorical innovation in "Radical Chic" was that by mocking the shallowness of the glitterati's support of the Black Panther cause, you could essentially have license to trivialize radical Black activism by proxy. (The essay paired with "Radical Chic" in its published form, "Mau-Mauing the Flak-Catchers," is a deliberately grotesque, witheringly unsympathetic caricature of antipoverty programs in

San Francisco—what Wolfe calls "the poverty scene"—farcically describing emasculated white bureaucrats being alternately duped and bullied by Black thugs.) As opposed to Murphy's idea of the "art kettle," Wolfe's "Radical Chic" is an example of what you could call the "art wedge": how sympathy for left causes in elite cultural spaces can be weaponized against those same causes.

It must be admitted that Wolfe's mockery would not be so durable or so broadly effective if it did not strike at a weak point, channeling an archetype that the left itself had a shared investment in ridiculing: the image of feckless liberal allies who profess radical ideas that they don't truly believe. To get a sense of this reservoir of righteous irritation, go listen to folk singer Phil Ochs's "Love Me, I'm a Liberal" from 1964, his satire of people who are "10 degrees to the left of center in good times, 10 degrees to the right of center when it affects them personally." In her 1996 essay "Radical Chic and the Rise of a Therapeutics of Race," Elisabeth Lasch-Quinn makes use of Wolfe's account of the Bernstein affair as an example of the dead end of the 1960s focus on cultural struggle, of how activism aimed at taking on the state and changing the law was deflected into aestheticized gestures of interpersonal atonement, all under the hegemony of the liberal elite's clueless guilty conscience.[30]

Yet history offers us reason to question whether the left can fully embrace the Radical Chic critique without taking the bait of isolating left politics, which is what it is designed to do. Immediately after the first report of the Bernstein party hit the society pages of the *New York Times*, presidential domestic-affairs advisor Daniel Moynihan penned his infamous "benign neglect" memo to Nixon on race relations. There, Moynihan makes the following comment explaining how the administration's hard line against Black radicalism might be backfiring, referencing the recent police assassination of Panther leader Fred Hampton:

> The Panthers were apparently almost defunct until the Chicago police raided one of their headquarters and transformed them into culture heroes for the white—and black—middle

class. You perhaps did not note on the society page of yester-
day's *Times* that Mrs. Leonard Bernstein gave a cocktail party
on Wednesday to raise money for the Panthers. Mrs. W. Vin-
cent Astor was among the guests. Mrs. Peter Duchin, "the rich
blond [sic] wife of the orchestra leader" was thrilled. "I've never
met a Panther," she said. "This is a first for me."[31]

This cameo in the Moynihan memo is mentioned in Wolfe's essay
as being embarrassing to the Bernsteins, because it further amplified
the scandal touched off by the original report in the society pages. But
it also stands as proof that, however odd the Bernstein/Panther fund-
raiser seemed, it got the attention of the powerful. The event's very
incongruity was a signal, in the moment, that the Nixon administra-
tion had lost control of the narrative about an organization, the Black
Panther Party for Self Defense, that it considered "the greatest threat
to internal security of the country"—it suggested that sympathies for
the Panthers were spreading in uncontrolled ways.

Conversely, when Wolfe's acid-tinged *New York* piece came out
months later, it was so effective at rendering such support radioac-
tively uncool that Nixon's assistant, Raymond K. Price Jr., personally
wrote a note of praise to Wolfe: "I've seldom enjoyed a magazine
article as much. . . . Truly a classic."[32] Indeed, even in Wolfe's own
impishly reactionary account, he's quite clear that the Radical Chic
phenomenon had a potential political charge. Describing the fallout
of the negative press that greeted the Bernstein fundraiser, he writes:

> In general, the Radically Chic made a strategic withdrawal,
> denouncing the "witchhunt" of the press as they went. There
> was brief talk of a whole series of parties for the Panthers in
> and around New York, by way of showing the world that so-
> cialites and culturati were ready to stand up and be counted in
> defense of what the Panthers, and, for that matter, the Bern-
> steins, stood for. But it never happened. In fact, if the socialites
> already in line for Panther parties had gone ahead and given
> them in clear defiance of the opening round of attacks on the
> Panthers and the Bernsteins, they might well have struck an
> extraordinary counterblow in behalf of the Movement. This is,

after all, a period of great confusion among culturati and liberal intellectuals generally, and one in which a decisive display of conviction and self-confidence can be overwhelming.[33]

Clearly, this passage is disingenuous: Wolfe's essay was bringing the full force of his literary talent to bear on making any such perseverance more difficult. Jamie Bernstein, daughter of Leonard and Felicia, claims that her father later found in his FBI file proof that the bureau had deliberately cultivated division between Black and Jewish activists throughout the period, and argued that Wolfe's "snide little piece of neo-journalism rendered him a veritable stooge for the FBI."[34] Yet the fact remains that even the person who coined the term "Radical Chic" damned his targets, ultimately, not for fumbling toward solidarity but for being inconstant in that solidarity.

It is worth turning to the autobiography of Don Cox, the Panther spokesperson at the center of the account. Cox lived an eventful life. His description of the Bernstein incident takes place between visiting exiled Panther leader Eldridge Cleaver in Algeria and debating politics against future congresswoman Eleanor Holmes Norton on the *Dick Cavett Show*. In all, the events of "Radical Chic" are given just a few paragraphs—a blip amid the larger backdrop of police intimidation and the increasingly terrible internal fights within the party itself. By the time the Panthers became radically chic, they had been put in the pressure cooker.

Cox describes the Bernstein party as "a curious evening to say the least"—but he has positive things to say about the Bernsteins as well as film director Otto Preminger, another subject of Wolfe's filleting. He has less positive things to say about broadcaster Barbara Walters and opera singer Leontyne Pryce. He notes, "We managed to collect a decent sum to help toward bail money for the New York 21, but it was writer Tom Wolfe who profited most from the evening," branding him a "leech of the worst kind." Here, however, is the key passage:

> As this layer of American society began to give us support, the reaction from the authorities was immediate and fierce. They

launched a national campaign of slander and intimidation against what they, following Tom Wolfe, called "radical chic." Many of our supporters from that class were intimidated and retreated, and the rest of the evenings we had planned similar to the Bernstein affair were canceled. I had a secret meeting with Felicia Bernstein at the studio where she painted, and she told me of the misery she and Leonard had endured since the night of the gathering. They had been receiving constant hate mail and phone calls, including threats to their lives. She wanted to know if there was anything I could do to help. I could think of nothing, other than to reiterate my belief that all people should stand up and defend what they believe. Otherwise, fascism has fertile ground in which to grow.[35]

The story of "Radical Chic" looks very different, therefore, told not from the imagined insides of the Bernsteins' party guests' heads but from the point of view of the political organizers involved. The incongruity, guilty conscience, and mixed motives are part of what makes politics within elite cultural domains brittle—but the obsession with these qualities, on the whole, replicates that milieu's own elite concerns with appearances. (As the critic Morris Dickstein once wrote of Wolfe, the "snobbishness and triviality" of his characters "mirrors his own interests.")[36] From the point of view of actual movement activists, the evils of "Radical Chic" were not the dominant concern; the key concern was finding allies for practical purposes. The important thing was not abandoning the cultural space but rooting what happened within that space in a movement perspective outside of itself. The message was not to abandon solidarity but to deepen it.

The Case of Mário Pedrosa

When you consider the above examples, you are left with a seemingly contradictory insight: that the movement of politics into artistic spaces can represent the deflection of political energy away from popular struggle—but also that the very criticism of how politics

expresses itself in such spaces can be a tool to deflect energy away from popular struggle.

The question of political culture and its contradictions falls squarely within the purview of a set of problems covered by the classic Marxist theory of "hegemony": how parts of civil society with a more middle-class social base relate to movements and organizations of the working class or the oppressed. For the Marxist thinker Antonio Gramsci, revolutionary organizations couldn't rely on simply asserting their program, assuming that all other forces would jump on the bandwagon at once and follow; they would have to win leadership in coalition, developing alliances with other forces and incorporating some of their demands so as to advance their own. The theory was meant to cut against the self-isolating sectarianism of political groups speaking in the name of a revolutionary consciousness that did not yet exist and abstaining from any actually existing movements as impure—the kind of groups for whom "general strike to bring down capitalism" was always the slogan, whatever the immediate situation.[37]

The term "hegemony" has today been reduced to a buzzword of cultural criticism, such that anything from US foreign policy to TikTok to a particular color palette can be described as "hegemonic." This depletion of meaning can itself be seen as part of the retreat of politics into culture, post-'60s. As social movements stalled out, intellectuals started out looking to the theory of hegemony for answers as to what the left could do better but gradually allowed their perspective to get more and more centered on struggle at the level of the symbolic, isolated from any movement or organizational program, as discussion of "the politics of culture" became enclosed in academia. As Craig Brandist writes, "'Hegemony' now came to describe the formation of social subjects through the articulation of social relationships, but exclusively on ideological grounds, severed from painstaking analyses of the shifting relations between class forces of the type that permeated Gramsci's *Notebooks*."[38] This trajectory can, in turn, be seen as a side effect of mainstream liberalism reasserting its own hegemony, peeling intellectuals away from street radicals.[39]

The rise of officially sanctioned forms of critical art practice might be viewed as part of an ideological displacement whereby the mantle of change-making agency was transferred from mass movements and found compensatory outlet in professional artists and cultural experts among a middle-class that preferred less raucous forms of politics, as part of what the philosopher Olúfémi O. Táíwò calls "elite capture": "the control over political agendas and resources by a group's most advantaged people."[40] Yet as Marx famously said, people make their own history, but not under circumstances they choose—and the decline of the '60s movements was an objective factor felt across society. The isolating consequences of this withdrawing tide were felt as much by those small groups of Marxist radicals who decided to "industrialize," leaving the middle-class heartlands of the New Left to preach the gospel of socialism at the point of production, as by erstwhile lefties who found their outlets as professors and artists. Thus, the very same migration of politics into the cultural terrain might also be viewed as a conservation operation, where forms of progressive and occasionally radical thought were quarantined for preservation in the face of the hostile political climate of the neoliberal period, with artists trying to hold space for the idea of progress where they could while other forms of social change were blocked—even if this happens to mean they have been preserved where they are least dangerous. Since the ability to think in contradiction is a criterion for a dialectical approach, the question of cultural politics should probably be viewed as a mixture of both at once.

The idea of the "art kettle" can be stated as an axiom: that art serves as a container to isolate dissident social energies. What I am saying is that it is important to think of the problem *non*-axiomatically. It has to be thought of historically and contextually, as a dilemma emerging from the decline of an organized left and the dispersal of its energies, not as an immutable law about culture's relation to politics. It is clearly vitally important to think through how art, by virtue of its social position, recodes politics in ways that distance it from more popular types of struggle. It is just as important not to

let navel-gazing guilty consciousness about art's contradictory social position center the conversation in a way that takes away from whatever practical support it actually can provide for nascent movements.

To return to where we started, to Brazil: Roberto Schwarz's account of the '60s gives a sense of the potential for historic failure, when the confusion of cultural radicalism with broader political momentum serves to mask mounting isolation of progressives and the left. Yet you can pass through the same historical era to find evidence of one of the most important historic intersections between the art world and mass politics via the story of Mário Pedrosa—certainly one of the most pivotal characters in the history of twentieth-century art criticism.

Born in 1900, Pedrosa holds, in Brazil, something of the status of Clement Greenberg for postwar art in the United States, with his passionate, polemical defense of experimental abstraction. Like Greenberg, Pedrosa passed through Trotskyism (the two actually met in the late '30s). In his early years, he had been a street-fighting militant of the Brazilian Communist Party, deeply immersed in its developmentalist dogma. He encountered Surrealism and the writings of the Left Opposition alike while in Europe and returned to Brazil to form its first organized Trotskyist political cell and to organize. Later, while on sojourn to the United States, he was present, under the party name Lebrun, at the founding of the Fourth International, dedicated to dissident revolutionary Marxism outside the influence of the Stalinized USSR. He then broke with Trotsky's Fourth International, too, over the organization's approach to Latin America and disagreement with the exiled Russian revolutionary's analysis that the Soviet Union remained a "workers' state," however degenerated.[41]

Returning to Brazil, Pedrosa remained a committed, romantic socialist working toward founding a mass socialist party of some kind. As a critic, his ideas about art were informed by Trotsky's rejection of socialist realism and the explicitly cultural nationalist imagery promoted by the official Communist parties in favor of championing artistic experimentation. Pedrosa's formulation, as a

newspaper writer and as the center of a network of artists and intellectuals, that art should be the "experimental exercise of freedom," helped impel the turn in Brazilian art toward Concretist abstraction and later forms of participation in the '50s and '60s, these days much celebrated. "Mário's passage through the universe of fine arts was only one of his many facets," the artist Cildo Miereles recalled. "And this passage was, let's say, a foundational experience for contemporary art. However, I see Mário as mostly a political being."[42]

As an art critic, he explored some esoteric subjects. He made a mission, for a period of time in the late '50s, of passionately advocating for the quirky, hard-to-categorize abstraction of the Swiss-born German painter Paul Klee as a better role model for progressive Brazilian modernists than Pablo Picasso (then adopted as a hero of left culture by the mainline Communist Party). You might see in these professional interests, perhaps, some of the same deflection of political energy into cultural matters that Barbara Rose once detected in late '60s painting polemics in the United States. Yet Pedrosa persisted as a much more outspokenly radical figure. The same year that Rose penned her diagnosis of Greenberg and contemporaries, in '68, Pedrosa led a protest against the censorship by Brazil's junta of a show at the Museum of Modern Art, Rio de Janiero, following the consolidation of state repression with the Fifth Institutional Act. The action triggered an international boycott and was considered enough of a black eye for the dictatorship that, in 1970, it charged Pedrosa with "attempting to slander the Brazilian military government with denunciations of alleged torture in the country's prisons," issuing a warrant for his arrest and leading him to seek refuge in Chile. An open letter, signed by international artists Alexander Calder, Carlos Cruz-Diez, Henry Moore, Pablo Picasso, Pierre Soulages, and many others (eventually published in the *New York Review of Books* as "The Case of Mário Pedrosa") called on Brazil's president to halt the persecution.[43]

In Chile during the years of upheaval around Salvador Allende's popular left-wing government, Pedrosa would dedicate himself to founding a Museum of Solidarity, with the request for contributions from international artists serving as a way to spread support for the

embattled government. In '72, he barely escaped with his life, seeking exile in France during Augusto Pinochet's US-backed coup. By the time of the waning of the dictatorship in Brazil at the end of the 1970s, Pedrosa had spent a life equally engaging in the official institutions of art and working as a political polemicist. The institutional visibility of the former sphere often served as his lifeline amid persecution. He had, by this last decade, lost the belief in the potentials of avant-garde art to be the foundation of a creative language of international solidarity that had animated his earlier writing. But he remained engaged in the problems of art. He looked to champion the culture of Indigenous Brazilians and organized art shows touting the aesthetic significance of the drawing by patients from the Dom Pedro II mental hospital in 1979.

But in these final years of this critic's energetic life, in his late seventies, the return of independent workers organizing most engaged his mind. In 1978, in his "Letter to a Labor Leader," he wrote Steel Workers' Union president Luiz Inácio Lula da Silva, who led the first strike after the official end of the Fifth Institutional Act. Pedrosa called for the formation of a new party, so that "with the struggle for the re-democratization of Brazil, a truly profound, free, clearly working-class movement will emerge—one in which all legitimate popular forces will come together within a single branch of socialism."[44] With a coalition of Brazilian labor organizers and intellectuals returned from exile, he helped found the Workers' Party (Partido dos Trabalhadores, or PT) in 1980, a year before he died at eighty-one. As Michael Löwy wrote in the late '80s, the PT's model of a "new type of party," committed to socialism but containing multiple tendencies, with a democratic and grassroots orientation and outside the orbit of Soviet Communism, was "an almost unprecedented attempt to go beyond . . . the usual models of politics within the workers' movement," and closely watched internationally.[45] Mário Pedrosa put his signature to membership card number one of the new party, which has left a vast mark on history.

I make no comment here on the adventures and misadventures of the PT in subsequent neoliberal decades of Brazil (it explicitly

reformed itself to be more social democratic in orientation in the
'90s). Nor do I wish to smooth over the edges of a complicated figure
like Pedrosa, who was engaged in many difficult questions and high-
stakes political debates in his time. Romantic hero/villain narratives
about artists or writers are to be avoided in any useful theory, and
Pedrosa himself would have been the first to admit that the relation-
ship between his work in the art sphere and as a socialist intellectual
was a complex one. "In your eighty years of life, has art always gone
alongside politics without any conflict?" an interviewer asked him in
his final years. "No, no, no, I cannot say it was a flawless romance,"
he replied.[46]

I would simply say that the case of Mário Pedrosa illustrates the
fact that the esoteric domain of museum art and its publics needn't
merely be a dead end or a distorting glass. Despite and also because
of its eccentric social position, art and its official institutions do
contain the power to incubate and sustain ideas that might matter
a great deal beyond the museum walls—though how they interact
concretely with forces beyond those walls is always of decisive im-
portance. Politics can't afford to isolate itself in culture. It also can't
afford to isolate itself from culture.

Chapter 3

The Art World
and the Culture Network

In 1914, the *New York Times* introduced a new verb, "to film," into acceptable usage: "Having gained currency, it must be graciously admitted to the language," the paper conceded, before explaining helpfully, "To 'film' means to make a picture for a 'movie' show." The *Times* writer granted that the new technology had its fascinations. But would movies ever rival the live theater, then the preeminent form of urban entertainment? "As a substitute for the theatre they will do well enough until there is a revival of real histrionics, until great actors come again to exercise their 'sway o'er hearts,'" the author postulated. The article concluded: "The vogue of the moving picture is surely at its height."[1]

In the coming decades, Hollywood film very definitively came to command the hearts of the largest mass audience and the most capitalist investment. As sociologist Jennifer Lena argues, the result was that the popular theater was forced to redefine itself via the Little Theatre Movement, rooted in a nonprofit model and with a sensibility aimed squarely at an educated middle-class audience. Instead of returning to the center of public life via "a revival of real histrionics," US theater changed to become newly arty and anti-melodramatic—the opposite.[2]

As that century-old *Times* article shows, inherited systems of prestige obscure the view beyond one's own horizon—but it is worth

trying to attain perspective, because in our own time we have been living through a major moment of changing popular expectations about culture. In the course of the 2010s, what writer Nicole Aschoff calls the "smartphone society"—the complex of new economic and cultural infrastructure grown up around the mass adoption of smartphones and the takeover of the public sphere by social media networks—reformatted social norms very broadly.[3] The mobile internet is both an unavoidable new pathway to engagement with art and a new rival to it. This has produced plenty of excitement among marketers, spawned a new ecosystem of art influencers, and elicited plenty of irritated and alarmed commentary about the culture of distraction and the trivialization of art.

Wide-ranging new technologically mediated forms of vision have the quality of what sociologist Pierre Bourdieu calls a "symbolic revolution," that is, a shift that "produces the very structures through which we perceive it," establishing "new cognitive structures, which become invisible the more they become generally recognized, widely known and incorporated by all the perceiving subjects in a social universe."[4] It is hard to recall what it felt like, not that long ago, to navigate urban space without a GPS-enabled device or to write about art without the ability to call up instantly a picture of most any work you are interested in to check its details against your memory. The technology erases its own tracks. But while the challenges that social media offers art are usually thought of either in terms of audience development for museums or artists' attempts to build visibility for their independent practices, the implications of the ubiquitous new modes of cultural circulation, mediated by commercial tech platforms, obviously run much more deeply, eating like an acid into the definition of artistic relevance itself, submitting it to new psychic pressures that need to be thought through critically.

Here, I want to retrace some (selective) incidents of art's collision with new forms of seeing and circulating images, to offer some analysis of how the last decade's flood of networked digital culture poses a "crisis of substitutability" very similar to the one early twentieth-century popular theater faced. "All this stuff out there made by

all these people is probably better than the stuff I'm making," Cory Arcangel, a contemporary artist with a knack for virality, said in a conversation in *Mass Effect*, a 2015 volume about online creativity. "How do you deal with that? That's one part of the question, and the second part of the question is where do I fit in with that, because essentially I'm doing the same thing that they are. As an artist, what is my role on the internet?"[5]

The dynamic whereby new technological advancements crowd out and displace some of the traditional, socially agreed upon functions of art, directing its energies into new types of practices, is one of the motors of artistic development. But it would be technological determinism to say that an abstract thing called "technology" caused another abstract thing, "art," to develop in any particular direction, like a natural law. Nothing prevents anyone at this moment from painting in the style of French realists from the mid-1800s or offering theatrical melodramas of the kind that drew crowds in the 1910s. Nevertheless, artistic practices compete in a social space for attention and material support, becoming more or less meaningful for different publics based on what kind of unique mission or energy they are able to embody. To chart what the last decade of change has meant for art institutions and artists, it will help first to hold in mind how the genre-bending, eclectic forms that came together to create the genre of "contemporary art," as they were forged in the 1960s and after, took some of their meaning and sense of mission from a particular cultural project that has actually been realized by the smartphone society—albeit in a perverse way.

The New Audience

That project was a form of refracted anti-elitism, rooted in making art more active and conversant with the forms of mass media that were familiar to a broad audience.

The curator and critic Lawrence Alloway is often credited with coining the term "pop art" in the 1950s. The most compelling aspect of his thinking, however, is that he didn't speak about "pop" as a *style*

of fine art. What he actually wrote about was what he called the "fine art–pop art continuum." For Alloway, the point was that the increasingly assertive creative world of postwar consumer pop culture, design, and merchandise was itself *already* creative; you couldn't create a hierarchy with "art" at the apex. It was a continuum, and a horizontal one.[6]

By contrast, the church-like atmosphere of the modern gallery and museum was designed specifically to be anything but popular. With its connotations of a world set aside from ordinary clutter, the airy alienness of the "white cube," as the critic and artist Brian O'Doherty famously termed the space of the modern gallery, had an embedded message: "Esthetics are turned into a kind of social elitism."[7] And so, the demands of radical art activists in the anti-establishment 1960s focused on making the museum less aristocratic and more accessible to a popular audience.

Importantly, it was the birth of modern mass media that created the sense that a rarified field like art could have a popular audience in the first place. Leonardo da Vinci's *Mona Lisa*, painted in 1503, was not the icon of culture that it is today until the twentieth century; it "wasn't even the most famous painting in its gallery, let alone in the Louvre," as one historian noted.[8] It was the media interest caused by its sensational theft in 1911, in the age of early newsreels and consolidating tabloid newspapers, that transformed it into the subject of public curiosity that would make it the most widely known painting in the world. "Wanted" posters appeared with *Mona Lisa*'s image throughout Paris. Newspapers offered rewards for its return. Lines of people came to the Louvre just to see the empty spot where the pilfered painting had hung.

This media circus was, in turn, the context for the most famous parody of the *Mona Lisa*, Marcel Duchamp's *LHOOQ*, the 1919 work of Dada art that took a reproduction of the now-famous image and put a mustache and a raunchy caption on it. Essentially the parodic, proto-conceptual artwork suggested that, in reproduction, the Leonardo painting had become a new kind of character, debased but also newly accessible. In the 1960s, Duchamp would become

the elder statesman of conceptual art in New York. The notion of an art spun from otherwise ordinary objects, through the power of the discourse around them, can be seen in relation to the popular, media-driven interest generated by the empty spot where the stolen *Mona Lisa* used to hang.

The next major stage in the *Mona Lisa*'s rise to world fame, in fact, came with its 1963 tour of the United States, arranged between the Kennedy administration and France's culture minister André Malraux (who himself famously wrote, in the essay "Museum Without Walls," of the ability of photographic media to make the world's treasures accessible to the masses). To this day, the tour is one of the most popular art events in US history: more than one million people filed past the painting at the Metropolitan Museum of Art in New York. Andy Warhol, characteristically, saw the frenzy not as representing the triumph of art but as representing the triumph of media spectacle within museum culture. "Why don't they have someone copy it and send the copy, no one would know the difference," he quipped, and made a tiled silkscreen canvas of the painting's image, rendering Leonardo's painting as a pop culture icon similar to his tributes to Marilyn Monroe and Coca-Cola.[9]

As artworks became celebrities, so did artists themselves. Hans Namuth's 1950 photos and film of the abstract expressionist painter Jackson Pollock flinging paint over a canvas in his Hamptons barn had captured the public's imagination about the experimental artist, transmuting his painting from a subjectless optical abstraction to the output of an intensely magnetic ritual. In Japan, the Gutai art group, founded in 1954, was inspired in part by seeing reproductions of Namuth's photos of Pollock at work. Gutai would come to place a new accent on the ceremony of creation over the art object itself, as with Kazuo Shiraga's performance-paintings that involved him acrobatically painting with his feet while suspended above the canvas, or Saburo Murakami's *kami-yaburi* (paper-breaking) works, actions where he threw his body through a series of paper screens. The experimental openness of the Gutai artists to nontraditional, everyday materials and actions correlated with a rethinking of the artist's relation to inherited

authority in post-imperial Japan. In the United States, Allan Kaprow referenced the images of Pollock painting when he coined the term "happenings," in 1959, to describe live-art events in which the actions of the artists were the art, which came to chime with the countercultural agitation against repressive '50s culture. In short, without necessarily meaning to, newly accessible and widely circulated images of the artist's life in the media not only changed the way artists were looked at, but also changed what the center of aesthetic experience itself was supposed to be—a fact worth remembering when thinking about how new and expanded media forms in our own period are altering the popular understanding of art.

The passionate popular interest in the *Mona Lisa* drew comparisons to Beatlemania, another characteristic mass-media spectacle of postwar pop culture. The degree to which artists were still by and large considered to stand in self-conscious opposition to mass culture can be summed up by the fact that when the experimental artist Yoko Ono began dating John Lennon, her New York art-world friends doubted whether the Beatle was a worthy match for her. "Yoko was a very important Fluxus artist," the performance artist Carolee Schneemann remembered. "And frankly, we all wondered if this . . . this . . . rock and roll guy was going to be smart enough for her."[10] Yet Ono herself was out to invent new forms of interactive sculpture whose mission was exactly to cut against the fussiness and priestly quality of traditional art spaces, to welcome the public in a newly active and participatory way. It was at a gallery show of her interactive works in London in 1966 that she and John Lennon met. The fact that her art's experimental quality felt in tune with the irreverence of contemporary youth culture is even a part of their meet-cute story. "There was an apple on sale there for two hundred quid; I thought it was fantastic—I got the humor in her work immediately," Lennon remembered. "I didn't have to have much knowledge about avant-garde or underground art, the humor got me straightaway."[11]

Ono created works important for the history of feminist art, performance art, and conceptual art. It is, of course, reductive to focus on her fascination as a celebrity and relationship with Lennon. In re-

tracing echoes of the '60s within the contemporary media situation, however, it's worth saying that a project like the 1969 *Bed-in for Peace*, a media stunt where Lennon and Ono held court for the press in their hotel as a protest against Vietnam, can be seen as synthesizing the conceptual-art interests in participatory theater and the body with the then new currents of pop celebrity and youth culture. It created a new form of hybrid spectacle, in other words, that played with the fluid lines of Alloway's fine art–pop art continuum and that also pointed forward to the melding of art, celebrity, PR, and politics today.

Another New York-based Japanese artist, Yayoi Kusama, pioneered her signature "Infinity Rooms" in this period: mirrored environments filled with repeating patterns of polka-dotted objects, hanging lights, or phallic forms, so that one's image appears to be melting away into infinitely repeating patterns. These represented, by her account, her personal experience of "desubjectification," the sense of psychic instability that caused her to feel like she was melting into her environment. Their aesthetic also grew out of her hard-hustling desire to become an art star, in a context where she was disadvantaged as a woman and a foreigner in the US: her art was openly exhibitionistic and hungry to plug into the language of media and New York celebrity around the early pop art scene. The installation *Kusama's Peep Show: Endless Love Show* (1966) invited visitors to stick their heads in one of two windows looking into a hexagonal mirrored room blinking with colored lights accompanied by Beatles music. Kusama photographed herself often amid her dizzying installations, her persona as a performer blurring together with her work as a sculptor in the documentation of the art. For an installation called *Narcissus Garden*, an unauthorized intervention she staged at the 1966 Venice Biennale, she sold mirrored balls for $2 apiece with a sign that read, "Your Narcissism for Sale," essentially prophesizing that the form of art with the most mass appeal would be selling the audience's own self-image back to it.

Broadly speaking, Kusama was a figure of the '60s counterculture, staging, for instance, an all-nude antiwar protest at the New Street Stock Exchange in 1968 and even presiding over what is re-

membered as the first gay wedding as an art performance for her self-created Church of Self-Obliteration. Both multimedia environments and performance had a rebel charge in a still-conservative cultural environment, a dynamic even better illustrated in Argentina by artists Marta Minujín and Rubén Santantonín, whose *La Menesunda* was staged in 1965 in Buenos Aires. *La Menesunda* was a warren-like series of immersive environments that guests made their way through: rooms stuffed with neon lights, closed-circuit TV streaming visitors' own images back to them, TVs banks playing the news of the day, and a functional beauty parlor nested inside a room shaped like a woman's head, among other things. The philosophy behind it was that rather than bowing down to artistic tradition or constructing a temple-like environment of contemplation, art should incorporate all the pressures of the present-day urban media world, distilling and exaggerating them. Illustrating once more how key the energy of pop music was to the pop art of the day (and by coincidence prefiguring *Bed-in for Peace*), one room featured a live tableau with a hip young couple lounging in bed listening to the Beatles, a scandalous collision of art and life in its moment.

La Menesunda's multimedia environment was a sensation, drawing news coverage and huge lines of stylish Argentines who were alternatively delighted and scandalized. Its aura of hedonism and media-savvy irreverence had countercultural juice in a Catholic country riven by sharpening debates about culture and morality. One year later, when military dictator Juan Carlos Onganía took power, ordinances banned kissing in public in Buenos Aires, as well as short skirts for women and long hair for men.

By the end of the decade, the program of art as media spectacle was a global phenomenon. In Japan, for the Expo '70 world fair, members of the Gutai group choreographed a massive, fantastical performance-art ceremony in a stadium, featuring men levitating on huge balloons and a fire truck spewing bubbles—interactive art as arena entertainment, which shared the program with Sammy Davis Jr., Sergio Mendes, and Andy Williams. In Vienna, in response to youth movements' questioning of traditional authority, the director

of the Museum of the 20th Century, Alfred Schmeller, took his mission to be decreasing the distance between the public and museum. He commissioned the art collective known as Haus-Rucker-Co to create *Giant Billiard* in 1970, an immense inflatable area, roped off like a boxing ring, with human-sized inflatable balls that guests could throw themselves against. It attracted enthusiastic media and huge crowds and toured to New York.

Alloway saw the 1960s as a time of tectonic shifts. Old-fashioned ideas of artists as solitary outsider geniuses were rubbing up against a new sense of visibility for art. He thought artists and critics were holding onto a kind of split consciousness. They had the righteousness of feeling committed to a form of culture that was self-consciously positioned above others (hence the Schneemann quote about Lennon) but also a new feeling of potential widespread relevance as visual art circulated before a wider and wider public. For his part, Alloway thought we should junk the pretensions of purity and enjoy surfing the "fine art–pop art continuum." He considered this ecumenical mindset more egalitarian, mixing high and low culture into fun new combinations without the "dogmatic avowals of singular meaning and absolute standards" of traditional elite culture.[12]

Marxism and Media Critique

While these developments toward experimenting with media may now seem like an alibi for commercialism, it's worth stressing the degree to which they were once charged with a radical sense of political optimism, a point best illustrated by the approach to art and media in Marxist art critic John Berger's 1972 *Ways of Seeing*. The slender tome, based on a BBC series of the same name, became, in the decades after its broadcast and publication, a foundational work of cultural studies for generations of students, with its clear, critical, socialist-feminist approach to European fine art. *Ways of Seeing* was, above all, an attempt to extend the anti-authoritarian energies of the 1960s into the project of demystifying aesthetics. Berger thought that the preachiness and preciousness around fine art was used ideo-

logically to whitewash the past that produced it. In key aspects, *Ways of Seeing* is about the democratic potentials of mass media for making the classics accessible to the average person, by allowing images to slip free of the stilted atmosphere of the museum and be reintegrated into life.

Alloway, in helping to promote and theorize pop art, had spoken of something he called the "tackboard aesthetic," that is, art woven from culling and collaging images from the wider popular culture rather than simply engaging with the symbols and techniques handed down and approved by established art history. As art historian Julian Myers explains of Alloway's concept, "Artists ought no longer go up against the best art of the past, in patriarchal, diachronic competition with a pantheon of legitimated foes . . . but would instead participate—horizontally and synchronically—in an expanded pan-disciplinary field. Accept this new situation with clear eyes and artists might finally exit the smoky Bohemian café and emerge into the cosmopolitan common culture."[13]

In *Ways of Seeing*, Berger would echo this idea, now giving it a form that made even more utopian promises while also sounding amazingly prophetic of contemporary media:

> The means of reproduction are used politically and commercially to disguise or deny what their existence makes possible. But sometimes individuals use them differently.
>
> Adults and children sometimes have boards in their bedrooms or living-rooms on which they pin pieces of paper: letters, snapshots, reproductions of paintings, newspaper cuttings, original drawings, postcards. On each board all the images belong to the same language and all are more or less equal within it, because they have been chosen in a highly personal way to match and express the experience of the room's inhabitant. Logically, these boards should replace museums.[14]

This personal sorting of images sounds very much like the absolutely familiar, everyday functionality of any number of image-sharing apps now. What made the vision seem like a cause to take up in 1972?

For its original viewers, the subtext of *Ways of Seeing* would have been clear when it was broadcast on BBC Four: it was a leftist response to another documentary, *Civilisation: A Personal View* by Kenneth Clark, which had aired in 1969. Clark, an art historian of formidable erudition and communicative gifts, had, during World War II, been director of Britain's National Gallery, where he created a program that tried to use the museum's cargo of imperial treasures to rally the nation to defend its heritage. He understood well the ideological role that museum art could play as propaganda, and *Civilisation* was an exercise in the fusion of mass media and aesthetic mythmaking with a mission.

Civilisation's sweeping, thirteen-episode tour of the masterpieces of European art also had a specific ideological point relating to the politics of the late 1960s. It was against the cresting tide of the era's unrest and counterculture—the *Bed-in for Peace* was the same year—that Clark was raising the great, timeless tradition of Europe's high culture as a bulwark. *Civilisation*'s first episode, "The Skin of Our Teeth," begins just after the fall of Rome, which is not a coincidence. "In the last few years," Clark told the viewer, gazing into the camera, "we've developed an uneasy feeling that this could happen again, and advanced thinkers, who even in Roman times thought it fine to gang up with the barbarians, have begun to question whether civilization is worth saving."[15] It is clear that the "barbarians" are the 1960s youth movements and that the "advanced thinkers" were the day's radicalized intellectuals.

After its tour of European cultural glories, from the Italian Renaissance through Modernism, the series ends with Clark's plea that "order is better than chaos," "human sympathy is more valuable than ideology," and—casting a bright light on the message for the present—"above all, I believe in the God-given genius of certain individuals, and I value a society that makes this possible."[16] The ideological message the series presented for the study of the art of the past was, in other words: *Respect your elders.*

Ways of Seeing was meant as a rebuttal to such bromides. That is why it begins as it does: in the first episode's deliberately provocative

opening seconds, Berger stands in front of a replica of Botticelli's *Mars and Venus* and slashes it open. Kenneth Clark disdained intellectuals who sided with the "barbarians"; Berger derided art critics who "are the clerks of the nostalgia of a ruling class in decline."[17]

In the final moments of the first episode of *Ways of Seeing*, Berger gives a monologue that serves as his own manifesto to the viewer:

> Remember that I am controlling and using for my own purposes the means of reproduction needed for these programs. The images are like words but there is no dialogue yet. You cannot reply to me; for that to become possible within the modern media of communication, access to television must be extended beyond its narrow limits. Meanwhile, with this program, as with all programs, you receive images and meanings which are arranged. I hope that you will consider what I have arranged, but be skeptical of it.[18]

Berger painted contemporary media's potential, in relation to the culture of his day, as half realized. It had opened up the means for people to see that cultural meaning was not given once and for all by authority. Appropriated as images, artworks could be remixed and filled in with your own meaning—but private ownership of media capital made it so that the voice of the owners and the experts still dominated.

Within the limits of what was possible with media at the time, Berger and his team for the BBC show attempted to model their ideal of conversational media within the series itself. The most famous segment of the program is episode 2, which makes the argument that the tradition of the nude in European art is less exalted than it appears, often a pretext to render women as sexual property for the pleasure of an implied male viewer.[19] Midway through the episode the camera cuts from Berger's video essay to a panel format, where a group of women put the art-historical question in the context of the women's liberation movement, speaking about personal experiences of sexist objectification and self-scrutiny. The episode, however, gives the last word to the socialist-feminist art historian Anya Bostock, who abruptly turns the conversation deep into art history, to a detail of *The Allegory of Good Government* (1338–39) by Sienese artist Ambrogio Lorenzetti:

There are some paintings, I think at this moment of one in particular, where there is a woman wearing a garment . . . that is so loose, so comfortable, so easy, and it is my idea that it is very much a picture of what a picture for women might be like. . . . It's a fresco, it's very, very old. It's a picture of a woman who is supposed to represent Peace. . . . She could be one of the liberated, or trying to be liberated, young women today. She is at ease, she is relaxed, she is not playing any part at all. She is able to combine pleasure with thought and with dreaming, and she might spring into action at any moment. For me, she has much, much more to do with nakedness, with the truth about oneself, than any number of nudes that I have seen.[20]

You have to appreciate how jarring, on one level, this claim is from a strictly art-historical point of view. An image by a late-medieval male artist, meant to make a female figure into an allegorical symbol, is read as an icon of women's liberation from the male gaze. And yet this was exactly part of Berger's point about the potentials of media to liberate art from the sense of being tied to an original meaning: the ability to talk back within and through the media might give art's images new life, he thought, opening them to new audiences and giving them new meanings. Whereas the flattening of a painting to an image and recaptioning it to make a contemporary point sounds like the most basic meme-making operation now—and indeed there are any number of social media accounts and whole books that do just this to famous paintings—here the notion still had a touching idealism to it. But this had everything to do with the kind of power that *Ways of Seeing* was meant to argue *against*, how the prestige of art and the invocation of cultural authority interlocked with authority more broadly understood.

From Touring Blockbuster to Media Stream

Where do we stand now in relationship to Berger's themes? The most obvious difference is that Kenneth Clark-style cultural politics have been reduced to an extreme minority position. He was already

fighting a rearguard action: when Clark says defiantly, in the closing minutes of *Civilisation*, that he is going to reveal himself as a "stick-in-the-mud," most viewers today are very likely to agree.

Museums themselves pivoted away from Clark-style connoisseurship. In Berger's earlier, 1966 essay "The Historical Function of the Museum," he recounted a scheme proposed by a French curator: "The museum of the future will be mechanized: the visitors will sit still in little viewing boxes and the canvases will appear before them on a kind of vertical escalator. 'In this way [the curator wrote], in one hour and a half, a thousand visitors will be able to see a thousand paintings without leaving their seats.'"[21] Though this sounds suspiciously like the scene in Stanley Kubrick's film *A Clockwork Orange* where the criminal protagonist is strapped down and his eyes wired open to be reprogramed, it was imagined as an optimistic vision, a solution for how to open the museum's riches to a broad public via technological wizardry.

Of course, such technology was neither practical nor truly desirable. Instead, faced with popular demands of a newly plugged-in post-'60s media sensibility and the increasing economic demands of the crisis-wracked '70s, the major museums turned themselves into conveyor belts of culture in a different way: via a focus on temporary shows of world treasures and name brand European Modernist heroes. Rather than passive storehouses of culture, museums became "active" sites where new attractions regularly arrived. In the 1970s, the highly hyped and merchandized "blockbuster" exhibition arrived, most famously in the touring show of the treasures of King Tutankhamun, which crossed the US from 1976 to 1979 and became a pop culture sensation. Lines stretched for hours; kids bought sleeping bags that looked like sarcophagi; vendors hawked women's T-shirts with "Keep Your Hands Off My Tuts" printed across the bust; comedian Steve Martin satirized the ultra-commercial spectacle with a novelty song on *Saturday Night Live*. *Treasures of Tutankhamun* vaulted the *Mona Lisa* to become the Metropolitan's biggest-ever show. Museums turned toward such touring spectaculars to draw big crowds, trying to justify their existence amid the

changing culture, as less buttoned-down Baby Boomer sensibilities went mainstream.

"The capitalist achievement does not typically consist in providing more silk stockings for queens but in bringing them within reach of factory girls," libertarian guru Joseph Schumpeter once said.[22] When art observers repeat the historical demand today that we bring "art into life," convey "art to the masses," or somehow "democratize the art market," this missionary imperative seems to me to ignore the degree to which that particular demand has *already* been fulfilled—just not in the form that critics imagined. "Art for the masses" already achieved a perverse consumerist fulfillment in the museum gift shop, offering a poster for every dorm room, a print for every price point.

For contemporary artists, the idea of opening up the media was still a kind of visionary horizon of cultural radicalism. In 1974, the "video sculptor" Nam June Paik, known for creating installations of stacked TV monitors, wrote a paper for the Rockefeller Foundation called "Media Planning for the Postindustrial Society," credited with coining the term "information superhighway." He proposed a vision of an immense public works project to lay down the network infrastructure to make the transmission of video easy and widely available, predicting teleconferencing. Paik thought such a vision would bring a whole new kind of democratic aesthetic to mass media: "Eventually, telecommunication will cease to be only an ersatz and a lubricant to keep the gears running. It will become our springboard for new and surprising human endeavors."[23]

But it was in the emerging technology industry, not in art, where the utopian ideas of media theory were absorbed into the mainstream of capitalist life most fully. "Ready or not, computers are coming to the people," Stewart Brand, the progenitor of hippie lifestyle manual the *Whole Earth Catalog*, wrote in *Rolling Stone* in 1972, the same year as *Ways of Seeing*.[24] The mid-'70s would confirm this prediction with the arrival of the personal computer. Brand would explicitly frame consumer technology as picking up the revolutionary aspirations of '60s cultural radicalism:

The early hackers of the sixties were a subset of late beatnik/ early hippie culture; they were longhairs, they were academic renegades, they spelled love l-u-v and read *The Lord of the Rings* and had a [worldview] that was absolutely the same as the Merry Pranksters' and all the rest of us world-savers.

But they had a better technology. As it turned out, psychedelic drugs, communes, and Buckminster Fuller domes were a dead end, but computers were an avenue to realms beyond our dreams. The hippies and the revolutionaries blew it, everybody blew it but them, and we didn't even know they existed at the time![25]

As Fred Taylor documented in *From Counterculture to Cyberculture*, by the '90s, Brand and the cadre of counterculture refugees around him were celebrated as thought leaders in Silicon Valley. *Wired* magazine, which styled itself as doing for technology what *Rolling Stone* had done for rock, embraced his "world-saving" vision of better living through technology.[26]

In 1995, Microsoft mogul Bill Gates's autobiography, *The Road Ahead*, imagined a device called Interactive Home Systems, which would fulfill the functions of the encyclopedic museum—but now as home entertainment. It resembled, in its prototype form in the Gates household, a bank of TV monitors that sounded very much like one of Nam June Paik's video sculptures. "If you're a guest," Gates wrote, "you'll be able to call up portraits of presidents, pictures of sunsets, airplanes, skiing in the Andes, a rare French stamp, the Beatles in 1965, or reproductions of High Renaissance paintings, on screens throughout the house."[27] This scheme foretold the collapse of different levels of culture into a single on-demand media space—but even in the 1990s it remained pretty far out. The idea didn't catch on. (Eventually Interactive Home Systems pivoted and was rebranded as Corbis, the stock photo archive, later purchased by Getty Images.)

When art historian Thomas Crow published *The Rise of the Sixties* in 1996, a book about the influence of the experimental art movements of the eponymous decade, the first page claimed the following: "In any large European or American city, intrigued audi-

ences in the tens of thousands find themselves drawn to exhibitions of this same difficult art in both its past and present incarnations. If much of the work on show nevertheless remains puzzling and remote to those without a secure initiation in the ways of the art world, it is because that wider audience lacks a useful explanatory narrative."[28] Two things are notable about this quote today. The first is that the kind of experimental media traditions that were first explored by '60s artists still remained fundamentally at odds with audience expectations about what you might find in a museum. The second is that the museum, despite the public's perceived incomprehension, retained its role as a cultural gatekeeper. The institution could expect the audience to come even if they didn't have "a useful explanatory narrative." Museum attendance in the United States peaked in the 1990s.[29]

The next year, internet-based art was first inserted into a major art show. Curators of documenta X, the tenth iteration of an important exhibition in Kassel, Germany, faced the problem of how to present it. They settled on an office-like environment of dedicated computer stations. At the time, this alien presence caused a prophetic shiver of anxiety to run through the space that presaged the erosion of the museum as an attention center. As art critic and curator Domenico Quaranta explained, "The internet connection was often seen as an open invitation to the user to leave the work, go and check her email, or, even worse, to freely surf the internet."[30]

From Art World to Culture Network

When Apple launched the iPhone in 2007, it asked the contemporary artist Christian Marclay to use a fragment of his art piece *Telephones* (1995), a video collage that spliced together footage from throughout film history featuring telephones, to market the device. Marclay said no, and so, infamously, Apple simply made its own version of the concept for its debut iPhone commercial. This shows how little respect the tech giant had for the intellectual property of artists, even as it vigorously policed its own. In another way, this incident is also a symbol of how the advent of ubiquitous digital tools

would redistribute communications power and thereby change expectations about media and art. *Telephones* was a clever idea in its moment, remixing film history in a new and quirky way. Now it resembles a simple supercut, a term coined in 2008 by Andy Baio to describe the genre of video that you find littered throughout YouTube and other social media channels, splicing together disparate clips on a common theme, for instance, every utterance of "I'm not here to make friends" from reality TV shows or every instance of "Nicolas Cage Losing His Shit" on camera.[31]

When it was launched, the iPhone was referred to by gadget enthusiasts as the "God Device." Another decade on, and the capacities of the mobile internet have become such an ordinary fact that it is hard to recall something like it was envisioned as a utopian outcome for culture not so long ago. Ubiquitous screens have made it so that the new video culture Paik envisioned is here: the average person consumes more than twelve hours of media each day, a staggering total that is possible only because people are often consuming multiple streams at once. Whatever is in front of you, there is always something potentially more interesting available at the swipe of a finger—French stamps, Renaissance paintings, potential hookups, candy-based slot machine apps—so that one's immediate social reality is always competing with the entire world's resources of entertainment, news, and information. Berger's prediction that a newly accessible form of media "should replace museums" seems no longer to be a romantic horizon of possibility. It's a reality that people literally carry with them.

In many ways, the empowered amateurism of present-day online culture seems a realization of many of the utopian hopes of a previous period. Yet this has happened even as the political ideal those hopes were connected to has receded from view. Berger erred in thinking that collective *authorship* would be a possibility opened up by a socialist project of collective *ownership* of the media. All this sharing, searching, and remixing may undercut certain functions of some big corporations, but it is also brought to you by other, even more massive corporations, whose algorithms and profit motives set the fundamental parameters of digital life. Meanwhile, while tra-

ditional cultural authority has been liquidated, it turns out capitalism doesn't need patrician figures nattering on about the value of respecting "real culture" to buttress its moral authority. Instead of extoling "civilization," power has gotten on just fine celebrating "innovation" and the promise of consumer novelties as a new ideology.

A sharp tendency in one direction tends to produce a counterpressure in the other. Thus the emergence of ubiquitous internet undercuts the power of old professional gatekeepers like museums, curators, and critics. Almost anyone with wifi and a device can enter the conversation as a creator or commenter. But the very flood of images and communication that social media enables requires new tools to navigate, search, and sort. The tic of online writing toward lists and rankings is a symptom of how culture is experienced as a sublime mass of information in need of some kind of filtering and structuring.

The implications of this for the internet's cultural potentials were not immediately clear. As late as 2012, the Marxist art critic Julian Stallabrass could conclude that the internet was mainly an optimistic and unalienated alternative to the mainstream art system, on the old utopian lines:

> The super-rich dominate the mainstream image of the art market, just as they do much to control the political agenda. Yet huge and diverse realms lie beyond the culture and the politics of this tiny elite. The years of the art boom were also those of social media, as millions started to show their photographs, videos, writings and art online. Many of them found that it is not so hard to make things that look like contemporary art. Another reflection—complex, contradictory, vulgar and popular, and in some respects less desolating—lies there.[32]

What had not become clear yet was that the flip side of the new and greater *freedom* for creative expression on the internet is the new and intensified *alienation* of creative expression on the internet, expressed as the intensified quantification of quality. While theoretically anyone with a data plan and adequate time can "make things

that look like contemporary art," the price of admission is that every image, comment, or post is constantly being submitted to scrutiny as to how it stacks up to everything else in terms of its popularity metrics, in newly vivid and public ways, and often in baldly numerical terms of likes, shares, comments, or real-time traffic rankings.

The effects for art are neatly illustrated by the career of Jonah Peretti, the prime mover behind the creation of both HuffPost and Buzzfeed, two of the companies that helped redefine culture on the internet in the 2010s. In the 1990s, a young Peretti had styled himself a postmodern critic of the emergent commercialization of the web, looking to Marxist thinkers like Fredric Jameson and Martha Rosler and queer theorists like Judith Butler. He saw appropriation art as a strategy for cultural liberation that web culture could take advantage of, using examples including "Warhol's soup cans" and "Duchamp's ready-mades" as embodying strategies for "dissociating advertising images from consumer products" to disrupt the top-down power of media, offering ways to "challenge capitalism and develop alternative collective identities"—a distant echo, again, of *Ways of Seeing*'s idea of a new kind of cultural dialogue.[33]

In 2001, at grad school at MIT and riding the energy of the anti-globalization movement, Peretti got his first taste of the limelight after attempting to subvert Nike's sneaker customization service by requesting a shoe emblazoned with the word "SWEATSHOP." Nike declined. Peretti sent his email exchange with the shoe giant to a few friends. It spread quickly and became a sensation. He theorized about the experience in an essay in the *Nation* called "My Nike Media Adventure," lauding the emerging activist power of what he called "micromedia" to reshape the public sphere. "My guess is that in the long run this episode will have a larger impact on how people think about media than how they think about Nike and sweatshop labor," he concluded. The experience of the political power of email forwards led Peretti to coin his own term: "contagious media." The term caught on.[34]

Shortly after the Nike incident, Peretti joined the art-and-technology incubator Eyebeam, founding the Contagious Media Lab.

In 2005, he and his sister, comedian Chelsea Peretti, had a show at the New Museum, also called "Contagious Media." The show celebrated the viral culture artifacts of the day, like the "Dancing Baby" meme, the "All your base are belong to us" meme, and Hot or Not, a website that allowed you to rate people by attractiveness (a prescient inclusion, as it would turn out to be the template for the creation of both YouTube and Facebook, which were about to reshape the sphere of communication). It also included squirm-inducing projects from the Perettis about white liberal tone-deafness about race (*Black People Love Us!*, 2002) and sexual harassment (*The Rejection Line*, 2002). "As art works, contagious media projects recall experimental television of the 1970s, which engaged audiences by infiltrating and subverting public television broadcasts," wrote curator Rachel Greene. "[They also have] a strong relation to the identity-based and political artwork of the 1980s such as the works of American conceptual artist Adrian Piper."[35]

The show was not well reviewed. Still, a conference accompanying the "Contagious Media" show attracted artists, designers, and creative directors, all trying, as NPR explained at the time, to crack "the science of goofy stuff on the Web."[36] Jonah Peretti also took the occasion to organize the Contagious Media Showdown, placing web-art projects in head-to-head competition with each other to see which could spread fastest. The satirically loutish winning entry was a line of GPS-enabled women's underwear that you could connect to your computer ("including cell phones!"): the Forget Me Not Panties. Its website racked up 615,562 unique visitors during the showdown. Two days after the Contagious Media Showdown ended, Peretti helped launch Huffington Post: a website model powered by celebrity, political sentiment, high volume, and low-to-no pay for writers. One year after that, he founded Buzzfeed, a site that would specialize in mining the web's momentary fascinations for entertainment, originally just an algorithm to sniff out what was popular.

The advent of viral web culture was thus very specifically experienced as simultaneously carrying the energies of contemporary art's critical program of opening up the museum *and* submitting aesthetic

value to new standards of quantification and flattening. "If you want to look at the entries as art or entertainment or social commentary, it is possible to think a project is great, even if it is not popular," Peretti explained candidly during the Contagious Media Showdown. "But for the showdown the ultimate yardstick is traffic."[37]

It had always been part of Lawrence Alloway's theory that the circulation of ideas and images of art was as much a part of the aesthetic experience as the in-person encounter with art: "It is not possible to restrict the meaning of a work to its literal presence," he wrote.[38] In 2008, artist Marisa Olson coined the term "post-internet art" to suggest that artists who were digital natives didn't view the web as any less real a venue than physical space. Another artist, Artie Vierkant, penned a manifesto, "The Image-Object Post-Internet," explicitly framing this mindset as developing the conceptual-art theories from the 1960s about art as information: "In the Post-Internet climate, it is assumed that the work of art lies equally in the version of the object one would encounter at a gallery or museum, the images and other representations disseminated through the Internet and print publications, bootleg images of the object or its representations, and variations on any of these as edited and recontextualized by any other author."[39]

But the realities of contemporary media also put these various faces of experience in competition with one another, with culture designed to circulate online better optimized to practically compete for attention. The details of an artwork's "literal presence"—actually going to see art at a museum or gallery, the subject of traditional critical writing—are reduced to a kind of "local news" status, compared to its significance as part of the more general circulation of images. And in journalism, digital media has been particularly ruinous for coverage of the local: "There's a crisis in local news, and I don't know what the solution is," Peretti said in 2019. "The internet favors global news because if you make a piece of content that people can view globally, that's just a much bigger addressable audience than if you make a piece of content that only people in one neighborhood care about."[40]

A viral hit of early 2019 was the Instagram account @world_record_egg, featuring just a single post of an unremarkable, speckled

brown egg framed against a white background. It rocketed to fame, becoming the all-time most-liked post of any kind on any social media platform. Viewed through an art lens, the great @world_record_egg incident of 2019 could be read as a kind of "people's conceptualism." Social media had made once-experimental art ideas into a kind of cultural commonsense: the pointed ordinariness of the egg could be seen as a largely unconscious update of the found objects of Duchamp or Warhol—or of Ono's *Apple* (1966), the conceptual humor of which John Lennon had connected with—just as social media could be seen as realizing the old dream that everyone could be an artist.

But this same episode also neatly illustrated how the very platforms that allowed this elevation of the everyday and distribution of media power also embedded new types of alienating pressures into the everyday lives of their billions of users. The caption that propelled the egg to fame was this: "Let's set a world record together and get the most liked post on Instagram. Beating the current world record held by Kylie Jenner (18 million)! We got this." The massive (if momentary) interest that the egg triggered was thus explicitly framed as an exercise in competition, and widely viewed as a kind of absurdist rebuke to the hold that Jenner and other celebrity mega-influencers had accrued over the cultural hive mind.

Instagram, in particular, has been criticized for creating feelings of inadequacy and envy by encouraging competition through aestheticized social performance.[41] The success of the lovably ordinary @world_record_egg was a kind of response to that sense of artifice and antagonism, the new dominance of the image over its felt reality. The same year saw the "Time Well Spent" movement gain traction in Silicon Valley, with the giants of platform capitalism suddenly expressing publicly that they would take measures to make their products less addictive—a suggestion of just how widespread anxiety about their impact had become. Indeed, the creators of the egg account eventually partnered with Hulu to make a public service announcement about the mental health effects of social media. "Recently I've started to crack. The pressure of social media is getting to me," the unhappy egg quipped in the resulting video, before offer-

ing places to seek help for depression and anxiety.[42] (Art historical legend has it that Hans Namuth's star-making photo-session with Jackson Pollock also triggered a spiritual crisis for the artist, making him feel like a phony and contributing to the alcoholic relapse that ended in his fatal 1956 car crash.)[43]

From Art Museum to Art Attraction

"For today's audiences, the definition of culture has democratized, nearly to the point of extinction," a Culture Track study from 2017 on the state of culture explained. "It's no longer about high versus low or culture versus entertainment; it's about relevance or irrelevance. Activities that have traditionally been considered culture and those that haven't are now on a level playing field."[44]

Such flattening has a suspicious resemblance to the effects of capitalist globalization and information technology on labor markets, where the disruption of traditional industries is pushed as a dogma and local borders no longer defend workers from competition from half a world away. But the new situation might also be thought of this way: If you take seriously the idea that the smartphone supersedes and disperses the classical promise of the museum as a gateway to both aesthetic experience and knowledge, then the core cultural dynamic today is no longer one of museums nominating what is important culture for their viewers; it's museums competing to try to get viewers to nominate them as important culture. At the beginning of the 2010s, museums were still trying to curb phone use and picture-taking in the galleries. By the end of the 2010s, museums were begging audiences to share pictures of their shows under dedicated hashtags, the vast majority falling comically flat in the virtual scrum. A label at the Museum of Fine Arts, Boston in 2017 summed up the new mindset: "If you don't share a photo from this exhibition, did you really visit?"

Museums increasingly encountered the need to compete as "experiences," a term whose very generality expressed the flattening cultural space. "I think if the art museum industry does not follow the

lead of other industries, there is a looming crisis in which galleries full of the world's truly greatest creative art will be empty," museum director Charles Venable said in a 2018 interview. "And that is not going to happen here." Venable oversaw the rebranding of the Indianapolis Museum of Art as Newfields: A Place for Nature and the Arts. The refreshed identity promoted the institution less as an arc of important cultural history and more as a hub for leisure, focusing on attractions like artist-designed mini-golf, a beer garden, Christmas light shows, and an outdoor nature park—a family-friendly version of the fine art–pop art continuum. In 2020, he shocked critics with the announcement that he would remove a floor of contemporary art to make way for a walk-in Vincent van Gogh-themed immersive light environment (before being forced to step down after posting a job announcement for the museum that referred to the need to preserve the institution's "core white audience"). But Newfields's proposed transformation was, it turned out, riding a wave in culture far larger than any one institution: no less than five separate companies competed in 2021 to open Van Gogh-themed projected light environments in pop-up spaces across the United States, largely outside of museums.[45]

Meanwhile, the most important US museum, the Metropolitan Museum of Art, set a string of attendance records in the 2010s, but this success reflected the "level playing field" described by the Culture Track survey in its own way: in 2018 the Met at last bested the all-time attendance record for a single exhibition, held since 1979 by *Treasures of Tutankhamun*, via its focus on fashion with *Heavenly Bodies: Fashion and the Catholic Imagination*.

The major institutions of art are nonprofits. Since profit is the motor force of a capitalist world, museums do not tend to be at the leading edge of cultural innovation. Their structures are relatively inflexible, sustained by elite patronage. The most thoroughgoing shifts capturing new "multimodal" cultural expectations logically began at the edges of art rather than at its center, with the creation of new kinds of endeavors and an aesthetic style some marketers call "artertainment," and that I call Big Fun Art—the *dominant* trend in visual art of the second half of the 2010s. (Indeed, it's a testament to its importance that, even in the

face of the need to social distance, investors doubled down on their bet on "experiences" in the midst of the 2020 pandemic.)[46]

In 2016, the art collective Meow Wolf opened its first environment, *The House of Eternal Return*, in a rehabilitated Santa Fe bowling alley, with seed capital from George R. R. Martin, author of *Game of Thrones*. Emerging from the New Mexico business accelerator Creative Startups, the Meow Wolf collective produced an explicitly for-profit theory of art experience, arriving at their attraction by market research into what made the most money in the larger contemporary museum ecology, which turned out to be children's museums. "What we did was focus on kids, because the admissions-based market is driven by kids," Meow Wolf's founder and director explained. "We also didn't want to alienate adults and teenagers so we still stayed true with very mature themes inside our exhibit."[47]

The result is a creatively conceived, artist-designed interactive haunted house, full of tricks, secret passages, tactile attractions, and eye-popping props. A pulpy sci-fi backstory suggests interdimensional travel, providing a loose explanation for the magic caves and futuristic tunnels you access by popping through the fireplace or refrigerator. Meow Wolf's lore is fantastical and imaginative but also resonant enough with familiar pop themes to be accessible to a broad audience. By mid-2018, a million people had visited *The House of Eternal Return*—more than six and a half times the number of people who live in Santa Fe County. Describing itself as an "Immersive Experiences Company," Meow Wolf has metastasized into a larger phenomenon, spinning off new environments in other cities—which is what you would expect, as the imperative of capitalism is growth, and this is a form of art installation unhooked from nonprofit restraints.

Drawing similar levels of attention, the Japanese art collective teamLab specializes in interactive light environments. I became aware of them in 2016 when they opened the exhibition "Living Digital Space and Future Parks," a timed-ticketed experience that the Pace Gallery held in a Menlo Park, California, building that used to be a Tesla showroom. Not only did it offer multiple immersive environments where digitally rendered flowers seemed to bloom around you

and you could traverse app-controlled glimmering light fields, it featured a separate children's section, allowing kids to scan in a drawing to make it seem as if it were swimming through a projected underwater environment. "This is not art" was the self-described reaction of Marc Glimcher, Pace's head, upon first seeing the collective's work,[48] but he came around to embracing these high-tech "future parks" as a new business line for the gallery, launching Pace Superblue in 2020, wholly dedicated to promoting immersive interactive art.

Takashi Kudo, one of teamLab's principals in Tokyo, has said the insight for founding the group came from a trip to the Louvre and the unpleasantness of being jostled by people jockeying to get a picture of the *Mona Lisa*. "The relation between art and people was one-by-one," he explained. "[teamLab's] artwork makes viewing collaborative."[49] The result is industrial-strength art specifically engineered for the swarming experience that culture has become in the age of mass tourism. Its interactive experiences have begun to dot the globe; teamLab Borderless, a dedicated, museum-like experience in Tokyo featuring its trippy light environments, attracted 2.3 million visitors in its inaugural year, making it, the group claimed, the most popular museum dedicated to a single artist in the world, topping Amsterdam's Van Gogh Museum.[50]

That claim, however, stretches the definition of "single artist" to the breaking point. There is a striking parallel at play across these two flagship Big Fun Art phenomena, as the collective nature of the art experience implied by their environments is mirrored back onto the identity of the art-makers themselves: art collectives scale into experience corporations, with both Meow Wolf and teamLab employing teams of hundreds of people (in 2020, amid the chaos of the pandemic, Meow Wolf's staff unionized.)[51] The Big Fun Art style alludes to the aura of museum art but doesn't need its distracting authorial concerns. By design, it requires no historical knowledge and context to be enjoyed. In effect, what these initiatives have opened up is an intermediate cultural niche between the scrappy experimentation of Minujín and Santantonín's *La Menesunda* and the imagineered thrills of Disney's Haunted Mansion.

These para-artistic cultural attractions realize Alloway's borders-blurring '60s sensibility more natively than traditional museums. They also better realize his concern with the circulation of images as being as key to the aesthetic experience as the in-person experience itself. Just as, in the '50s, increased access to the images of artists at work inspired new forms of art, in Gutai and happenings, that were all about the spectacle of artists in action, ever more ubiquitous smartphone and photo sharing have led to the creation of environmental art that stands essentially as stage sets for photographs and videos, with the locus of aesthetic experience moving away from the experience of "literal presence" to how they serve as a backdrop.

Sharing photos has become the main driver of the outside-the-home experience economy, and by 2019, social media advertising had become a more important channel to reach culture consumers than print, according to Culture Track.[52] It was, fittingly and tellingly, the spectacular rediscovery of Yayoi Kusama's mirrored art installations on Instagram that was the most visible symbol of the new interpenetration of art and social media. In 2017, the Hirshhorn Museum in Washington, DC, leveraged the mania around its show of Kusama's mirror rooms to increase its membership by 6,000 percent.[53] Tickets for museum shows sold out almost immediately, and new Kusama mirrored environments at galleries attracted hours-long lines of people waiting for a slot of anywhere from a minute to thirty seconds— just enough time to take a photo or two of one's own image framed by the glimmering environment.

Because the primary channel for experiencing art is the social media feed and not the museum, the hunger for this style of engaging visual environments exists indifferent to any allegiance to the institutional art context. Branded experiences (like the art/sponsored-content hybrid known as "29Rooms," made up of creator-designed selfie environments, launched as an annual attraction in 2015 by the website Refinery29) competed with retail spaces looking to refashion themselves as "experiences" to get some advantage over online shopping (like the Museum of Feelings, a pop-up series of environments designed as an ad for Glade scented candles in 2015, which summoned massive lines

and won awards for the marketing firm Radical Media, which created it). These, in turn, competed with the various new para-art pop-ups that now go head to head with museums for the adult-theme-park dollar, like the for-profit chain of immersive digital art galleries Artechouse or the Instagram experience Museum of Ice Cream.

At the very same moment that Indiana's Newfields ditched the "museum" label, the touring juggernaut that is the Museum of Ice Cream took it over. It is an attraction that quite literally aspired to be the visual equivalent of junk food, featuring various ice cream–themed environments tailor-made for selfies. Founded in 2016, the "museum" quickly became a serious force to be reckoned with: At one point, Instagram said that it was the tenth most photographed "museum" in the world, up there with the Metropolitan Museum and the Louvre—its signature pool filled with plastic ice cream toppings in the same league as the *Mona Lisa*.[54] In the early twentieth century, the advent of modern mass media had created the space for Leonardo's painting to become a popular icon and object of mass pilgrimage. The smartphone society's decentering and redistribution of media power created new icons and changed the face of cultural authority that would feel meaningful to push against.

Accelerated Media / Slow Art

One of the most celebrated artworks of the 2010s was Christian Marclay's *The Clock* (2010). Like his earlier *Telephones*, it cut together footage from throughout film history. The difference was how it related to time: here, each clip featured someone looking at a clock, synced up so that each moment corresponded exactly to the actual moment of the day that you were looking at it. You were experiencing cinema exploded, then reassembled into a new synthesizing structure. *The Clock* took the fragmented, decontextualized, atemporal way media had come to circulate in a post-internet media context and rewired it to reconnect with a sense of continuity and an experience of presentness. Its effect was inseparable from being with it in the moment. The magic trick was rewarded with huge popularity wherever it went

in the years after it was released. It suggested that the same forces that pressed toward a more and more decontextualized and dispersed consumption of culture also created an increased hunger for rooting experience in a specific, special time and space as a counterpoint.

I said at the start of this essay that one of the forces pushing cultural development has been the way in which changes in technology take over some of the traditional functions of art-making, forcing it to place value on new types of propositions. A logical question at this juncture, then, might be how artistic sensibilities are being displaced onto new terrain. In an influential 2013 lecture, the art historian Jennifer Roberts wrote of the value of a particular assignment for students: picking a single artwork at a museum and spending "a painfully long time looking at that object" (her suggestion was three hours). Artworks steeped in older ways of making served, in her estimation, as an ideal training instrument for a deliberately decelerated perception: "what students learn in a visceral way in this assignment is that in any work of art there are details and orders and relationships that take time to perceive." She wrote:

> During the past few years, I have begun to feel that I need to take a more active role in shaping the *temporal* experiences of the students in my courses; that in the process of designing a syllabus I need not only to select readings, choose topics, and organize the sequence of material, but also to engineer, in a conscientious and explicit way, the *pace* and *tempo* of the learning experiences. When will students work quickly? When slowly? When will they be expected to offer spontaneous responses, and when will they be expected to spend time in deeper contemplation?
>
> I want to focus today on the slow end of this tempo spectrum, on creating opportunities for students to engage in deceleration, patience, and immersive attention. I would argue that these are the kind of practices that now most need to be actively engineered by faculty, because they simply are no longer available "in nature," as it were. Every external pressure, social and technological, is pushing students in the other di-

rection, toward immediacy, rapidity, and spontaneity—and against this other kind of opportunity. I want to give them the permission and the structures to slow down.[55]

This is what you might call the "quiet car" program for the art institution. Thus, even as they were challenged to compete as social media attractions, museums in the 2010s also tacked on "mindfulness" as a side mission. An international "slow art" day, proposed as an analogy to the "slow food" movement, has been promoted since 2008 to encourage deep looking. Museums like the Tate Modern in London have embraced "slow art" tours, and MoMA promotes a web series on "Artful Practices for Well-Being." In essence, these fitful experiments attempt to reinvent the art experience around the very priestly, solitary, and contemplative values that the 1960s artists were rebelling *against* for their association with a conformist, repressive authority. "A new minimalistic material dimension is emerging that defines new habits . . . yet distinctly recalls much older kinds of minimalism," critic Alessandro Bava wrote in a 2020 essay on the resurgence of interest in the simplicity of Shaker design. He pointed to the "explosion of spiritual practices such as mindfulness . . . that have arisen in response to the extreme demands of cognitive work and the commodification of affect and emotion."[56]

A turn to such spiritual practices was, of course, another facet of 1960s counterculture in general and emerged as the counterpoint to the era's acceleration of media. The Beatles, seeking some spiritual grounding to buffer their hectic experience of mega-celebrity, ended up exploring Transcendental Meditation and popularized the interest very widely in the process. In the early '60s, before his turn to liberation through the personal computer, Stewart Brand was an associate of a San Francisco art group called USCO (the "Us Company"), which mixed multimedia installation with mysticism. Fred Turner describes a 1965 performance by USCO called *We R All One*, which

deployed slide and film projections, oscilloscopes, music, strobes, and live dancers to create a sensory cacophony. At the end of the performance, the lights would go down, and for

ten minutes the audience would hear multiple "Om's" from the speakers . . . the show was designed to lead viewers from "overload to spiritual meditation." In the final moments, the audience was to experience the mystical unity that ostensibly bound together USCO's members.[57]

In 1996, even as Brand's vision of world-saving networked technology was diffused into the lingo of technology entrepreneurs, he, inventor Danny Hillis, and musician Brian Eno started promoting the Long Now Foundation, which proposed building an enormous "10,000 Year Clock," sited within a mountain in West Texas and designed to function for millennia. Explaining the mission of both clock and foundation, a manifesto stated that

> civilization is revving itself into a pathologically short attention span. The trend might be coming from the acceleration of technology, the short-horizon perspective of market-driven economics, the next-election perspective of democracies, or the distractions of personal multi-tasking. All are on the increase. Some sort of balancing corrective to the short-sightedness is needed—some mechanism or myth which encourages the long view and the taking of long-term responsibility.[58]

Some of the most visible trends of the 2010s can be understood as reflecting this contrapuntal aesthetic. A surge of interest in 1960s Light and Space artists like James Turrell and Doug Wheeler marked the decade, for instance. Their installations were explicitly meant to provide decelerated experiences of duration and perception. Wheeler's *Infinity Environments*, including a room with no corners so that you seemed to float in a placeless volume, deployed precision engineering to plunge viewers into a sense of spectacular under-stimulation. Another big trend was the rising interest in Marina Abramović, who graduated from performance artist to guru with her "Abramović Method," a pseudo-ritualistic discipline described as "an exploration of being present," involving such exercises as resting one's head on a crystal while wearing noise canceling headphones. "The most straightforward task such as walking or breathing becomes a means through which partici-

pants can hone perception and investigate their individual mental and physical limits," a teaser explained.[59] An even more pointed hunger for an alternative consciousness was expressed in the popular fascination with rediscovering the art practices of historic female artists who worked as mediums or in occult traditions, including Hilma af Klint, Cameron, Georgina Houghton, Emma Kunz, and Agnes Pelton.

Like Marclay's *The Clock*, each of these examples both reacted against the ubiquitous demands on attention and also surfed the wave of the expanded image universe and field of culture. Critics have often rebuked the Light and Space artists for creating art that resembled works of high-tech design. Their spacey environments were a central influence on the new Instagram Trap attractions in the first place, which freely pillaged Turrell and Wheeler for design ideas. Marina Abramović's invented self-help rituals are perfectly consonant with an arty performativity that blurs seamlessly into social media exhibitionism and have been a popular prop for fashion influencers and celebrities looking to distinguish themselves in a clogged media ecosystem. And the new interest in occult spirituality, rather than representing a wholesale dropping out of the attention economy for less surveilled, secret offline spaces, was impelled by a flourishing community of "business witches" on social media platforms, displaying spiritual wares, sharing spells, and touting services.[60] That very active community not only further mainstreamed once far-out New Age beliefs but also greatly swelled interest in the recovery of historic spiritualist art at museums.

Nevertheless, the texture of these accumulated artistic examples suggests that, in response to over-stimulation in terms of inputs, imagery, and data, some portion of popular interest in aesthetic experience is migrating away from the examination of images, objects, or even performances and toward self-reflexive scrutiny of the quality of one's own consciousness and experience. This new sensibility has a social justice dimension, as in artist Tricia Hersey's The Nap Ministry, an initiative that advocates for rest as a racial justice issue, working, as its website says, through "performance art, site-specific installations, and community organizing to install sacred and safe spaces for the community to rest together."[61] It also has a rather

bourgeois dimension, in what the writer Kyle Chayka calls the "culture of negation": "a body of cultural output, from material goods to entertainment franchises to lifestyle fads, that evinces a desire to reject the overstimulation that defines contemporary existence," characteristic of a "millennial-yuppie cohort" and expressed in the rage for isolation tanks, sound baths, decluttering as a form of self-help, and a pervasive spa aesthetic.[62]

Just as Big Fun Art mainly started outside of traditional museums, so, too, the new interest in deceleration has been most eagerly claimed as a mission outside of art institutions, whose post-'70s business model relies on mass tourism and blockbusterization. Instead, the need for psychological breathers has found its most visible cultural rejoinder in the surging popularity of meditation and mindfulness practices, which mushroomed in the 2010s into a billion-dollar industry, even as museums struggled to redefine their pitch to an audience. Silicon Valley entrepreneurs, steeped in the ambient belief that technology inherits the utopian mission of connecting the world and unleashing individual liberation, now teach their own children meditation and send them to schools where screens are forbidden.[63] To some extent, deluxe meditation retreats and mindfulness conferences have displaced the function that being seen at the opera or museum gala once held for bourgeois high culture, providing signifiers to cement a common sense of cultivated identity and redemptive mission (as *Wired* put it, of one such meditation confab, it is "a networking opportunity with a light dressing of Buddhism").[64] The categories of taste, distinction, and exclusivity seem to be re-creating themselves along this fault line, which passes outside the art institution proper as gatekeeper.

Stress and Struggle

"As the world bifurcates into fast and slow lanes, museums will have to find temporal or spatial ways to accommodate different paces," the Center for the Future of Museums argued already back in 2015.[65] The upshot is that the 2010s saw contemporary art stretched be-

tween two poles: a deepening demand to compete for attention and a deepening demand to define an alternative form of consciousness. It is useful to define this fracture, because it has real consequences in terms of art's relation to its audience. But the sense of this angst about the powers that rule our cultural life dead-ends into a false choice if it is just seen as a dialogue between fast versus slow, technological versus spiritual, to be solved by picking one or the other.

Focus, attentiveness, and self-awareness are surely powerful coping tools for buffering the stress of relentless competition baked into digital life—as, indeed, is Jennifer Roberts's program of deep looking. But they can easily become individualistic boutique forms of opting out of problems whose roots are in political economy and whose solutions are in collective action. "The risk is that meditation can be misused as a numbing agent—a way of making yourself more productive at the thing that is causing the world pain," reporter Andrew Marantz writes, describing the popularity of spiritual retreats at the Esalen Institute (founded in 1962) among elite technologists.[66] Or as Ronald Purser puts it, "Mindfulness can be used for nefarious purposes when divorced from a larger ethical framework and deployed as a self-help technique that reinforces the atomization of individuals—relaying an implicit ideological message that the stresses and anxieties we experience are due to our poor lifestyle choices and mental ruminations, as opposed to the structures and environments in which we live and work."[67]

At the other pole, facing the grinding anxieties of cultural display within platform capitalism, John Berger's *Ways of Seeing* remains relevant, despite the fact that the relation of culture and power today has so dramatically shifted from when he was writing and broadcasting. It is true that Berger didn't anticipate how completely consumer technology would absorb and commodify the idealism of participatory culture, which he had seen as naturally radical. But at the same time, when it came to criticizing the culture of consumer capitalism, his emphasis was on reading its psychic effects politically, and this remains a vital perspective.

When I think of the "envy spiral" of Instagram, the sense of toxic competition social media welds into culture, the transformation

of image production and sociality into a technologically mediated contest, I think of Berger's socialist reading of how capitalist advertising sells the concept of "glamor." Whatever is dated in *Ways of Seeing*, this passage probably could have been written today (if you can forgive the use of the male pronoun):

> Glamour cannot exist without personal social envy being a common and widespread emotion. The industrial society which has moved towards democracy and then stopped halfway is the ideal society for generating such an emotion. The pursuit of individual happiness has been acknowledged as a universal right. Yet the existing social conditions make the individual feel powerless. He lives in the contradiction between what he is and what he would like to be. Either he then becomes fully conscious of the contradiction and its causes, and so joins the political struggle for a full democracy which entails, amongst other things, the overthrow of capitalism; or else he lives continually subject to an envy which, compounded with his sense of powerlessness, dissolves into recurrent day-dreams.[68]

The technological society that has made plausible the promise that everyone can be an artist but then transformed that into a new instrument of alienation is one ripening toward a crisis. In the end, that angst will connect with a new political project, or the fantasies it generates will turn ever more poisonous and compulsive.

Chapter 4

AI Aesthetics and Capitalism

As Big Tech unleashes artificial intelligence (AI) on the world in ever more efficient and intrusive ways, the question of how it affects artists may seem to be the least of our worries.

Yet, as author Margaret Boden long ago pointed out, the dream of AI-generated art has animated this entire field of research since the very beginning: "The proposal that led to the famous 1956 Dartmouth Summer School often remembered as the time of AI's birth mentioned 'creativity,' 'invention,' and 'discovery' as key aims for the newly minted discipline."[1] And as AI has touched unnerving new heights of sophistication in the last decade, the idea recurs again and again in the literature that when it can be taught to display humanlike creativity, it will have passed some very fundamental test.

"Art" stands in symbolically for the parts of cognition that do not seem machine-like. Getting a robot to master building an IKEA chair is actually a very complex technical challenge, but it does not trigger the uncanny thrill of unnerved excitement that the idea of an AI generating new compositions in the style of Bach, as Google's cutesy Doodle, its first powered by AI, did with ease in March 2019. New experiments in "AI art" are cropping up now with numbing regularity.

Faced with examples of AI art-making, the critical impulse is either to fall back into metaphysical assumptions about the ineffably unique, inviolably human qualities of "real" creativity or to nitpick each new creation's failures as "proving" that AI will never

master "real" art. Whether or not you agree with Google head Sundar Pichai's declaration that AI is more important to human history than the invention of fire or electricity, its advances are introducing very fundamental questions about work, creativity, representation, and agency.[2]

Some of the functions that are now served under the heading "art" *can* and *will* be displaced and taken over by some form of AI. It is urgent that the conversation move from whether it will create "art" to what kind of art it will create and how it does or does not fit with what we want art to be. And above all, as I will lay out in the points below, it is worth understanding how AI aesthetics are shaped by the specifically instrumental assumptions about art that capitalism bakes into this conversation.

Point 1: *The Balance of Forces Between Art and Technology Does Not Favor Art*

To begin with the promise of AI for art, let's consider two projects.

The first is by the art historian Aby Warburg, the *Mnemosyne Atlas*, his attempt at an "art history without a text." Unfinished at the time of Warburg's death in 1929, the *Atlas* consisted of sixty-three panels, on which he laboriously organized sequences of close to one thousand black-and-white reproductions depicting works of art and images from popular culture. His goal was to capture the growth and death of what he called "pathosformel," the visual motifs embodying the deep structures of human experience, which he saw as existing within and beyond traditional narratives of art history. On his bulletin board, Warburg clustered evolutionary strings of seemingly unconnected images according to themes like "Ascent to the Sun," "Nymph as Guardian Angel and as Headhunter," and so on.

Now consider Google Culture Institute's initiative known as *X Degrees of Separation*, released a few years ago. From the vast library of images of art that the programmers have acquired from museums around the world, you are offered the ability to pick any two works of art. Its algorithm thinks for a second, then calls up a series of

other images from its archive, using them to visually connect the two artworks you selected. The result looks like a logical evolution, but the links in the chain are forged of connections conjured by the machine's understanding of visual logic, which are often pleasantly unexpected.

Thus, when I selected Raphael's *Madonna in the Meadow* (from the Kunsthistorisches Museum in Vienna) and a photo of a 2013 "Soundsuit" sculpture by the Chicago artist Nick Cave (from the Baltimore Museum of Art), *X Degrees* created a visual pathway that passed through a Giulio Romano *Madonna and Child*, a Cranach *Pieta*, an Eliot Porter picture of crab legs, and a Wangechi Mutu painting of a bust made of amoeboid, collage-like forms. It reworked art history into this quirky new visual path in seconds.

If we compare these two projects, what new connections do we make? Warburg's visual *Atlas* has inspired fields beyond art history and generated an endless stream of interpretive hubbub—but it has also come under criticism. The connections it proposes are what art historians call pseudomorphic ("an apparent but groundless formal analogy"); the notion of an unconscious language of images is both too subjective and too universalizing to mean anything. David Freedberg writes that in Warburg's *Atlas*, "the images have little of their original force, and in their servitude to a curious kind of genealogical encyclopedism, all are strangely and improbably drained." Warburg's "art history without a text," he concludes, embodies "the etiolation of contemplation that is implicit in the modern multiplicity of images"[3]—an even more apt description of *X Degrees*, where you are explicitly encouraged to see images of artworks as arbitrary visual assets, links in a chain of visual associations that happen entirely outside of your own cognition.

Yet Warburg's passion project has had a tremendously long afterlife, whereas the Google experiment, with its incalculably greater powers of connection, feels amazing the first time you do it, amusing the second, and arbitrary every time thereafter.

The *Mnemosyne Atlas* has a fascination akin to those boards that the detective hero is always maniacally working on in movies, charting

the web of connections between incidents and players in a far-flung plot. More than that, its allure is clearly what is most at a right angle to the superhuman efficiency of its AI-enabled descendant: Warburg's quirky esotericism, the strange Jungian poetry breaking down and re-assembling art history according to poetic archetypes. These insert a level of fanciful interest back into the space cleared by its otherwise neutralizing "encyclopedism." At any rate, Warburg's imagination gives the mind more to dwell on than the mission Google Cultural Institute director Amit Sood offered when pitching the experiments to *Wired*:

> People have too myopic a view of what art and culture is. For some people, a very long curatorial narrative on impressionist art will not work. But if I say: hey, you want to see what bling used to be like in 1800? I think there's a lot of opportunity for disruption, for changing people's minds.[4]

Instead of proposing hidden depths, the explicit goal is to reduce all of art history to surface. Indeed, Sood's rhetoric implies that art history is getting in the way of people's appreciation of art, that the old-fashioned attachment to context and narrative is ripe for Silicon Valley disruption.

Such was also true of the output of the Metropolitan Museum of Art's 2019 "The Met x Microsoft x MIT" initiative, "a two-day hackathon session to explore how artificial intelligence could connect people to art." The results, as you might expect of a two-day collaboration, were not XPRIZE material but did include a fun application called Gen Studio. The site pulls up pictures of six different artifacts from the museum's collection: ewers, goblets, purses, armor, and the like. Click on any point in the screen between the arrangement of six objects, and a picture of an invented object is generated, formed from a synthesis of their visual properties—a new, never-was treasure. Click on a different spot between the artifacts, and their attributes are re-mixed in a different way, adding a little more of one and a little less of another based on how far away you are, creating another art-historical mutant. The results are weird and cool. They are also meaningless.

Visual interest would not necessarily be first on the list of why any of these artifacts was collected in the first place. Only when you look at the image for a moment do you see the slightly wonky character of the form, the bubbles and imperfections pocking the pale blue glass, marking it out as being definitely preindustrial. In this case, the goblet hails from Cyprus during the Late Imperial or Early Byzantine period. Today, its pathos is all about that handcrafted quality, as a record of the human effort to wrestle a useful design from molten glass at a distinctly different technological moment.

Today, one takes for granted—to the point of not even being able to see that it is a specific, technologically conditioned idea—that one object can look almost exactly like another, that cups can be punched out, again and again, all cleanly echoing the shape of some original design. In the Met goblet, you see the tangible evidence of a material culture that didn't even yet have the idea of perfectly replicable, machined forms, which then throws into relief an assumption that you might not have even known you had. And yet Gen Studio's machine vision treats this image in a way that completely pushes vision in the other direction. In fact, it takes the power of replication to a new level, even eliminating the need to scrutinize the object in order to abstract its visual properties.

As Sood might say, the goal here would seem to be to use engaging digital techniques to interest a tech-savvy public in art. But while I've given some historical details about this one particular glass goblet, the truth is that I had to work to find these: it's not easy to find data about the background of the source artworks from the Gen Studio site. That fact—that digging up the basic art historical context is relatively difficult while conjuring up glitchy new treasures is as easy as a single click—is very much a representation of the balance of forces between art and technology. AI is unleashed on art even as art's biggest institutions haven't solved basic problems about how to present and promote their historical collections online. This fact may seem incidental, but technological change is "path-dependent"— future conditions will be shaped by foundational choices in ways that can't be undone. And the products of the

present balance of forces are likely to serve as propaganda for very sophisticated uses of technology, but a very rudimentary idea of art.

Point 2: The Dominant AI Aesthetic Is Novelty

In the last few years, Generative Adversarial Networks, or GANs, have fired the imagination of the art-AI conversation. The setup is ingenious once you understand it. It involves two competing neural networks. One, the "discriminative network," has access to a data set: say, pictures of sunflowers. The other, the "generative network," is tasked with trying to create something that resembles the source material blindly. Each time the "generator" spits out a picture, the "discriminator" gives it a signal that is either encouraging or discouraging, depending on how well it matches the qualities of the original pictures of sunflowers. Repeating the operation many millions of times, the generative network "learns" how to create, from nothing, something that fits the characteristics of the source dataset, without copying it: seemingly random, fresh pictures of sunflowers. It creates something new, like but not of the original. It therefore seems to work the way a human artist would work if you told it to "draw me a sunflower."

Computer scientist Aaron Hertzmann bluntly calls such exercises "glorified data-fitting procedures"—in effect, the old idea that a team of monkeys with typewriters would eventually bang out Shakespeare has become an actual form of art.[5] Even so, the results can be spooky both in spite of and because of the strange results. It was a GAN that allowed the French art collective Obvious to create *Edmond de Belamy* (2018), the first artwork created using AI to be featured in a Christie's auction. Printed on canvas and put in a gold frame, it resembles a smudged, ghostly picture of a man and is "signed" by the formula "min G max D x [log (D(x))] + z [log(1 - D (G(z)))]," a shorthand for the algorithm that "authored" it. It was made with a reference set of fifteen thousand portraits fed into the "discriminative network"; the collective selected one of the most convincingly interesting images dreamed up by the "generative

network." In truth, as digital art advocates were quick to point out, this was a relatively primitive exercise relative to where the field already was at—though this fact didn't stop the novelty from selling for close to half a million dollars, briefly touching off talk of "GAN-ism" as an art movement.

Still more attention has been garnered by Ahmed Elgammal, head of Rutgers University's Art and Artificial Intelligence Laboratory, which has experimented with Creative Adversarial Networks, or CANs, a different spin on the GAN idea. The insight of this type of process is that GANs, by their nature, are only accidentally creative, since they are trying to match a source set to come up with the closest thing to a copy. The CAN therefore recalibrates the way its discriminative network works, signaling that the generative network has succeeded if it yields an image that gets close to the properties of the source set, but penalizing it if it gets *too* close, placing a premium not just on fidelity but originality. Having generated various works of abstract art using the system, Elgammal and his team claim that in online slideshows, humans can't tell the difference and sometimes prefer abstractions generated by their program, which they call "AI-CAN," to the work of real human artists. He boasts that viewers even describe AI abstractions as "having visual structure" and being "inspiring" and "communicative"—faint praise, but a feat all the same.

I'll set aside any objections I have to the actual visual qualities of AICAN's art. What I think is most illustrative about Elgammal's CAN idea as an example is that it is premised on an explicit theory of aesthetic value that can be judged. Promoting the AI art revolution in *American Scientist*, Elgammal explains:

> When designing AICAN, we adhered to a theory proposed by psychologist Colin Martindale. He hypothesized that many artists will seek to make their works appealing by rejecting existing forms, subjects, and styles that the public has become accustomed to. Artists seem to intuitively understand that they're more likely to arouse viewers and capture their attention by doing something new.
> In other words, novelty reigns. . . .

At the same time, AICAN adheres to what Martindale calls the "least effort" principle, in which he argues that too much novelty will turn off viewers. This careful combination ensures that the art generated will be novel but won't depart too far from what's considered acceptable. Ideally, it will create something new that builds off what already exists.[6]

Elsewhere, Elgammal and his co-thinkers draw on Daniel Berlyne, the twentieth-century progenitor of cognitive aesthetics. The key, for Berlyne, was the "Wundt curve," an inverted-U graph, suggesting that artistic pleasure first gets more intense as a given sensory variable increases and then drops off and becomes negative with further increases. The way Elgammal uses it, an experience has aesthetic value if it is novel but not too novel; the ideal artwork hits the sweet spot in between.

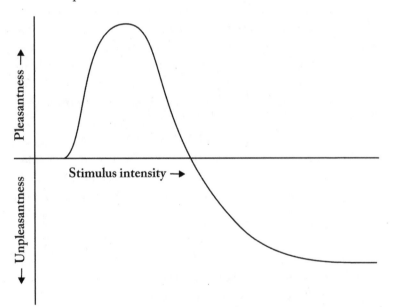

The Wundt curve (Berlyne 1960)[7]

Others in the field have criticized Berlyne for reducing aesthetic effect to the single factor of "hedonic value"—the measure of how

arousing something is to the nervous system. And even by the standards of Berlyne's own theory, which described how pleasure came from "collating" multiple values—of which novelty was just one—Elgammal's statement that in art "novelty reigns" is rather narrow. Nevertheless, introducing a discrete amount of pleasant novelty into an environment definitely is *one* function of artworks. This is one of the traits of appealing décor, for instance, and it is not impossible to believe that an algorithm could be calibrated to solve that particular problem. Indeed, in 2019, when Elgammal made the passage from the university laboratory to a start-up called Artrendex that provided "artificial-intelligence innovations for the art market," his business partner, art adviser Jessica Davidson, conjured a vision of taking over the market for hotel and office art. "Given enough data about user preferences for visual images," an article in the *Atlantic* explained, "AICAN and its cousins could, in theory, deduce the hippest looks for the next season, and Artrendex could create and manufacture low-cost editions suitable for hanging in guest rooms or office lobbies."[8] This is a hilariously vulgar vision for the application of cutting-edge art technology, but it seems perfectly plausible. Can AI exceed humans in generating original abstract art that's good enough to hang above the bed at a DoubleTree? Why not?

"The algorithm favors generating more abstract works than figurative ones," Elgammal writes. "Because it's tasked with creating something new, AICAN is likely building off more recent trends in art history, such as abstract art, which came into vogue in the 20th century."[9] A better way to think about this might be to say that *all art history is abstract for AICAN* and kindred types of AI art. The history of art is conceived of as a set of patterns to be apprehended and varied, independent of the original contextual significance of its symbols. AI-based abstract art appears to sidestep the question of social meaning by removing us from recognizable subject matter. But it's worth asking whether this is an adequate theory of how abstract art has functioned historically.

As art historian Leo Steinberg once observed, mid-century formalist criticism of US abstract expressionist painting by the likes of

Clement Greenberg framed advances in painting as "a kind of design technology," adding, "It is probably no chance coincidence that the descriptive terms which have dominated American formalist criticism these past fifty years run parallel to the contemporaneous evolution of the Detroit automobile."[10] This formalist rhetoric may well have left behind the impression that "abstract art" is amenable to technological emulation, as little more than the pleasing variation of colors on canvas.

Yet, as art historian Darby English has noted, "You can't get to the reality of abstract art without engaging the discourse of abstract art, which, ironically, is the most discursive art of the modern era."[11] What kinds of narratives art viewers brought to abstraction greatly affected how it was valued. Even for the ultra-formalist Greenberg, an elaborate narrative about how the history of art was one of progressively shedding subject matter for pure form lent his advocacy of postwar abstract expressionism a sense of historical mission. For his archrival, Harold Rosenberg, the term "action painting" offered an alternative system of value. "What was to go on the canvas was not a picture but an event," Rosenberg wrote, seeing each individual painting as being about how an individual human being confronted the problem of leaving a mark.[12]

Making something pleasant out of abstract shapes and colors, after all, is not that hard ("my child could do that" is the most stereotypical reaction to abstract painting, making it particularly amusing that it is now a domain AI is looking to conquer). Rosenberg's criticism identified quality within abstract painting with the signs that the artist had struggled to make something individual, singular, humanly intentional at the edge of randomness and entropy. His particular aesthetic theory was thus imprinted with the pathos of the era's existentialist philosophy, viewing abstract art as an expression of the attempt to wrest human meaning from the meaningless, to reclaim a sense of self-determination from a mechanistic universe.

We need not, here, endorse any one of these critical narratives about abstraction. The point is that without these frameworks for un-

derstanding the historical and social significance of art, these famous paintings of the '40s and '50s would have been neither more nor less moving than designer Raymond Loewy's boomerang-patterned Formica countertops of the same era—or a randomly selected Photoshop color gradient today.[13] If you cut away the layers of debate and criticism about what the art means, you don't just have a more efficient route to the same kind of experience; you have eliminated part of what made abstract art a passionate interest for its audience in the first place.

Point 3: AI Art and Contemporary Art Have Opposed Theories of Substitutability

About the same time that Rosenberg wrote "The American Action Painters" in the early 1950s, the computer scientist Alan Turing was theorizing his famous "Turing Test" in the paper "Computing Machinery and Intelligence." The test was based on a Victorian party game, where a person stood behind a curtain and participants would have to guess whether they were talking to a man or a woman, based on how they answered written questions slipped to them. The key benchmark for Turing was whether a computer would be able to achieve a simulation of humanlike communication (via a text-based interface) convincing enough that someone interacting with it could not tell whether they were engaging with a human or a machine. Similarly, with the slideshows that ask you to distinguish between human- and AI-made art, aesthetic success is measured by convincing the viewer that humanlike creative subjectivity has manifested— that AI art "looks like real art." Thus, the principle of *substitutability* governs a lot of thinking about value within the field of computer creativity.

What fascinates me about the Turing Test as an artistic measure is that much of contemporary art theory is founded on exactly the opposite assumptions about substitutability. The philosopher Arthur Danto, in his 1964 paper "The Artworld," took the example of Andy Warhol's *Brillo Box (Soap Pads)* (1964), a pop-art sculpture that re-

sembles a stack of the brightly colored boxes of a household clean-
ing product. Nothing, Danto claimed, distinguished the outward
experience of Andy Warhol's sculpture from the actual packaging
of something you could buy in a supermarket. What did this sub-
stitutability mean? Rather than suggesting that identical outward
appearance proved that the two images had the same artistic val-
ue, à la the Turing Test, Danto took *Brillo Boxes* as a philosophical
proof that something *more* than just appearance determined how we
understand and perceive art. For Danto, the substitutability meant
that the outward visual form of the artwork was less important than
the symbolic world around it that made sense of that form. "To see
something as art requires something the eye cannot decry—an at-
mosphere of artistic theory, a knowledge of the history of art: an
artworld," he wrote.[14]

This argument may sound mystifying. It is really just a way of
recognizing that the same symbol in different contexts can mean
different things depending on who is using it, the way a rose can be
a symbol of romance or of socialism (or, in very specific contexts,
of both). Knowledge of the world around an object makes us feel
connected to it, causing different aspects to stand out as meaningful.
In Danto's example, it tells us whether to view the boxlike object in
question as disposable product packaging or to be amused (or exas-
perated) by the deadpan simulation.

While experiments show that people can be fooled by AI art
creations, they also show that just thinking an artwork is generated
by a computer causes people to view it as less pleasant—even if they
are, in reality, looking at the exact same image labeled differently.
Composer David Cope created a program that could generate in-
finite—and quite credibly appealing—brand-new compositions in
the familiar styles of Chopin, Mozart, Vivaldi, and so on; he named
it Experiments in Musical Intelligence, or Emmy for short. In 2004,
after a quarter of a century honing his creation, Cope destroyed
it, deciding that its output would never be taken seriously. "Since
1980, I have made extraordinary attempts to have [Emmy's] works
performed," he said at the time. "Unfortunately, my successes have

been few. Performers rarely consider these works seriously."[15] (He has since continued with a new and improved music generator, which he calls "Emily Howell.")

Bob Sturm, a scientist who helped create an AI that generates new versions of traditional Irish folk music, launching the new genre of "machine folk," tells an anecdote:

> The *Daily Mail* once wrote an article about our work, and they included a video—30 seconds of it—and asked what people thought. And the comments said things like, "Oh, this music sounds mechanical, robotic—it's cold and lifeless." But what the *Mail* actually excerpted was a traditional tune—they took the wrong segment—so they actually did a good thing in a sense, showing the bias people have against machine music.[16]

Such results are akin to those of studies of forgeries and counterfeits, where people rate works they are told are fakes as being less pleasant to be around, even if they are actually looking at an original that has been labeled a forgery.[17] An air of exasperation pervades a lot of the literature about this particular effect, as if the scientists were rolling their eyes at the uninformed public's irrational biases. Yet these findings only reveal that the general audience's way of processing art is a great deal less formalist than that of the scientists.

Classical music, for instance, is the best possible example of an art form where canon formation is very important, where knowledge of the finer points circulates as social currency. If its devotees have a deeply invested relationship with specific works in the repertoire that they return to over and over, with a knowledge of the history of how they have been interpreted, taking pleasure in knowing what exactly makes a great performance of a given work, then the idea of new, cloned variations naturally runs counter to that form of pleasure. For its part, Irish folk music is fun to listen and dance to, but its pleasure is also connected to associations with community and tradition and identity that are lost when you become aware that its outer forms have been mapped and remixed as a simulation.

Point 4: AI Aesthetics Are Most Effective Where
They Are Most Convenient for Capitalism

Given how fast technology is spitting out new wonders, it's worth stepping back from any specific avatar of AI aesthetics to wonder where they are heading. It is a bit silly to say that "AI will never make real culture" when all the resources of the capitalist "culture industry" are focused exactly on the creative operation that AI does best: analyzing what is already known to be popular, then slightly varying its pattern—sometimes very, very slightly—to create a marketable new version of the same.

Sociologist of science Harry Collins argues that we should be less worried about "the singularity"—the mythical point when machines become super-intelligent—and more concerned with what he calls "the surrender." "Much worse, and much more pressing, than the danger of being enslaved by enormously intelligent computers," Collins writes, "is our allowing ourselves to become the slaves of *stupid* computers—computers that we take to have resolved the difficult problems but that, in reality, haven't resolved them at all."[18] The major pitfall, for Collins, lies in the way in which AI simulates aspects of thought or functions of society that are "good enough" that we allow ourselves to forget how, beneath it all, their super-intelligent capacities merely conceal or even accentuate existing human problems. Infamously, predictive policing and sentencing algorithms are sold as a way to remove human bias, but the datasets they draw on are already shaped by racist policing practices. They provide a solution that is "good enough" to generate the semblance of technocratic objectivity while at the same time creating a feedback loop, so that previous racial profiling generates future racial profiling.[19]

It is worth considering the implications of AI aesthetics with Collins's warning about "the surrender" in mind. On one level, AI excels: analyzing existing features and qualities of past artworks and generating new versions of the same. On another, it is inept: grasping aspects of artistic cognition that pertain to historical significance and social meaning. Arguably it is the second level that determines

which types of artistic newness feel really significant and which feel merely like trivial novelty—but this fact shouldn't be too comforting. Margaret Boden talks of the "superhuman human fallacy"—that is, the tendency to dismiss the creativity of AI because its products don't always summit the heights of human creativity, despite the fact that most *humans* don't summit the heights of human creativity.[20] Most people can't make music like Mozart or rap like Rakim, and if they tried, the results would be just as historically inconsequential and botched as a lot of AI efforts.

The vast bulk of cultural consumption is about having something "good enough" to pass the time, not about transcendent aesthetic experiences. Pop music, franchise cinema, airport paperbacks, TV, and most big video games are *already* made using extremely simple formulae and basic elements, endlessly combined in "new enough" ways. The promise of AI aesthetics is to speed up this process dramatically, while redefining what an aesthetic object is in the process. According to this logic, no body of work that brings you pleasure need ever be considered a finite resource. If you want a new song that sounds like the Beatles or a new painting that looks like Basquiat, these are ultimately relatively trivial problems to solve.[21] One futurologist promises "AI characters and plot lines created on demand, anywhere, for anyone, at almost zero cost."[22]

Pornography has historically been the first-use case that opens new technological frontiers, and so it is in this case. Since the AI-enabled "deepfake" pornography that drew tons of media coverage when video first circulated of *Wonder Woman* actress Gal Gadot spliced into an adult film in 2017, copious amounts of media commentary has dissected the privacy implications, even as the genre has mushroomed. The technology makes it almost certain that users will be able to expect the ability to see anyone whose face is online engaged in any kind of sexual act, on demand.

The writer Chelsea Summers interviewed Jessica Stoya, an adult actress and founder of experimental adult site ZeroSpaces, about the potentials of the technology. "I could be making zero-risk intense porn scenes with this technology," Stoya enthused. "Synthetic

pornography" also expands the creative potentials of adult film, she thought: "We could do whatever we want and not be limited by the range of what a human body can handle." On the other hand, Summers reports, she also admitted its potential abuses:

> Stoya imagines a hypothetical performer, Suzy Bangmycheeks, who decides to quit the porn industry. "One of Suzy Bangmycheeks' fans just can't get enough of her," Stoya proposes, "and he starts making synthetic porn. Now she's trying to move on, but it looks like she's still releasing content all the time. And she's not profiting. She's being exploited."[23]

Suzy Bangmycheeks represents the fate of the artist in this equation. Power dynamics tip sharply toward the consumer and away from the producer; or, rather, AI aesthetics enshrine what is called the "prosumer" at the center of culture, that is, the consumer whose customization or participation creates the object in their own image. Artists invest a lot in specific bodies of work, making specific decisions about what makes a given piece a successful version of their creative vision, ending a series when they think they have said enough—but the post-AI point of view enshrines the "consumer sovereignty" valued by capital at the heart of creative experience, treating as an inefficiency any resistance to having work limitlessly permuted to meet the desires of new audiences.

Despite this potential for mass instant personalization, the AI-enabled aesthetic experience is also more *impersonal*. It outsources the function of imagining to a black-box algorithm. The creative act here is weighted toward what Elgammal calls "pre-curation" and "post-curation"—selecting the set of inputs you want AI to try to distill and then the outputs that best fit your desired version.[24] This certainly opens up new possibilities for creators. But all the tendencies of capitalism push toward expanding consumption and making us more and more dependent on large corporations. In a situation of intensive corporate control over the attention space, the dominant application of AI for culture is most likely refining ways to make our entertainment feeds more addictive—encouraging us to graze on the

"new enough" permutations of things we like while companies come up with new and better ways to anticipate our desires in order to feed us more things, as with procedurally generated videogames that create infinite levels so you never run out of game to explore, already widely available.

Here, it's worth shifting to the other end of the spectrum, from adult entertainment to children's entertainment, to get a glimpse of the near future. Also in 2017, YouTube Kids was flooded with complaints about its children's channels; its autoplay algorithm was connecting preschoolers to disturbing videos, some made by sadistic trolls deliberately trying to freak out toddlers.[25] Some of these videos seemed themselves to be algorithmically generated, with simple nursery-rhyme narratives and popular cartoons automatically mixed and remixed to create a limitless stream of children's entertainment, until Peppa Pig found herself in surreal or creepy company. "Algorithms are not a substitute for human intervention," an alarmed child advocate told the *New York Times*, "and when it comes to creating a safe environment for children, you need humans."[26]

Yet, as unsettling as the idea of machines exposing children to the dark side of the internet is, the more prosaic issue highlighted by the episode was this: for time-starved parents, an algorithm that knows enough about its young viewers to auto-curate a feed of entertainment perpetually novel enough to keep them engaged was already an indispensable part of contemporary child-rearing. (One study notes: "More than twice as many young people watch videos every day than did in 2015, and the average time spent watching has roughly doubled.")[27]

By default, AI aesthetics tend toward constructing an idea of culture in which any non-AI subjective decision that interrupts the flow of consumption is minimized as unprofitable dead time. You don't need to supervise what your child sees next—or, for an adult viewer, you don't need to talk to a friend for a recommendation of something that fits your mood, to seek out a critic whose opinion you like, or even to waste time personally deciding. Ideally you just get a selection of perpetually "good enough" options. Taste is not some-

thing you cultivate through a process of education and experiment. It is something that happens to you.

Point 5: AI Aesthetics Throw Art's Social Function into Relief

Alex Greenfield, a hardheaded critic of technophile cant, surveys the evidence of AI's emergent creative prowess and warns against underestimating it. Its intensifying, almost surreal capacities will transform culture. His image of the near future is both alarmed and elegiac:

> As it starts to condition the texture of everyday experience, this push past our own standards of beauty, resonance or meaning will do strange things to us, summoning up registers of feeling we'll find it hard to describe with any accuracy. I have little doubt that we'll feel occasional surges of shocked delight at the newness, and yet essential correctness, of something forged by an intelligence of the deepest alterity—an image, a spatial composition, a passage of music, some artform or expressive medium we don't yet have the words for—and these may be among the precious few sources of joy and wonder in a rapidly ruining world.
>
> I have equally little doubt that we'll more often find ourselves numbed, worn down by the constant onslaught of novelty when we have more pressing things to worry about. We'll feel pride that these intelligences have our DNA in them, however deeply buried in the mix it may be, and sorrow that they've so far outstripped the reach of our talents. It's surely banal to describe the coming decades as a time of great beauty and greater sadness, when all of human history might be described that way with just as much accuracy. And yet that feels like the most honest and useful way I have of characterizing the epoch I believe we've already entered, once it's had time to emerge in its fullness. [28]

I find the passage convincing and sobering. And in one sense we are *already* "worn down by the constant onslaught of novelty." A feat

like "neural style transfer"—assimilating an art style and then apply-ing that style to a new image, so that you can, say, turn a picture of the landscape outside your window into a Van Gogh painting—was once considered a nearly insurmountable test of AI's creative prow-ess; now that AI has mastered it, it is treated as if it were as inconse-quential as any other kind of photo filter. When the Google Arts & Culture app introduced a feature that instantly scanned hundreds of museum collections to find a portrait that looked like you, it was a breathtaking feat of machine vision (albeit one that unintentionally exposed the demographic biases of the museum canon, in its lack of options for non-white users). It was good for about a weekend of news interest. Taking their purpose as creating engaging novelty, these kinds of initiatives end up inspiring the public to treat each new AI marvel as, well, a novelty.

Greenfield's reflections help to define for me, if only negatively, some important aspects of artistic thought that are still worth advo-cating—aspects that are, indeed, more relevant than ever to emphasize in the immense, unsettling shadow of the oncoming AI art revolution.

In recent years, the superiority of machine intelligence has been proven in chess as successive human masters have fallen; in Go; and even in poker, where AI proves great at out-bluffing opponents. I know many might deny it, but these examples are relevant to art: great play in all three fields has an undeniable aesthetic element. Thus, an essay in the *New York Times* proclaimed that the chess pro-gram AlphaZero "played like no computer ever has, intuitively and beautifully, with a romantic, attacking style."[29] A Go master, com-menting on AlphaGo's defeat of eighteen-time world champion Lee Sedol, spoke in awe: "It's not a human move. I've never seen a human play this move. So beautiful."[30]

Why deny yourself appreciation of that super-cognitive beauty? "Whenever playing the bot, I feel like I pick up something new to incorporate into my game," poker professional Jimmy Chou said of playing the champion poker-playing AI.[31]

Yet overall I am continuously dismayed, as observers recount such technological feats, either with awe or with alarm, by the restricted

ideas of artistic value that they end up insinuating. Such fantastic AI conquests are undertaken as showpieces for corporations and governments and are useful for their PR goals, because competition and conquest are the most prized values in our ruthlessly competitive world. Who will win the race to unleash the most powerful AI? Google or Facebook? The United States or China? We live in a world that feels defined by fierce zero-sum competition, so games with a binary outcome stand as the appropriate metaphor for success. You win or you lose. But what a diminished idea of what game play is all about![32]

You can, of course, get great pleasure from competing with an appropriately calibrated AI. Anyone who has killed an afternoon playing video games knows that. But so important is the social dimension of game play that Twitch has created a billion-dollar empire out of just letting people watch each other goof around and spar with one another via their consoles. Years ago now, writing about a Twitch gaming stream called FatherSonGaming, where the trash-talking father-son team of Bill and Jason Munkel broadcast themselves playing *Call of Duty* together, I quickly realized that its fans tuned in only secondarily to admire the Munkels' prowess in the arena. If you spent any time following the chatter of the mostly young men in the comments stream, you learned that the pleasure of the channel was something like watching a dad playing ball with his son. What the virtual sniper action offered was in fact a vicarious sense of relatable, longed-for family connection.[33]

I've played a lot of games in my life. In only some of these did I care *only* about winning: chess I learned as a way to spend time with my dad, Go to meet new people in a strange city, poker to bullshit with friends. For millennia, humans have played games as a test of intellectual excellence but also as an excuse to joke and flirt and kill time, as a relatively harmless arena for working out conflict, as a way simply of being together. Professional sports (and Esports) make a win-lose mentality the default. But in many, many social situations, achieving victory is the excuse to play, and not the point. Everyone has a story about the one person who takes winning too seriously and ruins the fun for everyone else.

In one experiment about the effects of artificially intelligent social actors, groups of people were given a task to accomplish with the help of a robot. For some of the teams, the robot was designed to assist with flawless precision—humanlike, but efficient. For others, it was programmed to mess up periodically and apologize. "As it turned out, this clumsy, confessional robot helped the groups perform *better*—by improving communication among the humans," Nicholas Christakis, the professor who conducted the study, reported. "They became more related and conversational, consoling group members who stumbled and laughing together more often."[34] A super-effective AI actor, by contrast, might accomplish the task itself more effectively but also make people more impatient with the flaws of their human collaborators.

I've come to think of "art"—or a certain way of thinking about art—as serving a function similar to that malfunctioning robot: an activity that is valuable for its built-in failures rather than for its efficiency. A person walking into a gallery might know, based on experience and cultural knowledge, how to make sense of what is in front of them and form an opinion. But they might not. Perhaps a history or a worldview behind the artwork, once suggested, transforms how they see it. That breakdown and reshuffling of expectations is, as they say, a feature not a bug for this sort of aesthetic experience, a tool that allows you to expand how you approach the world and connect with new ways of seeing and fresh types of thinking.

Imagine you stand before an example of Chinese "shan shui" ("mountain and water") painting, such as *Poet in a Landscape* (ca. 1471) by Shen Zhou, a master of the Ming dynasty. The misty terrain it depicts is unreal; in this style of ink painting, the goal is not to depict a real place but to convey a state of mind through evoking typical features of landscape. Shan shui is therefore perfectly amenable to simulation—and indeed a team of computer science students in 2018 created an application called Shanshui-DaDA, which allows you to trace a few lines on a screen, then fills in the pattern with the look of a dreamy ink landscape.

And yet how different the symbolism of *Poet in a Landscape* is from that of the output of Shanshui-DaDA! The world as rendered by Shen

Zhou was meant to reflect the value of a way of life: the amateur-scholar dedicated to laborious study and solitary contemplation. The tiny figure on the bluff, dwarfed by his craggy environs, suggests cultivated humility before the natural world and a philosophy that places nature rather than the human at the center of things.

As for the output of Shanshui-DaDA, awareness of the fact that the landscape was generated by AI transforms the image into its symbolic opposite. It stands not for the value of contemplation but for the demotion of contemplation as a value; not for a sense of smallness before nature but for a sense of nature's mutability before the user's will.

As I said at the top, the impact of AI on artists may be the least of all worries about this technology. But the anxieties it raises can't be seen apart from those other, larger worries either, of technology's fusion with unaccountable power and amoral technocracy. As art and tech critic Nora N. Khan writes, "Giving the keys to defining reality to a secret group of engineering priests is cultural suicide."[35] Aesthetic experience is a mixture of formal invention and social meaning, and the better AI gets at automating visual interest and narrative novelty, the more directly it will force into relief the question of *what is meaningful* in our aesthetic worlds. This includes the question of why our cultural energy is invested in technology that locks people ever more inside their own customized taste bubbles at a historical moment when we need to be actively working toward a collective vision.

It is neither wishful thinking nor metaphysical delusion to say that there are aspects of artistic experience that are not amenable to simulation of the kind now insinuating itself into the cracks of our creative life, or that we are at risk of a surrender of those aspects if they are neglected. You can respect the wonders of the technology and still believe that.

Do you know what the most popular type of art is—a genre so broadly loved that it is collected utterly apart from any market value or popular acclaim? Art made by children. Before art is visually splendid, before it is even articulate, it is valued as a connection to a consciousness in formation. It is preserved as a symbol of the care taken for that consciousness.

Chapter 5

The Anarchist in the Network

John Perry Barlow, the one-time Grateful Dead lyricist and founder of the Electronic Frontier Foundation, released "A Declaration of Independence for Cyberspace" in early 1996. The document explicitly channeled the countercultural spirit of the 1960s in the direction of a nascent World Wide Web: "Governments of the Industrial World, you weary giants of flesh and steel, I come from Cyberspace, the new home of Mind. On behalf of the future, I ask you of the past to leave us alone. You are not welcome among us. You have no sovereignty where we gather."[1]

Hakim Bey, another artist and anarchist, formulated his idea of the "temporary autonomous zone" in the '90s in dialogue with emerging technology, which he thought could create new pathways for coming together beyond centralized control: "The full potential of non-hierarchic information networking logically leads to the computer as the tool *par excellence*."[2] *Wired* published an article praising Bey's model of social change in '96: "Carve out a space you can call your own, but don't plant any roots. When the heat comes, skedaddle."[3]

Electronic Disturbance Theater, an art group, created the paradigm for the DDoS attack in the '90s. It was meant as a creative gesture of solidarity with the autonomist Zapatista movement in Chiapas, Mexico, which had fascinated those around the world for how their horizontalist politics took advantage of the new openness of internet communications to get the word out. Styled as a "virtual sit-in," the first action was called SWARM, short for Stop the War in Mexico.[4]

113

Anne-Marie Schleiner, an artist, offered in the early 2000s her manifesto "Countdown to Collective Insurgence: Cyberfeminism and Hacker Strategies," enumerating tactics that she thought could advance the objectives of the broader cyberfeminist movement. It focused on actions like creatively disrupting male-dominated art contests, claiming pop culture role models, and hacking video games to insert feminist imagery. "If we no longer rely solely on broadcast mediums like television and film to feed us culture (after all, not every television show is as daring and brilliant as *Buffy the Vampire Slayer*), but instead actively refashion our own computer games and erotic entertainment, we will change the world we inhabit."[5]

Anonymous, the acephalous hacker collective, emerged in the late 2000s, taking its symbol, the Guy Fawkes mask, from *V for Vendetta*, an insurrectionist graphic-novel fable by Alan Moore turned middling 2006 movie. Through spectacular acts of terrorism, *V for Vendetta*'s Fawkes-masked vigilante hero inspires the exploited to spontaneously coalesce into a coordinated anti-authoritarian uprising.[6] In the early 2010s, Anonymous helped promote Occupy Wall Street, the quintessential "networked social movement," whose carnivalesque occupation, in turn, strongly echoed Bey's "temporary autonomous zone" idea.

These are disparate tendencies, each with more or less to recommend it. What strikes me, though, is what these notable moments in the history of digital activism, despite very different aims and diverse goals, have in common: it leans libertarian or anarchist. Its heroes are more often artists than workers. And it's less oriented on the state or organization building, more focused on the values of liberated personal expression and direct action. It's worth asking if something about the terrain shapes "digital politics" in this way, making this the default setting.

Social media has seemed only to turbocharge these underlying tendencies. In an essay about social media and the 2020 Black Lives Matter protest wave, philosopher Marielle Ingram attributed its vitality to how social networks allowed for a spontaneous leaderlessness that blew past the organizational limits of previous eras: "In the cur-

rent moment, unlike in the civil rights era, social media have allowed for a decentralized movement, which means there is no specific figurehead to demonize. In the 1960s, the American government targeted Malcolm X and Dr. King and tried to squelch the Civil Rights Movement, but today Donald Trump can only point at 'Antifa,' a non-unified movement of organizations committed to anti-fascism."[7] Ingram never explicitly identifies this leaderless ideal as relating to a self-conscious political philosophy—but that just makes the value placed on it more striking to me, as if an anarchistic logic emerges directly from the way political information circulates now.

Yet, in *From #BlackLivesMatter to Black Liberation*, Keeanga-Yamahtta Taylor wrote that the very same "decentralized" quality could be viewed as a vulnerability. In a section titled "The Tyranny of Structurelessness in the Age of Social Media," Taylor argued:

> The lack of clear entry points into movement organizing, and the absence of any democratically accountable organization or structure within the movement, left very few spaces to evaluate the state of the movement, delaying its ability to pivot and postponing the generalization of strategic lessons and tactics from one locality to the next or from one action to the next. Instead, the emphasis on autonomy, even at the cost of disconnection from the broader movement, left each locality to its own devices to learn and conjure its own strategy.[8]

So much has been written on the subject of social media activism that I should define what I am interested in, narrowly. Out of both theoretical preference and personal experience, I agree with Jo Freeman's critique of "leaderless" organizing in the essay that Taylor alludes to, "The Tyranny of Structurelessness," from 1972, hard-won wisdom from her experiences in the US feminist movement.[9] The pretense of leaderlessness sounds idealistic, but in practice it poses disabling problems. The difficulty of achieving total consensus makes united action impossible; the disavowal of hierarchy masks the hierarchies that are really there, since some people actually are doing more work and making practical decisions; initiative tends to

fall to those who can just out-endure everyone else, because they have the most free time to spare for limitless discussion.

I think you have to accept the practical value of leaders—of democratic leadership, accountable to the people who have entrusted it with their interests. And I think formal organizations are indispensable to making movements effective in the long run. Everyone can't just do their own thing in an ad hoc way. There has to be coordinated division of labor and sustained commitments. That's just the reality of taking serious fights seriously.

And so it's important to reckon with the ways that social media, by its design, makes this kind of politics more challenging. (This also means that many of the pitfalls of "social media politics" are already prefigured within classic Marxist debates over the stakes of organization.) This isn't a matter of saying what goes down on YouTube or Instagram or TikTok is "fake." You can say, if you want to use a Marxist cliché, that the case is dialectical: it may be that the very thing that is social media's greatest strength as a political tool also poses its greatest obstacle and that effective politics involves passing through this contradiction.

Parties on Paper

A command of communications, in the form of propaganda to win the unconverted and agitation to mobilize action, has always been part of the project of gaining power. Let's consider how the classic media of political propaganda related to forms of political organization: from the Bolsheviks to the Black Panthers, revolutionaries were associated with the revolutionary newspapers they sold. It was probably never pleasant or cool to sell a newspaper ("My God! How I hated selling the *Worker*," one former Communist Party USA member recalls in Vivian Gornick's *Romance of American Communism*),[10] but it was at least defensible for the period during which this was an efficient way to get out your message and newspapers actually formed a major part of street life.

But spreading the gospel was actually only *one* of the desired ends of the revolutionary newspaper in the first place. Lenin, the

figure most associated with the political newspaper tradition, expounded at length on its significance in *What Is to Be Done?*, not uncoincidentally his major text on party organization. As usual with Lenin, it was a theoretical text pitched at the needs of a moment in time, Russia in the early 1900s. He was arguing (among other things) for an all-Russia newspaper against foes who thought that a multiplicity of local newspapers would be the better solution and that the effort of national publication was a distraction from other forms of on-the-ground work. His point was partly that information should be shared between all localities, the better to coordinate a united national struggle against the czar.

But the revolutionary newspaper, in Lenin's formulation, was also the "scaffolding" around which the political organization would grow. The very collective labor involved in printing a newspaper in the early twentieth century—of reporting, writing, delivering copy, editing, printing, distribution, street corner sales—guaranteed coordinated activity among large numbers of comrades to make it happen, and thus created the pathways along which sustained and coordinated action could flow. "The organization, which will form round this newspaper, the organization of its collaborators (in the broad sense of the word, i.e. all those working for it), will be ready for everything, from upholding the honor, the prestige, and the continuity of the Party in periods of acute revolutionary 'depression' to preparing for, appointing the time for, and carrying out the nation-wide armed uprising."[11]

There was thus a particular coincidence at this moment between media form and the desired form of struggle. Nothing better represents how the hard labor of maintaining a newspaper might train one to understand the realities of collective working-class struggle than the fact that a few years after *What Is to Be Done?*, it would be a strike by typesetters that detonated the 1905 revolution. "They demanded a shorter working day and a higher piecework rate per 1,000 letters set, not excluding punctuation marks," Trotsky recalled. "This small event set off nothing more nor less than the all-Russian political strike—the strike which started over punctuation marks and ended by felling absolutism."[12]

Print newspaper circulation reached its peak in 1984.[13] Mainstream newspapers were sharply undercut and undermined in the 2000s, as attention moved online and then onto mobile devices. In major urban centers through the first decade of the new millennium, you still could rely on picking up an alt-weekly paper or being handed a free commuter newspaper like *Metro* or *amNY*. These are all mainly gone or dying. At a certain moment in history, having a newspaper made a political organization seem like a respectable institution; after a certain point, it associated them with institutions that were dying.

The New New Middle Class

In surveying the history of anarchist tendencies, socialist scholar Hal Draper called them "the primal scream of the petty bourgeois in a squeeze": "In the course of its development [anarchism] reflected various class elements in a blind alley: artisanal workers fearfully confronting modern industry; recently proletarianized peasants fearfully meeting new societal pressures; lumpen-bourgeois elements fearfully facing an empty future; and alienated intelligentsia fearfully resenting the indignities of a money-obsessed society."[14] Quite logically, forms of radicalism rooted in individualistic property relations—whether a peasant's ownership of a small bit of land or an artist's claim to specific intellectual property and signature style—flowed toward forms of action and demands that would honor and defend individualism.

There is, of course, plenty to learn from the anarchist tradition, and there's no shortage of "petty bourgeois" elements among today's socialists! I'm only rehashing these somewhat schematic arguments because they help put into focus the significance that shifting media structures might have for Marxism. Lenin thought that the collective project of building a newspaper would help fuse its members into an effective unit that made them fit for the kind of coordinated and sustained action working-class struggle demanded. One of the internet's big buzzwords, by contrast, has been "disintermediation," the removal of middlemen in favor of more direct representation. In

retail, you don't have to find a store to stock your wares; you can sell them directly through the web. In publishing, you don't have to find an established publishing organization to write for; you can just publish your thoughts directly into cyberspace and hustle for attention, outside of any institution.

The result is that discourse is detached from stable workplaces altogether, and the individual writer/producer is less and less a part in a machine and more a fully functional machine on their own. As Astra Taylor has emphasized, the boosterish rhetoric of internet culture tends to emphasize one kind of autonomy—the freedom to publish and gain an audience independently—and skate over the fact that larger media institutions, in some ways, provided the basis for other kinds of autonomy: legal protection, benefits, training, investments in longer-term projects. "Many structures of the old-media system, however flawed, relieved some of the burdens now borne solely by individuals."[15] Even having an editor is a rarity today. With blogging in the 2000s, this empowered amateurism became a major form of journalism that rivaled mainstream publications. Then, the widespread adoption of social media by the 2010s made even the blogs look cumbersome, as each social media platform knit everyone using its services together and made them content-producers by default.

To the extent that, through advertising, sponsorships, or patrons, this solo operation potentially becomes a career, publishing essentially takes on the form of a classic "middle class" self-employment, where the worker is their own boss.[16] Indeed, "content creator" has been described as the fastest growing type of small business.[17] In response to ridicule provoked by a 2019 study that showed that "influencer" and "YouTuber" were the #2 and #3 career choices of British youth (behind #1: doctor), Talking Influence, a site dedicated to influencer marketing, gallantly rushed to the defense of a noble profession, saying that it was not just a career but a grueling form of small proprietorship:

> For an influencer to be in a position where brands will actually pay them for collaborations, they will have great content

creation skills, whether that's in photography, videography, styling or illustration. They will have also amassed an audience, steadily building a connection over the years, adding value to their followers' lives, fastidiously replying to their comments and DMs. It will have taken time, dedication, skill and often a fair amount of kit.

Once those brand collaborations come, it doesn't get any easier. An influencer will wear many hats. Handling negotiations, monitoring trends, creating custom content, deciphering analytics and constantly reinventing themselves to stand out in an increasingly crowded market. Should they take their foot off the pedal, there's a queue of creators behind them, eager to take their place.[18]

In the '80s, Marxist theorists came up with the idea of the New Middle Class, to explain the vacillating middle-manager base of a certain kind of neoliberal reaction: "Unlike the old middle class of artisans, shopkeepers, small farmers, and self-employed professionals, the professional managerial class was not independent of the capital-labor relation but was employed by capital for the purpose of controlling, managing, and administering to the working class," Neil Smith wrote of the shift.[19] In essence, the present-day disintermediated media ecosystem creates something like a New New Middle Class, a layer that returns to a lot of the older characteristics of the unincorporated middle class of shopkeepers, artisans, and the self-employed in new digital forms. Indeed, the so-called "Californian Ideology," the sunny techno-optimism of '90s-era *Wired* magazine that promised leveling of hierarchies and entrepreneurship for all, imagined the net's promise as "a new 'Jeffersonian democracy' in cyberspace."[20] Already in the first wave of scrutiny of "Web 2.0" in the mid-2000s, media analyst Nicholas Carr coined the term "digital sharecropping" for content creators working on big corporate platforms that snarfed up most of the advertising gains and data—so there is even an established conceptual analogy to the most classically volatile form of disaffected "petit bourgeois," the small farmer.[21]

The professional positions to which the "online political commentator" is most proximate are the journalist and the intellectual. But while these roles still have symbolic clout and attract plenty of aspirants, as actual jobs attached to stable institutions, each has been savaged in the last decade, stimulating new forms of class struggle: newsrooms have been decimated, and recent years have seen successive waves of defensive unionization efforts at digital media sites once seen as replacing the titans of old media such as Buzzfeed, Refinery29, and Vice. Meanwhile, academia has been in a long-term state of breakdown, with overproduction of PhDs and dismal conditions for adjuncts also leading to protests and organizing.

The general economic dynamics, then, suggest exactly the kinds of pressures that lead to political radicalization. At the same time, self-promoting independent commentators and authors don't have a newsroom or a campus to organize within; that form of struggle is not available to them. In fact, they are in implicit competition with "mainstream" journalists and academics for public attention, and their only comparative advantage is their independence and superior visibility in the venue where they appear, the social network. You could see how this fact would, in turn, create a strong pressure to emphasize the values associated with the social media platform as being the decisive ones for new social struggle: networks over organizations, immediacy over deliberation, personality over neutral voice.

Of course, only a minority of social media users is committed to carving out a career or reputation as a media personality—though almost by definition, this is a very visible minority. Most simply dip into and out of political debate online with the occasional passionate desire to win an argument or publicize a cause. But just as activists distributing political newspapers on street corners didn't have to be paid for this labor for the paper to model collective discipline, the self-directed default style of online propagandizing doesn't have to be commercially motivated for it to model a more individualistic style of politics overall for those operating within its field of influence.

Networked Protest and Tactical Freeze

Networked platforms have clearly allowed for new possibilities in radicalizing the political sphere, not to be taken for granted. Theorist Zeynep Tufekci, in *Twitter and Tear Gas*, points out that the ability to cut through layers of centralized communications and top-down media control has real effects for freedom struggles of various kinds. In authoritarian countries where official censorship has kept citizens from seeing how widely shared discontent is, mass access to networked communications suddenly cuts through "pluralistic ignorance"—letting people know that if they go into the street, they have a good chance of not being alone.[22]

But Tufekci also notes a downside in the social movements that have sprung up around the new "scaffolding" of the smartphone and social media. In truth, its strength is its weakness. Exactly because social networks lower the bar for getting the word out, many more people can be mobilized in a short time period with limited ground organization. But this also means that there are *no established structures* within these movements. Partly for this reason, she thinks, the last decade's networked social movements like Occupy Wall Street have been extremely volatile, with massive spikes of public support and equally confusing turnarounds.

Overall, such protest events are characterized by a vulnerability Tufekci calls "tactical freeze":

> The lack of decision-making structures, mechanisms for collective action and norms within the anti-authoritarian, mostly left-wing networked movements . . . often results in a tactical freeze in which these new movements are unable to develop and agree on new paths to take. First, by design, by choice, and by the evolution of these movements, they lack mechanisms for making decisions in the face of inevitable disagreements among participants. In addition, their mistrust of electoral and institutional options and the rise of the protest or the occupation itself as a cultural goal—a life-affirming space . . . combine to mean that the initial tactic that brought people together

is used again and again as a means of seeking the same life affirmation and returning to their only moment of true consensus: the initial moment when a slogan or demand or tactic brought them all out in the first place.[23]

Accelerating the speed at which radical ideas propagate should, in theory, increase the potential power of a movement, just as a faster engine should make it easier to win a race. But you also need to steer the car as the track curves. If you cannot, then the faster engine just causes you to crash faster.

Under these new networked conditions, the significance of mass mobilizations becomes harder to measure. Tufekci uses the comparison of the March on Washington in 1963, which involved a quarter of a million people, to the Women's March of 2017, which drew nearly a half million people to DC and millions more across the country in a mighty display of outrage that was reported as the largest-ever simultaneous protest. But the former culminated a decade of civil rights organizing and took many hard months to plan, given the difficulty of getting the word out and coordinating across space; the latter coalesced in a few short weeks following the election of Donald Trump. The smaller, earlier march symbolized that a seasoned cadre of leaders had been produced that could act together. The larger, later march, because of its viral origins, symbolized a much less concentrated, more diffuse force.[24]

Lenin on Trashing

Faced with conservative media attacks keen to paint leftists as intolerant scolds, a reflex is to frame contemporary attacks on "cancel culture" as a cover for a reactionary agenda (they often are), but also to deny that there can be any problem at all with being too dogmatic, if the goal is justice for the marginalized and oppressed—despite the fact that large numbers of otherwise sympathetic people clearly consider online left discourse alienating. To address this, Loretta Ross (among others) has emphasized "calling in" rather than "calling out," placing

more emphasis on offline or private critique, and stressing the overall goal of building a culture of respect and avoiding the default recourse to public shaming as a tactic. "Call-outs make people fearful of being targeted," Ross writes. "People avoid meaningful conversations when hypervigilant perfectionists point out apparent mistakes, feeding the cannibalistic maw of the cancel culture."[25]

Toxic cultures are not new on the left—though it bears remembering that history shows they are nothing to be sanguine about, standing as real factors in left isolation and dispersal. Jo Freeman wrote of all but dropping out of the feminist movement after experiencing "trashing" in the late '60s and early '70s. She described this as a practice where political debate was replaced with ostracization and personal attack: "In effect, what is attacked is not one's actions, or one's ideas, but one's self."[26] Notably, Freeman sees this style of atomizing interpersonal hostility, in part, as a symptom of the amorphously anarchistic style of activist politics that dominated in these circles: "[Trashing] is much more prevalent among those who call themselves radical than among those who don't; among those who stress personal changes than among those who stress institutional ones; among those who can see no victories short of revolution than among those who can be satisfied with smaller successes; and among those in groups with vague goals than those in groups with concrete ones."[27]

Freeman's text has recently been rediscovered as particularly relevant to debates over the excesses of digital activist culture. There is much to write about the psychology of online shitstorms. But the emphasis has to be on how the climate of debate is shaped by a style of politics that is in turn shaped by the affordances of the platforms where it takes place. Exhortations to "be nicer" or avoid "uncomradely" behavior don't really address this. The unpleasantness should be viewed as a symptom of how social media, by hardwiring the kind of "leaderless" and "structureless" politics that Freeman criticized into the way most new activists engage in debate, leads to potentially disabling practical problems for radical politics.

"It is not only Right doctrinarism that is erroneous; Left doctrinarism is erroneous too," Lenin once wrote in *Left-Wing Com-*

munism. Revolutionaries, of course, had to fight constant pressure to sell out, compromise core principles, or be mollified by symbolic gestures.[28] But Lenin saw another set of pitfalls as equally dangerous: getting stuck in rigid sloganeering, being unable to change the way one argued so as to win wider layers, failing to form tactical alliances with others who didn't totally agree with your program. He identified this self-isolating "ultra-left" tendency as "petty-bourgeois, semi-anarchist (or dilettante-anarchist) revolutionism"—the radicalism of armchair pundits, professional commentators, small self-selected groups, and artists.[29]

For the present discussion, what is key to me is that Lenin saw this type of political temperament as arising in a condition where "propaganda work" dominated over "practical action":

> As long as it was (and inasmuch as it still is) a question of winning the proletariat's vanguard over to the side of communism, priority went and still goes to propaganda work; even propaganda circles, with all their parochial limitations, are useful under these conditions, and produce good results. But when it is a question of practical action by the masses, of the disposition, if one may so put it, of vast armies, of the alignment of all the class forces in a given society for the final and decisive battle, then propagandist methods alone, the mere repetition of the truths of "pure" communism, are of no avail. In these circumstances, one must not count in thousands, like the propagandist belonging to a small group that has not yet given leadership to the masses; in these circumstances one must count in millions and tens of millions. In these circumstances, we must ask ourselves, not only whether we have convinced the vanguard of the revolutionary class, but also whether the historically effective forces of all classes—positively of all the classes in a given society, without exception—are arrayed in such a way that the decisive battle is at hand . . .[30]

The sequence of distinct moments Lenin lays out is important. "As long as" one is in the phase of building a vanguard audience for radical ideas, even the "parochial limitations" of the propaganda

approach are a net positive; once in struggle, the same emphasis on "'pure' truths" that helped define this vanguard is an impediment to putting its program into action.

It can then be seen how the very communication tools that have the positive effect of more widely distributing the means of "propaganda" and making the diffusion of radical ideas historically easier *also* provide an obstacle to overcome when you enter the "practical struggle" phase, where the task is not just to distinguish radical ideas from the pack but to lead the pack, concretely, toward a desired objective. In fact, Lenin describes the consequences of being stuck in the "propaganda circle" mentality very similar to Tufekci's "tactical freeze": "We have only to say . . . that we recognize only one road, only the direct road, and that we will not permit tacking, conciliatory maneuvers, or compromising—and it will be a mistake which may cause, and in part has already caused and is causing, very grave prejudices to communism."[31]

A class diagnosis also implicit in Lenin's analysis is relevant to our analysis of social media. "A petty bourgeois driven to frenzy by the horrors of capitalism is a social phenomenon which, like anarchism, is characteristic of all capitalist countries," he wrote. "The instability of such revolutionism, its barrenness, and its tendency to turn rapidly into submission, apathy, phantasms, and even a frenzied infatuation with one bourgeois fad or another—all this is common knowledge."[32] Substitute "bourgeois fad" here for "trending topic," and you have a nice description of present tendencies.

It is not just the simple fact of scaled-up communication possibilities that shapes the "ultra-left" quality of social media politics; it is the fact that platforms interpolate users as small-communication entrepreneurs, invested in maintaining their relevance. This is, in a notable way, distinct from an analysis that says that the problem of online politics is that it is "too dogmatic." Mark Zuckerberg once said of Facebook's multitudinous users that they were "building an image and identity for themselves, which in a sense is their brand,"[33] and countless posts explain how to "build your brand online." But any brand's value is only in how it maintains its connection to a unique product and distinguishes

itself from others. A strong psychic and material incentive exists, if you are invested in maintaining a social media "brand" for yourself, toward staking a claim on an intellectual position and working to distinguish your version of it from others. Otherwise, you lose value as your voice ceases to be distinct from the pack.

The middle-class, self-managing nature of the professionalized social media commentator therefore helps explain the centrifugal pattern of the political conversation, its constant drive toward splintering.

Viral Left / Organized Left

The political scientist Yascha Mounk has fretted that the experience of direct forms of participation (or pseudo-participation) in online communities is having the effect of eroding "liberal democracy": "The Internet threatens to end the hegemony of liberal democracy not only by amplifying the voice of a small band of haters and extremists, but also by alienating a much larger number of digital natives from the decidedly analogue institutions by which they are governed."[34] The crisis of contemporary politics, in this view, is something like how, at any party where one doesn't know other people, it is now easy to migrate your attention to your phone rather than going through the awkwardness of trying to strike up a conversation with a stranger.

The thing is: frustration with a corrupt and decrepit capitalist state that is captured by the rich, feeds on racism and hatred, and is shepherding us toward planetary doom must be seen as both understandable and actually positive. Nevertheless, because of the lethal inertia of institutions of power, building enough pressure to force durable change requires collective organizations that operate outside hyper-individualistic and distractible norms of online self-expression.

Richard Seymour's *The Twittering Machine* approaches the political consequences of social media atomization without Mounk's centrist nostalgia but with a similar emphasis on the historic and dangerous effects for the political sphere: "We should take seriously the possibility that something about social media is either incipiently fascistic, or particularly conducive to incipient fascism."[35] He

sees this in how its very business model of commodifying emotional engagement "magnifies our mobbishness, our demand for conformity, our sadism, our crankish preoccupation with being right on all subjects,"[36] logically playing into the hands of reactionary tendencies. And indeed, I've argued above that social media incorporates its users as something like a New New Middle Class, and a downwardly mobile middle class has always been thought to be the basis for fascism. ("Everyone is making media at all times," CNN reporter Elle Reeve reported of the chaotic January 6, 2021, assault on the US Capitol by supporters of Donald Trump. "It's crazy. It's like, 'Were you there if you didn't livestream it?' And they're all hoping for that viral moment that will give them more clout on social media.")[37]

Can the same tools be used to build a left-wing project? Clearly, social media does more than just provide a place for lefties to vent; it makes spikes of networked street protest possible at a scale previously undreamed of, forcing real crises for corporations, the police, and the state. But the question of digital fascism returns here in another way. The very speed of the new forms of protest also risks forcing serious confrontation with power without serious preparation. Intervening into the Marxist debates about the relative value of "spontaneity" versus "organization," Antonio Gramsci wrote:

> It is almost always the case that a "spontaneous" movement of the subaltern classes is accompanied by a reactionary movement of the right-wing of the dominant class, for concomitant reasons. An economic crisis, for instance, engenders on the one hand discontent among the subaltern classes and spontaneous mass movements, and on the other conspiracies among the reactionary groups, who take advantage of the objective weakening of the government in order to attempt coups d'etat. Among the effective causes of the coups must be included the failure of the responsible groups to give any conscious leadership to the spontaneous revolts or to make them into a positive political factor.[38]

Gramsci argued that modern capitalist ruling classes achieved hegemony via the combination of "consent" and "force," that is,

both by posing themselves as moral leaders and by wielding direct repression. It seems obvious that social media activism, in the right circumstances, has the ability to challenge a ruling class's ability to win "consent" for its worldview by giving broader layers of people direct voice. This undermines *one* of the pillars of rule. But by the same logic it makes confronting that other pillar, "force," more imminent. If explosions of spontaneous/viral struggle increasingly characterize politics, partisans had better be able to scale up the other pole—organization, discipline, coordination, continuity. If they do not, then they are not taking seriously the logical outcome, which is an intensification of *organized* repression.

A "coup d'état" may not be the exact right term for what to expect. As Seymour notes, classical fascism was rooted in military clubs and street gangs—real-life institutions to enforce physical terror. Even proto-fascist right-wing formations of the likes of the Proud Boys, Oath Keepers, Three Percenters, and Boogaloo Bois remain relatively fragmented (though they remain scary, and the fragmentation can always change). But there is no reason to think that violent reaction has to take the exact same form today as it did in the days of Franco, Mussolini, and Hitler either. "The 'swarm,' which began as a metaphor for conscientious citizens holding power to account, might well become a metaphor for the twenty-first century version of fascist street gangs," Seymour writes.[39] He cites the concept of "stochastic terror:" in a networked communications ecosystem, a call for violence can trigger seemingly random but predictable acts—a kind of crowdsourced flash-mob version of political terror (of which the anarchic thuggery of the January 6 Capitol attack may be a glimpse).[40]

Strange as it may sound, something like "stochastic solidarity" also exists, where mutual aid doesn't pass through any real coordinating organization. Every time someone posts into the void of Facebook or Twitter a call to donate to a cause, they are modeling this form of action. It is clear, however, that there are limits to such random and voluntaristic forms of networked action.

Likewise, "stochastic protest" can be a force to be reckoned with, as viral outrage metastasizes into formidable street action—but it

can just as easily lose fire as the news cycle moves on and dispersed calls to action no longer get the same viral lift. And the "stochastic strike" is not really a viable option at all. Either workers will be able to unite for coordinated action over a long enough period to exert the pressure needed to win their demands, or they will not. The power is all in preparation, organization, discipline.

Social Media / Social Revolution

What, as they say, is to be done? Now and into the near future at least, new waves of people coming into politics will almost certainly enter through social media, since it has captured so much social energy. So collective abstention seems impossible and probably counterproductive.

Brands and reputations are built and broken in the hustle for attention online. Given this, it is now standard for capitalist institutions of all kinds to have official social media guidelines for workers and affiliates. Intel directs its workers to disclose employee status when talking about the company, says what language to use to distinguish a personal opinion from an official statement, and even advises how to apologize if you have incautiously made a false claim about Intel products in a social media setting. The US Air Force encourages sharing personal stories to promote recruitment—but also directs service members to a public affairs contact for questions about whether an anecdote contains mission-sensitive information, and offers separate recommendations under headings "Social Media for Leaders," "Social Media for Airmen," and "Social Media for Families."

For left political organizations, such bureaucratic guidelines would likely be experienced as encroaching on individual autonomy and replicating the alienation of the capitalist workplace in a way that would repel newly radicalizing people. But that very fact highlights the problem: it is implausible that radicals are going to coalesce into a larger force that meaningfully challenges the most powerful, well-resourced, and deep-rooted institutions of capitalist

society without some kind of basic communications discipline that makes them accountable to one another.

We undoubtedly need to accept both the need to be present online and the need to become aware of the serious limits of digital politics. It is clearly folly to continue to focus all one's efforts on selling newspapers on street corners in an age of movements defined by hashtags. Yet, whatever the good of spreading the gospel online, rooting in neighborhoods and workplaces entails an entirely different set of skills, knowledge, and manner of engagement, and is maybe more urgent.

In some ways, social media is an equal-opportunity disruptor: its rise has coincided with the diffusion of a new socialist politics and given a platform to oppressed identities that have been ignored—but it has also accelerated the spread of a virulent alt-right politics and apocalyptic disinformation. The filter bubbles of corporate algorithms and the fractiousness of online discourse pose challenges for political projects across the spectrum as well. But my final point here is that for a specifically Marxist politics, the advent of social media also offers a specific, additional, and important challenge.

A socialist politics still has to see sustained movements, mass organizations, and united workers as its key change agents—not intellectuals making their moral case, or artists inspiring people, or guerrillas taking to the mountains, or tiny groups of dreamers who fire the imagination with their alternative ways of living. Of course, effective action draws on and draws in all kinds of allies.[41] But without durable and coordinated worker power where it matters, "socialism" is an empty term. This is a practical, not a moral, proposition: it is not that workers are the "chosen" people over all other groups because they are the most sympathetic; it is that, if you want to change capitalism and redistribute its resources, you have to have leverage at the heart of capitalist economic power, which is the workplace.

Contemporary capitalism has offered more and more power for individuals to express themselves at the same time that it has beaten down unions and absorbed social movement energy into professionalized nonprofits, with their self-consciously limited missions.

It is logical, then, that radicals emerging in this era might view their most plausible power to be at the level of communications.[42] Social media has served as a tool to break certain kinds of old information monopolies, but it has channeled its users toward seeing themselves as small, hyper-competitive information entrepreneurs, whose self-conception and livelihood depend on an endless quest for differentiation in an attention economy. So, the very same media conditions that have allowed for the recent diffusion of socialist ideas also incentivize the kinds of individualist ideas of political change that a socialist politics needs, ultimately, to break with. Organizing a single Amazon distribution center would be worth more than a million people making "radical content," in terms of showing that it is actually possible to change the way society is run.

We can take comfort in the fact that the problem of bringing intellectuals and other middle-class types into alignment with a working-class politics is not a new one, and is not impossible to solve: Marx was a journalist, after all. The present situation represents a tricky new version of an old challenge, or of its reemergence at a new and more general level. But if the very structures of political communication now tilt the field toward disorganized forms of political action, and so put a socialist politics at a disadvantage, the latter still has one advantage, if only potentially. A materialist analysis should be able to see the dilemmas of digital politics in terms of structuring forces and class incentives rather than merely as faulty arguments or skewed perspectives—in other words, it should be able to see its real problems as real problems, which is a more promising place to start to build real power.

Chapter 6

Cultural Appropriation and Cultural Materialism

Organized before the 2016 election of Donald Trump, the 2017 Whitney Biennial was nevertheless read as the first big post-Trump art exhibition, a referendum on how art was responding to a troubled moment in society. Curated by Mia Locks and Christopher Lew, it was full of spirited and challenging work and more or less a success, I thought, including on the level of including an unusually diverse collection of artists. The conversation around it, however, would be dominated by a single artwork: *Open Casket* by Dana Schutz.

The small painting depicted a famous photo of Emmett Till, a Chicago fourteen-year-old murdered by racist white vigilantes in 1955 while he was visiting the South, his mutilated face rendered in a distorted expressionist style. Famously, Till's mother, Mamie Till Mobley, had left his casket open so that the world could see what white supremacy had done to her son, an act that had resonated widely and helped radicalize the emerging Civil Rights Movement. At a moment when images of police and vigilante violence against Black youth were once again radicalizing a generation, the grisly image had a new charge. "I made this painting in August of 2016 after a summer that felt like a state of emergency—there were constant mass shootings, racist rallies filled with hate speech, and an escalating number of camera-phone videos of innocent black men being shot by police," Schutz explained. "The photograph of

Emmett Till felt analogous to the time: what was hidden was now revealed."[1]

To a number of artists who had been engaged in recent debates about media exploiting Black pain for profit, the gesture represented a callous appropriation. In a widely circulated Instagram post from the show's opening, artist Parker Bright was pictured blocking the view to *Open Casket*, wearing a shirt that said "Black Death Spectacle." The well-respected British artist and critic Hannah Black circulated an open letter on social media addressed to the curators: "I am writing to ask you to remove Dana Schutz's painting 'Open Casket' and with the urgent recommendation that the painting be destroyed and not entered into any market or museum." Placing the painting squarely within a charged contemporary conversation about cultural appropriation, Black wrote:

> Although Schutz's intention may be to present white shame, this shame is not correctly represented as a painting of a dead Black boy by a white artist—those non-Black artists who sincerely wish to highlight the shameful nature of white violence should first of all stop treating Black pain as raw material. The subject matter is not Schutz's; white free speech and white creative freedom have been founded on the constraint of others, and are not natural rights. The painting must go.[2]

The explosively bitter debates over *Open Casket* defined this show, and the year in art. The acrimonious back and forth saw participants accusing other participants of being either bigots or book burners. In the *New Republic*, Jo Livingstone and Lovia Gyarkye penned "The Case Against Dana Schutz":

> Emmett Till died because a white woman lied about their brief interaction. He died because his side of the story did not mean anything to the two white men who killed him, just as it meant nothing to the jury that acquitted them. For a white woman to paint Emmett Till's mutilated face communicates not only a tone-deafness toward the history of his murder, but an ignorance of the history of white women's speech in that

murder—the way it cancelled out Till's own expression, with lethal effect.[3]

Replying to both the *New Republic* authors and Black's letter in the art website Hyperallergic, the artist Coco Fusco, a powerful voice within the debates over multiculturalism and representation that defined the '90s, wrote:

> Black makes claims that are not based in fact; she relies on problematic notions of cultural property and imputes malicious intent in a totalizing manner to cultural producers and consumers on the basis of race. She presumes an ability to speak for all black people that smacks of a cultural nationalism that has rarely served black women, and that once upon a time was levied to keep black British artists out of conversations about black culture in America.[4]

Maurice Berger, a white scholar who had written extensively about racism in visual culture, penned a piece for the *New York Times* Lens blog condemning Schutz. "While some critics have made Ms. Schutz's race the overarching issue—that a white artist should not traffic in black pain—the problem is not about her race," he wrote. "White artists should, and indeed have a responsibility to, examine the most vexing and intransigent issue of our time." He continued: "But cross-cultural work demands insight, respect, sensitivity and rigor. It also requires honesty about and self-inquiry into one's own racial attitudes. To be an artist, no matter how expressive or interpretive, does not give anyone license—or cover—to casually appropriate African-American history and culture." Berger concluded that the work felt "like another violation of Emmett Till's body."[5]

By then, the polarized debate over *Open Casket* was throwing off such a massive volume of online energy that it leapt from the confines of art media into the mainstream news. It made the chat show *The View* as a discussion topic. "You may be an artist, but you need to grow up," comedian Whoopi Goldberg declared, chiding Black. "You should be ashamed of yourself." *The View*'s discussion did not exactly impress with its sophistication—Joy Behar used

Mark Twain's *The Adventures of Huckleberry Finn* as an example of a white artist showing solidarity with Black struggle, when that novel's depiction of Jim has been endlessly contested as demeaning. But it was the rare topic on which the panel of hosts was in agreement. "It seems like they don't really understand what cultural appropriation is," co-host Sunny Hostin said. "This is not cultural appropriation. This is—I think—trying to make sure that Emmett Till's pain is America's pain, and trying to show it through art."[6]

Months later, the novelist Zadie Smith weighed in within the pages of *Harper's*. Assessing the rhetoric of the attacks on the painting versus the experience of seeing the work at the Whitney itself, Smith wrote:

> I stood in front of the painting and thought how cathartic it would be if this picture filled me with rage. But it never got that deep into me, as either representation or appropriation. I think of it as a questionably successful example of both, but the letter condemning it will not contend with its relative success or failure; [Black's] letter lives in a binary world in which the painting is either facilely celebrated as proof of the autonomy of art or condemned to the philistine art bonfire. The first option, as the letter rightly argues, is often just hoary old white privilege dressed up as aesthetic theory, but the second is—let's face it—the province of Nazis and censorious evangelicals.[7]

The comparison to Nazism did not cool tempers. Recrimination over the offense of Dana Schutz's painting rolled on. At the end of the same month Zadie Smith published her take, a travelling show of paintings by Schutz was set to appear at the Institute of Contemporary Art (ICA) in Boston. Though the show did not feature *Open Casket* and had been planned before the Whitney Biennial, it immediately started to attract anger on Facebook. The institution reached out to its online critics, asking to meet with them in advance to try to head off protest. Unsatisfied after the results of that conversation, the protesters—this time self-described as "a group of mostly white folks"[8]—issued a new open letter demanding that the ICA "pull the show":

Even though the painting will not be shown, even in its absence, backing its artist without accountability nor transparency about proceeds from the exhibition, the institution will be participating in condoning the coopting of Black pain and showing the art world and beyond that people can co-opt sacred imagery rooted in oppression and face little consequence, contributing to and perpetuating centuries-old racist iconography that ultimately justifies and socially sanctioned violence on Black people.[9]

In response to the renewed criticism of Schutz, a group of high-profile figures, including well-known Black artists such as Dread Scott, Kara Walker, and Jack Whitten, signed on to a letter in support of the show. It was "[of] the utmost importance to us," the letter stated, "that artists not perpetrate upon each other the same kind of intolerance and tyranny that we criticize in others. We support the ICA-Boston and its decision to exhibit the works of Dana Schutz, and to maintain programming that fosters conversations between people with different points of view, especially given our current political climate of intolerance."[10]

The twists and turns of the *Open Casket* controversy were disorienting. The language of humanist universalism framing many of the defenses of Schutz struck me as flat. The uncompromising rhetoric attacking white privilege made the criticism of the painting feel resonant with the radicalism demanded by the time. Yet the calls to destroy the painting and permanently shun its artist were disturbing. Any glance at the right-wing media saw it exultant at having a convenient opportunity to paint social justice as censorious and narrow-minded and to legitimate its own ascendant intolerance and extremism.[11]

There were people of color on each side, and white people too. Indeed, one of the things that struck me about the controversy was that it was more of a generational debate than anything else, with most (not all) of the voices against Schutz being part of the younger generation of social justice–minded artists and critics, attuned to a specific contemporary discourse about representation, and most of the voices criticizing their premises (not all) being older—though

often themselves deeply engaged with issues of representation and racism. I met younger art students from minority backgrounds who were passionately animated against Schutz, finding in the controversy a way to voice their own alienations from an art system that felt at best opportunistic about its embrace of contemporary political questions. I heard from a white artist who had done important work in solidarity with the international movement against apartheid in South Africa in the 1980s, who said, in bewilderment, that if this had been the state of the conversation at that time, they would have been paralyzed in expressing public solidarity. The conversation would seem to demand silence about struggles that didn't directly reflect personal experience.

In assembling this essay, I've tried to educate myself and to reference scholars and writers of color who have been theorizing cultural appropriation, sometimes for decades—but I am very aware that my writing on the subject may itself be seen as problematic because of my own identity. Why write about it, then? My personal sense of what was at stake in recent debates over appropriation related to my experience, a few years earlier, in the movement to stop the execution of Troy Davis, a Black man sentenced to death in Georgia in 2011 despite the fact that the majority of witnesses who had testified against him had recanted. The slogan of that movement had been "I Am Troy Davis." It had faced some controversy, with critics arguing that white people should not say the words "I Am Troy Davis," given the role of prisons and police as instruments of white supremacy. Some saw the white activists wearing "I Am Troy Davis" shirts as attempting to absolve themselves of responsibility for racism with a symbolic gesture rather than reckoning with their part in it.[12] But through the Campaign to End the Death Penalty, I had worked directly with Troy's sister Martina Correia, who had herself advanced the slogan to increase the visibility of her brother's case.[13] It had done tremendous good as a simple message of public solidarity, showing that masses of people of all backgrounds cared about the injustice in Georgia. The criticism of the slogan had not, on the whole, affected the main work of the campaign, and I saw it as being based on a

misunderstanding the nature of the movement, erasing Correia. But now, in the *Open Casket* controversy, I could see clearly that we were in a new political moment, one in which "I Am Troy Davis" would never have gained the same kind of unifying momentum. It fact, it clearly would have backfired and ground the campaign to a halt. Inasmuch as the controversies within art were having a wider political impact, they pointed in a different direction. What were the productive ways to act within these evolving terms of debate?

Social Movements and the Movement of Culture (1)

In the art world and well beyond, "cultural appropriation" has been one of the dominating themes of mainstream cultural criticism in recent years, emerging centerstage in the media concurrent with the rise of the Black Lives Matter movement. It has by now transformed what it means to be an engaged political artist and transformed how culture in general is circulated, marketed, and criticized, often in very positive ways. Yet the conversation around the topic is extraordinarily unwieldy.[14] The term has been used to condemn everything from the bitter historic injustice of the white-run music industry ripping off Black musicians to non-Hindu people practicing yoga today; from white Jewish scholar Jessica Krug, a self-described "decolonial historian of Black political thought," assuming the completely made-up Afro-Latinx identity of "Jess la Bombalera"[15] to a white teenager from Utah wearing a thrift-store cheongsam to prom.[16] While the most common interpretation of the term focused in particular on a dominant, usually European or European-American culture's theft and commercial degradation of Black and Indigenous culture, the more recent surge of popular debate has created a new level of vigilance around maintaining clear borders between cultures of all kinds, at all levels. White celebrities like Iggy Azalea, Katy Perry, and Justin Timberlake were the subject of heated charges of cultural appropriation, nonwhite celebrities including Awkwafina, Beyoncé, Jennifer Lopez, Bruno Mars, Nicki Minaj, and Pharrell Williams

all came to be accused of appropriation of different kinds as well, prompting talk that the term had attained a new level of all-purpose generality.[17] The trend of weighted blankets has been labeled cultural appropriation of autistic culture.[18] So thoroughly has the theme permeated psychic life that Pam Grossman, host of a popular podcast on modern-day witchcraft, found herself addressing "cultural appropriation in the mystical community" by advising a listener about whether she was allowed to worship the goddess Lilith despite her lack of Jewish heritage. "I cannot continue wholeheartedly in my devotion while this question hangs in my mind," the woman wrote. You would think the fact that, by the listener's account, Lilith had personally appeared to her in a red cloak with the message "You have asked for me and here I am" would have cleared up the uncertainty.[19]

It is tempting, in the face of the extreme amounts of attention demanded by the subject in the click-hungry, high-speed world of online debate, to say we should simply focus energy elsewhere. It's therefore necessary to begin by going back to the last period of left gains, the 1960s, to be reminded that symbols and the popular standards set for how they circulate between communities do actually matter for "real" movements.

"Symbol-making is a necessary part of any social movement; it provides a quick, convenient way of proclaiming one's views to the world," feminist activist Jo Freeman wrote, remembering the efforts, at a women's liberation conference outside of Chicago in 1968, to create a resonant symbol to give visibility to a movement that had yet to truly gain widespread attention. After the false start of a "double X surrounded by a circle" ("It flopped"), the soon-to-be world-famous "Woman Power" symbol—a raised fist within the Venus symbol for women—was designed by Robin Morgan as a graphic for a protest of the 1969 Miss America Pageant.[20] Morgan's simple design quite clearly drew on militant iconography of the time: the upraised "Black Power" fist had been seared into the public imagination for all time at the Mexico City Olympics the previous year, when runners Tommie Smith and John Carlos had raised their gloved fists from the winners' podium.[21]

This background has in more recent years led writers such as Lindsey Weedston to argue that fellow white feminists should not use Morgan's woman power symbol at all, excising this "quick, convenient way of proclaiming one's views to the world" from acceptable social justice discourse: "This symbol does not belong to us. That's why I don't use it. If you're not black, you should also not use it. And for the love of god, don't get a tattoo of it."[22] Yet, crucially, the Black Power salute itself drew on a larger existing iconography of radical politics. The raised fist had been associated with the Industrial Workers of the World and was used by communists during the Spanish Civil War as a deliberate counterpoint to the open-palmed fascist salute.

Meanwhile, concerns about another kind of potential appropriation loomed as early as the first deployment of the "Woman Power" symbol at the 1969 Miss America protest, which would put the women's liberation movement on the map of mainstream discussion. "Ever conscious that major corporations like to co-opt incipient protest movements, [Robin Morgan] imagined that the cosmetic firm sponsoring the pageant might respond by manufacturing a matching lipstick named 'Liberation Red,'" Freeman remembered. "Therefore, if we were asked about the button, we were instructed to reply that the color was 'Menstrual Red.' No one would name a lipstick that."[23]

You have to appreciate the spiky good humor. But this pinpointed a dilemma: the realities of the battle for visibility within a rapacious consumer economy put those trying to chart a course in a double bind, policing the edges of the very symbols that they wanted to spread more widely. Any struggle that gains purchase on the public imagination has to wrestle constantly with having its emblems stolen and twisted by cynical political actors to diffuse their impact and utility for defining an authentic community of interest.

The project of reclaiming overlooked women's history was a key part of early feminist consciousness-raising. But to the irritation of women's liberation activists, already by 1969, Virginia Slims was running ads juxtaposing historical images of female struggle with full-color images of modern, independent women striding smilingly

into the future, cigarette in hand, with the tagline, "You've Come a Long Way, Baby"—using the enthusiasm of the movement to sell an extra-thin cigarette that actually gave you less tobacco for your buck.

In another domain, the phrase "Black Power," when declared by Stokely Carmichael in October 1966, was associated with Black militancy. But the slogan would also be appropriated by Richard Nixon—though he meant supporting "black capitalism," wielding it as a way to isolate Marxist-influenced groups like the Black Panther Party.

At the same time, the historic social movements of the 1960s are also one long example of mutual inspiration, in tactics and symbols. Even the term "sexism" is an example of cultural appropriation, of a kind. "Sexism is intended to rhyme with racism," Caroline Bird said in 1968, in one of the concept's first theorizations. "Both have been used to keep the powers that be in power."[24]

Black activists in the US were inspired by the independence struggles of African nations against European colonialism. In turn, Black demands for dignity and self-determination helped give a wide variety of other groups in struggle a language to articulate their own experiences, from the Chicano Civil Rights Movement to the anti–Vietnam War movement. From another direction, in the wake of the Stonewall Uprising, the Gay Liberation Front chose its name as a parallel to Vietnam's National Liberation Front, showing how much Third World and anticolonial struggles were inspirations for revolts against oppression in the heart of the empire. In an epoch of social change on many fronts, what organizer and musician Bernice Johnson Reagon called "the movement force" tended to move around, the locus of initiative and inspiration passing from one area of struggle to the next, opening up ideas and tactics that the others benefited from and then took up. It was for this reason that Reagon would write in her essay "Coalition Politics" that the political skill of the century to come was "how to cross cultures and not kill yourself."[25] Without the process of appropriation and adaptation of both tactics and symbols—sometimes explicit, sometimes unconscious—movement history would have been greatly impoverished.

In a 1991 essay, the scholar and activist Angela Davis wrote of a very personal experience of cultural appropriation: "I know that almost inevitably my image is associated with a certain representation of black nationalism that privileges those particular nationalisms with which some of us were locked in constant battle." The image of Davis with her Afro and raised fist became world-famous during the "Free Angela Davis" agitation of the late '60s and entered pop culture in graphics, posters, hip-hop, and endless highlight reels of "the Sixties." Asking why her own politics were so consistently misrepresented, she would briefly hypothesize that it had to do with the fact that the kinds of internationalist Marxism and coalition politics that she had fought for had been defeated and marginalized, while Black cultural nationalism—she mentions the Nation of Islam—had remained as a mass force organizing Black communities, thereby entering hip-hop and popular culture as the main available avatar of radical identification.

Even so, Davis wrote of her own complex relationship to the kind of cultural politics that her image had come to represent:

> Today, I realize that there is no simple or unitary way to look at expressions of black nationalism or essentialism in contemporary cultural forms. As my own political consciousness evolved in the sixties, I found myself in a politically oppositional stance to what some of us then called "narrow nationalism." As a Marxist, I found issues of class and internationalism as necessary to my philosophical orientation as inclusion in a community of historically oppressed people of African descent. But, at the same time, I needed to say "black is beautiful" as much as any of the intransigent antiwhite nationalists. I needed to explore my African ancestry, to don African garb, and to wear my hair natural as much as the blinder-wearing male supremacist cultural nationalists.[26]

That parallax perspective, to me, seems a hard-won insight worth holding on to in the face of the present polarized discussion—both seeing how certain claims on culture narrow the frame of struggle *and* respecting culture's importance, particularly for

people from historically oppressed communities, as a place where political investments are formed. Looking directly at that apparent contradiction is the starting point for a properly dialectical approach to the theme of cultural appropriation.

From Postmodernism to Cultural Appropriation

By consensus, the dramatic new mainstream interest in cultural appropriation started around 2013.

There is a longer, important history of scholarship around cultural appropriation (I'll touch on it below). Yet, as cultural appropriation has become a pop-culture buzzword and fuel for endless debate on social media, the concept has functioned more as a new commonsense than as a reference to a body of theory. Know Your Meme, a site meant to be a guide to various internet controversies, defines "cultural appropriation" as "the practice of adopting various aspects of a minority culture by individuals belonging to a dominant cultural group, including iconography, music, language and social behavior."[27] Yet those visiting the site looking for a deeper understanding of the history and theory behind the concept would find this: "The exact origin of the term 'cultural appropriation' is unknown, although the concept appears to have been predominately used in academic circles in sociology and anthropology prior to the Internet."[28]

It is difficult to overstate the degree to which the new overriding interest in the harms of cultural appropriation was experienced as a reordering of progressive priorities in the recent period, even among those engaged with anti-racism. Stuart Hall, the Jamaica-born Marxist theorist of cultural studies often cited in conversations about the politics of culture, wrote in a famous essay from 1981: "Cultural domination has real effects—even if these are neither all-powerful nor all-inclusive . . . The danger arises because we tend to think of cultural forms as whole and coherent: either wholly corrupt or wholly authentic. Whereas, they are deeply contradictory; they play on contradictions, especially when they function in the domain of the 'popular.'"[29]

In the academy, the mainstream of intellectual and cultural discourse through the 2000s was still heavily invested in the notion of "postmodernism." The positive terms of postmodern thought were hybridity, remix, the deconstruction of binaries, irony, and anti-essentialism. In contrast, the contemporary mainstream cultural appropriation critique seems to posit clearly articulated, knowable, distinct cultures. It also poses a clear ethical binary of the very "corrupt/authentic" type that Hall was decrying, with appropriation viewed as univocally destructive and harmful.

You can actually see the abrupt shift in contemporary discourse using Google Trends, which measures public search interest in terms. In 2010, "cultural appropriation" barely registered as a term of interest for the web-searching public. In 2012, interest in "cultural appropriation" began to rise. In August 2013, the uproar over Miley Cyrus's twerking performance at the MTV Video Music Awards made debate over appropriation a hot topic. As cultural critic Lauren Michele Jackson noted, "That was when the term really exploded in headlines . . . and everyone realized this is the term that we use now to describe this thing that has really been eternal to American culture."[30] Even then, "postmodernism" still drew more interest from curious web-searchers than "cultural appropriation." Starting in 2015, "cultural appropriation" spiked ahead. From then on it has attracted anywhere between twice and three times the search interest as "postmodernism," which has been trending down.[31]

From Patricia Bell Collins[32] to Chela Sandoval,[33] a variety of important scholars—in particular scholars of color—have long expressed uneasiness with postmodernism's exclusive language, its focus on theoretical as opposed to on-the-ground struggle and its framework of addressing race through the abstract lens of "difference." In a sharp text that first appeared in 1990, "Postmodern Blackness," the theorist bell hooks wrote the following:

> The failure to recognize a critical black presence in the culture and in most scholarship and writing on postmodernism compels a black reader, particularly a black female reader, to interrogate her interest in a subject where those who discuss and write about it seem not to know black women exist or to even consider the possibility that we might be somewhere writing or saying something that should be listened to, or producing art that should be seen, heard, approached with intellectual seriousness. . . . Postmodern theory that is not seeking to simply appropriate the experience of "otherness" in order to enhance its discourse or to be radically chic should not separate the "politics of difference" from the politics of racism.[34]

Yet in the same text, hooks still wrote of the potential of "radical postmodernism" as a useful tool that could advance the Black liberation struggle, seeing its intellectual decentering of old cultural certainties as possibly leading to new forms of coalition:

> The overall impact of the postmodern condition is that many other groups now share with black folks a sense of deep alienation, despair, uncertainty, loss of a sense of grounding, even if it is not informed by shared circumstances. Radical postmodernism calls attention to those sensibilities which are shared across the boundaries of class, gender, and race, and which could be fertile ground for the construction of empathy-ties that would promote recognition of common commitments and serve as a base for solidarity and coalition.[35]

Thus, even as hooks paid close attention to the ethics of authorship and how racism worked through culture in essays like "Eating

the Other" and "Is Paris Burning?" she would also write positively of the identification of a new generation of white youth with Black culture in the '90s, in terms almost certainly at odds with today's commonsense understanding of cultural appropriation:

> Black rage against injustice, against systems of domination, particularly as it is expressed in black youth culture, is mirrored in the rebellion against the white supremacist bourgeois sensibility expressed by white youth. Calling attention to this connection in a recent interview in *Artforum*, radical gay filmmaker John Waters comments: "One thing that I find fascinating, now that my generation has kids and those kids are rebelling, is that if they're white the only way they can rebel is to be black. My generation marched for Martin Luther King, Jr., but they didn't want their kids to be blacks. That's the difference between my generation and their kids." This is a generation of kids who are tired of racism and white supremacy, who are less willing to engage in denial, a generation that may be willing to launch organized collective resistance. White and black conservatives alike fear them and want to wipe out both their sense of connectedness and any possibility that they might join together to engage in processes of radical politicization that would transform this nation.[36]

This shift in the discourse around culture is further thrown into relief if you look at the earliest concrete intellectual reference Know Your Meme offers to explain the present-day, internet-era usage of the term "cultural appropriation": *Everything but the Burden: What White People Are Taking from Black Culture*, a 2003 collection of essays edited by music critic Greg Tate. Tate is known as an unsparing critic of racism in the music industry, and the essays collected in *Everything but the Burden* analyze appropriation within the framework of white supremacy. Yet his introduction to the collection also contains the following passages:

> In popular music since the sixties, complicated characters like Bob Dylan, Frank Zappa, Joni Mitchell, Steely Dan, Johnny Rotten (and now Eminem) complicated the question of how

race mythology can be creatively exploited. They have also made us understand how influence and appropriation can cut both ways across the racial divide. These are white artists who found ways to express the complexity of American whiteness inside Black musical forms. In turn, these artists came to appeal to many among the post-Soul-generation African Americans who have no problem, as their forebears Lester Young, Miles Davis, and Charlie Parker didn't, in claiming a white artistic ancestor. . . .

African-American admirers of white artists have historically transcended the picayune boundaries that define the world's race-obsessed ideas about skin and cultural identity, drawing freely from the world's storehouse of artists for models. Ellington loved Debussy and Stravinsky. Jimi Hendrix had a special thing for Bach, Bob Dylan, and Handel. Jean-Michel Basquiat held special fondness for Dubuffet, Twombly, Rauschenberg, Warhol, and *Gray's Anatomy*. Charlie Parker embraced country-and-western music, much to some of his idolaters' chagrin. Ralph Ellison credited T. S. Eliot with inspiring him to study the craft of writing as assiduously as he already had that of European concert music. Toni Morrison speaks of García Márquez, Fuentes, and Cortázar as if they were blood relations, and so on. There should be no revelation in this, but the sad truth about the dehumanization of Black people is that it can strap blinders on us all regarding the complexity of human desire within the divided racial camps.[37]

What Tate offers is a specifically *noncategorical, context-sensitive*, and *multidirectional* picture of the stakes of cultural appropriation—one that does not fit a simple binary logic of "appropriation" as good or bad, corrupt or authentic. Appropriation can be an instrument of racism, but cultural appropriation is not, in this view, another name for racism. It thus seems that as the term "cultural appropriation" has come to dominate the conversation and circulate much more widely, it has also come to function much more categorically, and much more restrictively.

A Complex "Crossing"

Partisans of contemporary cultural appropriation critique tend to frame contemporary appropriation as a continuation of historical processes of dispossession of non-European peoples (as when Lauren Michele Jackson says it is "the term that we use now to describe this thing that has really been eternal to American culture"). Critics of the critics, eager to score points and win over those perplexed or alienated by the new demands on culture, tend to frame cultural appropriation as a synonym for all cultural interchange (as with conservative troll Bari Weiss, who writes that appropriation is simply a name for "syncretism—the mixing of different thoughts, religions, cultures and ethnicities that often ends up creating entirely new ones. In other words: the most natural process in a melting-pot country like ours.")[38]

Yet the most illuminating enigma to unpack seems to me to be the historical specificity of the contemporary conversation: Why did this particular conversation about culture take root in the particular polarized and public form it did in the 2010s, and with such ferocity?

Writing of the birth of nationalism, historian Benedict Anderson once described it as "the spontaneous distillation of a complex 'crossing' of discrete historical forces . . . that, once created . . . became 'modular,' capable of being transplanted, with varying degrees of self-consciousness, to a great variety of social terrains."[39] It is just such a "crossing" of distinct factors, I'd argue, that have come together recently in the newly ever-present awareness of cultural appropriation that has developed.

There are surely many factors at play, from the new understanding of "mainstream" culture brought on by demographic shifts in the United States toward a "majority minority" society to the production of a critical mass of expertise about the history of cultural appropriation itself in the academic fields of cultural studies, feminist studies, and ethnic studies that formed post-'60s. Below, I offer three broad regions where I think a cultural materialist analysis is useful in thinking through why the concept might harden into the new, expansively applied, polarized, and "modular" form it has.[40] Some

points here will seem more directly related to cultural appropria-
tion than others. Because so often criticism of the concept frames
it simply as an incomprehensible intellectual error perpetrated by a
particular dominant form of progressive opinion, I've tried to include
moments in the wider field of debates that resonate with the recent
interest in appropriation, to show how this new sensibility reflects
larger shifts in how economic and political power intersects with
culture.

1. The Expansion of Cultural Capitalism

Contemporary cultural appropriation critique often involves the ques-
tion of offensive stereotypes and degradation of minority cultures, but
these are overlaid with a particular intense emphasis on benefit: Who
profits, either in terms of real or social capital, from cultural forms?
It would seem relevant, then, to consider how society's emphasis on
culture as a center of profit-making has shifted and expanded under
neoliberalism: between 1998 and 2014, the contribution of arts and
culture to US GDP grew by 35.1 percent.[41] As culture has become
more and more commodified, it follows that the sense of any kind of
cultural space outside of profit calculation has been squeezed.

Indeed, from the 2000s on, Richard Florida's theory that a "cre-
ative class" of knowledge workers and cultural entrepreneurs was the
replacement for the "working class" as the engine of a competitive
economy became part of the urban policy lingo and very widely re-
peated.[42] The decline of manufacturing employment was accompa-
nied by the expansion of the service sector, with an ideological focus
on creative industries that diffused very widely through society. If
you wanted to "be someone," culture was more and more the avenue
toward which your aspirations were channeled. "That was part of
this yearning that I see in a lot of young kids, that they wish they
were on TV," radical musician and filmmaker Boots Riley explained
of his work as a political organizer. "It comes out of this idea that
we're not important and those are the important people."[43]

At the same time, consumer spending ballooned as a share of

economic activity in the US during this period, to close to 70 percent of the economy. Immense and increasing amounts of investment were poured into making consumers feel emotionally invested in the things they buy, to keep the wheels of commerce turning. "Just 20 years ago, most retailers did not even have a proper marketing department," marketing guru Marc de Swaan Arons marveled in 2012, contrasting that with the present, when "the average western consumer is exposed to some 3,000 brand messages a day." This quantitative intensification of brand exposure, he argued, entailed cultivating new expectations of symbolic communion with consumers: "A brand is the contract between a company and consumers. A bundle of contracts, in fact. And the consumer is the judge and the jury. If he or she believes a company is in breach of that contract either by underperforming or misbehaving, the consumer will simply choose to enter a contract with another brand."[44] This vast corporate interest in making psychic investments in commodified culture feel emotionally resonant thus foreshadowed that consumers would, in return, make new demands on commodified culture.

In 2010, the Gap tried to change its logo, triggering a backlash so virulent that the retailer backed down. "For years, logo redesign was a very esoteric thing," the designer Michael Bierut recounted. "I don't remember a normal person ever asking me about a logo before. That started happening more and more." Bierut described being bombarded by waves of angry voicemails and emails. "The one thing that was really obvious was the thing that really bothered them the most was the sense that giant, impersonal corporate forces were arbitrarily changing things that they cared about personally."[45] This was, he pointed out, an unintended side effect of the fact that the advertisers had been effective in the first place: Customers had formed enough meaningful personal associations with the brand that the rebranding was experienced as a kind of cultural betrayal.

"The frantic economic urgency of producing fresh waves of ever more novel-seeming goods (from clothing to airplanes), at ever greater rates of turnover of capital" was part of the way Marxist literary critic Fredric Jameson described "postmodernism" as the cultur-

al counterpart to the waves of neoliberal globalization that washed over the world in the 1980s and '90s.[46] This acceleration, Jameson thought, led to a particular new emphasis on "pastiche": the remixing of culture as "dead styles"—a name for a kind of cultural appropriation. By the mid-2000s, another theorist, Martin Roberts, wrote that the cultural environment had become so competitive, and the process of commodifying culture so sped up, that the "culture industry" was essentially best understood as the "subculture industry:" a constant race to harvest new niche styles that retained some trace of authenticity or specialness outside of the dominant. It would thereby train its operations more and more on minority and non-Western cultures as signs of cool: "Whereas throughout the history of modernity standards of taste have tended to be driven in a 'top-down' fashion by socio-economic elites, today the reverse is often the case, with the mythical 'street' driving creative decisions across the spectrum of the culture industry."[47]

The fashion industry in particular underwent a period of dramatic acceleration in the new millennium. "Fast fashion" became the industry buzzword of the 2000s—meaning the idea of capturing new markets with ultra-cheap garments that responded to warp-speed fashion cycles. This meant an intensification of the dual pressures toward harvesting whatever signifiers felt authentic—but treating them as more and more disposable. Jean-Paul Gautier's 1993 collection, inspired by Hasidic Jewish culture, had been a kind of avant-garde landmark at the time. Ever more outlandish efforts to capture attention meant ever increasing cultural borrowing, with disastrous examples like Victoria's Secret models sporting "warbonnet"-style feathered headdresses, Riccardo Tisci declaring his inspiration to be "Chola Victorian," or Gucci plundering Harlem designer Dapper Dan's 1980s designs.

In her 2012 critique of fast fashion, *Overdressed*, Elizabeth L. Cline would write: "We're rotating through entire paradigms of fashion now within a few seasons (boho, androgynous, hippie-chic, sailor-inspired), while we're also seeing fashion within a single season change in almost capricious ways."[48] In this maniacal context,

fashion media, in particular, became a crucible for the new type of cultural appropriation criticism, inaugurating the new pop-semiotic project of unpacking every new collection for problematic signifiers. Scholar Adrienne Keene, a citizen of the Cherokee nation, kicked off the blog Native Appropriations in 2010 with a post titled "It Starts With a Trip to Urban Outfitters," ridiculing the kitschy dream catchers, mukluks, and desktop totem pole sculptures for sale at an Urban Outfitters in Harvard Square.[49] She would go on to find plenty of commercial appropriations to analyze, from such fare as the Gap's "Navajo Tracker Hat"[50] to the general trendiness of "tribal fashion" among tastemakers.[51] Her blog was one of the vectors credited (by Know Your Meme, among others) with carrying cultural appropriation critique into the center of media discussion. "Does that mean that designers, companies and media creators cannot incorporate native elements into their work?" Keene would write in the *New York Times* in 2015. "Absolutely not. I just ask for partnership, for collaboration and for equal power and control over how our communities are represented."[52]

Meanwhile, within the mainstream of corporate culture itself, an intensified emphasis on "intellectual property" has been a very public aspect of neoliberalism, as the major economies restyled themselves away from manufacturing and toward the high value-added areas of design, technology, and marketing. The 1994 North American Free Trade Agreement (NAFTA) was the first trade agreement to include obligations to protect intellectual property rights. The World Trade Organization's Agreement on Trade-Related Aspects of Intellectual Property Rights (TRIPS), signed the same year, enshrined intellectual property protection within international trade. "Since around 2000 we have seen the rise of public awareness of intellectual property," writes cultural historian Siva Vaidhyanathan.[53] He argues that the "copying industries"—film, music, software, publishing—have become second only to agriculture as a US export. The business press every day amplifies the idea that policing some forms of immaterial property is a major source of prestige and wealth. Pharmaceutical companies go to war to protect patents on life-saving drugs and prevent generic competitors.

Luxury good producers are massively invested in attacking counterfeits. Apple and Samsung have fought each other across the world over who "owns" the idea of a square tablet device with rounded corners. Amazon infamously patented the ideas of "one-click" online shopping and product photography against a white background.

By the 2010s, intellectual property even became the centerpiece of the most mainstream of all mainstream pop culture. Faced with fierce competition for the public's attention, Hollywood bet the farm on licensing intellectual property to gain a stable commercial edge. Disney's $4 billion purchase of the *Star Wars* universe in 2012 made "IP" both an industry buzzword and a term casually spoken by fans. Such a business strategy depends both on harnessing a fandom's deep affection for a given cultural property and on claiming exclusive right to make work "inspired" by it—leading to berserk online debates about how true to the source films or TV shows are, with wars over the finer points of DC and Marvel lore resembling Bizarro World parodies of political sectarianism and, indeed, the most intense cultural appropriation controversies. (Indeed, online firestorms over the casting of nonwhite actors as characters who were depicted as white in the original fantasies have amounted to "reverse cultural appropriation" controversies.)

In the late 2000s, the escalating visibility of intellectual property in the business press led cultural theorists to place a new emphasis on how denying IP to Black cultural producers had historically been an instrument of racism. "While individual black artists without question have benefited from the IP system, the economic effects of IP deprivation on the black community have been devastating," scholar K. J. Greene wrote in 2007. "Intellectual property today is perhaps the preeminent business asset."[54] Noting that traditional intellectual property law only protected individuals and placed creativity rooted in communal tradition or improvisation beyond protection, Greene called for a reworking of laws to redistribute wealth and redress historic injustice (though what these new standards could be, without further reifying heretofore uncommodified communal practices, was unclear): "IP can be re-engineered to bring about results of dis-

tributive justice and to foster norms of race and gender equality."[55] (Greene's writing would be a direct influence on the discussions of the commodification of Black slang discussed in the next section.)

Cultural appropriation claims center very heavily on power, and in particular on the harm done to historically oppressed communities when more powerful groups profit from cultural goods. Yet it's instructive to note that the attempt to make claims rooted in cultural origins as a way to fight back against the amoral marketplace is, in fact, *not* unique to historically marginalized communities but can be understood as a predictable result of intensified economic competition. For instance, one counterreaction to an increasingly global economy saw US manufacturers lean into the "Made in the USA" label and play on pride in national identity. The label became a major part of auto and apparel marketing in the '80s; by the mid-'90s, the term was used (and abused) enough that the Federal Trade Commission had to specify what did and did not count as wholly or partly American-made, in terms of percentages of parts and labor coming from within the United States.

Yet in a racially riven capitalist society, it is not surprising that escalating pressure on cultural goods as a profit nexus caused intellectual property issues to intersect directly with ideas of identity. Most notably, the Indian Arts and Crafts Act of 1990 was a result of, as attorney Jennie D. Woltz wrote, "the high demand for Indian goods, fueled in part by the New Age movement and increased travel and consumerism in America in the 1970s and 1980s."[56] These factors made handicraft production increasingly vital to the economies of tribal communities. At the same time, this increased demand also stimulated a flood of counterfeit goods in the newly globally interconnected economy, mass produced overseas. The 1990 act prohibited the sale of Native American or Alaskan Native art unless the producer was tribally enrolled or recognized as an artisan. "In practice," Woltz wrote, "this Act effectively makes Indianness a trademark, vesting the exclusive right to use the term 'Indian' to those recognized as 'Indian' under the Act."[57] Cultural identity, thus, became thought of specifically through the lens of property.

Such formal legal means are not the main way of defending minority enterprise. The main one is what the scholar Ellis Cashmore calls "the commodification of authenticity," that is, marketing the cultural origins of a product as a selling point.[58] An early example was FUBU, standing for "For Us, By Us," launched as a street wear line in 1992, specifically advertising itself as Black-designed apparel targeted at Black consumers (though it is worth noting that one of the first places that the brand broke big was Japan; as founder Daymond John says, "A lot of people look back at our launch and think we were made by these little stores in our black communities, but that's not how it happened.")[59] By 2011, superstar marketer Steve Stoute could write a book called *The Tanning of America: How Hip-Hop Created a Culture That Rewrote the Rules of the New Economy*, narrating how the ability of Run DMC's 1986 anthem "My Adidas" to sell shoes led him to the epiphany that the "urban youth culture" could position products as "the real thing" in a fiercely competitive marketplace flooded with duplicate commodities. Through the '90s and accelerating into the 2000s, hip-hop branding became the main pillar of commercial pop culture, making the fortunes of brands like Tommy Hilfiger, Versace, Timberland, and Nautica through association. As Stoute explained of his own marketing work, it "involved representing the core values of artists while grooming them as entrepreneurs and philanthropists, and on the flip side bringing the worldwide creative directors of brands such as Gucci and Crest toothpaste physically into the inner city."[60]

In *Who We Be: The Colorization of America*, Jeff Chang traces the history of how activist and artist demands for more diverse representation became integrated into corporate America's marketing strategies. By the end of the first decade of the new millennium, this phenomenon had reached an inflection point, according to Chang. Multicultural branding had become mainstream, meaning more diverse faces in the media. But corporate instrumentalization, he wrote, was producing a sense of jadedness, distrust, and a newly widespread critical awareness that identity was being traded as a commodity: "For the young generation in the target sights, the

question was now: How did it feel to no longer be a problem, but just another stick of gum for lifestyle capitalism to chew up?"[61] In a first pass, then, we can theorize that the recent popular resonance of cultural appropriation appears as a way to register the intensified psychic strains produced by a system that relies more and more on marketing the values of cultural authenticity while simultaneously commodifying, instrumentalizing, and debasing anything resembling authentic culture.

2. The Impact of Digital Media

Dwelling on the role of social media is a cliché in commentary on recent cultural appropriation debates—which makes sense, as social media is where a lot of these conversations have played out. Nevertheless, I think that it is worth retracing the last decade's shifts in how information circulates in slightly finer detail than is ordinarily offered, paying particular attention to how profit models and corporate machinations reshaped popular understandings of power and privilege.

For traditional media publications of all kinds, the 2010s were a period of economic pain and existential crisis. By the beginning of the decade, the web moved from being a side show to the center of attention and prestige, with print increasingly relegated to marginal status. The internet vaulted past newspapers as the public's primary source of news consumption in 2011, trailing only TV, which came under increasing pressure from web video. The ease of entering the online conversation led to a fragmentation and proliferation of different voices. Yet almost none of the new ad spending on the internet went to news organizations or publications of any kind; it mainly went to a coterie of giant internet companies, which only aggregated and indexed content.[62] This is exactly the kind of situation—an expanded number of competing voices and a shrinking or static pie of potential benefits—that would be expected to intensify struggle over who gets compensated and for what, which is one of the distinctive features of the cultural appropriation critique.

Tellingly, another major reversal of popular wisdom took place exactly concurrent with the new debates over appropriation: the way that "free culture" was viewed. It is hard to remember now, but "sharing" culture on the internet was once viewed as such a consensus political good that various Pirate Parties sprung up in countries around the world, starting in 2006, with defending the righteousness of internet piracy as their main issue. But by 2013—exactly the moment the new concern with the harms of appropriation manifested—technologist Jaron Lanier was preaching that the destruction of creative careers in the internet age could be "an early warning of what is to happen to immeasurably more middle-class jobs later in this century," and arguing that "free" culture was simply an ideology large internet companies were using to turn a profit.[63] By the middle of the 2010s, paywalls started going up on websites with increasing regularity, something that was once viewed as anathema to everything web media stood for. In other words, this was a period when *everyone* professionally involved with writing or culture started viscerally to feel the need for cultural production to be compensated and not be exploited as a free asset. And one way to do that, in a fiercely competitive environment, was through various kinds of moral claims about the importance of supporting writing or creative production one felt to be worthy.

The hunt for new audiences in a rapidly crowding media environment meant tapping underserved niches, including progressive, minority, and even previously radical viewpoints considered too outspoken for legacy media, whose business model meant defaulting to a neutral voice. (The so-called "view from nowhere" of mainstream US newswriting, which banished opinion from reporting, was originally a very specific product of the imperative to command the largest possible audience for mass advertising purposes.) Media that is more "voice-y" logically draws attention to the question of the identity of the person or people writing. This, in turn, coincided with pressure from the increasingly cutthroat market for ad revenue to shift away from high-investment genres like original in-depth reporting and toward aggregation and commentary, which could be produced at

higher volume for a lower price. (The term "hot take" coalesced in sports media around 2012 and rapidly entered the general vocabulary by 2014 as a name for moralizing instant commentary.)

Online media properties like Salon[64] or Mic.com[65] staked their growth strategies on what Jay Caspian Kang would christen "'woke' pop culture writing."[66] This had the positive impact of mainstreaming critical voices heretofore considered marginal, but it was in the context of all-out war for audience share, which instrumentalized righteousness. In some cases this meant subordinating social justice opinion to templated form, requiring consistently replicable formulas. "Mic trafficked in outrage culture," one former writer recalled. "A lot of the videos that we would publish would be like, 'Here is this racist person doing a racist thing in this nondescript southern city somewhere.' There wouldn't be any reporting or story around it, just, 'Look at this person being racist, wow what a terrible racist.'"[67] Another former writer emphasized how the advertising model led systematically to overemphasizing the urgency of otherwise small-bore cultural controversies: "It ratchets everything up to 11, to a point where if everything is an outrage, nothing is an outrage. Everything is the biggest deal in the world because you're trying to create traffic, and it desensitizes us to what are actually huge breaks in social and political norms."[68]

In a way, the acceleration of digital media inserted a new anxiety about appropriation at a structural level. In her 2014 book on digital labor, Ursula Huws wrote of the corrosive effect of a sped-up information environment on intellectual production in the university, where there was, she said, a

> growing pressure to disobey the commandment "Thou shalt not steal" when it comes to one's neighbor's intellectual property. I am not just referring here to out-and-out plagiarism but to those subtler forms of theft that include stealing ideas, failing to acknowledge sources, and selective citation. This is not always done in malice. More usually it arises from a combination of pressure of time, pressure of competition, and the ease with which new technologies allow one to cut and paste from exist-

ing work. But the effect is to destroy solidarity and to create an atmosphere of suspicion and secrecy that is the enemy of collegiality and, incidentally, also of good teaching.[69]

In the frenetic world of web media, these pressures were exponentially more intense, though with the same solidarity-destroying effects—hardly confined to fringe commentators. A new aura of suspicion and recrimination pervaded media from top to bottom. The Huffington Post's model of reblogging news "amounts to taking words written by other people, packaging them on your own Web site and harvesting revenue that might otherwise be directed to the originators of the material," the *New York Times*'s editor in chief Bill Keller would write in 2011. "In Somalia this would be called piracy. In the mediasphere, it is a respected business model."[70]

Yet the quest for traffic in an environment of tenuous profit meant that the pressure was relentless for everyone to pile on to comment on whatever attracted attention. Such competition was perfectly designed to inflame sensitivities toward crediting and misuse, as powerful institutions or professional voices reaped the increasingly limited spoils of material originally produced by the less powerful, the marginalized, and those without any official job—particularly when the controversies touched on matters of racism, sexism, homophobia, or transphobia. For instance, in 2014, media pundits divided over whether it was OK to quote freely from social media. A Buzzfeed story had picked up on a Twitter trend started by a user who had asked followers to raise awareness by posting what they were wearing when they were sexually assaulted. The Tweets were public and aimed at the public, but the Buzzfeed writer failed to ask the woman who had started the trend—a survivor herself—for permission to spotlight her writing, touching off fierce debate over the ethics of quotation.[71]

After the election of 2016, copious think pieces argued about how social media encourages political polarization, because engagement metrics favor items that generate conflict, rewarding inflammatory, one-sided claims that invite outraged reaction. It is almost

certain that the newly categorical idea of cultural appropriation gained such high visibility as social media took over the information environment precisely because it is more polarizing, and therefore more "engaging" from an algorithm's point of view. [72]

The once-utopian scenario of media platforms where anyone can participate has made traditional institutions seem stale and exclusionary by comparison, intensifying impatience with any sense of being "spoken for." But the contradiction was that the very platforms that facilitate easier expression also made monitoring and cooptation dramatically easier as well. [73] "Black Twitter" became a hot topic in the early 2010s, theorist André Brock showed, not just because higher proportions of Black people used social media than other groups, but because the service itself suddenly created a centralized and streamlined pathway to discovery of Black culture by a non-Black audience: "Black Twitter hashtag domination of the Trending Topics allowed outsiders to view Black discourse that was (and still is) unconcerned with the mainstream gaze. . . . Black Twitter would have been considered 'niche' without the intervention of the hashtag/trending topic." [74]

From the earliest days of the internet, researchers noted that "computer-based communities" tended to encourage new communicative protocols to "defend their electronic boundaries," specifically through ostracizing participants deemed not sufficiently knowledgeable, through attacking those perceived to violate community norms so as to drive them away, and through generating opaque, specialized languages that made them illegible to casual observers. [75] This new communication style stemmed exactly from a dilemma faced by online subcultures that social media further exaggerated: the web made communities of interest easier to discover, but that accessibility also put them more under the eye of dabblers and pretenders, amplifying concerns with what theorist Lisa Nakamura called "identity tourism," that is, that hostile or clueless interlopers might be sampling or ripping off a culture or trying on identities for sport. [76] It stands to reason that the migration of more and more social interaction into mediated spaces put more and more emphasis on policing the edges of culture in general. [77]

In the through-the-looking-glass online universe of 4chan, a phenomenon took place that unintentionally paralleled the debates of this same moment over pop culture and identity politics. Pepe the Frog, an obscure indie comics character, became heavily traded as a symbol of the nihilistic subculture of disaffected, downwardly mobile young white men who populated its message boards. In 2014, Pepe memes gained enough critical mass that they broke through to the web mainstream, with female pop stars Katy Perry and Nicki Minaj both sharing Pepe jokes, popularizing the icon. Experiencing this as vandalism and dilution of their subculture, 4chan users counterattacked by creating virulently racist and sexist Pepe memes to try to drive off the normies—that is, they set out to "defend their electronic boundaries." The origin of Pepe the Frog's ascent to alt-right icon was, in other words, a cultural appropriation controversy.[78]

In 2012, Facebook had gone public, officially marking the moment social media had become big business, the center of the attention economy. The commercialization of social media meant that there was real money and reward at stake in the forms of micro-celebrity being built within these communities (though the term "influencer" wouldn't enter the dictionary until 2014). Viral media and online celebrity were a pathway to a career or serious social currency. This implied a new and greater interest in thinking of quips, observations, and put-downs as a kind of property, one that could be diluted by appropriation. As I noted in chapter 5, Mark Zuckerberg once said of his multitudinous users that they were "building an image and identity for themselves, which in a sense is their brand."[79] Well, brands are proprietary, they are competitive, and they are senseless outside of an audience's investment in their authenticity—all components of arguments about appropriation.

I already mentioned the accelerating cannibalization of subcultures as a factor that could lead to increased sensitivity to appropriation. Since the immemorial nature of cultural sharing and borrowing is a frequent talking point in these debates, it is worth underlining the dramatic speed-up of this process that has occurred as a result of social media. The comparison of two examples tells the story. A

cheeky 2004 MTV ad traced the process of cultural co-option: the ad begins with an animation of two rappers onstage chanting "bling bling"; cuts to a fan in the audience, who then repeats the phrase to a basketball player friend; who repeats it to a reporter; and so on through cartoon society, until the final vignette shows a wealthy white lady lunching with her elderly grandmother, pointing to her diamond earrings, and saying "bling bling!" The ad ends with a screen that reads: "'Bling Bling'—1997–2003."

That six-year life cycle, which was already meant to illustrate how comically accelerated the process of chewing up Black slang had become, is rendered quaint by the speed of appropriation that Doreen St. Felix tracked ten years later in the case of "on fleek"—a process turbo-charged by the frenetic drive to market the latest in realness.[80] South Side Chicago teenager Kayla Newman has been credited with first popularizing the words in a six-second clip on the now-defunct platform Vine, posted June 21, 2014, which then went viral. From that moment, it took only four months for "on fleek" to pass to the Twitter feed of the International House of Pancakes— which, on October 21, 2014, posted the fateful phrase "pancakes on fleek." As the marketing experts in charge of the breakfast chain's digital marketing explained to *Ad Age*, "Twitter for us skews younger so it's important to talk the talk when it comes to that fan base."[81]

Five years later, the time frame had compressed even further on platforms like TikTok that are powered by mimetic sharing, going from months to weeks. On September 25, 2019, Atlanta teen Jalaiah Harmon posted a dance she had concocted, the Renegade, to Funimate and Instagram, where it won 13,000 enthusiastic views. A user named @global.jones brought it to TikTok, where it spread fast— before it went parabolic, when fast-rising dance influencer Charli D'Amelio posted herself doing the Renegade on October 20, 2019. It became a calling card for her and helped propel her to Gen Z superstardom. By January, D'Amelio was signed by a Hollywood talent agency; by February, she was appearing in a Super Bowl ad. Meanwhile, as the Renegade became ubiquitous, Jalaiah Harmon's name remained largely unknown—one of many examples of Black creators

having their viral dances circulate uncredited. "I think I could have gotten money for it, promos for it, I could have gotten famous off it, get noticed," Harmon said. "I don't think any of that stuff has happened for me because no one knows I made the dance." [82] (After a *New York Times* story spotlighted Harmon as the dance's originator, she got an invitation from the NBA to perform the Renegade at the 2020 All Star Game.)

An entertainment culture where life-changing amounts of money and fame are based on the vicissitudes of credit for trends that exhaust themselves almost as fast as they arrive is absolutely guaranteed to give a more and more urgent edge to the question of who benefits. Digital natives are growing up in a radically more appropriative environment than previous generations.

One of the most undeniably serious and important developments associated with the rise of digital media in the United States in this period was how the combination of ubiquitous camera phones and social media accelerated a movement for racial justice, exposing wider and wider audiences to unfiltered images of police violence that previously would have never made it on the news. But endlessly shared and repeated footage of the horrific murders of Black people—over and over—had terrible side effects, provoking what the psychologist Monnica Williams calls "vicarious trauma" for those who have experienced racism, even triggering symptoms of PTSD. [83] Processed by a palpably desperate-for-clicks web media and a social media environment dominated by competition for relevance, the circulation of such images generated sharp new criticism about non-Black people profiting from imagery of Black death. Writing in the *Washington Post* in 2016 after footage of police killing Alton Sterling in Baton Rouge went viral, activist April Reign argued for an end to the practice of sharing such imagery at all:

> The media is complicit in this morbid voyeurism, when it chooses to be. Horrifying video was shown on morning television of Sterling being killed as a result of state-sanctioned violence. However, when reporter Alison Parker and cameraman Adam Ward of WDBJ-TV were gunned down on live televi-

sion, the consensus by the news media was that the video was too graphic to be shown. What distinction was made? Why is the video of white people being killed considered too graphic for replay, but videos of black women, men and children are replayed on a seemingly endless loop to the point of numbness?[84]

That traumatic context raised the stakes and sharpened the tone of the surrounding cultural debates that intersected with racism, media, culture, and appropriation. It was the immediate backdrop for the controversy over *Open Casket* in 2017.

Black Lives Matter entered the conversation as a social media hashtag, greatly facilitating the rapid dissemination of both a message and consciousness of a movement. Yet the very speed and breadth of its spread almost immediately detonated arguments about ownership and abuse. In 2015, when Better Ed, a conservative nonprofit promoting "school freedom," distributed flyers with the "#BlackLivesMatters" hashtag, a clenched black fist symbol, and statistics about declining public school literacy rates in St. Paul, it was called out for cynically appropriating the movement's iconography to push school privatization.[85] The same year, activists who used the hashtag #MuslimLivesMatter to build solidarity after three Muslim Americans, Deah Barakat, Yusor Abu-Salha, and Razan Abu-Salha, were gunned down in Chapel Hill were also hit with charges of cultural appropriation. In the latter case, the proprietary claim seemed a brake on what Bernice Johnson Reagon had called "the movement force," the process of co-inspiration among movements that has been so important historically to change.[86]

3. The Exhaustion of Liberal Multiculturalism

Technology, whatever its affordances, doesn't create meaning on its own. Its uses—and abuses—are shaped by the larger political climate.

It was actually debates in Canada, during a series of late 1980s and early 1990s battles that paralleled the "culture wars" in the United States, that gave the first consistent articulation of the way the

term "cultural appropriation" has come to be widely used today.[87] As Shuja Haider has argued, in cultural studies up to that point, "appropriation" had generally been used by thinkers like Stuart Hall and Kobena Mercer as a way to cut *against* essentialist ideas of race, emphasizing how cultural identities borrowed from one another.[88] The debate in Canada, however, would fix "cultural appropriation"— also then called "voice appropriation"—as a synonym for racism. It was experienced as a reversal at the time: as theorist Rosemary J. Coombe observed, "a term I had used to connote progressive, subversive forms of cultural politics on behalf of subordinated social groups had been seized—exclusively to denote the invidious practice of white elites stealing the cultural forms of others for their own prestige and profit."[89]

Not uncoincidentally, Canada was the first country to write the value of "multiculturalism" into official law in the 1980s. Official celebration of "multiculturalism" had grown out of, among other things, a ploy in the negotiation of a new Constitution to come up with a framework to neutralize demands for independence by both Quebec separatists and First Nations. Even so, on the conservative right, a new nationalist populism in the same era framed "multiculturalism" as a case of guilty liberals making too many concessions to greedy minorities. "A policy area [multiculturalism] that has had relatively meager financial and support structures has been vilified as the root cause of such varied problems as Canadian unity and racism," social scientists Yasmeen Abu-Laban and Daiva Stasiulis described in the mid-1990s. "The speed with which a consensus on the orthodoxy of multiculturalism within the political mainstream has been transformed into a rough-and-tumble free-for-all is breathtaking."[90]

From the right, the attack on multiculturalism focused on claims that traditional Canadian cultural symbols were being debased (a huge amount of energy was spent debating whether Sikh men in the Mounties should be forced to wear the traditional Stetson hat). From the left came the argument that symbolic celebration of culture was deflecting from more substantial political claims. "The ideological aspect of multiculturalism is best illustrated by its focus

on the non-controversial, expressive aspects of culture," sociologist Kogila Moodley wrote. "As long as cultural persistence is confined to food, clothes, dance, and music, then cultural diversity provides color to an otherwise mundane monotonous technological society."[91]

Canada's "voice appropriation" wars grew out of this same moment of dispute over "multiculturalism." In 1990, Ojibway author Lenore Keeshig-Tobias penned a hotly debated editorial in the *Toronto Globe and Mail* called "Stop Stealing Native Stories." It analogized white Canadian writers writing from the point of view of Native Canadians (such as *Field of Dreams* author W. P. Kinsella's 1989 *The Miss Hobbema Pageant*) to the theft of Native land and artifacts. The context given by Keeshig-Tobias's final lines is important and not often noted:

> As [*Half Breed* author Maria] Campbell said on CBC Radio's *Morningside*, "If you want to write our stories, then be prepared to live with us." And not just for a few months.
>
> Hear the stories of the wilderness. Be there with the Lubicon, the Innu. Be there with the Teme-Augama Anishnabai on the Red Squirrel Road. The Saugeen Ojibway. If you want these stories, fight for them. I dare you.[92]

In 1988, the Red Squirrel Road had been the site of blockades by the Teme-Augama Anishnabai and allied environmentalists, after Ontario approved a logging road through their land. The Saugeen Ojibway were in the midst of a struggle to reassert their treaty rights over fisheries and land, and would that summer organize a march the length of Ontario's Bruce Peninsula to publicly announce their intention to pursue them. The conditional phrase "if you want these stories, fight for them" takes on a different meaning in light of this history of struggle.

Thus, the kind of cultural appropriation discussion that has become the norm today emerges out of the contradictions within the liberal capitalist conception of multiculturalism—the idea that symbolic celebration of cultural value could serve as a fig leaf for the persistence of the business as usual of dispossession and exploitation.

Given this historical foundation, it becomes clearer how this partic-
ular construction of cultural appropriation discourse could gain in-
tensified traction in recent years in the US, as a mainstream embrace
of minority culture was accompanied by actual stagnation or rever-
sal of civil rights-era material gains. As one report from UCLA's
Civil Rights Project put it on the sixty-fifth anniversary of *Brown
vs. Board of Education*, "Since 1988, the share of intensely segregat-
ed minority schools—schools that enroll 90-100% non-white stu-
dents—has more than tripled."[93] Here's Greg Tate, once again from
the introduction of *Everything but the Burden*, the book that helped
propel the ascent of the idea of cultural appropriation:

> If hip-hop had done nothing but put more money in the hands
> of Black artists and business managers than ever before, it would
> mark a milestone in American cultural history. What that wealth
> has not been able to transform, however, is the social reality of
> substandard housing, medical care, and education that afflicts
> over half of all African-American children and accounts for as
> many as one out of three (and in my hometown of Washington,
> D.C., our nation's capital, one out of two) African-American
> males being under the control of the criminal justice system. . . .
> Nor have the gains made in the corporate suite fully dismantled
> the prevalent, delimiting mythologies about Black intelligence,
> morality, and hierarchical place in America.[94]

The defining events of the late 2000s were the 2008 financial
crisis and the election of the first Black president. Barack Obama
came into office on a tidal wave of enthusiasm, with massive hopes
invested in him to seize the moment to confront America's discred-
ited financiers and also to usher in a new era that finally promised
movement on longstanding racial injustices.

But the Great Recession mutilated a generation. Even as Black
homeowners were decimated in one of the largest collective loss-
es of wealth in US history, Obama did very, very little other than
symbolic finger-wagging to punish Wall Street for its crimes. When
Occupy Wall Street erupted in 2011 out of the sense of grotesque,
unaddressed unfairness, the movement was experienced as a dramat-

ic return of class to mainstream discussion, a new coming-together of anti-corporate sentiment in the face of the inertia of the liberal political order. A generation's experience of seeing the literal expropriation of wealth—and the exposed racism of the banks that preyed heavily on Black and Brown homeowners—can't help but to have sharpened the resonance of appropriation among a rising generation.

Clearly, the major explosion of interest in cultural appropriation in 2013 coincided with the advent of the Black Lives Matter movement, which had a titanic impact on popular culture and the media. Historian Keeanga-Yamahtta Taylor has argued that the mobilizations against anti-Black violence need to be understood in the context of the tremendous hope and optimism that Barack Obama inspired as the first Black president—and then the disappointment and impatience when so little of what people hoped for actually came to be. Taylor cites writer Vann R. Newkirk II, writing in 2014, in the midst of Obama's second term, about the journey from hope to disillusionment for Black millennials:

> The jubilation that I felt: the jumping for joy; the tears. They were not just my own but those of people who'd marched before me. The experience was spiritual.
> But that idealism soon eroded.
> What we didn't expect was the false dream of blind post-race would supplant and masquerade as the dream of post-racism. The struggle to reconcile the president's racial identity and its meaning within American racial and cultural structures led us to interesting, unexpected places. The alternating currents of willful ignorance of racial issues and virulent racist responses to the president frustrated many black millennials, especially those indoctrinated on Obama's progressive ideal of hope. We were left struggling to find a way to voice our concerns when the momentum of the campaign ended.[95]

Newkirk went on to describe how that frustrated energy went in two directions: first, into "Facebook, WordPress, and Twitter" and cultural production, to create a "golden age of young black media creators;" and second, into the powerful struggles against racist violence

that marked Obama's second term.[96] It was in the space between these two that the massive spike of interest in cultural appropriation appeared—not just among Black millennials and other minorities but also among white progressives looking to signal their own awareness of the bankruptcy of "post-racial" rhetoric.

As in Canada in the 1990s, the changed symbolic expectations derived from liberal multiculturalism's emphasis on celebrating symbolism and then its failure to deliver. But given the dramatically greater promise of Obama, the fallout in culture was dramatically greater, too, resulting in a new accepted wisdom among a large swath of the public coming into consciousness at that time—far beyond the artists, writers, academics, and arts administrators who had incubated the appropriation critique in the first place.

Yet, the more that liberal politicians were faced, in the coming period, with demands for radical change that would challenge the limits of mainstream politics, the more intensely they leaned into emphasizing the importance of symbolic gestures, creating glaring contradictions between symbolism and reality and rendering gestures of solidarity suspect by association. In the wake of the vast Black Lives Matter protests of summer 2020, Democratic politicians including Nancy Pelosi and Chuck Schumer, clad in kente cloth, symbolically "took a knee" for George Floyd, to promote the weak tea of the proposed George Floyd Justice in Policing Act (as Dereka Purnell would write of the legislation, "The George Floyd Act wouldn't have saved George Floyd's life. That says it all").[97] The fact that the strange stunt was at the suggestion of the Congressional Black Caucus only served to emphasize the growing gulf between not just white politicians and Black Lives Matter activists but, as Doreen St. Felix argued, the widening gap between Black liberals and Black radicals.[98]

Social Movements and the Movement of Culture (2)

The artist Richard Fung was on the panel tasked with figuring out how the Canada Council would practically respond to the questions

raised by the early '90s cultural appropriation debates. Having reviewed the intense back and forth, in a text summing up the lessons called "Working Through Appropriation" he wrote:

> This is the contradictory reality of using the voice, sound, image, dance, or stories of another: it can represent sharing or exploitation, mutual learning or silencing, collaboration or unfair gain, and, more often than not, both aspects simultaneously. Most positions for or against the use of the concept of cultural appropriation nevertheless disregard this complexity and promote blanket prescriptions or endorsements—at least on the surface.[99]

This conclusion is similar to Stuart Hall's admonition against thinking of culture as either "wholly corrupt or wholly authentic." It echoes Angela Davis saying that there is "no simple or unitary way to look at" the politics of representation. It seems to be where many scholars who consider the politics of appropriation arrive.

But the particular set of forces that I have just outlined as helping to explain the mainstreaming of the concept of "cultural appropriation" via art, fashion, and pop culture have pushed the conversation in exactly the opposite direction. The escalating pressures on culture as an economic resource and as a political battleground have meant that "blanket prescriptions or endorsements" have become inescapable, while keeping faith with the "complexity" that Fung talks about seems more difficult, because the stakes feel high.

It may therefore be worth looking at how the new pressures on culture played out in struggle in the 2010s to see why resisting a for-it-or-against-it framework matters practically, on the ground.

In 2016, the protests against the Dakota Access Pipeline became a generation-defining struggle that laid bare the United States's brutal indifference to Native rights and the power of Native leadership in the fight for a just and sustainable world. The environmental concerns and questions of Indigenous sovereignty were crystal clear. But the #NoDAPL protests were also, crucially, about cultural rights.

Many considered the land targeted by the pipeline, though just outside the technical boundaries of the reservation, to be sacred.

After tribal cultural expert Tim Mentz Sr. surveyed some of the territory and filed a request for an injunction, identifying potential historic sites, graves, and landmarks threatened by the construction, the pipeline company moved in preemptively, ignoring the Labor Day holiday, and leveled the terrain before the motion could be heard. Activists stated they believed that the cultural expert's findings were used as a road map for what to destroy. Those rushing to stop the desecration were met with attack dogs and pepper spray.[100]

Here was a battle over cultural appropriation in the most urgent and inarguable sense: the literal expropriation of Native lands and waters and the despoilment of Native culture and beliefs before the needs of fossil-fuel capitalism.

The struggle at Standing Rock was magnetic, the largest gathering of Native American peoples in more than one hundred years. It was also, as with any truly high-stakes popular movement, riven with debate. As the struggle's momentum built, the camp attracted more scrutiny and more visitors, including many non-Native sympathizers and would-be allies, with varying levels of political consciousness and cultural self-awareness, who needed to be integrated into the specific rules of the space in a way that did not disrupt the ongoing political organizing. Tribal leaders encouraged this support, even providing helpful advice on how to participate. A website gave directions to the camps and advice on what to bring, as well as offering information about cultural sensitivities that outsiders might be unaware of:

> When you are at Sacred Stone Camp, you are a guest of the Lakota/Dakota/Nakota nation. If you are told to do or not do something according to tradition, please be respectful and comply. Photography is not allowed during ceremony or prayer. If you are a woman, you are asked not to attend ceremony, including sweat lodges, while you are on your moon (menstruating). Certain traditional events, items, and clothing are only to be attended/used/worn by Native people. Please ask before collecting sage, berries, or any other plant from the area. When in doubt, ask an elder or local.[101]

Some debate would come to center on the media and who had the right to tell the story of the struggle. Viral footage from Amy Goodman's *Democracy Now!* of protesters being attacked in early September helped put this movement on the remote plains under a national spotlight. (Goodman herself would face charges of "riot" for her reporting.)[102] The protest started to attract hordes of documentarians, media activists, and video bloggers of varying degrees of seriousness and sensitivity. By mid-December, there would be some thirty-four teams on the ground, according to tribal officials. Native filmmakers trying to document the struggle spoke of a lack of respect or knowledge on the part of non-Natives and bitterly reported overhearing artists talk about how being at Standing Rock "would make their career."[103]

On November 28, 2016, the UK-based *Independent* published an article under the headline "Standing Rock: North Dakota Access Pipeline Demonstrators Say White People Are 'Treating Protest Like Burning Man.'"[104] Written from London, the piece was based on four social media posts. But it combined Burning Man, something people loved to hate, with the #NoDAPL uprising, something people thought was important to support. And so it took off.

By the end of that same news day in the States, the "Burning Man" crisis at Standing Rock became fuel for the hot-take machine. More often than not, the hue and cry came not from Native American organizers on the ground but from remote white media observers trying to put themselves on the right side of a debate. "Dear Fellow White People: Standing Rock Isn't Goddamn Burning Man," *GQ* fumed, viewing the situation solely through the lens of the *Independent's* coverage and recirculating the same four social media posts.[105] *Paper* magazine went further, discouraging white activists from heading to North Dakota so as to avoid potential cultural disrespect. Its article, too, relied on the *Independent*, though it added the authority of a Tweet from an astronomer—sent, not from the Sacred Stone camp, but from San Cristóbal de La Laguna, Spain—that warned, "White people: do not tell other white people to go to Standing Rock. It's not Burning Man. Send money or supplies. #NoDAPL."[106]

The charge of a "Burning Man" takeover leapt to the right-wing media, magnified by the *Daily Caller*[107] and the *Washington Times*.[108] Ultimately, it became a talking point for state authorities as they sought to discredit the #NoDAPL movement before an international media that was closely scrutinizing the images of brutality coming out of North Dakota. Jon Moll, a sheriff's deputy, would decry the movement to PBS as having become "a big white hippie Burning Man on the plains of North Dakota in the middle of winter."[109] As Nick Estes, activist and author of an account of the #NoDAPL movement, *Our History Is the Future*, put it, "Politicians and media attempted to play up divisions in the camps, depicting Water Protectors as 'hippies' who treated the movement like 'Burning Man.' Those elements existed, and some Native people played along. But such portrayals gloss over meaningful solidarities."[110]

In truth, whatever problems existed with so-called white "vision questers," naive newcomers, or clueless campers unprepared for the harsh realities of winter on the plains, it was growing mainstream solidarity, not cultural appropriation, that truly worried Energy Transfer Partners and its government allies. The righteousness of the Native resistance in the face of concussion grenades and tear gas had started to attract a level of wider support that was rattling both the corporation and the law as they plotted to dislodge the camp and undercut its message. (And say what you will about them, but groups associated with Burning Man had mobilized to support Standing Rock, consulting tribal elders and camp leadership and donating infrastructure for the freezing cold, including a giant canvas dome that became a meeting place at the camp.)[111]

The very same week that the "Burning Man takeover" meme broke big, North Dakota officials were threatening to blockade and stop supplies to the camp as a way to force evacuation, with the excuse that the oncoming winter made it unsafe to stay. Three days before the *Independent*'s quickie post dropped, local media had begun to report that a group calling itself Veterans for Standing Rock was mobilizing "a peaceful, unarmed militia" to "defend the water protectors from assault and intimidation at the hands of the mili-

tarized police force and DAPL security."[112] At exactly the moment *Paper* magazine was warning people away, some four thousand army veterans, both Native and non-Native, were heading to the camp from across the country to act as "human shields" against the threat of forced displacement of the protest camps.

This mobilization, despite its own chaos and internal disputes, vividly underscored just how dangerous the increasing resonance of the #NoDAPL message was becoming. With the protest threatening now to spiral into a true insurgency, on December 4, the Army Corps of Engineers postponed construction of the final, disputed section of the pipeline.

Powerful as the Standing Rock struggle was, the forces ranged against it were implacable. The camps could not sustain themselves indefinitely. In 2017, a newly elected President Trump ensured as a first order of business that the briefly halted project would go on. In subsequent months, documents obtained by the *Intercept* revealed that Energy Transfer Partners had employed the private security and intelligence company TigerSwan, which engaged in extensive infiltration of the camps and an intricate attempt at data monitoring, with the aim of undermining the movement.

The documents showed the security company's attention to media coverage and the dynamics of how word was spreading more widely. ("This article is only in the Huffington post, but the expansion of the tribe's narrative outside of the Native American community media outlets is of concern," one report noted.) They also showed keen interest in monitoring potential splits in the movement ("Social media post suggests that protestors are trying to resolve discord between some groups in camps") and spreading misinformation. Tactically, TigerSwan's motto could have been the time-honored strategy of colonizers: divide and rule. "Exploitation of ongoing native versus non-native rifts, and tribal rifts between peaceful and violent elements is critical in our effort to delegitimize the anti-DAPL movement," wrote the mercenaries.[113] Nick Estes explains the insidious results: "The effects were devastating, and many of the planted stories continue to circulate as truth, the divisions cleaved still festering."[114]

In light of that revelation, can we learn from how the theme of cultural appropriation was taken up within this vast and complex movement?

One thing that is clear is that the concern with culture has to be taken seriously, particularly in the case of a struggle that was in some sense *about* defending cultural rights. Leaders at Standing Rock made clear their demands for cultural respect; engaging with these was the baseline of serious solidarity for anyone wanting to show it. At the same time, clearly, rhetoric from the cultural commentariat based on amplifying cultural missteps by potential allies into permanent "rifts" put a weapon into the hands of the enemy looking to shatter potential coalitions and isolate a powerful movement from public sympathy.

The battle at Standing Rock opens onto a cross-section of threats that loom larger and larger over the present: intensifying political sclerosis, right-wing reaction, and corporate capture of government; an economic system hell bent on chewing up everything in sight; a militarized and racist police and prison system; the specter of the quickening climate apocalypse that demands dramatic action. In the face of the dangers posed to vast populations by these threats, the kinds of controversies that eat up massive amounts of mental energy among cultural commentators can seem little more than a distraction. But to the extent that they have served as an efficient tool to split parts of a too fragile left that urgently need each other, they do matter.

If we can see them as not just random explosions of controversy or trending topics but as symptoms of how an increasingly rapacious racial capitalism has toxified our cultural life at ever more profound and intimate levels, then we might also view the intractable debates that have become a fixture of media and cultural spheres as something like the spontaneous defense mechanism of a system that has a vested interest in keeping its critics divided. The task, as Bernice Johnson Reagon long ago argued, is threading together all the many movements necessary to change that system into a workable coalition, negotiating terms of respect and solidarity. There is not a quick

intellectual formula that provides a short cut to this practical work. But in some ways, Reagon's words seem even more apt now than they were when she first spoke them: the question remains "how to cross cultures and not kill yourself."

Chapter 7

The Mirror of Conspiracy

It is not an exaggeration to say that performance artist Marina Abramović's bit part in the final days of the 2016 presidential election marks one of the most important intersections of art and politics of recent memory. Eight years before, the street artist Shepard Fairey had defined the optimistic image of Barack Obama with his "HOPE" poster. Abramović's indirect association with Hillary Clinton, in contrast, would become a component of an altogether more dangerous mythology that came to define the cultural period marked by the arrival of Donald Trump in the White House and after.

In the final days of the 2016 election, the term #SpiritCooking spiked on Twitter after a note from Abramović turned up in the email trove of John Podesta, Hillary Clinton's campaign chair, released by WikiLeaks. It was just two sentences from the artist, forwarded from Tony Podesta, John's brother, and it amounted to an invitation to a party. "I am so looking forward to the Spirit Cooking dinner at my place. Do you think you will be able to let me know if your brother is joining?" John, as far as we know, never replied.[1]

Through the hard work of Googling the term "Spirit Cooking," right-wing web sleuths discovered footage of an obscure Abramović performance at an Italian gallery in 1996, in which she painted poetic instructions—for instance, "with a sharp knife cut deeply into the middle finger of your left hand eat the pain" or "saliva of your lover mix with morning dew collected from eucalyptus leaves"—on the white wall with pig blood. If you were so disposed, it was easy to

believe that you were looking at evidence of an authentic Satanic rite rather than a goony art installation and that the Podesta reference to "Spirit Cooking" was the smoking gun that revealed a secret world of demonic elites.

Abramović, by this time, was one of the world's most celebrated artists, known for feats of endurance theater and the remixing of the rituals of world cultures into cathartic performances. One work, *Balkan Baroque* (1997), saw her ceremoniously clean a pile of cow bones as a way to expiate the atrocities committed in her homeland, the former Yugoslavia, during the Balkan conflicts of the '90s. It had won her an award at the Venice Biennale. Another, her 2002 *House With the Ocean View*, had been re-created in an episode of *Sex and the City*. In 2010, her career retrospective at MoMA had stamped performance art into mainstream consciousness via *The Artist Is Present*, a marathon piece for which she sat in place and engaged in a staring contest with anyone who sat down opposite her—a media sensation that drew crowds. Lady Gaga worked with her on a video to promote her proposed Marina Abramović Institute in upstate New York.

The email passed between the Podesta brothers, in fact, was connected to the Kickstarter campaign for that institute. Tony had been a supporter at the $10,000 level, where the prize was a "dinner night with Marina during which she will teach you and other backers at this level how to cook a series of traditional soups, which you will all enjoy together." It also promised that guests would eat a "Gold Ball," a sweet made from almond, coriander, peppercorn, and honey, an idea she had picked up while studying Tibetan Buddhism. Abramović, who would be painted as an all-powerful high priestess of Satan, was actually unable in the end to get the funds together to build the proposed center to promote her work.

For his part, Tony Podesta "personified DC influence and wealth for decades," as *Politico* put it, founding his Podesta Group with his brother to push the corporate interests of the likes of BAE Systems, Blue Cross/Blue Shield, Lockheed Martin, and Walmart in the halls of power.[2] A major Democratic fundraiser, he would ironically lose his business in disgrace a year after Trump's election, in 2017, amid

questions about his role promoting the same pro-Russian interests in Ukraine that snared Trump crony Paul Manafort. The internet sleuths obsessed with Satanic cabals gave short shrift, in a way, to the more basic conspiracy: the interlocking networks of behind-the-scenes ruling-class power that held DC in their thrall.

Tony was also a major art collector. Among other things, he had bought Shepard Fairey's original "HOPE" poster, donating it to the National Gallery of Art. But his personal taste, according to a 2004 profile in the *Washington Post*, favored "in-your-face nudity and social critique."[3] He liked art that made guests uncomfortable and made clear his power to control the conversation and his disregard of conventional niceties. A long-time centerpiece was British artist Sam Taylor-Wood's *Soliloquy VII* (1998), a wall-filling, eight-foot photo of a nude man laid out on a bed, shot from a foreshortened perspective from the feet so that his genitals loomed at the center of the picture, based on a Renaissance image of Christ by Masaccio. As the *Post* explained, prophetically, given how much trouble the association with Podesta's art caused the Clinton campaign: "Tony often uses the work to launch into a story about Hillary Clinton's visit, when she ducked and tiptoed around the work lest any photo opportunity capture her alongside the naked figure."[4]

Still another profile of Tony's art collection, this one in 2015 for *Washington Life* magazine, began with the fateful line, "If you've ever dreamed of strolling through a museum with a slice of pizza and glass of wine in hand, you need to befriend superlobbyist Tony Podesta."[5] The report described how he would hold parties where guests wandered his mansion to view his art, catered by the pizza restaurant Comet Ping Pong. This detail became one of the seeds for the "Pizzagate" conspiracy theory, which held that DC elites were molesting children in the basement of Comet Ping Pong. "Pizzagate," in turn, became a conduit for the QAnon master conspiracy theory about a secret apocalyptic war against celebrity pedophiles, which began to metastasize ever more dramatically in the Trump years, turning into a super-cyclone during the pandemic and 2020 elections, partly impelling a chaotic assault on the US Capitol in early 2021.

In early April 2020, as Covid-19 completely upended life, the software giant Microsoft put out an ad featuring Marina Abramović, boasting that the company's HoloLens 2 mixed-reality headset would be the vehicle for *The Life*, the first ever mixed-reality artwork to be sold at art auction by Christie's. To the online legions of people who believed that Abramović was the center of a Satanic cult, the ad spot was taken as proof that former Microsoft chairman Bill Gates was conspiring with the Devil and the Deep State to use the pandemic as an excuse to deploy mind-control technology on the population. Four days after it was posted, Microsoft took down the ad in the face of a tidal wave of bile. In an interview with the *New York Times* in the wake of the brouhaha, Abramović would reveal that since the WikiLeaks drop in 2016 she had received as many as three death threats every day.[6]

Fundamentals and Transcendentals

Support for the QAnon conspiracy theory is heavily skewed toward US evangelicals. Such a social basis accounts, in part, for the fact that debunking its theories by appealing to the authority of journalistic or scientific fact showed little effect. It also accounts for the literalist way that art gets read as it is sucked up into these narratives, which are rooted in a hermeneutical system fundamentally opposed to the one assumed by most contemporary art institutions.

Religious fundamentalism is in fact not a name for immemorial superstition; it is modern itself. It was the conviction that society was changing into something unrecognizable amid the disorienting urbanization, industrialization, inequality, and squalor of the early twentieth century that led to the publication of *The Fundamentals: A Testament to the Truth,* a pamphlet series put out by the Testimony Publishing Company of Chicago between 1910 and 1915, giving its name to the phenomenon. The initiative, funded by Union Oil founder Lyman Stewart, a devout Presbyterian, insisted on the need to resist allegorical and literary readings of the Bible—the so-called Higher Criticism—to return to a literal, direct reading of the text

and preserve traditional forms of worship in the face of social disintegration. It emerged as a counterattack to another religious movement responding to the same shocking conditions of US industrial society, the "social gospel," which had seen Progressive Era religious reformers advocating social change in the here and now rather than waiting for the Kingdom.

As it so happens, then, religious fundamentalism arrived in the exact same context as the country's first moral panic over child sex slavery, inspired by anxieties over the debasement of "womanhood" and the decline of the family evidenced by increasingly independent urban women. Presaging Pizzagate and QAnon, the book *War on the White Slave Trade*, published by Chicago clergy in 1910, warned alarmed parents that "ice cream parlors of the city and fruit stores combined, largely run by foreigners, are the places where scores of girls have taken their first step downward." This agitation in turn directly led to the White-Slave Traffic Act, aka the Mann Act, passed the same year, banning the transportation of any girl or woman across state lines for "immoral" purposes. Responding to the demand to enforce it, in 1912, Teddy Roosevelt created the forerunner of the FBI.[7]

Meanwhile, in art, symbolic values were being unsettled in another way. When Henri Matisse painted *Portrait of Madame Matisse* in Paris in 1905, it famously became an art scandal exactly because it strayed from literalism. The image featured a green stripe down the center of its subject's face that didn't seem to be related to any physical characteristic—it was a purely painterly choice, and this symbolic arbitrariness seemed almost sacrilegious at the time. When art by Matisse and other modern artists toured the United States in 1913, exposing the still-isolationist country to the new styles, they were condemned as not just aesthetically but morally wrong. Their abstract quality was connected to moral breakdown, seen as representing individual artistic caprice overstepping social norms. Teddy Roosevelt himself penned a review of the 1913 Armory Show in New York, calling its modernists "extremists" and a "lunatic fringe."[8] When the same art toured to Chicago later that year, it caused an

uproar, condemned by a volley of outraged letters in the papers as "lewd," "obscene," and "immoral." The Illinois Senate got involved, ultimately resulting in the anti-vice "White Slave Commission" investigating whether the art was "harmful to public mores." (In the end, the show was allowed to go on.)[9]

Today, I take it for granted, as an art critic, that symbols are arbitrary, that artists are constantly reshuffling them, and that someone like Marina Abramović is playing with meaning in highly personal ways. But someone disposed to believe in the literal existence of demons (which in 2019 was the position of four out of every ten Americans, according to a YouGov poll)[10] is also likely to be predisposed to look at, for instance, Abramović's *Spirit Cooking* in a much more literal way as well.

Yet if religious dogma is the hard kernel of the rise of apocalyptic internet cults in the present, it cannot alone explain their recent rapid spread. Christianity in the United States has been in contraction in the last decade, even as conspiracy theories like QAnon have exploded in influence in public life. In the wake of the disorienting and sudden shocks of Covid-19 in 2020, interest in QAnon and kindred theories scaled new and unnerving heights and quickly drew fresh converts. The upsurge took me by surprise and made me question whether the intellectual frameworks I had available to me were equipped to understand what was happening.

"Conspiracy theory" is customarily a term used a bit the way people use the term "hipster": always to dismiss someone else's tastes, never to describe one's own. In January 2021, the eminent art theorist Rosalind Krauss penned a succinct letter to the *New York Times*, quibbling with the paper of record's recent coverage of the plague of disinformation online:

> The ubiquitous use of "conspiracy theory" referring to the circulation on the web of dark plots within government is itself misinformation. "Theory" refers to analysis spun around a thread of truth, at least.
>
> More accurate and healthy would be the term "conspiracy fantasy."[11]

While one appreciates Krauss's attempt to defend the valor of "theory," what was notable was how quickly sophisticated theorists retreated to claims about self-evident truth and facts that would have seemed unsophisticated a short time before. One of the lessons of the psychoanalytic theory that Krauss built her reputation on was that "fantasy," too, contained "threads of truth." In any case, starting out by emphasizing what is most noxious, delusional, and outlandish in various "conspiracy theories," it seems to me, only makes it more difficult to understand why seemingly incomprehensible ideas have traction in the first place. Therefore, what I want to focus on here is how difficult it can be to distinguish "conspiracy" thinking from some clear-cut "ordinary" way of thinking about the world. In fact, it may be that "nonconspiratorial" thinking may be actually the eccentric, fringe phenomenon in need of figuring out how to explain itself.

QAnon, Adrienne LaFrance argued in a spring 2020 *Atlantic* cover story responding to the surge of conspiracies as the pandemic hit the United States, "is a movement united in mass rejection of reason, objectivity, and other Enlightenment values."[12] This formulation flattered the self-image of the "enlightened" liberal reader of the *Atlantic*. It was not, however, very helpful for understanding QAnon's appeal to so many people, since rejecting "reason, objectivity, and Enlightenment values" doesn't reflect the self-understandings of those most engaged in the theories LaFrance was describing. "What caught my attention was 'research.' *Do your own research. Don't take anything for granted*," one adherent told her, expressing something that would sound like an appeal for basic critical media literacy if it weren't for the context.[13]

Immanuel Kant, the European thinker most associated with the Enlightenment, separated his major work into three critiques, focusing on Reason, Ethics, and Aesthetics—essentially corresponding to the three philosophical "transcendentals" since antiquity: the True, the Good, and the Beautiful. As a first approach at trying to figure out how to engage with the unnerving transformations of public discourse in the present, it may be worth briefly saying how we might understand "conspiracy thinking," not as some incomprehensible re-

jection of reality, but as an impulse responding to each of these three "Enlightenment" values.

The Epistemological Dimension

Let us start with conspiracy as a hunt for truth. "I don't think that there's anybody in the academic world who will even go near conspiracy theory at this point," Mike Kelley, an artist known for exploring trauma and marginality, remarked in a 1992 interview with *Bomb*. "Once it starts to become obvious how it is a motivating factor in real life, then people will start to write about it as a mythology or an ideology."[14]

Kelley had a wonderful antenna for all that was repressed by a middle-class culture of consumption and respectability and disembodied intellect, and how it tended to return in displaced form with an eerie, intensified power. He correctly predicted a flourishing of interest in conspiracy theories, emblematized by the pop-culture sensation of the TV show *The X-Files*, which launched the year after that interview. (Its slogan, if you say it in a certain tone, sounds like an Enlightenment rallying cry: "The Truth Is Out There.")

In his 1992 book *The Geopolitical Aesthetic*, Marxist literary theorist Fredric Jameson analyzed various forms of then recent "conspiracy narrative" in film, from *The Parallax View* to *Videodrome*. An increasing globalization of capitalism was the order of the day, and what Jameson proposed was that high-tech capitalism had made the world more and more difficult for the average person to feel as if they adequately understood it. The forces governing lives are more and more difficult to comprehend using inherited explanations and traditional symbols. The food you eat, the products you buy—none have origins that can be connected to any community experience, and local reality is ever more governed by forces that are remote and mysterious. (The intensified consumer emphasis on recovering "local" production in food and crafts is, in this sense, another index of this same intensified alienation.)

The leaps of logic in conspiracy, in Jameson's reading, are an attempt to recover a narrative for a world that has grown too willfully

complex to wrap one's head around, offering "a narrative structure capable of reuniting the minimal basic components: a potentially infinite network, along with a plausible explanation of its invisibility."[15] Conspiracies imagine the broken pieces of the world as a puzzle that promises revelation, if you just piece it together. Instead of being adrift in a shifting sea of random, mysterious images and events, you have a master signifier of a narrative that gives meaning to it all— and a corresponding sense of subjective power (of being able to have a theory to interpret the world) and intellectual purpose (of teaching others that knowledge).

The rise of the internet economy has only magnified these tensions. The inner workings of digital technology are orders of magnitude more confounding to the non-expert than analog technology, and so open to eliciting all kinds of superstitions. The cultural historian Mike Jay has even pointed out that increasingly inscrutable and invasive contemporary tech has come more and more to resemble the most basic ideations associated with clinical paranoia: invisible institutions monitoring your thoughts and desires and tweaking your reality to fit interests that aren't your own.[16]

The Political Dimension

The most elementary point to make about conspiracy theories is that, from the sinking of the battleship *Maine* to the Tuskegee syphilis experiment to the Jeffrey Epstein sex ring, history provides unrelenting testimony to the fact that whatever dark thoughts you have about what goes on behind the scenes with the wealthy and the powerful, the truth is likely much, much worse. The exposure of real conspiracies clearly creates the conditions for "conspiracy theory" to catch fire, and the more the actions of actual cabals have mutilated US society, from the lies that powered the Iraq War to the amoral chicanery that triggered the 2008 Great Recession, the more convincing the suspicion that everything is one giant, malign plot becomes.

The Cold War liberal historian Richard Hofstadter is the go-to reference on the political dimension of conspiracy theories, via

his 1964 essay "The Paranoid Style of American Politics." There, Hofstadter charts how fantasies about Catholic cabals, Jewish puppet-masters, Freemasonry, and foreign plots have been an animating feature of US political life. Sharp critics including Chris Lehmann[17] and Eve Kosofsky Sedgwick[18] have pointed out problems with Hofstadter's framing of the "paranoid style." Nevertheless, I appreciate the diagnostic value of this line from the essay: "[The] central situation conducive to the diffusion of the paranoid tendency is a confrontation of opposed interests which are (or are felt to be) totally irreconcilable, and thus not susceptible to the normal political processes of bargain and compromise."[19] This provides a credible mechanism to explain the increasing visibility of conspiracy in the recent past: as inequality has set record-busting extremes in the US, a variety of not at all radical commentators have declared that we live in an oligarchy rather than a democracy, given that the preferences of ultrawealthy people and big corporations seem to rule our public institutions.[20] As the gulf grows between the outward rhetoric of politics and the felt reality of how institutions actually function, once-animating narratives about an "American Dream" seem to be doublespeak covering over some deeper and malicious reality; the fantasy space is thus ripe to fill up with all kinds of dark images.

At the same time, the early '90s that triggered Mike Kelley's prediction was also the time when the Cold War had just ended. Very serious people were talking very seriously about the "end of history," in Francis Fukuyama's phrase: there were no more big ideologies to motivate people; left and right could converge in a "Third Way" era of technocratic government; globalization and capitalism would continue unfolding forever with a logic so ironclad that it didn't even really have to explain itself. In art and in the academy, this was the high-water mark of "postmodernism," which arrived as a philosophical declaration of the "Death of Master Narratives," that is, big ideological stories that gave a meaning and direction to human endeavor.

Conspiracy theories are, exactly, "master narratives." And the increasing sway they have had on public life up to the present can be

seen as the return of the repressed when it comes to ideology—if the technocratic centrists don't offer a political story that gives people a sense of agency and justice, alternative stories that do will have fertile soil to grow.

In their study of US conspiracy culture, Joseph E. Uscinski and Joseph M. Parent look at a century of data and find a predictable oscillation: political conspiracy theories flourish on the side of the political spectrum that is currently out of government. From this they draw a conclusion that, I think, transcends the US two-party politics, summed up by the tongue-in-cheek formula "conspiracy theories are for losers." They write:

> Whether or not conspiracy theorists realize it, their talk must conform to the present distribution of power to resonate widely. In this way, conspiracy talk has a strategic logic. Sharing conspiracy theories provides a way for groups falling in the pecking order to revamp and recoup from losses, close ranks, staunch losses, overcome collective action problems, and sensitize minds to vulnerabilities. Emerging groups, minor groups, and social movements will turn to conspiracy talk for similar reasons.
>
> Successful conspiracy theories can meet these goals because they have an infectious effect and function as mental inoculation. Conspiracy talk provides a unifying narrative of a terrifying enemy. Communicating conspiracy theories heightens alertness to avert tragedy. The tendency of conspiracy theorists to scapegoat, however reprehensible, channels anger, avoids internecine recriminations, and aims at redemption.
>
> We assert that perceived power asymmetries drive the direction of resonant conspiracy talk.[21]

In the late 2010s, all kinds of conspiracy theories swirled among mainstream Democrats, including truly feverish ones, like the claim that the painting *Salvator Mundi*, purported to be by Leonardo da Vinci, had been sold at Sotheby's for $450 million in 2017 as a secret bribe to Donald Trump.[22] Nevertheless, the term "conspiracy theory" today is liable to be associated in popular discourse with violent right-wing extremism. Uscinski and Parent argue that this is mainly

an optical illusion generated by the fact that academics and jour-
nalists skew Democratic, and their research and punditry tend to
dwell on the harm of ideas they do not agree with, focusing on the
most attention-getting, extreme cases. In reality, belief in conspira-
cy theories is much more diffuse and diverse.[23] "There is not much
evidence that either side is significantly more prone to conspiracy
theorizing."[24]

They describe what they call the "conspiracy dimension" of po-
litical thought, defined very broadly as the propensity to report be-
lief that a small, secretive group behind the scenes holds power and
controls society in their own interests—the basic outline that dif-
ferent theories fill in with various colorful specifics.[25] This they find
to be "independent of party affiliation or political ideology," equally
prevalent across the left-right axis (though more present in groups
that have historically faced repression and among people who sup-
port third parties or no parties).[26] In fact, the "conspiracy dimension"
functions as a kind of secret passageway connecting one side of the
official political spectrum to the other, with people scoring high on
the "conspiracy dimension" more likely to be alienated from aspects
of mainstream conservative or liberal ideology when "their" side is
in power.[27]

This diffuse and quasi-independent quality is important to grasp,
because it shows how certain theories can unexpectedly leap to new
audiences—particularly at moments when there is an unexpected
collapse of political narratives and new kinds of "perceived power
asymmetries" are exposed. In early 2020, as the Covid-19 pandemic
upended life in the United States, a YouTube conspiracy film called
Out of Shadows went viral at the very moment that the Microsoft Ho-
loLens/Marina Abramović spot was attracting online fire, taking off
from Pizzagate and telling a sweeping story that Satanic celebrities
(in particular Abramović) were using pop culture for mind control
and manipulating the political order. The film actually stops its spec-
ulations about MK-Ultra and Anton LaVey dead at a certain point
to present a long clip of beatnik comedian George Carlin, a 2005 riff
much beloved by lefties. It's Carlin at his vulgar-street-preacher best,

arguing that politics has been completely captured by money and that the system benefits from keeping people ignorant:

> Forget the politicians . . . they're irrelevant. The politicians are put there to give you the idea that you have freedom of choice. You don't. You have no choice. You have owners. They own you! They own everything! They own all the important land. They own and control the corporations. They've long since bought and paid for the Senate, the Congress, the state houses, and city halls. They got the judges in their back pocket. And they own all the big media companies so they control just about all of the news and information you get to hear . . .[28]

This is an almost Marxist picture of economic domination. "The owners of this country know the truth," Carlin concludes. "It's called the American Dream because you have to be asleep to believe it."[29]

Donald Trump's presidency represented an inflection point in US political life in that, while conspiracy theories previously thrived most on the losing side of elections, his time in office only turbocharged conspiracies among his supporters, including QAnon. Decades before, the entry of evangelical Christianity into politics had been a feature of the arrival of neoliberalism, with Ronald Reagan being the first to activate a mass base that had previously cultivated an indifference to party politics, to sell his pro-banker agenda. The Christian Right subsequently became a durable fixture of US political life. It is possible that Trump's legacy represents a similar arrival of the "conspiracy dimension" as a force.

The Aesthetic Dimension

Probably the most novel dimension we can consider—the least explored and most thought-provoking—might be that conspiracy theory also serves a kind of aesthetic function. This is, perhaps, why art tends to get pulled up into it so easily.

One theory of the prevalence of conspiracy thinking is that it relates to the natural aptitude of humans for identifying and mak-

ing patterns.[30] Spotting shapes in the clouds is an enduring symbol of creative imagination. For that matter, the oldest kind of art-like activity, very likely, is not painting on cave walls but instead the way that our very distant ancestors collected rocks in which they recognized the echo of human features. (The oldest cave art is some tens of thousands of years old, whereas the Makapansgat Pebble, a stone thought to have been collected for its resemblance to a human face, was gathered some millions of years ago.)[31] Recognizing predictable patterns is a primal skill for survival, and pleasurable to show off. The activity of grouping together elements to form a picture echoes in the conspiracist cliché of "connecting the dots" to find the secret plot that suggests an identifiable and predictable order behind a chaotic and capricious reality.

Reckoning with the aesthetic dimension of conspiracy thinking helps account for a notable feature of the phenomenon: the fact that, as if in some kind of reversal of Occam's razor, its theories seem likelier to thrive if they are elaborate and outlandish, rather than simple and logical. If finding patterns in historical events serves an aesthetic purpose, then forced symmetries and inventive rhymes are part of its appeal. And if part of the function of conspiracy theory is equivalent to the pleasure of finding the semblance of a human face in a rock—the perceptual thrill of identifying a pattern where you wouldn't expect it—then by its nature it will inherently propagate to more and more unlikely venues. This aesthetic dimension can account, in part, for how the attempts to satirize or parody the excesses of conspiracy theories in art have so often backfired badly, because the excesses are a feature, not a bug.

In some accounts, the conspiracy fantasy of the Rosicrucian Order was birthed from a piece of proto-science fiction: a 1616 book entitled *The Chymical Wedding of Christian Rosenkreutz*. It may even have been an attempt to mock the era's other obsessions with secret societies—before then taking on a life of its own as both an actually believed alchemical doctrine with real adherents and a phantasm of evil puppet-masters.[32] The modern obsession with the Illuminati began in the 1960s as a satirical religion, Discordianism, propagated by

artist pranksters as a satire of conspiracy theories, with the quixotic hope that absurdly attributing every historical event to a single cabal would inspire skepticism about such sweeping claims.[33] And one of the earliest internet-era conspiracy theories, "Ong's Hat"—a belief that scientists had opened up a gateway to an alternate dimension in New Jersey—also began as an online art project by Joseph Matheny and collaborators. It took on an eerie life of its own, and despite Matheny's later protestations that the project was born as an attempt at hoaxing the media in order to make people second-guess the narratives they were consuming, there are those who still believe this is all part of the cover-up of a secret world of parallel dimensions.[34]

Conspiracy is flamboyant and colorful and involves leaps of imagination—and for that reason it makes life seem not just righteous (the political dimension) and meaningful (the knowledge-seeking dimension) but also exciting. Though generally unvoiced, this thrill is clearly part of its traction, particularly as available mass culture becomes stripped of deep meaning by hyper-commodification. Conspiracy clearly has the appeal of being in on a secret language, of finding symbolic community with others. Anyone who's ever been a teenager drawn to something precisely because their parents hate it understands that the outrageous, the weird, the offensive can actually be virtues when it comes to subcultural cachet, helping carve out a sense of group identity.

From Conspiracy to Conspirituality

No community really has a lock on conspiracy thinking. Reams have been written, for instance, on the circulation of conspiracy material in hip-hop. Scholar Travis L. Gosa has argued that New World Order, Five-Percent Nation, and Illuminati references (among many others) in hip-hop reflect the contemporary experience of racist dispossession, with the idea of secret plots and veiled knowledge helping to "make sense of racial inequalities that are ignored or discussed in race-neutral coded language in a colorblind society."[35] Such references also, Gosa writes, flow from an emphasis on the value of

ground-level experience over expertise associated with a hostile system, a tendency within hip-hop that he links to the much broader "waning trust in authoritative expertise" in American life.[36] Most intriguingly, on top of these political and epistemological layers, Gosa makes the case that dabbling in the "cultic milieu" serves as a defensive aesthetic strategy in the face of the commercialization and commodification of the scene: "Given recent complaints that hip hop has lost its creative edge, a la 'hip hop is dead,' the conspiratorial offers jaded fans a compelling treasure hunt: they can 'connect the dots' by playing tracks backwards and looking for secret Masonic handshakes in music videos."[37]

I want, however, to focus on a different example, specifically because it points to art's capacity to grasp unfamiliar ways of thinking. For the art industry in recent years has quite clearly been in the grips of a romance with the occult—not Satanic orgies behind the scenes, but a flirtation with New Age revelation, right out in the open. This vogue was one of the defining trends of the 2010s, with immense museum crowds turning out for shows of Victorian spiritualist Georgiana Houghton in London and Swedish mystic Hilma af Klint in New York. In 2019 and 2020, a show of works by Agnes Pelton, the early twentieth-century "desert transcendentalist" who believed she communicated with spirits through her airy, odd, semi-abstract paintings, toured the United States to great acclaim.[38]

The press about such contemporary museum shows tends to water down what artists like af Klint and Pelton actually believed into some vague, Instagram-friendly "spirituality" for popular consumption, rather than getting into the weeds of their personal spiritual systems. But in general, one has to think that the recent popularity of this rediscovered mystical art is very much on account of, not in spite of, its promise of esoteric meaning. The occult turn in art is just one expression of a much larger recent popular surge of interest in alternative spiritualities and witchcraft, with sales on "mystical services" reaching $2.2 billion in 2018.[39]

Explaining the explosion of interest in magical art, critic and art historian Eleanor Heartney has outlined social factors very close

to those outlined above for conspiracy theory: a generalized sense of hopelessness about the social order that leads to a hunt for new narratives of empowerment; a feeling of encroaching chaos that amplifies the appeal of alternative codes of meaning to give an order to it all; a disenchantment with soulless commercial culture—including "a revulsion against today's over-the-top commodification of art"— that leaves people looking to attach themselves to the romance of secret knowledges.[40]

Astrology—which 29 percent of Americans believe in, according to a 2017 Pew poll[41]—functions very much like the revelation of a cosmic conspiracy. It is replete with esoteric graphs and charts revealing secret patterns, a sense of meaning both universe-spanning and intimately concerned with your personal affairs, and the revelation that behind the fluctuations of history there are just a few immutably repeating characters. The first newspaper astrology column, "What the Stars Foretell for Princess Margaret" by R. H. Naylor, appeared in 1930 in Britain's *Sunday Express*—a time when the traumatizing global fallout of Wall Street's sudden collapse gave the ability to foresee the future a particular appeal.[42] As journalist William Grimes once put it: "The early horoscopes read more like Nostradamus than Dear Abby. Astrologers worried about political events, about war, famine and pestilence."[43]

Writing for the *New Yorker* in 2019, Christine Smallwood quoted an astrologer on the surge of interest in star science following the 2008 crash: "All of those structures that people had relied upon, 401(k)s and everything, started to fall apart. That's how a lot of people get into it. They're like, 'What's going on in my life? Nothing makes sense.'"[44] The shock of the 2016 election intensified these energies among liberals. "In the Obama years people liked astrology," another astrologer told Smallwood. "In the Trump years, people need it."[45] In the midst of the first months of the Covid crisis, in summer 2020, the *New York Post* would report, "While storefronts are going bust across the Big Apple due to the coronavirus pandemic, New York's psychics and fortune-tellers say they are seeing more clients—and making more money—than ever before."[46]

A movement like QAnon is an entirely more apocalyptic phenomenon than the kind of arty occultism that has fired the imagination of museumgoers in recent years. The former shades into paramilitary violence whereas the latter's underlying politics are mainly a spiritualized feminism. Yet in the summer of 2020, a new term, "conspirituality," entered public consciousness, as QAnon found a new well of recruits among wellness influencers and New Age practitioners. (The term was actually coined all the way back in 2011 by Charlotte Ward and David Voas, who described conspirituality as "a rapidly growing web movement expressing an ideology fueled by political disillusionment and the popularity of alternative worldviews.")[47]

This is another pathway for ideology to travel along, potentially connecting people coming from seemingly very different backgrounds. Nevertheless, the point of reading conspiracy and mysticism together, for me, isn't to draw a false equivalence, but actually to say that you may already intuitively understand how a seemingly unintelligible phenomenon works better than you think you do. For the average person in ordinary times, speculation about various conspiracies is probably more like trading wisdom gleaned from horoscopes: something that people dabble in for amusement, that connects them to other people in their circles, that gives a sense of agency or fate, that serves as a coping mechanism, that they draw from in dribs and drabs overlapping with a lot of other beliefs.

When Adrienne LaFrance, writing about QAnon for the *Atlantic*, described its appeal as being "a very welcoming belief system, warm in its tolerance for contradiction,"[48] that's actually exactly how scholars have also described the particular appeal of eclectic New Age philosophy for the American temperament, its "epistemological individualism" and "revelational indeterminacy" providing a kind of à la carte meaning-making activity.[49] And when LaFrance described Q followers as looking to interpret cryptic online prognostications to understand current events, it sounded as if it scratched the same itch as any one of a number of other forms of fortune telling—albeit one that, at its extremes, was taking its adherents beyond interpretation and toward violence to enforce its prophecies.

QAnon's particular prophecy about current events collided with reality in the 2020 election: Donald Trump did not, in fact, arrest his enemies and unveil his secret master plan, the mysterious Q went silent, and social media channels moved sharply to restrict talk about its themes. But those facts seemed unlikely to stop the underlying tendencies at work—any more than newspaper astrology was doomed by the fact that R. H. Naylor's astrological predictions spectacularly missed World War II. ("Hitler's horoscope is not a war-horoscope," he wrote mid-1939.)

Conspiracy Criticism vs. Conspiracy Critique

In the book *Ideology: An Introduction* (published in 1991, the same end-of-history era that triggered Mike Kelley's "conspiracy theory" remark), literary theorist Terry Eagleton distinguished "criticism," which put its faith in the raw power of facts, with what he called "ideology critique": "'Criticism,' in its Enlightenment sense, consists in recounting to someone what is awry with their situation, from an external, perhaps 'transcendental' vantage-point. 'Critique' is that form of discourse which seeks to inhabit the experience of the subject from inside, in order to elicit those 'valid' features of that experience which point beyond the subject's present condition."[50]

Why does this perspective shift matter? If you are actually trying to win the war over conspiracy theories, two operations are key. The first, as Joseph Uscinski argues, is to identify whether the person you are talking to falls into the "true believer" camp or is part of the broader, looser class of the "curious" and "uncertain." You probably cannot win over the true believers—but if you want to starve them of converts, how you approach the latter group is strategically important.[51]

Which makes a second point key: all studies of how to win people away from dangerous beliefs suggest that the worst thing you can do is to approach them as if they are foolish, gullible, or evil for sharing the information—in Eagleton's terms, attacking them "from an external, perhaps 'transcendental' vantage-point." That kind of

criticism tends to harden belief, sending people looking for sympathetic information sources to defend their sense of self, and cutting the lines of communication (the so-called "backfire effect.")[52] You want instead, researchers say, to try to find some point of identification, to understand what anxieties are leading someone to find the dubious theories credible in the first place, to connect with these, and then offer an alternative explanation, in other words, "to inhabit the experience of the subject from inside."

And it must be said that the mainstream of liberal media and culture is less and less disposed to role-model this kind of basic empathy. Its reaction to the intensifying fracture of culture in the last decades has been increasingly to double down on the style of infotainment that the writer Emmet Penney calls "lectureporn": "You sit and watch someone ingratiate themselves to you while they eviscerate someone you don't like who is, in turn, unlikely to watch said lecture." This is great for flattering the enlightened self-image of an affluent and educated audience in fractious times. But "the problem," Penney continued, "isn't just that lectureporn is snide, tedious, elitist, lazy, and naive—and it is. The problem is that it's dangerous. It breeds confirmation bias and a lack of empathy."[53] One of the things you notice, when following the recent media conversation about conspiracy theories, is that it oscillates wildly between panic that a large number of people believe in them (in 2021, polls showed that anywhere between 4 and 15 percent of Americans believed some form of the Satanic media-and-government cabal theory, numbering its adherents in the millions no matter what)[54] and mockery of them as being transparently childish fantasies that no serious person could believe in—between "we need to take this seriously" and "no one can possibly take this seriously."

It is surely dangerous to give ground to delusional beliefs. The global pandemic saw political conspiracy theories coalesce with New Age and anti-science ideas, and soaring vaccine skepticism has led to untold preventable deaths. Yet the very urgency of the health crisis, which exposed collective interdependency, triggered a reckoning with the way that science has been communicated. Again and again,

it is now emphasized, echoing Eagleton, that if you want to actually win over vaccine skeptics, you cannot simply tell them how to think. Rather you have to understand their frame of reference, take seriously their concerns, and treat them as if you have a common interest. The *New York Times* even offered an online quiz to train its readers in this humbling art.[55] Earlier, the 2018 documentary *Behind the Curve* looked at a more innocuous but still astounding bloom of recent conspiracy theory: the renaissance in belief that science is hiding the truth of a flat earth. That film also stressed that the embedded elitism of the debunkers was partly to blame.

Here's Spiros Michalakis, a Caltech professor, in the film:

> The problem I see is actually not from the side of the conspiracy theorists. It is actually from our side, from the side of science. Very often it is difficult not to look down. My friend said, "Sometimes the only way to change somebody's mind is to shame them." And I say, I don't think that is the last resort, ever. . . . The worst case scenario is you just completely push these individuals at the fringe of society and then society has just lost them.

And here is Lamar Glover, another scientist and activist:

> These folks are potential scientists gone completely wrong. Their natural inquisitiveness and rejection of norms could be beneficial to science if they were more scientifically literate. So every Flat Earther shouldn't be held with contempt but [should] serve as a reminder of a scientist that could have been, someone who fell through the cracks. And we, as ambassadors of science, are called upon to do more.[56]

The Rabbit Hole and the Slow Red Pill

In the case of political conspiracies, the problem is not just that a certain media discourse has eroded empathy, it is the inability to propose any positive counter-ideology. Consider the *New York Times*'s blockbuster *Rabbit Hole* podcast in 2020, which set out to show how social

media was a radicalization tool drawing people into conspiracies of various kinds. It did so through the story of Caleb Cain, described as a lonely young man, raised amid the decline of "postindustrial Appalachia," failing to find a place for himself at college, then finding himself working aimlessly at a series of jobs—Dairy Queen, packing boxes at a furniture warehouse—without much of a sense of self-worth or future prospects.[57] From this life situation, this young man who started out as an Obama supporter discovers YouTube self-help content to fill his empty nights. This leads him to the men's-rights content that leads him to the so-called "alt-light" content that leads him to dipping into the deeper waters of extremist content.

But by the time the *Times* talked to him, Cain had been both successfully radicalized and then deradicalized on YouTube. At some point, he found his way to videos where his alt-right heroes debated left-wing ideas, put out by BreadTube, a loosely affiliated group of self-consciously ideological "anarchists, democratic socialists, [and] Marxists" who were out to engage with reactionary online entrepreneurs and counter them on their own turf.[58] There was actually a kind of vindication of the power of effective intellectual praxis in hearing how Cain was won away from the abyss by watching his favorite alt-right YouTube stars get owned by online lefties rolling up their digital sleeves to engage with their arguments and offer alternate explanations for the alienation and demoralization of his actual lived condition.

Yet, perplexingly, *Rabbit Hole* host Kevin Roose took a totally other lesson away from this parable. Toward the end of his profile, he revealed that Cain himself had started a YouTube channel where he was trying to use his experience to reach people like himself who might be attracted to the nastier ideas he had found himself dabbling in. Here is how Roose engaged with Cain on the matter:

> I guess what I am sort of wondering is that it seems like, you know, you went pretty far down this alt-right rabbit hole. You didn't get to the bottom maybe, but really close. And then you kind of found this path to this other part of YouTube that works kind of the same way, but with just a different ideology, and got sucked pretty far down into that by some of the same

algorithms and the same forces that had pulled you into the alt-right. And I guess I'm wondering if that makes you feel like the problem is still that you kind of are in the rabbit hole, but you're just in a different one. You're still susceptible if the algorithm were to change in the future and lead you down some other path that was maybe more dangerous, that this could happen to you again.[59]

You almost feel like Roose is about to say, "Instead of YouTube, have you instead considered . . . a subscription to the *New York Times*?" (Cain's answer to Roose, incidentally, is the right one: "There's always that concern. It's always possible. I just have to be conscious of it." This is what you would call basic social media literacy.)

"Although much of the current discourse about online radicalization has focused on the effects of recommendation algorithms, that is only part of the story," the artist Joshua Citarella writes. "In many cases people go down ideological rabbit holes not because they are cynically misled by platforms, but because they cannot find satisfactory answers in mainstream media or discover hypocrisies in the narratives they have been told."[60] Citarella has dedicated an extraordinary amount of time to studying how social media subcultures interact with politics. He has analyzed, for instance, a strategy rightwing activists use that he calls the "slow red pill": creating political meme accounts that post popular normie content to accumulate followers, then slowly salting in more extreme content, testing the limits until they get banned and then start again, having led some number of onlookers to their desired destinations. Citarella writes:

> Perhaps it is time to accept that this kind of political mobilization is here to stay. In the past, young people were politicized through radical movements and underground subcultural spaces. But today, platforms have caused all countercultural scenes to sublimate and recollect online. Meme pages, influencers, and online groups aren't going anywhere. If we don't like their views, the answer is not to cozy up with big tech in an endless game of whack-a-mole moderation, but to meet their message with our own.[61]

Caleb Cain was drawn into the YouTube alt-right ecosystem looking for meaning and purpose; he finds a new sense of meaning and purpose in trying to use his own experience to see the error of those ways of thinking. And yet Roose's reaction to his story ends up illustrating the very hypocrisies and lack of satisfactory answers in dominant media narratives that Citarella mentions as motivating the search for alternative information in the first place. The *Times* reporter actually argues that Cain should *stop doing* the very thing that his own reporting suggests is helping beat back the right-wing ideas whose dangerous spread is the purported point of the series. This is strong ideology at play. It's just ideology that's invisible to itself as ideology, viewing the problem it is facing as simply as "extremism" or "dogma," stripped of any political specificity and opposed to some imaginary nonideological neutral ground. [62]

Rabbit Hole amounted to one long argument that YouTube, Facebook, and the rest were derelict in their duties to stop society's polarization and should be more forceful moderators of the extremes. Cain's offline material conditions and life experiences are mentioned—but their implications are not addressed. "The radicalization of young men is driven by a complex stew of emotional, economic and political elements, many having nothing to do with social media," Roose writes in the *Times* article that provided the seed for the podcast—but that is as much thought as he gives the subject, as if the "complex stew" of emotional, economic, and political factors were either too obvious to investigate or simply an inevitable background that was impossible to change.[63]

To be clear, there's no doubt that the business models of the social media giants have helped chew up the social fabric and empower the spread of hateful ideas, creating baleful echo chambers and amplifying cynical hate-mongering. But the sole focus on moderating away the problem seems to me to appeal to a certain affluent audience with a proximity to the centers of culture precisely because it doesn't require any self-reflection. If you can just hit a button to stop the spread of bad ideas, then you don't have to worry about the question of what makes them compelling to large numbers of peo-

ple in the first place. You don't have to think about the condition of "postindustrial Appalachia." You can avoid the inconvenience of taking seriously "anarchist, social democratic, and Marxist" programs that might actually promise to do something about the fundamental imbalances of wealth, power, and opportunity that fuel a swelling sense of powerlessness, disconnection, and alienation that right-wing ideological entrepreneurs capitalize on.

By openly advocating an alliance between purportedly progressive ideology and the widely hated cabal of high-tech capital, this type of argument makes conspiracy theories targeting the former more and more plausible to wider and wider layers. And, perhaps worse, when cultural authorities like Roose use their platforms to chide radical ideology and organizing as just another "rabbit hole" to be avoided, they are actively *aiding society's drift to the right,* helping to sideline forces that are actually doing the unpleasant work of taking right-wing ideas seriously and organizing in the information space, while offering little but platitudes about being nicer or getting off the internet or the importance of listening to experts— solutions that appeal most to people who are least in need of being appealed to.

The Mirror of Conspiracy

This is not, finally, just an esoteric subject. There's an urgent question here about how politics will work in the near future.

If, as Uscinski and Parent argue, "conspiracy theories are for losers," then one understands why contemporary liberal politics would be uniquely incapable of constructively approaching them: oriented increasingly on a base of educated, relatively affluent professionals as its core constituents, official liberal politics presents itself as an ideology of facts and expertise, of meritocracy and the upwardly mobile. But the material basis for that kind of politics is in decline. Generational upward mobility is not something widely believed in anymore, and meritocracy is increasingly a sour joke, seen as an ideology that covers over entitlement and self-exploitation.

And a radical and left-wing politics does *not* identify with the winners in our current order. If a common premise of conspiracy theory is that the system is broken and malignant, a left politics *shares that sense*—society isn't producing more and more winners. A left analysis doesn't view capitalism as naturally self-correcting. It predicts that, without profound redistribution of money and power, the basic trajectory is clear: life gets worse as opportunities stagnate, the rich get richer, corporate power consolidates, the police state ramps up, wars and social violence loom, and disasters accumulate. And so the class of "losers" will swell. And thus conspiracy theories of ever more breadth are likely to be a force at greater and greater levels in political and cultural life, appealing to wider and wider layers of people.

A left that is serious about mass politics should prepare for that pragmatically. Things are going to get weirder.

One need not, and one should not, adapt oneself to the most hateful, terrorizing, and outlandish ideologies out there. But neither should the contemporary left—itself too isolated among an educated base (albeit on the downwardly mobile end of its spectrum) and so likely to bring a scholastic bias to its politics—adapt itself to the liberal establishment view of conspiracy theories: that they are evil lies that only benighted others believe.

It is actually much more hopeful to think that even the more alarming conspiracy theories might be the return of that which is repressed in mainstream ideology: negative images of something missing. They offer a sense of clear narrative about the world, of moral purpose, and of cultural meaning not otherwise on offer in a political-economic system that is deliberately obfuscatory, manifestly unprincipled, and commercially degraded. If that wager is true, then the existence of authentic left movements and an associated left culture might provide alternative paths to channel those same energies away from the far right, though this is likely to be a difficult balancing act, and humbling.[64]

As for art, in theory it should be a venue that helps its audience understand the eccentric and sometimes fantastic ways that diverse kinds of people find meaning and make cultural value. It should help

us read the disorienting new genres of political narratives coursing through society as "mythology or an ideology," as Mike Kelley advocated. But in practice, the mainstream institutions of contemporary art have very weak ties to any definable alternative culture and are very connected to liberal conceptions of technocratic politics and intellectual status marking, mainly affirming an educated audience in its belief that it is in possession of the right opinions in the guise of educating an imaginary, absent audience. This is part of why a lot of contemporary political messaging in art feels so bloodless and low stakes (and also why mystical art, on the contrary, is having its moment).

Conspiracy true believers display a zeal for evangelizing their cause that would be admirable if it weren't for their actual cause. The term "red-pilling" is derived from the 1999 movie *The Matrix*, where Neo, our hero, "takes the red pill" that deactivates the program that keeps him from seeing that he lives in a simulation.

In the film, just after Neo takes the fateful pill, he turns to look at himself in the mirror. Reaching out to touch his reflection, he finds that it sticks to his finger. Its mirrored surface then slowly spreads like a goo to engulf his body, at which point he wakes to the horror of the real world.

I think it is very important, as a first step, to be able to see your own reflection in conspiracy theory. I also think that doing this risks—and requires—a sense of obliterating your own self-image as separate, better-than, and so forth. If you cannot understand it, on any level, then you will be hard-pressed to counter its appeal. Then all you are left with is your own form of delusional belief and your own form of magical thinking.

Chapter 8

Art and Ecotopia

In 2005, famed author and environmental activist Bill McKibben wrote the following:

> Here's the paradox: If the scientists are right, we're living through the biggest thing that's happened since human civilization emerged. One species, ours, has by itself in the course of a couple of generations managed to powerfully raise the temperature of an entire planet, to knock its most basic systems out of kilter. But oddly, though we know about it, we don't know about it. It hasn't registered in our gut; it isn't part of our culture. Where are the books? The poems? The plays? The goddamn operas? Compare it to, say, the horror of AIDS in the last two decades, which has produced a staggering outpouring of art that, in turn, has had real political effect. I mean, when people someday look back on our moment, the single most significant item will doubtless be the sudden spiking temperature. But they'll have a hell of a time figuring out what it meant to us.[1]

Fifteen years later, the activism of McKibben and others, the increasingly outspoken and alarmed statements of scientists, and the evidence of now almost constant fires, hurricanes, and floods have all placed climate change squarely at the center of the public conversation. Against this background, it would be hard indeed for any culture claiming relevance *not* to address the threat to human survival in some way.

Where were "the goddamn operas," McKibben asked in 2005. In 2019, at the Venice Biennale, the big hit was the Lithuanian Pavilion's staging of *Sun & Sea (Marina)*, an opera-performance conceived by filmmaker and director Rugilė Barzdžiukaitė, writer Vaiva Grainytė, and artist and composer Lina Lapelytė. Visitors stared down from balconies, watching the performers from above on a stage covered with sand to suggest a beach. Dressed in swimsuits and laid on beach towels, they sang a morose and wistful cycle of songs: "Wealthy Mommy's Song," "Chanson of Too Much Sun," "Sunscreen Bossa Nova," and so on. Each character expressed in a different way what a day at the beach was like at a wrecked future planet. One lamented:

> *I cried so much when I learned that corals will be gone.*
> *And together with the Great Barrier Reef the fish would go extinct*
> *From sharks to the smallest fry.*
> *I cried so much when I learned bees are massively falling from the sky,*
> *And with them all the world's plant life will die.*
> *I cried so much when I understood that I am mortal,*
> *That my body will one day get old and wither.*
> *And I won't see, or feel, or smell ever again.*[2]

What was most striking about *Sun & Sea (Marina)* was its almost sedated atmosphere. It was art for the age of "climate grief," for coming to terms with a sense of loss amid mounting evidence of inevitable catastrophe. At the same time, the very aura of idleness and contemplation suggested another reading: that such a work could be digested by the globe-trotting culture consumers who made up the Biennale's audience; less as a prophetic call to change their ways and more as permission to resign themselves to being passive observers—that the extermination "of all the world's plant life" was simply as inevitable as their own mortality.

Sun & Sea (Marina) raised for me the question of what you could or should demand of climate art now. The reality of climate change will increasingly make *any* gesture feel unequal to its task. McKibben hoped art might give visibility to climate change and thereby have

a political effect. Now every climate summit spawns a side program of cultural events, while eco-art nonprofits proliferate, and "climate art" is part of the mainstream. Ecological lineages for art have been rediscovered and eco-art has moved from the edge of professional art practice toward its center. That raises new questions—not just the question of creating visibility but what the aims of that visibility are.

The forms contemporary environmentalism takes in art are too complex to taxonomize or discuss as one genre.[3] Here, I want to talk about three of the roles art has taken up amid this demanding new climate, and the contradictions that they force observers to confront: art as warning, art as remediation, and art as a positive vision of the future.

Art as Warning

As environmental concerns have become more and more pressing, a genre of awareness-raising art has become more and more central to the practice of an increasing range of artists, from Maya Lin's *Ghost Forest*, a stand of forty-nine dead trees transplanted to Madison Square Park, to Olafur Eliasson's protest-cum-public-art-gesture *Ice Watch*, for which he transported twenty-four giant blocks of Greenland ice to London to confront the public with the reality of melting glaciers, to Mel Chin's augmented reality work for Times Square, *Unmoored*, which let you gaze through a headset to see the streets of New York filled with water by rising seas, to John Akomfrah's video *Purple*, which in its six channels weaves together images of environmental despoilment around the world from Greenland to the Marquesas Islands.

For his *Underwater HOA* project, Xavier Cortada encouraged the residents of the small town of Pinecrest, Florida, to put up yard signs, each showing the number of feet of ocean rise that would put them underwater: "By mapping the impending crisis, I make the invisible visible," he explained. "Block by block, house by house, neighbor by neighbor, I want to make the future impact of sea level rise something impossible to ignore."[4] For *Sinking House*, Katey Burak and Rob

Higgs floated a half-sunken cottage down the Thames as a statement about the threat of rising sea levels: "When I hear the facts about climate change my brain can scarcely comprehend them, they are vast and scary," the artists wrote in a statement posted to the website of the group Extinction Rebellion. "We wanted to make something that people can visually connect to, whilst leaning on the government and the experts to make the changes that need to be made."[5]

Indeed, melting ice and transplanted trees have become almost trendy as references in recent art. For December 2019, to coincide with the art-themed conspicuous consumption of the Art Basel Miami Beach art fair, the tony Shore Club in Miami unveiled Rubem Robierb's work *How Dare You*, a thirty-six-foot-long ice sculpture spelling out the scathing words from teenage climate activist Greta Thunberg to world leaders. These ice sculptures were left to melt away into the hotel's pool during an evening event sponsored by Celebrity Cruises. Posting images of the party that accompanied the unveiling of this bit of eco-art on its Instagram account, the Shore Club enthused, "Stay tuned for more of the excitement we have going on for #MiamiArtWeek! #thisisbeyond #worldofsbe."[6]

Climate change denial remains pervasive and profitable, so promoting art that opens up space to think about its realities is not nothing. At the same time, it is unclear to me that "raising awareness" of the issue is the key task of the day—the very fact that a work like *How Dare You* can blend so easily with luxury consumption is proof that an educated and affluent audience finds some expression of concern not just appropriate but actually a kind of status marker. The task isn't telling people that climate change exists but mobilizing the large number of people who are aware of climate change but feel disengaged or disempowered. One may even suspect that a defanged rhetoric of sponsoring "awareness" becomes the funder-friendly way to avoid promoting interventions, artistic and otherwise, that say anything too concrete about what must be done.

Separated from the specifics of a particular political program, even the most effectively alarming demonstration of the impact of climate change risks having the opposite effect of a successful politi-

cal mobilizing project. Research into climate change communication suggests that provoking a sense of terror can actually be demobilizing.[7] Fear directly undermines the ability to think beyond the present, makes people feel helpless, and hobbles the risk-taking and exploratory aspects of thinking, promoting a bunker mentality. If art is going to help build for the kind of system-level changes needed, it needs to inspire exactly the *opposite* of these reactions: creating solidarity beyond one's immediate social environment, risking one's comfort for others, and exploring alternative ideas of how society might work.

Art as Remediation

Falling broadly within the genre of art-as-community-organizing known as "social practice" is what has sometimes been called the "remediationist" strain of environmental art. Ditching the idea of being art *about* environmental issues, such projects actually seek to solve environmental problems directly.

The precedents that advanced remediationism in recent decades are many, often associated with the feminist movement's rethinking of traditional ideas of creation. Artists such as Patricia Johanson have specialized in forms of landscape design and ecosystem recovery; her work on Dallas's badly degraded Leonhardt Lagoon in the early 1980s, with its attention to native species, microhabitats, and walkways for humans and ducks, is considered one of the first examples of "bioremediation" art. Lynne Hull's work, starting in the late 1980s, shifted perspective from "art about wildlife" to "art for wildlife": sculptures, sited in nature, that serve practical uses for animals (such as a platform for nesting geese or a basin carved into the rock to catch water for desert wildlife), while doubling as symbolic "eco-atonement for their loss of habitat to human encroachment."[8]

More recently, urban farming initiatives like Frogtown Farm in St. Paul, Minnesota, founded by artists and community activists Seitu Jones and Soyini Guyton, have become touchstones. They offer creative community empowerment, turning abandoned land into

community greenspace and bringing fresh food to a marginalized "food desert." Mary Mattingly's *Swale*, begun in 2016, aimed to grow fresh fruits and vegetables on a floating food barge around New York. For *A Constellation of Remediation*, begun in 2019, T'uy't'tanat-Cease Wyss and Anne Riley were commissioned by the city of Vancouver to create Indigenous Remediation Gardens on abandoned lots, with the intent of both cleaning toxins from the soil and creating a safe zone for Indigenous youth.

Pragmatic projects like this are hard to dislike. They escape containment in the gallery's luxury bubble, do measurable good, and, done right, can galvanize different sorts of communities that might also be activated for wider campaigns for change. The worst you could say about them might be that they are so hard to dislike—which is to say that by design they don't really threaten any major interests.

The trend in a lot of recent political art has been inevitably toward micropolitical gestures that unite community organizers, nonprofit funders, and urban bureaucrats. Frances Anderton, curator of an exhibition documenting pragmatic solutions that artists and designers were pursuing to deal with rising sea levels, *Sink or Swim: Designing for a Sea Change*, laid out the impulse underlying that show in a way that unintentionally reveals the lowered expectations that "remediationism" can conceal: "There's a lot of talk in this climate change conversation about mitigation—and that usually involves big ambitious projects with lots of money thrown at them. But what you see in [*Sink or Swim*] is the exact opposite. It's people saying that we can't assume that there will be governmental commitment or resources to do a Netherlands scale of [seawall] building. So, instead, they come up with other simple and ingenious solutions."[9] The stress on tangible, small-bore gestures fills the space left by the retreat from attempting to imagine large-scale change.

As author Anand Giridharadas stressed in his best-selling book about neoliberal philanthropy, *Winners Take All*, the recent era has seen the thorough takeover of the rhetoric of "doing good" by elites funding a vast industry of nonprofit initiatives that shape the rhetoric of social change in ways that flatter their own egos while buying

off potential critics. The resulting culture of "thought leaders" and "changemakers" that has grown up rests on reframing systemic problems in feel-good, bite-sized ways. Giridharadas sums up the three rules of success within this terrain: "focus on the victim, not the perpetrator" (thus avoiding the blame falling on potential funders or their friends); "personalize the political" ("your job is to help the public see problems as personal and individual dramas rather than collective and systemic ones"); and "be constructively actionable" (don't focus on anything that requires too much in the way of collective action).[10]

I wouldn't condemn any of the examples I mention above as the direct expression of such a cynical mindset. Most predate its full emergence in the public sphere. I am saying that this ideology— what Giridharadas calls "win-win-ism" (politics stripped of political antagonism)—has shaped how such art gestures are received. Creative forms of "remediation" might well offer aid in compensating for some of the worst effects of environmental despoilment and dispossession. They may even be necessary survival mechanisms. But we should also not be naïve about why powerful people might be interested in promoting community gardening or local clean-up initiatives as the key images of acceptable intervention—not as a complement or precursor to politics focused on system change, but as a replacement for and deflection from it.

Bad Utopia

Naomi Klein's book on climate change, *This Changes Everything*, offers the following insight: when it comes to the climate crisis, there are no non-radical solutions remaining. This "inconvenient truth," she argues, is the intellectual starting point for any honest environmental politics. No less than the Intergovernmental Panel on Climate Change put it in much the same way in its 2018 report, saying that preventing mass hardship on an unthinkable level meant "far-reaching and unprecedented changes in all aspects of society."[11] Dramatic, large-scale change of some kind is not just necessary but

inevitable. Failing to propose a "people's vision" of what a future that responds to the challenges of climate crisis might look like, Klein writes, cedes the terrain to futures that replicate and accentuate all the worst features of our present political-economic setup:

> What I am saying is that the science forces us to choose how we want to respond. If we stay on the road we are on, we will get the big corporate, big military, big engineering responses to climate change—the world of a tiny group of big corporate winners and armies of locked-out losers that we have imagined in virtually every fictional account of our dystopic future, from *Mad Max* to *The Children of Men* to *The Hunger Games* to *Elysium*. Or we can choose to heed climate change's planetary wake-up call and change course, steer away not just from the emissions cliff but from the logic that brought us careening to that precipice. Because what the "moderates" constantly trying to reframe climate action as something more palatable are really asking is: How can we create change so that the people responsible for the crisis do not feel threatened by the solutions? How, they ask, do you reassure members of a panicked, megalomaniacal elite that they are still masters of the universe, despite the overwhelming evidence to the contrary?[12]

Artistic strategies of awareness-raising or local improvement are easily appropriated as an instrument for exactly this kind of triangulation. Whatever good individual examples do, the larger perspective—the fact that systemic change is inevitable and is going to involve a struggle with capital if it is not going to lead to a future that cuts the majority loose to perish—has to be part of our assessment of art's role in this moment.

Yet something else sticks out about this passage from *This Changes Everything* to me: at the same time Klein is attempting to rally readers to embrace a more positive "people's vision" of adaptation, the cultural images of the future available for her to draw on— *Mad Max*, *The Hunger Games*, and others—are exclusively dystopian. Providing metaphors and symbols that help integrate as yet unarticulated experiences is one of the commonly understood functions

of art. This absence of *positive images of the future as cultural reference points* identifies a potential art task.

The absence is particularly glaring given the fact that, though artists are stereotyped as impractical lefty dreamers, it is the right wing that is pushing its agenda through images of big-picture re-imaginings of society—and these have clearly been part of their ideological hegemony over the broader public. Writer Sarah Resnick writes of being immersed in the miserablism of New York's literary left culture in the 2010s, with the distinct feeling that some initiative had been ceded to capital: "Even as I absorbed the fatalism of the Left and struggled to find an upside to no-futurism, I noticed that, on the opposite end of the country, in Silicon Valley, utopian think-ing was thriving." The language of the future had been completely taken over by libertarian technology freaks, making promises that our sci-fi dreams were about to come true and gibbering on Twitter about the power of unfettered disruption. "I read these elated tweets and the blogs congratulating their authors and felt disempowered," Resnick wrote. "At the same time, surveying Silicon Valley's reveries suggested that constructing images of alternative worlds has an es-sential social function, and that it can symbolize—even determine—the agency of the constructors." [13]

Consider, for instance, the far-out proposals of the Seasteading movement, a contemporary faction of libertarian utopianism that has actually received funding from Silicon Valley types such as PayPal cofounder Peter Thiel. Declaring that government is the enemy of cul-tural and political progress, seasteading proposes to build future cities on the sea, using the legal freedom of international waters to experi-ment with new governments on custom-designed luxury islands. The advent of a global pandemic in 2020 actually pushed the movement to new extremes, imagining underwater cities: "If we lived under water in isolation or in our small groups, and we're down there for extended periods of time, we wouldn't have to worry about the coronavirus," the co-host of *Colonize the Ocean*, a seasteading podcast, suggested. [14]

It doesn't take any particular political acuity to see that, actually implemented, Seasteading would quickly turn into a nautical-themed

neo-feudalist nightmare. It is easy to ridicule. But at least its images and propositions offer a vision of a radically altered but articulable future, soaking up conversation, inspiring designers, and stimulating argument about what is possible in the present. More important than its actual potential, perhaps, is its propaganda value for a libertarian worldview, associating it with daring ideas through its dreaminess.

Art as Positive Vision

Marx and Engels defined their own theories of social change, in part, against the foil of the then-influential "utopian socialists"— essentially, reformist dreamers who responded to the horrors of the early-capitalist era by planning ideal communities. The authors of the *Communist Manifesto* believed that the various strains of utopian socialism proposed by Henri de Saint-Simon, Charles Fourier, Étienne Cabet, Robert Owen, and Henry George were stuck in the past, imagining that it was possible to opt out of capitalism even as the system spread its spores everywhere. Instead of building a politics that aimed at enfranchising the masses of people, redistributing the available wealth of society, and reorganizing power, the utopians' belief in the virtuousness of their personal imaginative plans led them to appeal to the bourgeoisie to fund alternative lifestyles, rather than to the proletariat to fight for them.

Nevertheless, Marx and Engels conceded that the utopians' "fantastic pictures of future society" might "contain also a critical element," in that they "attack every principle of existing society." The various utopian visions served as propaganda, they wrote, for "the abolition of the distinction between town and country, of the family, of the carrying on of industries for the account of private individuals, and of the wage system"—all of which they agreed with, and even learned from.[15]

Recovering the contribution of the nineteenth-century artist and socialist William Morris, the historian E. P. Thompson once argued that, among other things, in its stridency to appear "scientific," the orthodox Marxist left erred in dismissing all positive speculation

about the future. A certain kind of optimistic and imaginative promise of a future delivered from present hardships had been a strength of radical left politics, and of left-wing culture more specifically. In addition to being a foundational figure for the Arts and Crafts movement and a comrade of Engels, Morris was also the author of works of what was effectively utopian science fiction. His *News from Nowhere* (1890) was framed as a political Rip Van Winkle tale, depicting a man who wakes up in the year 2102 to discover a society transformed for the better by social revolution.

Fantasies of a better future, Thompson argued, need not be thought of as "doctrine or systematic description of the future society," pursued as an alternative to building a mass politics in the present; they can "embody in the forms of fantasy alternative values sketched in an alternative way of life," standing as invitations to debate about what we are fighting for in the first place, opening up the space to speculate about how, in changed circumstances, we could actually live differently and better.[16] The impetus for Morris's *News from Nowhere*, in fact, can be read as proto-environmentalist: the book was a response to another political fable, Edward Bellamy's very popular *Looking Backward: 2000–1887* (1888), which Morris deemed to be too celebratory of the industrial side of progress and not attentive enough to the pastoral.

In recent art, Helen and Newton Harrison, some of the earliest creators of ecologically informed practice, offer a bit of the spirit of Morris with their multipart research-based project *Peninsula Europe*, begun in 2001. Looking to the effects of climate change with respect to near-term drought and rising seas, they imagine, through manifestos, concept art, and maps, what a constructive coordinated response could look like from the point of view of a continent-wide landscape intervention, imagining "re-terraforming one million square kilometers to create water-holding landscapes that will turn into a series of oasis-like food production sites centered around a biodiverse wetlands. Around each oasis a new form of circular farming will need to be invented, that accounts for greater availability of water towards the center and far less at the perimeter."[17] Yet this

earnest vision has remained relatively marginal in art and certainly in the imagination of a general public, the depressive and dystopian tone of contemporary culture not giving it much of a lift.

Importantly, there *has* been an infusion of properly utopian speculation into culture in recent years—and on a truly popular level. A massive surge of interest in the visionary current of Black science fiction known as Afrofuturism has emerged alongside the cultural ferment around the Black Lives Matter movement. In art, the term is associated with works like John Akomfrah's influential 1996 video essay *The Last Angel of History*, which imagined a time-travelling Data Thief scanning the archives of Black pop culture looking for "the distributed components of a code to a black secret technology that is the key to diasporic future."[18] But "Afrofuturism" achieved pop culture ubiquity after the blockbuster success of *Black Panther* in 2018, the superhero film's imagining of a secret central African kingdom of Wakanda providing a confidently magnetic image of Black autonomy and high-tech harmony with nature.

Even so, the most notable on-the-ground action inspired by *Black Panther*'s Afrofuturist world-building may be less utopian and more in the Seasteading vein of technocratic boutique paradises: singer Akon successfully used the film's popularity to fundraise for a $6 billion "real-life Wakanda" in Senegal, called Akon City, promising futuristic undulating towers, parking for flying cars, and resorts for the rich, all run on his own bespoke cryptocurrency. The project has delighted international investors and its US-based contractor, KE International.[19]

Such seamless translation of political futurism into marketing patter makes you appreciate all the more the wry negations of "The Mundane Afrofuturist Manifesto," a much-discussed 2013 text from artist Martine Syms. She proposes a set of guidelines for aesthetic speculation about the future that include "No alternative universes," "No revisionist history," and "No magical or supernatural elements," alongside "No forgetting about political, racial, social, economic, and geographic struggles" and "No inexplicable end to racism—dismantling white supremacy would be complex, violent,

and have global impact." Syms acknowledges the "harmless fun" of "fantasy bolt-holes"—but the point of her Mundane Afrofuturism is to push the genre toward its critical potentials. She writes of "the imaginative challenge that awaits any Mundane Afrofuturist author who accepts that this is it: Earth is all we have. What will we do with it?"[20]

Faced with increasingly urgent breakdown of planetary systems and renewed youth-powered activism, the environmental movement is today by necessity advancing a new and intensified focus on offering tangible images of the future. "Done right, investments in climate action could facilitate real freedom for everyone, the kind that only economic security for all makes possible," write Kate Aronoff, Alyssa Battistoni, Daniel Aldana Cohen, and Thea Riofrancos, the authors of *A Planet to Win*. As they argue, the environmental movement needs to do more than simply make a case for what we need to give up to reduce our planetary impact in the here and now. It needs a vision of a future system transformed *for the better*. You cannot rally mass numbers of people for major change or fight reactionary us-against-them ideology without a vision of something positive to offer. "Who will march," they ask, "for green austerity?"[21]

Aronoff and colleagues spell out the various practical ways that a plan of climate change adaptation might dramatically improve people's lives. I won't repeat their details, but they range from meaningful jobs building coastal defenses and rebuilding ecologies to the conveniences of expanded public transportation and housing to the deeper human connections in a world that places more value on communal care and shared infrastructures of play than on continuously expanded private consumption. They write:

> We should keep these visions of a possible near-future in mind as we tackle the details of decarbonizing. For decades, climate politics revolved around abstract plans that named targets like "80 by 50"—meaning 80 percent decarbonization by 2050. Such slogans were meaningless to those not in the know, and their long timelines were a gift to procrastinating politicians. By 2050, it'd be someone else's problem.

By contrast, we think fighting for a new world starts with imagining it viscerally. People mobilize around concrete projects that appeal to their desires and values.[22]

If the most widely available models of eco-art in the recent past have nevertheless focused on the "warning" and "remediation" paradigms, it may be precisely because of the ineffectual abstraction of official policy (such as "80 by 50"), which has not really offered any plausible vision of deliverance to make tangible through art. A movement in which various Green New Deals and eco-socialist climate action plans are moving onto center stage offers new opportunities to reactivate this impulse.

This potential is the spirit I take from *Metamorphosis*, a three-part video art project by the collective called the Institute of Queer Ecology, released online in 2020. Narrated by the rapper and poet Mykki Blanco, it weaves together clips from Godzilla movies, dreamlike animation, and documentary footage of both nature and its destruction to create something like a video manifesto for a queer eco-socialism. It's both poetic in its arty nature-documentary imagery and serious in its argument for seizing and expanding the potentials of the Green New Deal: "Climate change actually presents a huge opportunity for most people on the planet: the opportunity to build a coalition against oligarchy."

Metamorphosis uses the imagery of insects shedding their larval forms as they develop as a symbol throughout. In this the video finds a motif that naturally binds three themes, to open a circuit of potential coalition: the ecologically informed perspective of viewing ourselves in community with other species instead of dominating them; queer ideas of shedding the limits of fixed and inherited identities; and an anticapitalist view of our own economic system as a form that we can shed and will move beyond.

Radical *Rorschach* Blots

In 1920, the great sociologist, historian, socialist, and civil rights activist W. E. B. Du Bois published *Darkwater: Voices from Within the*

Veil, a collection of personal essays, political analysis, and spirituals. Among its patchwork of texts is a science fiction story, "The Comet," which can perhaps today be taken as a cautionary parable about utopian promise in the face of ecological calamity.[23]

Du Bois's protagonist, Jim, is sent to do a menial task in the remote subbasement of the bank he works in, only to emerge to find that a comet, passing near the earth, has exterminated the entire population of New York with its poisonous tail. Combing the lifeless city, he finds one other survivor, a wealthy white woman named Julia. At first she flees Jim, finding the thought of having to depend on a Black man repellent. At last, though, they find themselves alone together reflecting on their fate, slowly coming to terms with the idea that they will have only each other. "How foolish our human distinctions seem—now," Julia says. "Yes—I was not—human, yesterday," Jim replies. Together, in what is presented as a religious revelation, they have a vision of their destiny as the Adam and Eve of a new civilization, one that will move beyond ideas of Black abjection and white chauvinism.

And it is at that moment in the text when it is revealed that only New York City was affected by the comet, leaving the rest of the United States unscathed. A rescue party headed by Julia's wealthy father and fiancé find them. At first they assume Jim has molested her and threaten to lynch him, then offer him a token reward for service. Julia abandons Jim, and the flicker of conviction in a post-disaster, post-racial possibility vanishes instantly.

The cynicism the Julia character inspires shows how much baggage any promise of a future built on solidarity has to reckon with. Still, the fleetingly glimpsed possibility of equality and a new society that Du Bois holds out here was not meant purely as a mirage. Elsewhere in *Darkwater*, he argued forcefully that racism was not just a psychic disease of whites, but a condition nurtured by the "deeper, mightier currents" of an unequal economic system that has thrived on dividing groups against one another.[24] Given how deeply racism structures life, Du Bois seems to say in "The Comet," perhaps only the leveling shock of catastrophe can force an embrace of the realities of interdependence, opening the path for a new, more equal type of

social order to take root. And yet, Du Bois's final word is that any faith invested even in that tragic sort of deliverance is doomed—as long as the bad old order survives.

I admit that I hesitate to sign on fully for the "utopian turn" for art because I think that it can go so wrong. There are, after all, good reasons that Marx and Engels distanced themselves from utopian socialist fantasizing—what Marx called "writing recipes for the cookshops of the future."[25] Putting the stress on envisioning the ideal plan lends itself to a kind of technocratic thinking that focuses on appealing to experts rather than inspiring wider layers of people, and it invites the popular backlash that comes from having someone else's vision imposed on you. The history of colonial dispossession, urban renewal, and environmental racism is one of oppressed communities having someone else's plans imposed from above—a literally toxic legacy. The very idea of progress is so tainted that the website Indigenous Action has put out "An Indigenous Anti-Futurist Manifesto": "As Indigenous anti-futurists, we are the consequence of the history of the colonizer's future."[26]

On this score, artistic imaginings might offer some benefit over totally worked-out practical schemes, precisely because of their distance from practical expectations. They might serve more as conversation prompts, metaphors for possibilities, and ways to engage people as they come into action rather than as literal plans to be implemented from the top down. In an Earth Day address at the University of Wisconsin's Nelson Institute for Environmental Studies, socialist sci-fi author China Miéville proposed the importance of utopian projection for contemporary struggle:

> What utopias are are new Rorschachs. We pour our concerns and ideas out, and then in dreaming we fold the paper to open it again and reveal startling patterns. We may pour with a degree of intent, but what we make is beyond precise planning. Our utopias are to be enjoyed and admired: they are made of our concerns and they tell us about our now, about our pre-utopian selves. They are to be interpreted. And so are those of our enemies.[27]

Still, a criticism of artistic eco-topia remains. All my instincts tell me to cut against the impulse to celebrate the capacity of artists as "changemakers" on their own. The entire art industry is built on the fantasy of artists as a special class of visionaries whose imagination will Change the World—and it is always more palatable for powerful people to fund an art show of radical images than actually to get behind radical change.

On its own, fantasizing about the future is neither inherently political nor particularly mobilizing. To the hungry, the destitute, and the depressed, the airbrushed images in advertising and media of smiling people enjoying lives of perpetual consumption and easy sex are already a kind of an unattainable "utopia" rubbed in their faces every day. Repeating an image of a remote better world without a bridge to it from the present is as likely to breed demobilizing despair and self-loathing as it is positive action.

The philosopher Ernst Bloch, whose major topic was the utopian imagination, stressed how dreaming of a better future recurred across the social spectrum, from religious depictions of heaven to the happy endings of fairy tales to idle fantasizing about what you'd do if you won the lottery. Bloch argued that the existing social order always had a use for imaginings of its own alternative to compensate for its hardships and disappointments.

Bloch wanted revolutionaries to be attentive to and connect with the utopian reflex in culture rather than being perpetual killjoys. But he also cautioned that dreams of the future that were isolated from any real forces pushing toward change would bear the stamp of the disempowered situation that spawned them. "Castles built in the air of walks and quiet moments," Bloch wrote, in what amounts to a warning for putting too much faith in artistic utopias, "are often empty and shaky because the fixtures and foundations have received little attention during construction, yet often extravagantly daring and beautiful because building costs were never a consideration."[28] Bloch insisted on drawing a distinction between what he called the "utopistic" and the "utopian," or between "abstract" and "real" utopias, the former merely cerebral projections of hopes and wants, the

latter connected to the potentials brought into play by social forces and their attempts to change the world (what Bloch called, in his elaborate style, "the constructional equipment of externality").[29]

But in a time of concussive disruption, how easy will it be for the isolated artist or writer to trace out this terrain convincingly, offering both the persuasive force of an ideal and the conviction of real possibilities? As the authors of *A Planet to Win* write: "We rarely see climate narratives that combine scientific realism with positive political and technological change. Instead, most stories focus on just one trend: the grim projections of climate science, bright reports of promising technologies, or celebrations of gritty activism. But the real world will be a mix of all three."[30] Which is simply to say, in the end, that the imaginative depth that will make images and narratives useful as popular symbols depends on their contact with the actual forces battling for a potential better future.

A New World

In the '80s, Cold Warriors laid siege to labor saying that "There Is No Alternative" to opening the floodgates of free-market capitalism; in the '90s, this became the "end of history," the more settled idea that we couldn't hope for anything besides more of the same neoliberalism, expanding ever wider across the globe and grinding ever deeper into our pores. This sense that there were no big stories of liberation to hold on to, that all that could be hoped for was rare personal success and tinkering political reform, sank into the tissue of intellectual life.

But we are in a new period now. A sense of being part of a shared historical narrative is back. The End of the World is about as concrete and global a "master narrative" to hold on to as one can imagine. Naomi Klein says "there are no non-radical solutions left"—we are *forced* to imagine the future in terms of radical change of one kind or another. The neutral center ground, where you imagine that the future will be just like the present, only with different fashions and improved gadgets, is flooding over. The logic of Rosa Luxemburg's

old line that the choice is "socialism or barbarism" has perhaps never been easier to grasp.

But despite the inspiring revival of radicalism that has marked the last decade, the "barbarism" part is vivid while the "socialism" part is fuzzy. And without a positive shared narrative or image of the future to hold on to, the psychic consequences will be both predictable and horrible. Then, the mental weight of the end-times narrative can only be expressed via metastasizing death cults and sociopathic nihilism, as the lack of a positive future renders the present meaningless. A critical utopian culture is not, in this light, a nice thing to have or an intellectual pet project to nurture. What art might offer is always modest on its own, and, from one angle, art has never looked smaller. But from another angle, in the right conditions, it might offer something close to an actual survival skill.

Epilogue

Art in the After-Culture

The following first draft of a report was prepared in Year 10 of the Near Post-Capitalist Era (NPCE).

Only now is post-revolutionary society recovering sufficiently from recent cataclysms to take stock of matters artistic. The first decade of the NPCE has been a time of gut-wrenching changes and urgent reconstruction. But the battle has stabilized enough now for some accounting of where matters stand culturally and where things might be blocked or capable of going further.

Much remains to be done in moving past the various pathologies associated with the Late Capitalist Era (LCE) and the Capitalist Crisis Era (CCE). The tasks of combating the death squads of a retreating capitalist class combined with building the basic infrastructures of survival in the midst of overlapping disasters have been consuming. The demands of all-in mobilization have left an imprint on a generation.

The present we find ourselves in is neither the fully automated videogame utopia that some in pre-crisis times had hoped for nor a neoprimitivist anti-modernism. It is true that for those who still remember LCE times, NPCE culture is experienced as one of comparative deceleration given the unsustainable overproduction of the previous system. We are, indeed, still dealing with the disastrous levels of waste and toxic pollution left by the late-stage capitalist system that led to ecosystem breakdown.

224

To take only the emblematic examples, while the food shortages of the high crisis years lay behind now, the previous time's diets based on a globalized food system are, of necessity, a relic of the past. So is the previous continuously expanding techno-culture based on short-lifespan personal gadgets, assembled out of components harvested from around the world in conditions of misery and environmental destruction.

Yet researchers have been encouraged to find that, despite this apparent contraction and slowdown in cultural circulation, the public reports increased average "strong positive" feeling in relationship to recent developments in the so-called "after-culture." Several explanations have been floated.

A first is the so-called "Revolutionary Bonds" thesis. In the crisis years, our enemies had both superior command of resources and superior access to the instruments of violence. They were relentless in appealing to racism and even constructed new fields of division from whole cloth in their propaganda. It was ultimately only because the dispossessed capitalist class did such an astounding job of discrediting itself—its ruling institutions hollowed out, its leaders corrupt and self-interested—that a movement was able to buy the time to come together and organize effectively across society.

The solidarity culture formed in the years of revolutionary upheaval was a necessary product of this historic struggle. Thus, the crisis period's demands had already shifted the balance of cultural values from personal diversion to a new communal feeling—there would have been no Anti-Capitalist Alliance of any efficacy without this strong political-cultural foundation. The gain in terms of this sense of social solidarity explains why few would want to return to the previous texture of life, despite the amenities it offered the First World consumer.

A second and related explanation is the "Cultural Decompression" thesis. Economic democracy at both the local and higher coordinating levels has been a priority in the post-stabilization reconstruction period. Theorists of the pre-crisis (LCE) period often argued that the promise of consumer novelty provided the psychic

compensation for lack of true political agency and meaningful life choices under capitalism. The reverse effect has proved true as well: greater sense of popular control over society's direction has meant less of a need to invest hopes for happiness in perpetually renewed fantasies of contentment and power sold through commercial culture.

Yet, on the whole, the recent past has proved to be a time of dazzling imagination in culture, not a time of spartan retreat—this, despite the continuing difficulties of ecological transition. Which brings us to the third explanation: the "Autonomy as Communal Luxury" thesis.

Promises of limitlessly expanding consumption are not something the NPCE can use as an ideology of social cohesion. But the successful decommodification of shelter, care, and food has guaranteed to wider numbers of people freedom from anxious scarcity. This basic sense of security and freedom to shape oneself independent of market survival has dramatically expanded the sense of "autonomy" that is the basis for genuine leisure, artistic experiment, self-development, and deepening social bonds. In the time of inequality, this sense of stable "autonomy" remained essentially a luxury for the independently wealthy or those with their patronage.

So it is that today's society can feel both less consumptive but still offer more to more people. Or, as a popular saying has it, "the free development of all has been the condition for the free development of each."

The dramatic explosion of recent cultural production speaks for itself, even amid all the urgent, demanding work that remains to be done. There has been a flourishing of localism and startling art movements, often filling in where advertising's invented mythologies of desire previously took up mental space. Much artistic effort has focused on the work of memorial, grieving, and reconciliation, given the deep social scars left by recent traumas. But also, a great deal of creative enthusiasm has been drawn to new forms of celebration, as society finds a new human equilibrium and learns to savor its gains.

For veterans of the recent upheaval, quiet tears, born of the shock of feeling steady and realistic hope after long years without it, flood the eyes.

Clearly, giving a sense of the breadth and consequence of these recent changes is difficult within the confines of a general outline. The accompanying NPCE Culture Case Studies will help begin discussion about the phenomena at hand, which remain unprecedented in history and in search of a new vocabulary.

[NOTE: Case Studies in development. Do not release until reporting is complete.]

Notes

Introduction

1. See Ben Davis, *9.5 Theses on Art and Class* (Chicago: Haymarket, 2013).
2. Raymond Williams, *Marxism and Literature* (Oxford: Oxford University Press, 1977), 131.
3. Susan Watkins, "Paradigm Shifts," *New Left Review* 128 (March–April 2021), https://newleftreview.org/issues/ii128/articles/susan-watkins -paradigm-shifts.
4. "CultureTrack '17" (New York: LaPlaca Cohen, 2017), https://2017study. culturetrack.com/home.
5. Danah Boyd, "how 'context collapse' was coined: my recollection," Apophenia blog, December 8, 2013, https://www.zephoria.org/thoughts /archives/2013/12/08/coining-context-collapse.html.
6. Kit White, *101 Things to Learn in Art School* (Cambridge: MIT Press, 2011), 32.
7. Ben Davis, "A New Protest Culture's Challenge to Art," Artnet News, December 16, 2014, https://news.artnet.com/opinion/after-ferguson-a -new-protest-cultures-challenge-to-art-194601.
8. Lucy R. Lippard, *Get the Message? A Decade of Making Art for Social Change* (Boston: E.P. Dutton, 1984), 10.
9. Carl Swanson, "Is Political Art the Only Art That Matters Now?" *New York*, April 20, 2017, https://www.vulture.com/2017/04/is-political-art -the-only-art-that-matters-now.html.

Chapter 1: Connoisseurship and Critique

1. Jeremy Melius, "Connoisseurship, Painting, and Personhood," *Art History*, April 2011, 289.
2. Hugo Chapman, quoted in Allan Wallach, "Bully Pulpit," *Panorama* (Fall 2015), https://editions.lib.umn.edu/panorama/article/whither -connoisseurship/alan-wallach.

Notes 229

3. Michael Shanks, "car collection—connoisseurship and archaeology," mshanks.com, March 8, 2015, http://www.mshanks.com/2015/03/08/car-collection-connoisseurship-and-archaeology.

4. Shoshy Ciment, "The Canadian investor who just dropped more than $1.2 million on 100 pairs of rare sneakers reveals why he thinks it's worth the investment," BusinessInsider.com, July 24, 2019 https://www.businessinsider.com/investor-who-bought-sothebys-rare-sneakers-explains-why-2019-7.

5. John Kernan, Oliver Chen, Krista Zuber, and Jared Orr, "Sneakers as an Alternative Asset Class, Part II," Cowen, July 20, 2020, https://www.cowen.com/insights/sneakers-as-an-alternative-asset-class-part-ii.

6. Matt Welty, "Do You Have to Know Everything About Sneakers to Be a Real Sneakerhead?" Sole Collector, October 31, 2018, https://solecollector.com/news/2018/10/do-you-have-to-know-everything-about-sneakers-to-be-a-real-sneakerhead.

7. Cam Wolf, "How a Single Pair of Sneakers Explains the Booming Billion-Dollar Sneaker Resale Industry," GQ, August 16, 2019, https://www.gq.com/story/stadium-goods-tracking-a-sneaker.

8. Holland Cotter, "Toward a Museum of the 21st Century," New York Times, October 28, 2015, https://www.nytimes.com/2015/11/01/arts/design/toward-a-museum-of-the-21st-century.html.

9. Hal Foster, "After the White Cube," London Review of Books, March 19, 2015, http://www.lrb.co.uk/v37/n06/hal-foster/after-the-white-cube.

10. Larry Shiner, The Invention of Art: A Cultural History (Chicago: University of Chicago, 2003), 70.

11. Ibid., 187.

12. Eric Hobsbawm, The Age of Capital: 1848–1875 (New York: Vintage, 1996), 335.

13. Dave Beech, Art and Postcapitalism: Aesthetic Labour, Automation and Value Production (London: Pluto Press, 2019), 42.

14. Simon Gikandi, Slavery and the Culture of Taste (Princeton: Princeton University Press, 2014), 30.

15. Elaine O'Brien, "The Location of Modern Art," in Modern Art in Africa, Asia, and Latin America: An Introduction to Global Modernisms, eds. Elaine O'Brien, Everlyn Nicodemus, Melissa Chiu, Benjamin Genocchio, Mary K. Coffey, Roberto Tejada (Hoboken, NJ: Wiley-Blackwell, 2013), 5.

16. In her introduction to the English version of the book, Chelsea Foxwell argued that, because he "analyzed the rise of the conceptual and institutional infrastructure that modern art historians would apply to pre-modern works," Satō "exposed many new areas of the field that were previously incapable of inclusion within the narratives of modern Japanese art because they had been structurally eliminated by bijutsu and its systems." She mentions ikebana flower arrangement. Chelsea Foxwell, "Introduction," in Dōshin Satō, Modern Japanese Art and the Meiji State: The Politics of Beauty (Los Angeles: Getty Research Institute, 2011), 5.

17. "In the Meiji period and later, it is reasonable to think that the elements of *kōgei*, corresponding to fine art and *Schönekunst* (fine art) in the West were extracted to form *bijutsu* and that these chosen art forms were positioned higher than the rest, while the remaining elements continued to be regarded as *kōgei* or became part of *kōgyō* [manufacturing industry] and were positioned below *bijutsu*. The genres chosen to compose *bijutsu* were *kaiga* [painting], *chōkoku* [sculpture], and *bijutsu kōgei* [artistic craft]. As to when these genres came to exist, we can use Meiji 20 (1887) as a signpost, when the Tokyo School of Fine Arts opened its doors and these art forms were offered as academic subjects." Satō, *Modern Japanese Art and the Meiji*, 70.

18. Chika Okeke-Agulu, *Postcolonial Modernism: Art and Decolonization in Twentieth-Century Nigeria* (Durham, NC: Duke University Press, 2015), 7.

19. Osman Jamal, "EB Havell and Rabindranath Tagore: Nationalism, Modernity and Art," *Modern Art in Africa, Asia, and Latin America*, 150–59.

20. Among other things, Tagore, a Nobel Prize winner in literature, received a knighthood in 1915 and then publicly renounced it in protest in 1919 after British imperial forces massacred hundreds in the Amritsar Massacre. See Tobias Harper, "Titles, Medals and Ribbons," *Aeon*, October 29, 2018, https://aeon.co/essays/the-shame-of-sir-british-honours-and-decolonisation.

21. Jamal, "EB Havell," *Modern Art in Africa, Asia, and Latin America*, 162.

22. Edmonia Lewis, quoted in Penelope Green, "Overlooked No More: Edmonia Lewis, Sculptor of Worldwide Acclaim," *New York Times*, July 25, 2018, https://www.nytimes.com/2018/07/25/obituaries/overlooked-edmonia -lewis-sculptor.html.

23. Kirsten P. Buick, "The Ideal Works of Edmonia Lewis: Invoking and Inverting Autobiography," *American Art* 9, no. 2, 19.

24. Giovanni Morelli, *Italian Painters: Critical Studies of Their Works*, trans. Constance Jocelyn Foulks (London: John Murray, 1892), 59.

25. Ibid., 60.

26. Ibid., 25.

27. Ibid., 9.

28. Gibson-Wood, 246.

29. Bernard Berenson, *Rudiments of Connoisseurship: Study and Criticism of Italian Arts* (New York: Schocken Books, 1962), 114.

30. Because the idea of the artist proposed retroactively centuries later represented a fictional construct imported from a different era, it was possible to conjure a coherent "artistic personality" where none existed. Such is the case with Berenson's creation "Amico di Sandro," his name for a previously unknown Renaissance artist that he deduced lay behind a sequence of works that were connected to, but did not fit the exact signatures of, any of an array of major figures. The intuition later proved to be false. As writer S. N. Behrman pointed out, "In Amico di Sandro [Berenson] created an artist who was more consistent, more distinctive, and more readily recognizable than any actual artist. S. N. Behrman, *Duveen: The Story of the Most*

Spectacular Art Dealer of All Time (London: Daunt Books, 2014), 107.

31. Michel Foucault, "What Is an Author?" in *Aesthetics, Method, and Episte-mology*, ed. James D. Faubion (New York: New Press, 1999), 210–11.

32. Andrew Sarris, "Notes on the Auteur Theory in 1962," in *Film Culture Reader*, ed. Adams P. Sitney (New York: Cooper Square Press, 2000), 132.

33. According to Hitchcock's biographer, Truffaut's book of interviews "hurt and disappointed just about everybody who had ever worked with Alfred Hitchcock, for the interviews reduced the writers, the designers, the pho-tographers, the composers, and the actors to little other than elves in the master carpenter's workshop." Donald Spoto, *The Dark Side of Genius: The Life of Alfred Hitchcock* (Cambridge, MA: Da Capo Press, 1999), 495.

34. Foucault, "What Is an Author?" 222.

35. Eric Hobsbawm, *Age of Extremes: A History of the World, 1913–1991* (New York: Vintage Books, 1991), 513.

36. David Harvey, "The Art of Rent," *Rebel Cities: From the Right to the City to the Urban Revolution* (London: Verso, 2012), 109–10.

37. Of course, I just argued that Berenson and others projected the idea of the individual artist backwards onto Renaissance art, in which often it was the patron, not the unique artist, who was considered the author. These types of works and the art-historical myths spun around them, nevertheless, form the template for what audiences expect of "museum art" even today.

38. Fascinatingly, Walter Benjamin, the theorist of the revolutionary potentials of "mechanical reproducibility," also seems to give the best account of rev-olutionary connoisseurship: "The most profound enchantment of the col-lector is the locking of the individual items within a magic circle in which they are fixed as the final thrill, the thrill of acquisition, passes over them. Everything remembered and thought, everything conscious, becomes the pedestal, the frame, the base, the lock of his property. The period, the region, the craftsmanship, the former ownership—for a true collector the whole background of an item adds up to a magic encyclopedia whose quintessence is the fate of his object." Walter Benjamin, "Unpacking My Library: A Talk about Book Collecting," *Illuminations*, trans. Harry Zohn, ed. Hannah Arendt (New York: Schocken Books, 1969), 60.

39. See the discussion of John Berger's *Ways of Seeing* in Chapter 3, "The Art World and the Culture Network."

40. Some recent examples: Critical effort has been given to recovering the stories of female workers for Tiffany glassworks factory, including Clara Wolcott Driscoll, who conceived many of the company's famous lamp designs, previously sold simply under the label "Tiffany"; Tyrus Wong, credited simply as "background artist" on the Walt Disney Company's 1942 *Bambi*, is recognized now as having lent his entire artistic vision to the film, inspired by his knowledge of Song dynasty painting; McKinley Thompson Jr., Ford's first Black automotive designer and the person who conceived the designs for cars including the Bronco, was largely obscure until being recently spotlight-

ed. See Jeffrey Kastner, "Clara Driscoll, One of the Guiding Lights Behind Tiffany's Success," *New York Times*, February 26, 2007, https://www.nytimes.com/2007/02/26/arts/26iht-tiff.html; Margalit Fox, "Tyrus Wong, 'Bambi' Artist Thwarted by Racial Bias, Dies at 106," *New York Times*, December 30, 2016, https://www.nytimes.com/2016/12/30/movies/tyrus-wong-dies-bambi -disney.html; Phoebe Wall Howard, "2021 Ford Bronco Designer Follows in Footsteps of the Jackie Robinson of Car Design," *Detroit Free Press*, July 13, 2020, https://www.freep.com/story/money/cars/ford/2020/07/13/2021-ford -bronco-chris-young-mckinley-thompson-jr/5384019002/.

41. Theodor Adorno, "Adorno to Benjamin," *Aesthetics and Politics* (London: Verso, 2007), 123.

Chapter 2: Elite Capture and Radical Chic

1. Betty Farrell and Maria Medvedeva, "Demographic Transformation and the Future of Museums," Center for the Future of Museums (Washington, DC: AAM Press, 2010), 14–15.

2. "Can Too Many Brainy People Be a Dangerous Thing?" *Economist*, October 24, 2020, https://www.economist.com/finance-and-economics /2020/10/22/can-too-many-brainy-people-be-a-dangerous-thing.

3. Gabriel Winant, "Professional-Managerial Chasm," *n+1* (online only), October 10, 2019, https://nplusonemag.com/online-only/online-only /professional-managerial-chasm.

4. Roberto Schwarz, "Culture and Politics in Brazil, 1964-1969," *Misplaced Ideas: Essays on Brazilian Culture* (New York: Verso, 1992), 127.

5. Ibid., 146.

6. Sinéad Murphy, *The Art Kettle* (London: Zero Books, 2012), 5.

7. Barbara Rose, "Problems of Criticism IV: The Politics of Art, Part I," *Artforum* (February 1968), https://www.artforum.com/print/196802 /problems-of-criticism-iv-the-politics-of-art-part-i-38546.

8. Lucy R. Lippard, "The Pink Glass Swan: Upward and Downward Mobility in the Arts," *Get the Message?: A Decade of Art for Social Change* (New York: E. P. Dutton, 1984), 90.

9. Roxanne Dunbar-Ortiz, *Outlaw Woman: A Memoir of the War Years, 1960–1975* (Norman: University of Oklahoma Press, 2014), 107.

10. John Clark, Stuart Hall, Tony Jefferson, and Brian Roberts, "Subcultures, Cultures and Class: A Theoretical Overview," *Resistance through Rituals: Youth Subcultures in Post-War Britain* (New York: Taylor & Francis, 2002), 66.

11. Jeff Chang, *Who We Be: The Colorization of American* (New York: St. Martin's Press, 2014), 55–64.

12. Karen Ferguson, *Top Down: The Ford Foundation, Black Power, and the Reinvention of Racial Liberalism* (Philadelphia: University of Pennsylvania Press, 2013), 175.

Notes 233

Notes 233

13. Hans Haacke, quoted in *Hans Haacke: All Connected*, eds. Massimiliano Gioni and Gary Carrion-Murayari (London: Phaidon Press, 2019).

14. Hans Haacke, "The Constituency," *Working Conditions: The Writings of Hans Haacke* (Cambridge, MA: MIT Press, 2016), 75.

15. Julia Bryan-Wilson, *Art Workers: Radical Practice in the Vietnam War Era* (Oakland: University of California Press, 2011), 111.

16. Hans Haacke, interviewed by Yve-Alain Bois, Douglas Crimp, Rosalind Krauss, "A Conversation with Hans Haacke," *October* 30 (Autumn 1984), 35.

17. Mierle Laderman Ukeles, "Manifesto for Maintenance Art 1969!—Proposal for an Exhibition 'Care'" *Mierle Laderman Ukeles: Maintenance Art*, ed. Patricia C. Phillips (New York: Prestel, 2016), 210.

18. Silvia Federici, *Wages Against Housework* (London: Power of Women Collective, 1975), 1.

19. Kaegan Sparks, "Dirty Pictures: The Art of Picking up 85,000 Tons of Trash," *Lux* (January 2021): 23–24.

20. George Yúdice, *The Expediency of Culture: Uses of Culture in the Global Era* (Durham, NC: Duke University Press, 2004), 1.

21. Quoted from a letter on display in Ukeles's Queens Museum of Art retrospective in 2016. See Ben Davis, "What Mierle Laderman Ukeles's 'Maintenance Art' Can Still Teach Us Today," Artnet News, September 20, 2016, https://news.artnet.com/exhibitions/mierle-ukeles-laderman-manifesto-655478.

22. Lippard, *Get the Message?*, 92.

23. Lucy Lippard, quoted in Jean Shapland, "New Mexico Woman," Southwest Contemporary, May 24, 2019 https://southwestcontemporary.com/new-mexico-women-lucy-lippard/.

24. Brian Boucher, "People Are Calling for Museums to Be Abolished. Can Whitewashed American History Be Rewritten?" CNN.com, July 12, 2020, https://www.cnn.com/style/article/natural-history-museum-whitewashing-monuments-statues-trnd/index.html.

25. Writing of political posturing on social media, *New York Times* columnist Amanda Hess says the following: "In the '70s, Americans who styled themselves as 'radical chic' communicated their social commitments by going to cocktail parties with Black Panthers. Now they photograph themselves reading the right books and tweet well-tuned platitudes in an effort to cultivate an image of themselves as politically engaged." This is a hash: no one ever "styled themselves" as "radical chic." Amanda Hess, "Earning the 'Woke' Badge," *New York Times*, April 19, 2016, https://www.nytimes.com/2016/04/24/magazine/earning-the-woke-badge.html.

26. Tom Wolfe, "Radical Chic: That Party at Lenny's," *New York*, April 15, 2008, https://nymag.com/news/features/46170.

27. New York Times Editorial Board, "False Note on Black Panthers," *New York Times*, January 16, 1970, https://www.nytimes.com/1970/01/16/archives/false-note-on-black-panthers.html.

28. Michael E. Staub, "Black Panthers, New Journalism, and the Rewriting of the Sixties," *Representations* 57 (1997): 52–72.

29. Wolfe, "Radical Chic."

30. Elisabeth Lasch-Quinn, "Radical Chic and the Rise of a Therapeutics of Race," *Salmagundi*, no. 112 (Fall 1996): 8–25.

31. Daniel P. Moynihan, "Memorandum for the President," Nixon Library, January 16, 1970, https://www.nixonlibrary.gov/sites/default/files /virtuallibrary/documents/jul10/53.pdf.

32. Raymond K. Price Jr., quoted in "Tom Wolfe's 'Radical Chic': An Oral History," *New York*, May 28, 2018, https://www.vulture.com/2018/05 /tom-wolfe-radical-chic.html.

33. Wolfe, "Radical Chic."

34. Jamie Bernstein, "The Time My Parents 'Took a Knee' for the Black Panthers," JamieBernstein.net, October 18, 2017, https://www.jamiebernstein .net/writings/the-time-my-parents-took-a-knee-for-the-black-panthers.

35. Don Cox, *Just Another Nigger: My Life in the Black Panther Party* (Berkeley: Heyday, 2019), Kindle edition.

36. Morris Dickstein, *Gates of Eden: American Culture in the Sixties* (New York: Liveright, 2015), 143.

37. The strategy of hegemonic struggle was thought to apply in particular to Western democracies with developed civil societies and parliamentary systems, diffusing left-wing energy. Yet in fact, the key symbol of the Russian Revolution, the hammer and sickle, was already a hieroglyphic for a particular kind of hegemonic alliance. It united two distinct political programs: the hammer representing the urban proletariat demanding collective democratic control over production, in alliance with the sickle representing the rural peasantry demanding land for small holders. See Craig Brandist, *The Dimensions of Hegemony: Language, Culture and Politics in Revolutionary Russia* (Chicago: Haymarket Books, 2016), 11.

38. Brandist, *The Dimensions of Hegemony*, 4.

39. See A. Sivanandan, "The Hokum of New Times," *Catching History on the Wing: Race, Culture and Globalisation* (London: Pluto Press, 2008), 19.

40. Olúfémi O. Táíwò, "Being-in-the-Room Privilege: Elite Capture and Epistemic Deference," *The Philosopher* 108, no. 4 (Autumn 2020), https://www.thephilosopher1923.org/essay-taiwo.

41. See M. Lebrun, "Mass and Class in Soviet Society," *The New International* 6, no. 4 (May 1940), https://www.marxists.org/history/etol/newspape/ni /vol06/no04/lebrun.htm.

42. Cildo Mireles, interviews in *Formas do Afeto. Um filme sobre Mário Pedrosa*, directed by Nina Galanternik (Gala Filmes, 2010), https://vimeo.com/95897947

43. Alexander Calder, Henry Moore, Cristiane Du Parc, Cruz Diez, Jovenal Ravelo, et al., "The Case of Mario Pedrosa," *New York Review of Books*, March 9, 1972, https://www.nybooks.com/articles/1972/03/09/the-case -of-mario-pedrosa.

44. Mário Pedrosa, "Open Letter to a Labor Leader," *Mário Pedrosa: Primary Documents* (Durham, NC: Duke University Press, 2015), 438.

45. Michael Löwy, "A New Type of Party: The Brazilian PT," *Latin American Perspectives*, no. 55 (Fall 1987), 464.

46. Mário Pedrosa, interviews in *Formas do Afeto*.

Chapter 3: The Art World and the Culture Network

1. "The Verb 'To Film,'" *New York Times*, May 26, 1914, https://timesmachine.nytimes.com/timesmachine/1914/05/26/100092545.html?pageNumber=10.

2. Jennifer C. Lena, *Entitled: Discriminating Tastes and the Expansion of the Arts* (Princeton: Princeton University Press, 2019), 8.

3. See Nicole Aschoff, *The Smartphone Society: Technology, Power, and Resistance in the New Gilded Age* (Boston: Beacon Press, 2020).

4. Pierre Bourdieu, *Manet: A Symbolic Revolution*, trans. Peter Collier and Margaret Rigaud-Drayton (Cambridge: Polity Press, 2017), 3.

5. Cory Arcangel, "Net Aesthetics 2.0 Conversations, New York City, 2006: Part 1 of 3," *Mass Effect: Art and the Internet in the Twenty-first Century*, eds. Lauren Cornell and Ed Halter (Cambridge: MIT Press, 2015), 104.

6. See Julian Myers, "Living in the *Long Front*," *Tate Papers*, no. 16 (Autumn 2011), https://www.tate.org.uk/research/publications/tate-papers/16/living-in-the-long-front.

7. Brian O'Doherty, *Inside the White Cube: The Ideology of the Gallery Space* (Berkeley: University of California Press, 1999), 76.

8. James Zug, quoted in "The Theft That Made the 'Mona Lisa' a Masterpiece," NPR, July 30, 2011, https://www.npr.org/2011/07/30/138800110/the-theft-that-made-the-mona-lisa-a-masterpiece.

9. Andy Warhol, quoted in Jerry Saltz, "Christie's Says This Painting Is by Leonardo. I Doubt It," *New York*, November 14, 2017, https://www.vulture.com/2017/11/christies-says-this-painting-is-by-leonardo-i-doubt-it.html.

10. Carolee Schneemann, quoted in Nell Baram, "The Book That Inspired 'Imagine,'" *Slate*, July 4, 2014, https://slate.com/culture/2014/07/yoko-onos-grapefruit-at-50-the-book-that-inspired-john-lennons-imagine.html.

11. John Lennon, quoted in Joshua Barajas, "Burn This Story About Yoko Ono After You've Read It," PBS, September 21, 2017, https://www.pbs.org/newshour/arts/burn-story-yoko-ono-youve-read.

12. Lawrence Alloway, "Network: The Art World Described as a System," *Artforum* (September 1972), https://www.artforum.com/print/197207/network-the-art-world-described-as-a-system-33673.

13. Julian Myers, "Living in the *Long Front*."

14. John Berger, *Ways of Seeing* (London: British Broadcasting Corporation, 1972), 30.

15. "The Skin of Our Teeth," *Civilisation: A Personal View*, narrated by Kenneth Clark, episode 1, BBC Two, February 23, 1969.

16. "Heroic Materialism," *Civilisation: A Personal View*, narrated by Kenneth Clark, episode 13, BBC Two, May 18, 1969.

17. Berger, *Ways of Seeing*, 3.2.

18. "Episode 1," *Ways of Seeing*, narrated by John Berger, BBC, January 8, 1972.

19. Again, this is a rebuttal of Clark, whose book *The Nude* proposed the distinction between the state of being "naked," as between merely unclothed, and the artistic "nude," as a tradition representing the humanist virtues of the body transformed into an aesthetic ideal.

20. "Episode 2, *Ways of Seeing*, narrated by John Berger, BBC, January 15, 1972.

21. John Berger, *Selected Essays* (New York: Vintage, 2003), 94.

22. Joseph Schumpeter, *Capitalism, Socialism, and Democracy* (New York: Harper Perennial Modern Classics, 2008), 67.

23. Nam June Paik, quoted in William Kaizen, "Computer Participator: Situation Nam June Paik's Work in Computing," *Mainframe Experimentalism: Early Computing and the Foundations of the Digital Arts*, eds. Hannah B. Higgins and Douglas Kahn (Berkeley: University of California Press, 2012), 236.

24. Stewart Brand, "Spacewar: Fanatic Life and Symbolic Death Among the Computer Bums," *Rolling Stone*, December 7, 1972, reproduced at https://www.wheels.org/spacewar/stone/rolling_stone.html.

25. Stewart Brand, quoted in Mark Dery, *Escape Velocity: Cyberculture at the End of the Century* (New York: Grove Press, 1997), 27.

26. See Fred Taylor, *From Counterculture to Cyberculture: Stewart Brand, the Whole Earth Network, and the Rise of Digital Utopianism* (Chicago: University of Chicago Press, 2010).

27. Bill Gates, quoted in David Joselit, "Citizen Cursor," *Communities of Sense: Rethinking Aesthetics and Politics*, eds. Beth Hinderliter, Jaleh Mansoor, Seth McCormick, and Vered Maimo (Durham, NC: Duke University Press, 2009), 160.

28. Thomas E. Crow, *The Rise of the Sixties: American and European Art in the Era of Dissent* (London: Laurence King, 2004), 7.

29. "Museum attendance grew rapidly through much of the 20th century. It peaked in the 1990s, when up to 40.8 percent of U.S. adults reported having visited an art museum, according to the National Opinion Research Center." Mary Carol McCauley, "In Baltimore and Nationwide, Art Museums Fight Sharp Declines in Attendance," *Baltimore Sun*, January 12, 2018, https://www.baltimoresun.com/entertainment/arts/bs-fe-museum-attendance-20171002-story.html.

30. Domenico Quaranta, "In Between," *Post-Like & Share* (Pasadena, CA: Art Center College of Design, 2016), 20.

31. Andy Baio, "Fanboy Supercuts, Obsessive Video Montages," Waxy.org, April 11, 2008, https://waxy.org/2008/04/fanboy_supercuts_obsessive_video_montages.

32. Julian Stallabrass, "A Sad Reflection on the Art World," *The Art Newspaper*, December 5, 2012, https://www.theartnewspaper.com/articles/A-sad -reflection-on-the-art-world/28099.

33. Jonah Peretti, quoted in Eugene Wolters, "From Deleuze to LOLCats, the Story of the Buzzfeed Guy," Critical-Theory.com, http://www.critical-th eory.com/from-deleuze-to-lolcats-the-story-of-the-buzzfeed-guy/.

34. Jonah Peretti, "My Nike Media Adventure," *Nation*, March 22, 2001, https://www.thenation.com/article/archive/my-nike-media-adventure/.

35. Rachel Greene, "Contagious Media," archived at https://archive .newmuseum.org/exhibitions/424.

36. Robert Smith, "'Contagious Media' Contest Targets You," NPR, May 19, 2005, https://www.npr.org/templates/story/story.php?storyId=4658961.

37. Jonah Peretti, quoted in Jen Chung, "Jonah Peretti, Director of R&D at Eyebeam," Gothamist, June 4, 2005, https://gothamist.com/arts -entertainment/jonah-peretti-director-of-rd-at-eyebeam.

38. Alloway, "Network."

39. Artie Vierkant, "The Image-Object Post-Internet," retrieved from http://jstchillin.org/artie/pdf/The_Image_Object_Post-Internet_us.pdf.

40. Jonah Peretti, quoted in Max Read, "BuzzFeed's Jonah Peretti on Making the World a Meme," *New York*, November 26, 2019, https://nymag.com /intelligencer/2019/11/buzzfeed-jonah-peretti-2010s.html.

41. Kara Fox, "Instagram Worst Social Media App for Young People's Mental Health," CNN.com, May 19, 2017, https://www.cnn.com/2017/05/19 /health/instagram-worst-social-network-app-young-people-mental-health.

42. Todd Spangler, "Instagram's World Record Egg Mystery Cracked, Hulu Pays for Mental-Health PSA," *Variety*, February 4, 2019, https://variety.com /2019/digital/news/instagrams-world-record-egg-mystery-cracked-hulu -pays-for-mental-health-psa-1203127578/.

43. See Sarah Boxer, "Critic's Notebook: The Photos That Changed Pollock's Life," *New York Times*, December 15, 1998, https://www.nytimes.com/1998 /12/15/arts/critic-s-notebook-the-photos-that-changed-pollock-s-life.html.

44. CultureTrack, quoted in Julia Halperin, "Is the Museum of Ice Cream the Future of Culture? If Museums Aren't Careful, It Might Be, Says a New Study," Artnet News, October 18, 2017, https://news.artnet.com/art-world /culture-track-2017-report-summary-1120559.

45. Christina Morales, "Immersive van Gogh Experiences Bloom Like Sun-flowers," *New York Times*, March 7, 2021, https://www.nytimes.com/2021 /03/07/arts/design/van-gogh-immersive-experiences.html.

46. Zachary Small, "Entrepreneurs Bet Big on Immersive Art Despite Covid-19," *New York Times*, January 10, 2021, https://www.nytimes.com /2021/01/10/arts/design/immersive-art-investors.html.

47. Vince Kadlubek, quoted in Stephanie Guzman-Barrera, "The Meow Wolf Business Plan: How This Art Exhibit Is Being Run as a For-profit Venture," *Albuquerque Business First*, April 1, 2016, https://www.bizjournals.com

/albuquerque/news/2016/04/01/the-meow-wolf-business-plan-how-this
-art-exhibit.html.

48. Marc Glimcher, quoted in Julie Baumgardner, "A Very Different Kind of
Immersive Art Installation," *New York Times*, February 4, 2016,
https://www.nytimes.com/2016/02/04/t-magazine/art/teamlab-living
-digital-space-future-parks-pace-gallery-california.html.

49. Takashi Kudo, quoted in Madelyne Xiao, "Digital Dreamscapes," *Stanford
Arts Review*, February 13, 2016, archived at https://web.archive.org/web
/20190609105328/https://stanfordartsreview.com/digital-dreamscapes/.

50. Naomi Rea, "teamLab's Tokyo Museum Has Become the World's Most
Popular Single-Artist Destination, Surpassing the Van Gogh Museum,"
Artnet News, August 7, 2019, https://news.artnet.com/exhibitions
/teamlab-museum-attendance-1618834.

51. Meagan Day, "Workers at the Immersive Entertainment Company Meow
Wolf Are Unionizing," *Jacobin*, October 19, 2020, https://jacobinmag.com
/2020/10/meow-wolf-workers-collective-santa-fe-union.

52. See Halperin, "Is the Museum of Ice Cream the Future of Culture?".

53. See Julia Halperin, "Anatomy of a Blockbuster: How the Hirshhorn Mu-
seum Hit the Jackpot With Its Yayoi Kusama Show," Artnet News, May
15, 2017, https://news.artnet.com/exhibitions/yayoi-kusama
-hirshhorn-museum-959951.

54. Sarah Cascone, "Here Are Instagram's Most Popular Art Posts of 2017—
and Why," Artnet News, November 29, 2017, https://news.artnet.com
/art-world/awol-erizkus-beyonce-pregnancy-photo-instagram-1162772.

55. Jennifer L. Roberts, "The Power of Patience," *Harvard Magazine* (Novem-
ber–December 2013), https://harvardmagazine.com/2013/11/the-power
-of-patience.

56. Alessandro Bava, "Every Force Evolves a Form," *Mousse*, no. 70 (Winter
2020), http://moussemagazine.it/every-force-evolves-a-form-alessandro
-bava-2020.

57. Turner, *From Counterculture to Cyberculture*, 51.

58. Stewart Brand, quoted in Arden Reed, *Slow Art: The Experience of Looking,
Sacred Images to James Turrell* (Berkeley: University of California Press,
2017), 7.

59. "Experiencing the Method: An Exploration of Being Present," Marina
Abramovic Institute, March 9, 2019, https://mai.art/terra-comunal-content
/2015/3/9/experiencing-the-method.

60. See Margaret Sullivan, "Business Witches of Instagram," Mashable, July
22, 2017, https://mashable.com/2017/07/22/witches-instagram-business/.

61. "About," The Nap Ministry, https://thenapministry.wordpress.com/about/.

62. Kyle Chayka, "How Nothingness Became Everything We Wanted," *New
York Times Magazine*, January 19, 2021, https://www.nytimes.com
/2021/01/19/magazine/negation-culture.html.

63. See Nellie Bowles, "The Digital Gap Between Rich and Poor Kids Is Not

What We Expected," *New York Times*, Octber 26, 2018, https://www
.nytimes.com/2018/10/26/style/digital-divide-screens-schools.html.

64. Noah Schactman, "In Silicon Valley, Meditation Is No Fad. It Could Make
Your Career," *Wired*, June 18, 2013, https://www.wired.com/2013/06
/meditation-mindfulness-silicon-valley.

65. Elizabeth Merritt, "Slooow: Better a Tortoise Than a Hare," American
Alliance of Museums, May 1, 2015, https://www.aam-us.org/2015/05/01
/slooow-better-a-tortoise-than-a-hare.

66. Andrew Marantz, "Silicon Valley's Crisis of Conscience," *New Yorker*,
August 26, 2019, https://www.newyorker.com/magazine/2019/08/26
/silicon-valleys-crisis-of-conscience.

67. Ronald Purser, "The Future of Mindfulness," openDemocracy.com,
December 19, 2015, https://www.opendemocracy.net/en/transformation
/future-mindfulness.

68. Berger, *Ways of Seeing*, 148.

Chapter 4: AI Aesthetics and Capitalism

1. Margaret A. Boden, "Computer Models of Creativity," *AI Magazine*, no. 30
(Fall 2009): 23, https://ojs.aaai.org//index.php/aimagazine/article/view/2254.

2. Amy Thomson and Stephanie Bodoni, "Google CEO Thinks AI Will Be
More Profound Change Than Fire," *Bloomberg*, January 22, 2020, https://
www.bloomberg.com/news/articles/2020-01-22/google-ceo-thinks-ai
-is-more-profound-than-fire.

3. David Freedberg, "Warburg's Mask: A Study in Idolatry," *Anthropologies of
Art*, ed. M. Westermann (Clark Institute, 2005), 17, http://www.columbia
.edu/cu/arthistory/faculty/Freedberg/Warburgs-Mask.pdf.

4. Amit Sood, quoted in Oliver Franklin-Wallis, "History Is Being Locked
Away. Google's Museum Is Changing That," *Wired*, September 14, 2016,
https://www.wired.co.uk/article/google-cultural-institute-art-museums.

5. Aaron Hertzmann, "Can Computers Create Art?" *Arts* 7, no. 2 (2018),
https://doi.org/10.3390/arts7020018.

6. Ahmed Elgammal, "AI Is Blurring the Definition of Artist," *American
Scientist* (January–February 2019), 18, https://www.americanscientist.org
/article/ai-is-blurring-the-definition-of-artist.

7. Reproduced based on the figure available at www.researchgate.net/figure
/The-Wundt-curve-Berlyne-1960_fig1_262245493.

8. Ian Bogost, "The AI-Art Gold Rush Is Here," *Atlantic*, March 6, 2019,
https://www.theatlantic.com/technology/archive/2019/03/ai-created-art
-invades-chelsea-gallery-scene/584134.

9. Elgammal, "AI Is Blurring the Definition of Artist."

10. Leo Steinberg, *Other Criteria: Confrontations with Twentieth-Century Art*
(Oxford: Oxford University Press, 1975), 79.

11. Darby English, "Art Historian Darby English on Why the New Black Renaissance Might Actually Represent a Step Backwards," Artnet News, February 26, 2021, https://news.artnet.com/art-world/darby-english-1947080.
12. Harold Rosenberg, "The American Action Painters," *Art News*, November 1, 2007, https://www.artnews.com/artnews/news/top-ten-artnews-stories-not-a-picture-but-an-event-181.
13. I argued in chapter 1 that this investment is ultimately changeable, and there are very definitely connoisseurs of Raymond Loewy's industrial design work who have their own narratives of appreciation that allows them to see it as more than just visual pattern. I chose the example of Photoshop gradients because of contemporary artist Cory Arcangel's "Photoshop Gradient" series, for which he makes large and beautiful paintings by clicking a single point in Adobe Photoshop's color selection tool—best appreciated, not as a pure digital abstraction, but as a joke about a purely technical understanding of digital art.
14. Arthur Danto, "The Artworld," *Journal of Philosophy* 61, no. 19 (1964), 580.
15. David Cope, quoted in Margaret Boden, *Creativity and Art: Three Roads to Surprise* (Oxford: Oxford University Press, 2010), 204.
16. Bob Sturm, quoted in Alex Marshall, "Is Music About to Have Its First AI No.1?" BBC.com, February 28, 2019, https://www.bbc.co.uk/music/articles/0c3dc8f7-4853-4379-b0d5-62175d33d557.
17. Stefanie Wolz and Claus-Christian Carbon, "What's Wrong with an Art Fake? Cognitive and Emotional Variables Influenced by Authenticity Status of Artworks," *Leonardo* 4 (2014): 467–73.
18. Harry Collins, *Artifictional Intelligence: Against Humanity's Surrender to Computers* (Hoboken, NJ: Wiley, 2018).
19. Will Douglas Heaven, "Predictive Policing Algorithms Are Racist. They Need to Be Dismantled," *MIT Technology Review*, July 17, 2020, https://www.technologyreview.com/2020/07/17/1005396/predictive-policing-algorithms-racist-dismantled-machine-learning-bias-criminal-justice/.
20. Boden, "Computer Models of Creativity," 24.
21. In 2016, computer scientists worked with musicians to create "Daddy's Car," a "new" Beatles song that they claimed was the first original pop song generated by the technology. In 2020, at AI start-up created STiCH, an AI artist that paints like Basquiat. The output of both is, as yet, not wholly convincing. See Olivia Goldhill, "The First Pop Song Ever Written by Artificial Intelligence Is Pretty Good, Actually," Quartz, September 24, 2016, https://qz.com/790523/daddys-car-the-first-song-ever-written-by-artificial-intelligence-is-actually-pretty-good/; and Tom May, "AI 'Artist' Creates New Work Inspired by Jean-Michel Basquiat," CreativeBoom, September 14, 2020, https://www.creativeboom.com/inspiration/ai-artist-resurrects-the-iconic-jean-michel-basquiat-to-mark-32-years-since-his-death.
22. Peter H. Diamandis, "AI Is About to Completely Change the Face of Entertainment," Singularity Hub, May 3, 2019, https://singularityhub.com

/2019/05/03/ai-is-about-to-completely-change-the-face-of-entertainment/.

23. Chelsea Summers, "From Virtual Lolitas to Extreme Sex, Deepfake Porn Is Blurring the Lines of Consent and Reality," *Document Journal*, July 23, 2020, https://www.documentjournal.com/2020/07/from-virtual-lolitas-to-extreme-sex-deepfake-technology-is-making-porn-fantasies-come-true-while-blurring-the-lines-of-consent.

24. Elgammal, "AI Is Blurring the Definition of Artist."

25. See James Bridle, "Something Is Wrong on the Internet," Medium.com, November 6, 2017, https://medium.com/@jamesbridle/something-is-wrong-on-the-internet-c39c471271d2.

26. Josh Golin, quoted in Sapna Maheshwari, "On YouTube Kids, Startling Videos Slip Past Filters," *New York Times*, November 4, 2017, https://www.nytimes.com/2017/11/04/business/media/youtube-kids-paw-patrol.html.

27. Victoria Rideout and Michael B. Robb, "The Common Sense Census: Media Use by Teens and Tweens," *Common Sense Media* (San Francisco: Common Sense Media, 2019), https://www.commonsensemedia.org/sites/default/files/uploads/research/2019-census-8-to-18-full-report-updated.pdf.

28. Alex Greenfield, *Radical Technologies* (New York: Verso, 2018).

29. Steven Strogatz, "One Giant Step for a Chess-Playing Machine," *New York Times*, December 26, 2018, https://www.nytimes.com/2018/12/26/science/chess-artificial-intelligence.html.

30. Fan Hui, quoted in Cade Metz, "How Google's AI Viewed the Move No Human Could Understand," *Wired*, March 14, 2016, https://www.wired.com/2016/03/googles-ai-viewed-move-no-human-understand/.

31. Jimmy Chou, quoted in Katherine J. Wu, "Artificial Intelligence Can Now Bet, Bluff, and Beat Poker Pros at Texas Hold 'Em," PBS.org, July 12, 2019, https://www.pbs.org/wgbh/nova/article/pluribus-texas-holdem.

32. In Yasunari Kawabata's elegiac 1951 novel, *The Master of Go*, which tells the story of changes in Japanese culture through the story of a single tournament between two Go masters of separate generations, the narrator relays the following: "Everything had become science and regulation. The road to advancement in rank, which controlled the life of a player, had become a meticulous point system. One conducted the battle only to win, and there was no margin for remembering the dignity and the fragrance of Go as an art." Yasunari Kawabata, *The Master of Go*, translated by Edward G. Seidensticker (Knopf: New York, 1972), 52.

33. Ben Davis, "Why Would Amazon Want to Buy Video-Game Livestreaming Site Twitch?" *New York*, August 25, 2014, https://www.vulture.com/2014/05/google-and-twitch-tv-video-game-live-streaming.html.

34. Nicholas A. Christakis, "How AI Will Rewire Us," *Atlantic* (April 2019), https://www.theatlantic.com/magazine/archive/2019/04/robots-human-relationships/583204.

35. Nora N. Khan, *Seeing, Naming, Knowing* (Columbus: Columbus College of Art and Design, 2019), 22.

Chapter 5: The Anarchist in the Network

1. John Perry Barlow, "A Declaration of Independence of Cyberspace," Electronic Frontier Foundation website, https://www.eff.org/cyberspace-independence.
2. Hakim Bey, *T.A.Z.: The Temporary Autonomous Zone, Ontological Anarchy, Poetic Terrorism* (New York: Autonomedia, 1991), 105.
3. Andrew Leonard, "Net's Pirate Sensibilities Thrive on TAZ," *Wired*, November 28, 1996, https://www.wired.com/1996/11/nets-pirate-sensibilities-thrive-on-taz.
4. Colin Lecher, "Massive Attack," *Wired*, April 14, 2017, https://www.theverge.com/2017/4/14/15293538/electronic-disturbance-theater-zapatista-tactical-floodnet-sit-in.
5. Anne-Marie Schleiner, "Countdown to Collective Insurgence: Cyberfeminism and Hacker Strategies," February 2002, http://opensorcery.net/countdown.html. Accessed March 6, 2021.
6. Tom Ough, "Anonymous: How the Guy Fawkes Mask Became an Icon of the Protest Movement," *Independent*, November 4, 2015, https://www.independent.co.uk/news/uk/home-news/anonymous-how-guy-fawkes-mask-became-icon-protest-movement-a6720831.html.
7. Marielle Ingram, "Contracirculation," *Real Life*, June 29, 2020, https://reallifemag.com/contracirculation.
8. Keeanga-Yamahtta Taylor, *From #BlackLivesMatter to Black Liberation* (Chicago: Haymarket, 2016), 228.
9. Jo Freeman, "The Tyranny of Structurelessness," accessed March 6, 2021, https://www.jofreeman.com/joreen/tyranny.htm.
10. Sarah Gordon, quoted in Vivian Gornick, *The Romance of American Communism* (New York: Verso Books, 2020), 110.
11. Vladimir Ilyich Lenin, *What Is to Be Done?: Burning Questions of Our Movement*, trans. Joe Fineberg and George Hanna, https://www.marxists.org/archive/lenin/works/1901/witbd/v.htm.
12. Leon Trotsky, *1905*, trans. Anya Bostock, https://www.marxists.org/archive/trotsky/1907/1905/ch07.htm.
13. "Newspaper Fact Sheet," Pew Research Center, July 9, 2019, https://www.journalism.org/fact-sheet/newspapers.
14. Hal Draper, *Karl Marx's Theory of Revolution, Vol. IV* (New York: Monthly Review Press, 1989), 108.
15. Astra Taylor, *The People's Platform: Taking Back Power and Culture in the Digital Age* (New York: Henry Holt and Company, 2014), 215.
16. The term "class" is a notoriously fuzzy concept. Here, I am specifically not referring to income, wealth, or education level but to the Marxist idea of class as relating to where one falls within the structure of capitalism. "Working class" is defined by selling one's labor power to a boss, whereas "middle class" is defined by being able to set the terms

of one's own labor (in other words, "being one's own boss"). The status of any particular job is dynamic and in flux, but it seems clear that social media "content producers" are close to artists and writers (classic petit-bourgeois categories), though some sell their creative labor directly to companies as employees, while others scale up to become substantial businesses of their own. See Davis, "Art and Class," *9.5 Theses on Art and Class.*

17. Yuanling Yuan and Josh Constine, "SignalFire's Creator Economy Market Map," SignalFire Blog, September 23, 2020, https://signalfire.com/blog /creator-economy.

18. Aaron Brooks, "Being an Influencer Is a Career Choice Not Just a Hobby," Talking Influence, August 13, 2019, https://talkinginfluence.com/2019 /08/13/being-an-influencer-is-a-career-choice-not-just-a-hobby/.

19. Neil Smith, *The New Urban Frontier: Gentrification and the Revanchist City* (New York: Routledge, 1991), 91.

20. Richard Barbrook and Andy Cameron, "The California Ideology," *Mute* 1, no. 3, (September 1, 1995), https://www.metamute.org/editorial/articles /californian-ideology.

21. Nicholas Carr, "Digital Sharecropping," Rough Type, December 19, 2006, http://www.roughtype.com/?p=634.

22. Zeynep Tufekci, *Twitter and Tear Gas: The Power and Fragility of Networked Protest* (New Haven: Yale University Press, 2017), 26.

23. Ibid., 77.

24. Zeynep Tufekci, interviewed by Bob Garfield, On the Media, January 26, 2018, https://www.wnycstudios.org/podcasts/otm/segments/power-protest.

25. Loretta Ross, "I'm a Black Feminist. I Think Call-Out Culture Is Toxic," *New York Times*, August 17, 2019, https://www.nytimes.com/2019/08/17 /opinion/sunday/cancel-culture-call-out.html.

26. Jo Freeman, "Trashing: The Dark Side of Sisterhood," JoFreeman.com, https://www.jofreeman.com/joreen/trashing.htm.

27. Ibid.

28. Vladimir Ilyich Lenin, *Left-Wing Communism: An Infantile Disorder*, trans. Julius Katzer, https://www.marxists.org/archive/lenin/works/1920/lwc /ch04.htm.

29. Ibid.

30. Ibid.

31. Ibid.

32. Ibid.

33. Mark Zuckerberg, quoted in "The Wired Interview: Facebook's Mark Zuckerberg," *Wired*, June 29, 2009, https://www.wired.com/2009/06 /mark-zuckerberg-speaks.

34. Yascha Mounk, "Can Liberal Democracy Survive Social Media?" *New York Review of Books*, April 30, 2018, https://www.nybooks.com/daily /2018/04/30/can-liberal-democracy-survive-social-media.

35. Richard Seymour, *The Twittering Machine* (New York: Verso Books, 2020), 171.

36. Ibid., 175.

37. Elle Reeve, quoted in Brian Stelter, "CNN's Elle Reeve: 'Donald Trump Plus the Internet Brings Extremism to the Masses,'" CNN Business, January 9, 2021, https://www.cnn.com/2021/01/09/media/elle-reeve-firsthand -account-riot/index.html.

38. Antonio Gramsci, quoted in Chris Bambury, "Gramsci on Spontaneity, Organisation and Leadership," Counterfire, August 30, 2012, https://www .counterfire.org/theory/79-gramsci/15990-gramsci-on-spontaneity -organisation-and-leadership.

39. Seymour, *The Twittering Machine*, 175.

40. Ibid., 195.

41. I'm not sympathetic to the official US Communist Party, with its Stalinist politics. Nevertheless, there are positive lessons to be learned from its history as a mass radical organization that focused on working-class struggle, and William Z. Foster's 1936 "Organizing Methods in the Steel Industry" is breathtaking in how broad its approach is, systematically thinking through how a workplace was connected to a community and mobilizing its various components as integral to what successful worker organizing meant. William Z. Foster, "Organizing Methods in the Steel Industry," Marxist Internet Archive, https://www.marxists.org/archive /foster/1936/10/organizing-methods-steel-industry/index.htm.

42. Nancy Fraser, writing of contemporary feminism, described a "two-dimensional approach" to gender justice, acknowledging different axes of struggle for "recognition" and "redistribution," but noting how questions of representation have been systematically privileged after "the cultural turn" in the academy. "Once centered on labor and violence, gender struggles have focused increasingly on identity and representation in recent years. The effect has been to subordinate social struggles to cultural struggles, the politics of redistribution to the politics of representation. That was not, once again, the original intention. It was assumed, rather, by cultural feminists and deconstructionists alike, that feminist cultural politics would synergize with struggles for social equality. But that assumption, too, has fallen prey to the zeitgeist. In 'the network society,' the feminist turn to recognition has dovetailed all too neatly with a hegemonic neoliberalism that wants nothing more than to repress socialist memory." Nancy Fraser, "Feminist Politics in the Age of Recognition: A Two-Dimensional Approach to Gender Justice," *Fortunes of Feminism: From State-Managed Capitalism to Neoliberal Crisis* (New York: Verso, 2013), 160.

Chapter 6: Cultural Appropriation and Cultural Materialism

1. Dana Schutz, interviewed by Brian Boucher, "Dana Schutz Responds to the Uproar Over Her Emmett Till Painting at the Whitney Biennial," Artnet News, March 23, 2017, https://news.artnet.com/art-world/dana -schutz-responds-to-the-uproar-over-her-emmett-till-painting-900674.
2. Hannah Black, quoted in Dayna Evans, "In an Open Letter, Artists Are Asking the Whitney to Take Down a Painting of Emmett Till," The Cut, March 21, 2017, https://www.thecut.com/2017/03/whitney-biennial -emmett-till-dana-schutz.html.
3. Jo Livingstone and Lovia Gyarkye, "The Case Against Dana Schutz," New Republic, March 22, 2017, https://newrepublic.com/article/141506/case -dana-schutz.
4. Coco Fusco, "Censorship, Not the Painting, Must Go: On Dana Schutz's Image of Emmett Till," Hyperallergic, March 27, 2017, https://hyperallergic .com/368290/censorship-not-the-painting-must-go-on-dana-schutzs-image -of-emmett-till.
5. Maurice Berger, "The Lasting Power of Emmett Till's Image," New York Times Lens blog, April 5, 2017, https://lens.blogs.nytimes. com/2017/04/05/controversy-contexts-using-emmett-tills-image/.
6. Benjamin Sutton, "Whoopi Weighs in on Emmett Till Painting as Schutz Storm Reaches Daytime TV," Hyperallergic, March 27, 2017, https://hy-perallergic.com/368242/whoopi-weighs-in-on-emmett-till-painting -as-schutz-storm-reaches-daytime-tv.
7. Zadie Smith, "Getting In and Out," Harper's, July 2017, https://harpers.org /archive/2017/07/getting-in-and-out.
8. Julia Halperin, "'Please Pull the Show': Dana Schutz Faces Renewed Protest Over Emmett Till Painting at ICA Boston," Artnet News, July 26, 2017, https://news.artnet.com/art-world/dana-schutzs-exhibition-at-the -ica-boston-faces-protest-1033961.
9. "A Community Response to ICA, Boston," quoted in Julia Halperin, "'Please Pull the Show.'"
10. Open Letter, quoted in Greg Cook, "Prestigious Artist Group Defends ICA Exhibit by Artist Behind Controversial Emmett Till Painting," WBUR, August 10, 2017, https://www.wbur.org/artery/2017/08/10 /dana-schutz.
11. Frank Camp, "Leftists Seek to Prevent White Painter From Paying Hom-age to Black Martyr," Daily Wire, July 31, 2017 https://www.dailywire.com /news/leftists-seek-prevent-white-painter-paying-homage-frank-camp.
12. Stephanie Gilmore, "Am I Troy Davis? A Slut?" Ms., October 11, 2011, https://msmagazine.com/2011/10/11/am-i-troy-davis-a-slut.
13. See Jen Marlowe and Martina Davis-Correia, I Am Troy Davis (Chicago: Haymarket Books, 2013).

14. In his book *Cultural Appropriation and the Arts*, philosopher James O. Young notes at least five separate types of action that are all thrown together under the concept "object appropriation," meaning the actual physical looting or theft of objects and artifacts; "content appropriation," meaning the reuse or borrowing of specific songs, stories, folklore, dances, and so on; "style appropriation," meaning creating new works meant to look as if they fit in some preexisting cultural genre; "motif appropriation," meaning the quotation or collaging of specific symbols or ideas; and "subject appropriation," involving an author or artist narrating, speaking from, or depicting a culture outside of their own direct experience. Even abstracted from the complexities of concrete cases, each of these five types of appropriation has different stakes and dynamics—but all are feeding into a single running discussion. James O. Young, *Cultural Appropriation and the Arts* (Hoboken: Wiley, 2010), 5-9.

15. Claire Lampen, "There's a New Rachel Dolezal," The Cut, September 9, 2020, https://www.thecut.com/2020/09/historian-jessica-krug-admits-to -posing-as-a-black-woman.html.

16. Jeff Yang, "The Shocking Viral Reaction to a Prom Dress," CNN.com, May 2, 2018, https://www.cnn.com/2018/05/02/opinions/the-shocking -viral-reaction-to-a-prom-dress-yang.

17. Nadra Nittle, "The Cultural Appropriation Debate Has Changed. But Is It for the Better?" *Vox*, December 18, 2018, https://www.vox.com/the -goods/2018/12/18/18146877/cultural-appropriation-awkwafina-bruno -mars-madonna-beyonce.

18. See Sara Luterman, "You Can't 'Culturally Appropriate' a Weighted Blanket," Slate.com, January 10, 2019, https://slate.com/human-interest /2019/01/weighted-blanket-appropriation-autism-controversy.html.

19. Pam Grossman, "Episode 64: Leila Taylor, Mistress of the Dark," *The Witch Wave* podcast, January 27, 2021, https://witchwavepodcast.com/episodes /2021/1/26/64-leila-taylor-mistress-of-the-dark.

20. Jo Freeman, "Say It With Buttons," *Ms.*, August 1974, https://www .jofreeman.com/buttons/saybuttons.htm.

21. Since solidarity and privilege are themes in this chapter, it's worth mentioning the third figure from the famous photo, white Australian runner Peter Norman. While Carlos and Smith gave the Black Power salute, Norman, the silver medalist finisher, wore a badge that said "Olympic Project for Human Rights" in solidarity with their cause. For the gesture, he suffered ostracization and official censure amid the backlash over the famous photo. Smith and Carlos were the lead pallbearers at his funeral in 2006. In 2012, Australian MPs proposed an official resolution apologizing "for the wrong done by Australia in failing to send him to the 1972 Munich Olympics, despite repeatedly qualifying; and belatedly recogniz[ing] the powerful role that Peter Norman played in furthering racial equality." See Dave Zirin, "Australian Government Will Issue Overdue Apology to

1968 Olympic Hero Peter Norman," *Nation,* August 19, 2012, https://www.thenation.com/article/archive/australian-government-will -issue-overdue-apology-1968-olympic-hero-peter-norman/.

22. Weedston erroneously claims that the Venus symbol with a fist was in use by Black feminists before Robin Morgan's design. This is not true. Nevertheless, the claim gained widespread traction. Lindsey Weedston, "Feminism and Cultural Appropriation," Sorry Not Sorry Feminism, November 20, 2014, http://www.notsorryfeminism.com/2014/11/feminism-and -cultural-appropriation.html.

23. Freeman, "Say It With Buttons."

24. Caroline Bird, "On Being Born Female," *Vital Speeches of the Day,* November 15, 1968, 90.

25. Bernice Johnson Reagon, "Coalition Politics: Turning the Century," *Home Girls: A Black Feminist Anthology,* ed. Barbara Smith (New Brunswick: Rutgers University Press, 2000), 350.

26. Angela Davis, "Black Nationalism: The Sixties and the Nineties," *Black Liberation and the American Dream: The Struggle for Racial and Economic Justice,* ed. Paul le Blanc (Chicago: Haymarket Books, 2017), 261.

27. "Cultural Appropriation," Know Your Meme, accessed March 7, 2021, https://knowyourmeme.com/memes/cultural-appropriation.

28. Ibid.

29. Stuart Hall, "Notes on Deconstructing 'The Popular,'" *Cultural Resistance Reader,* ed. Stephen Duncombe (New York: Verso Books, 2002), 187.

30. Lauren Michele Jackson, interviewed by Andy Boyd, "White Negroes: When Cornrows Were in Vogue . . . and Other Thoughts on Cultural Appropriation," New Books Network, August 19, 2020, https://newbooksnetwork .com/lauren-michele-jackson-white-negroes-when-cornrows-were-in-vogue -and-other-thoughts-on-cultural-appropriation-beacon-2019.

31. The Google Trends tool measures interest in a search term as a share of total searches, meaning the earlier and later measures are not directly numerically comparable.

32. See Patricia Bell Collins, "What's Going On? Black Feminist Thought and Postmodernism," *Fighting Words: Black Women and the Search for Justice* (Minneapolis: University of Minnesota Press, 1998).

33. See Chela Sandoval, *Methodology of the Oppressed* (Minneapolis: University of Minnesota Press, 2000).

34. bell hooks, "Postmodern Blackness," *Yearning: Race, Gender, and Cultural Politics* (New York: Taylor & Francis, 204), 24, 26.

35. Ibid., 27.

36. bell hooks, "Beyond Black Rage: Ending Racism," *Killing Rage: Ending Racism* (New York: Hold Paperbacks, 1996), 30.

37. Greg Tate, "Nigs R Us, or How Blackfolk Became Fetish Objects," *Everything But the Burden: What White People are Taking from Black Culture,* ed. Greg Tate (New York: Broadway Books, 2003), 10–11.

38. Bari Weiss, "Three Cheers for Cultural Appropriation," *New York Times*, August 30, 2017 https://www.nytimes.com/2017/08/30/opinion/cultural -appropriation.html.

39. Benedict Anderson, *Imagined Communities: Reflections on the Origin and Spread of Nationalism* (New York: Verso, 2016), 48.

40. The term derives from Raymond Williams's Marxist analysis of culture, as not an isolated object of consumption or contemplation but a material social activity rooted in collective experience: "a culture is a whole way of life, and the arts are part of a social organization which economic change clearly radically affects." The focus on collective experience was also meant to counter the moralism of the official Communist Party's take on culture in his day, which emphasized that existing capitalist culture needed to be rejected: "The Marxist interpretation of culture can never be accepted while it retains, as it need not retain, this directive element, this insistence that if you honestly want socialism you must write, think, learn in certain prescribed ways." Raymond Williams, "Culture Is Ordinary," *Resources of Hope: Culture, Democracy, Socialism* (New York: Verso, 1989), 95, 96.

41. "Latest Economic Data Tracks Arts and Cultural Jobs per State," National Endowment for the Arts, April 19, 2017, https://www.arts.gov/about /news/2017/latest-economic-data-tracks-arts-and-cultural-jobs-state.

42. See Richard Florida, *The Rise of the Creative Class: And How It's Transforming Work, Leisure, Community, and Everyday Life* (New York: Basic Books, 2012).

43. Boots Riley, interviewed by Kevin Coval, "Introduction: Music and Struggle," *Tell Homeland Security—We Are the Bomb* (Chicago: Haymarket Books, 2015), 13.

44. Marc de Swaan Arons, "How Brands Were Born: A Brief History of Modern Marketing," *Atlantic*, October 3, 2011, https://www.theatlantic .com/business/archive/2011/10/how-brands-were-born-a-brief-history-of -modern-marketing/246012/.

45. Michael Bierut, interviewed on "Negative Space: Logo Design with Michael Bierut," *99% Invisible* podcast, March 14, 2017, https://99percentinvisible .org/episode/negative-space-logo-design-michael-bierut.

46. Fredric Jameson, *Postmodernism, Or, The Cultural Logic of Late Capitalism* (Durham: Duke University Press, 1991), 4.

47. Martin Roberts, "Notes on the Global Underground," *The Subcultures Reader*, ed. Ken Gelder (New York: Routledge, 2005), 579.

48. Elizabeth L. Cline, *Overdressed: The Shockingly High Cost of Cheap Fashion* (New York: Penguin Portfolio, 2012), 103.

49. Adrienne Keene, "It Starts With a Trip to Urban Outfitters," Native Appropriation, January 15, 2015, https://nativeappropriations.com/2010/01 /it-starts-with-a-trip-to-urban-outfitters.html.

50. Adrienne Keene, "More Tribal Fashion: Gap 'Navajo Tracker Hat'," Native Appropriations, January 19, 2010, https://nativeappropriations.com /2010/01/more-tribal-fashion-gap-navajo-tracker-hat.html.

51. Adrienne Keene, "'Tribal Fashion': The Newest Trend?" Native Appropriations, January 18, 2010, https://nativeappropriations.com/2010/01/tribal-fashion-the-newest-trend.htmll.

52. Adrienne Keene, "The Benefits of Cultural 'Sharing' Are Usually One-Sided," *New York Times*, August 4, 2015, https://www.nytimes.com/roomfordebate/2015/08/04/whose-culture-is-it-anyhow/the-benefits-of-cultural-sharing-are-usually-one-sided.

53. Siva Vaidhyanathan, *Intellectual Property: A Very Short Introduction* (Oxford: Oxford University Press, 2017), 98.

54. K. J. Greene, "Intellectual Property at the Intersection of Race and Gender: Lady Sings the Blues," *American University Journal of Gender, Social Policy and the Law* 16, no. 3 (2008): 369.

55. Greene, "Intellectual Property at the Intersection of Race and Gender," 385.

56. Jennie D. Woltz, "The Economics of Cultural Misrepresentation: How Should the Indian Arts and Crafts Act of 1990 Be Marketed?" *Fordham Intellectual Property, Media and Entertainment Law Journal* 17, no. 2 (2006): 445.

57. Woltz, "The Economics of Cultural Misrepresentation," 447.

58. Ellis Cashmore, *The Black Culture Industry* (London: Routledge, 2006), 177.

59. Daymond John, *Display of Power: How FUBU Changed a World of Fashion, Branding and Lifestyle* (Nashville: Naked Ink, 2006), 79.

60. Steve Stoute, *The Tanning of America: How Hip-Hop Created a Culture That Rewrote the Rules of the New Economy* (New York: Gotham Books, 2012), xxv.

61. Chang, *Who We Be*, 233–34.

62. "It has been evident for several years that the financial realities of the web are not friendly to news entities, whether legacy or digital only. There is money being made on the web, just not by news organizations. Total digital ad spending grew another 20% in 2015 to about $60 billion, a higher growth rate than was reported in Amy Mitchell, Jesse Holcomb, and Rachel Weisel, "State of the News Media 2016," Pew Research Center, June 15, 2016, 6, https://assets.pewresearch.org/wp-content/uploads/sites/13/2016/06/30143308/state-of-the-news-media-report-2016-final.pdf 2013 and 2014. But journalism organizations have not been the primary beneficiaries.

63. Jaron Lanier, quoted in Eric Allen Been, "Jaron Lanier Wants to Build a New Middle Class on Micropayments," Nieman Lab, May 22, 2013, https://www.niemanlab.org/2013/05/jaron-lanier-wants-to-build-a-new-middle-class-on-micropayments/.

64. Kelsey Sutton and Peter Sterne, "The Fall of Salon.com," *Politico*, May 27, 2016, https://www.politico.com/media/story/2016/05/the-fall-of-salon.com-004551.

65. Adrianne Jeffries, "Mic's Drop," August 22, 2017, *The Outline*, https://theoutline.com/post/2156/mic-com-and-the-cynicism-of-modern-media?zd=1&zi=mjzga5so.

66. Jay Caspian Kang, quoted in Shaun Scott, "Woke Pop-Culture Criticism Is Supposed to Spur Us to Political Action. It's Paralyzing Us Instead," Quartz, June 21, 2017, https://qz.com/1011233/woke-pop-culture-criticism-is -supposed-to-spur-us-to-political-action-its-paralyzing-us-instead.

67. Jeffries, "Mic's Drop."

68. Ibid.

69. Ursula Huws, *Labor in the Global Digital Economy: The Cybertariat Comes of Age* (New York: Monthly Review Press, 2014), 83.

70. Bill Keller, quoted in Tim Wu, *The Attention Merchant: The Epic Scramble to Get Inside Our Heads* (New York: Vintage Books, 2017), 284.

71. See Kat Stoeffel, "Twitter, Rape, and Privacy on Social Media," The Cut, March 14, 2014, https://www.thecut.com/2014/03/twitter-rape-and -privacy-on-social-media.html.

72. "Those who advocate against cultural appropriation often assume the defi- nition of this term to be self-evident; those who disparage the formulation make it into something ridiculous," Richard Fung, "Working Through Appropriation," *Fuse* 15, no. 5–6 (Summer 1993), reprinted at http://www .richardfung.ca/index.php?/articles/working-through-appropriation-1993.

73. For a philosophically rich account of what is at stake in discussion of Blackness and meme culture, artist Aria Dean's "Rich Meme, Poor Meme" is fundamental: "But in the online attention economy, this imbalance is more complicated than the familiar, semi-linear relationship between black production and nonblack appropriation. The labor of online content pro- duction is done with hopes of an audience in mind; memes are created for the very purpose of virality and, by extension, appropriation. Memes move in cycles of production, appropriation, consumption, and reappropriation that render any idea of a pre-existing authentic collective being hard to pin down. . . . Likewise, memes—even when produced by black users—cannot be viewed as objects that once authentically circulated in black circles for the enjoyment of the black collective but instead are always already com- promised by the looming presence of the corporate, the capitalist." Aria Dean, "Rich Meme, Poor Meme" *Real Life*, July 25, 2016, https:// reallifemag.com/poor-meme-rich-meme.

74. André Brock, "From the Blackhand Side: Twitter as a Cultural Conver- sation," *Journal of Broadcasting & Electronic Media* 56, no. 4 (December 2012): 545.

75. Paul Hodkinson, *Goth: Identity, Style and Subculture* (Oxford: Berg Pub- lishers, 2002), 26.

76. See Lisa Nakamura, *Cybertypes: Race, Ethnicity, and Identity on the Internet* (New York: Routledge, 2013).

77. See Aisha Harris, "Who Coined the Term 'Catfish'?" Slate.com, January 18, 2013, https://slate.com/culture/2013/01/catfish-meaning-and-definition -term-for-online-hoaxes-has-a-surprisingly-long-history.html.

78. See Roisin Kiberd, "4chan's Frog Meme Went Mainstream, So They Tried

to Kill It," Vice.com, April 9, 2015, https://www.vice.com/en/article /vvbjbx/4chans-frog-meme-went-mainstream-so-they-tried-to-kill-it.

79. Mark Zuckerberg quoted in "The Wired Interview: Facebook's Mark Zuckerberg," *Wired*, June 29, 2009, https://www.wired.com/2009/06 /mark-zuckerberg-speaks.

80. Doreen St. Felix, "Black Teens Are Breaking the Internet and Seeing None of the Profits," *The Fader*, http://www.thefader.com/2015/12/03/on-fleek -peaches-monroee-meechie-viral-vines.

81. Darrin Kellaris, quoted in Garett Sloane, "Are Brands on Fleek With Slangy Tweets? IHOP Explains Its Hip New Voice," *AdAge*, October 23, 2014, https://www.adweek.com/digital/whos-behind-these-crazy-ihop -tweets-160955.

82. Jalaiah Harmon, quoted in Taylor Lorenz, "The Original Renegade," *New York Times*, February 13, 2020, https://www.nytimes.com/2020/02/13 /style/the-original-renegade.html.

83. Monnica Williams, interviewed by Jenna Wortham, "Racism's Psychological Toll," *New York Times*, June 24, 2015, https://www.nytimes.com /2015/06/24/magazine/racisms-psychological-toll.html.

84. April Reign, "Why I Will Not Share the Video of Alton Sterling's Death," *Washington Post*, July 6, 2016, https://www.washingtonpost.com /posteverything/wp/2016/07/06/why-i-will-not-share-the-video-of -alton-sterlings-death.

85. "Better Ed Criticized for Appropriating #Blacklivesmatter Hashtag, Black Fist," Fox 9 Minneapolis-St. Paul, March 12, 2015, https://www.fox9.com /news/better-ed-criticized-for-appropriating-blacklivesmatter-hashtag -black-fist.

86. See Keeanga-Yamahtta Taylor, *From #BlackLivesMatter to Black Liberation* (Chicago: Haymarket Books, 2016), 186–87.

87. See the essays in *Borrowed Power: Essays on Cultural Appropriation* (eds. Bruce H. Ziff, Pratima V. Rao), and Kelly Bondy Cusinato, *The Voice Appropriation Controversy in the Context of Canadian Cultural Practices*, http://www.collectionscanada.gc.ca/obj/s4/f2/dsk3/ftp04/mq30884.pdf.

88. Shuja Haider, "Safety Pins and Swastikas," *Jacobin*, January 5, 2017, https://www.jacobinmag.com/2017/01/safety-pin-box-richard-spencer -neo-nazis-alt-right-identity-politics.

89. Rosemary J. Coombe, "The Properties of Culture and the Possession of Identity," *Borrowed Power*, 75.

90. Yasmeen Abu-Laban and Daiva Stasiulis, "Ethnic Pluralism under Siege: Popular and Partisan Opposition to Multiculturalism," *Canadian Public Policy/Analyse de Politiques* 18, no. 4 (December, 1992): 365–86.

91. Kogila Moodley, quoted in Abu-Laban and Stasiulis, "Ethnic Pluralism under Siege: Popular and Partisan Opposition to Multiculturalism," 368.

92. Lenore Keeshig-Tobias, "Stop Stealing Native Stories," *Borrowed Power*, 73.

93. Erica Frankenberg, Jongyeon Ee, Jennifer B. Ayscue, and Gary Orfield,

quoted in P. R. Lockhart, "65 Years After Brown vs. Board of Education, School Segregation Is Getting Worse," Vox, May 10, 2019, https://www.vox.com/identities/2019/5/10/18566052/school-segregation-brown-board-education-report.

94. Tate, *Everything but the Burden*, 12.
95. Vann R. Newkirk II, "The Dream That Never Was: Black Millennials and the Promise of Obama," Gawker.com, December 1, 2014, https://gawker.com/the-dream-that-never-was-black-millennials-and-the-pro-1663448708.
96. Ibid.
97. Derecka Purnell, "The George Floyd Act Wouldn't Have Saved George Floyd's Life. That Says It All," *Guardian*, March 4, 2021, https://www.theguardian.com/commentisfree/2021/mar/04/the-george-floyd-act-wouldnt-have-saved-george-floyds-life-thats-says-it-all.
98. Doreen St. Felix, "The Embarrassment of Democrats Wearing Kente-Cloth Stoles," *New Yorker*, June 9, 2020, https://www.newyorker.com/culture/on-and-off-the-avenue/the-embarrassment-of-democrats-wearing-kente-cloth-stoles.
99. Fung, "Working Through Appropriation."
100. See Tara Houska, interviewed by Amy Goodman and Juan González, "Water Protectors Lock Their Bodies to Machines to Stop Dakota Access Pipeline Construction," *Democracy Now!*, September 7, 2016, https://www.democracynow.org/2016/9/7/water_protectors_lock_their_bodies_to.
101. "Frequently Asked Questions," Sacred Stone Camp website, accessed March 7, 2021, https://www.sacredstonecamp.org/faq/.
102. See Erin McCann, "Judge Rejects Riot Charge Against Amy Goodman of 'Democracy Now' Over Pipeline Protest," *New York Times*, October 17, 2016, https://www.nytimes.com/2016/10/18/us/judge-rejects-riot-charge-against-amy-goodman-of-democracy-now-over-pipeline-protest.html.
103. John Anderson, "'Respect the Feathers': Who Tells Standing Rock's Story?" *New York Times*, December 16, 2016, https://www.nytimes.com/2016/12/16/movies/standing-rock-sioux-tribe-filmmakers.html.
104. Roisin O'Connor, "Standing Rock: North Dakota Access Pipeline Demonstrators Say White People Are 'Treating Protest Like Burning Man,'" *Independent*, November 28, 2016, https://www.independent.co.uk/arts-entertainment/music/news/standing-rock-north-dakota-access-pipeline-burning-man-festival-a7443266.html.
105. Jay Willis, "Dear Fellow White People: Standing Rock Isn't Goddamn Burning Man," GQ.com, November 29, 2016, https://www.gq.com/story/standing-rock-burning-man.
106. Sandra Song, "White People Are Reportedly Treating the #NoDAPL Protests Like Burning Man," *Paper*, November 28, 2016, https://www.papermag.com/white-people-are-reportedly-treating-the-nodapl-protests-like-burning--2118455614.html.

107. Chris White, "White Hippies Descend on Standing Rock Protest, Treat It Like Burning Man," Daily Caller, November 28, 2016, https://dailycaller.com /2016/11/28/white-hippies-descend-on-standing-rock-protest-treat-it -like-burning-man.

108. Valerie Richardson, "Complaints Grow Over Whites Turning Dakota Access Protest Into Hippie Festival," *Washington Times*, November 28, 2016, https://www.washingtontimes.com/news/2016/nov/28/complaints -whites-co-opting-dakota-access-protest.

109. John Moll, interviewed in "Despite Protests, Dakota Access Pipeline Nears Completion," PBS.org, March 1, 2017, https://www.pbs.org/newshour /show/despite-protests-dakota-access-pipeline-nears-completion-2.

110. Nick Estes, *Our History Is the Future: Standing Rock versus the Dakota Access Pipeline, and the Long Tradition of Indigenous Resistance* (New York: Verso Books, 2019), 6–7.

111. See Christopher Breedlove, "From Black Rock to Standing Rock," The Burning Man Journal, December 6, 2016, https://journal.burningman. org/2016/12/global-network/burners-without-borders/from-black-rock -to-standing-rock.

112. Michael Edison Hayden, Catharine Thorbecke, and Evan Simon, "At Least 2,000 Veterans Arrive at Standing Rock to Protest Dakota Pipeline," ABC News, December 4, 2016, https://abcnews.go.com/US/2000-veterans -arrive-standing-rock-protest-dakota-pipeline/story?id=43964136.

113. See Alleen Brown, Will Parrish, Alice Speri, "Leaked Documents Reveal Counterterrorism Tactics Used at Standing Rock to 'Defeat Pipeline Insurgencies,'" *Intercept*, May 27, 2017, https://theintercept.com /2017/05/27/leaked-documents-reveal-security-firms-counterterrorism -tactics-at-standing-rock-to-defeat-pipeline-insurgencies.

114. Estes, *Our History Is the Future*, 3.

Chapter 7: The Mirror of Conspiracy

1. Benjamin Lee, "Marina Abramović Mention in Podesta Emails Sparks Accusations of Satanism," *Guardian*, November 4, 2016, https://www .theguardian.com/artanddesign/2016/nov/04/marina-abramovic -podesta-clinton-emails-satanism-accusations.

2. Anna Palmer and Theodoric Meyer, "The Sudden Fall of Washington's Ultimate Power Broker," *Politico*, October 30, 2017, https://www.politico .com/story/2017/10/30/tony-podesta-mueller-power-broker-244341.

3. Jessica Dawson, "Married, With Art," *Washington Post*, September 23, 2004, https://www.washingtonpost.com/archive/lifestyle/2004/09/23 /married-with-art/dee9a0d0-0f0d-4505-b0ef-2f0e1bd1e0e0.

4. Ibid.

5. Laura Wainman, "Inside Homes: Private Viewing," *Washington Life Maga-*

zine, June 5, 2015., https://washingtonlife.com/2015/06/05 /inside-homes-private-viewing.

6. See Alex Marshall, "Marina Abramovic Just Wants Conspiracy Theorists to Let Her Be," *New York Times*, April 21, 2020, https://www.nytimes.com /2020/04/21/arts/design/marina-abramovic-satanist-conspiracy-theory.html.

7. Ryan Grim, "Is QAnon the Future of the Republican Party?" *Intercept*, August 28, 2020, https://theintercept.com/2020/08/28/is-qanon-the -future-of-the-republican-party.

8. See Theodore Roosevelt, "A Layman's Views of an Art Exhibition," *Outlook*, 103 (March 29, 1913): 718–20. Reprinted in Roderick Nash, ed., *The Call of the Wild (1900–1916)* (New York: George Braziller, 1970).

9. Allan Antliff, *Anarchy and Art: From the Paris Commune to the Fall of the Berlin Wall* (Vancouver: Arsenal Pulp Press, 2007), 63.

10. Jamie Ballard, "45% of Americans Believe That Ghosts and Demons Exist," YouGov.com, October 29, 2019, https://today.yougov.com/topics/lifestyle /articles-reports/2019/10/21/paranormal-beliefs-ghosts-demons-poll.

11. Rosalind Krauss, letter to the editor, *New York Times*, January 27, 2021, https://www.nytimes.com/2021/01/27/opinion/letters/mypillow-capitol -riot.html#link-f95d46b.

12. Adrienne LaFrance, "The Prophecies of Q," *Atlantic*, June 2020, https://www.theatlantic.com/magazine/archive/2020/06/qanon-nothing -can-stop-what-is-coming/610567.

13. Ibid.

14. Mike Kelley, interviewed by John Miller, "Mike Kelley by John Miller," *Bomb*, January 1, 1992, https://bombmagazine.org/articles/mike-kelley/.

15. Fredric Jameson, *The Geopolitical Aesthetic: Cinema and Space in the World System* (Bloomington: Indiana University Press, 1995), 9.

16. Mike Jay, "The Reality Show," *Aeon*, August 23, 2013, https://aeon.co /essays/a-culture-of-hyper-reality-made-paranoid-delusions-true.

17. See Chris Lehmann, "What Richard Hofstadter Got Wrong," *New Republic*, April 16, 2020, https://newrepublic.com/article/157190/richard -hofstadter-got-wrong-paranoid-style-reissue-review.

18. See Eve Kosofsky Sedgwick, "Paranoid Reading and Reparative Reading, or You're So Vain You Probably Think This Essay Is About You," *Touching Feeling: Affect, Pedagogy, Performativity* (Durham: Duke University Press, 2003), 123–51.

19. Richard Hofstadter, *The Paranoid Style in American Politics* (New York: Knopf Doubleday, 2012), 39.

20. See John Cassidy, "Is America an Oligarchy?" *New Yorker*, April 18, 2014, https://www.newyorker.com/news/john-cassidy/is-america-an-oligarchy.

21. Joseph E. Uscinski and Joseph M. Parent, *American Conspiracy Theories* (Oxford: Oxford University Press, 2014), 132.

22. Ben Davis, "The Perplexingly Popular Conspiracy Theory That 'Salvator Mundi' Is Connected to #Russiagate, Explained," Artnet News, January 9,

2019, https://news.artnet.com/opinion/debunking-the-perplexingly
-popular-conspiracy-theory-that-salvator-mundi-is-connected-to
-russiagate-1434352?artnet-logout-redirect=1.

23. "Combining our findings, conspiracy theorists differ substantially from
their stereotypes. They are less wealthy, less politically engaged, less con-
servative, less white, and less likely to be male than perceptions suggest."
Uscinski and Parent, *American Conspiracy Theories*, 102.

24. Ibid, 93.

25. Specifically, the "conspiracy dimension" is a composite of respondents'
agreement with three statements: "Much of our lives are being controlled
by plots hatched in secret places"; "Even though we live in a democracy, a
few people will always run things anyway"; and "the people who really 'run'
the country are not known to the voters." Ibid., 79.

26. Ibid., 103.

27. During the Bush years, Republicans scoring high on the conspiracy
dimension were much more likely to be against the Iraq war. During the
Obama years, Democrats with high conspiracy dimension scores were
more against the Afghanistan war. See ibid., 93–94.

28. George Carlin, *Life Is Worth Losing*, directed by Rocco Urbisci, HBO (2005).

29. Ibid.

30. See Jan-Willem van Prooijen, Karen M. Douglas, and Clara De Inocencio,
"Connecting the Dots: Illusory Pattern Perception Predicts Belief in Con-
spiracies and the Supernatural," *European Journal of Social Psychology* 48, no.
3 (2018): 320–35.

31. See Ben Davis, "Duchamp Did Not Invent the Readymade. In Fact, It
May Have Been the First Human Art Form," Artnet News, April 19,
2018, https://news.artnet.com/exhibitions/first-sculpture-makapansgat-
pebble-1269056.

32. Peter Bebergal, "Reimagining a Shadowy Medieval Brotherhood That
Probably Didn't Exist," *New Yorker*, October 23, 2016, https://www
.newyorker.com/books/page-turner/reimagining-a-shadowy-medieval
-brotherhood-that-probably-didnt-exist.

33. Sophia Smith Galer, "The Accidental Invention of the Illuminati Conspir-
acy," BBC.com, July 11, 2020, https://www.bbc.com/future/article
/20170809-the-accidental-invention-of-the-illuminati-conspiracy.

34. Benjamin Frisch and Willa Paskin, "How Do You Start a Conspiracy
Theory?" Slate.com, October 29, 2018, https://slate.com/culture/2018/10
/ongs-hat-conspiracy-theories-decoder-ring.html.

35. Travis L. Gosa, "Counterknowledge, Racial Paranoia, and the Cultic Milieu:
Decoding Hip Hop Conspiracy Theory," *Poetics* 39, no. 3 (June 2011): 191.

36. Ibid.

37. Ibid., 195.

38. Pelton was, among other things, inspired by the Agni Yoga doctrine of
early twentieth-century spiritualists Helena and Nikolai Roerich. Helena

believed she had received secret, messianic wisdom via séance that became the foundation for their teachings. Nikolai was a painter and set designer (he did the scenography for Stravinsky's *Rite of Spring*), who was also an adventurer and mystic. Together they preached a coming "age of fire" and travelled Asia advocating for uniting a large swath of the continent into a "Second Union of the East." His association with Henry Wallace, FDR's vice president and the ultimate New Deal true believer, touched off a political scandal when foes leaked his adoring correspondence with the guru to the public, helping sink his left-wing Progressive Party challenge to Truman in 1948—a distant precursor of the #SpiritCooking scandal in 2016. See Mitch Horowitz, *Occult America: White House Seances, Ouija Circles, Masons, and the Secret Mystic History of Our Nation* (New York: Bantam Books, 2010), 164–91.

39. Sam Dean, "Astrology App Set to Shake up 'Mystical Services Sector,'" *Los Angeles Times*, March 20, 2019, https://www.latimes.com/business /technology/la-fi-tn-sanctuary-astrology-venture-20190320-story.html.

40. Eleanor Heartney, "Spirituality Has Long Been Erased From Art History. Here's Why It's Having a Resurgence Today," Artnet News, January 6, 2020, https://news.artnet.com/art-world/spirituality-and-art-resurgence -1737117.

41. See Claire Gecewitz, "'New Age' Beliefs Common among Both Religious and Nonreligious Americans," Pew Research Center, October 1, 2018, https://www.pewresearch.org/fact-tank/2018/10/01/new-age-beliefs -common-among-both-religious-and-nonreligious-americans.

42. Linda Rodriguez McRobbie, "How Are Horoscopes Still a Thing?" *Smithsonian Magazine*, January 5, 2016, https://www.smithsonianmag.com /history/how-are-horoscopes-still-thing-180957701.

43. William Grimes, "Starman," *New York Times*, September 15, 1991, https://www.nytimes.com/1991/09/15/magazine/starman.html.

44. Christine Smallwood, "Astrology in the Age of Uncertainty," *New Yorker*, October 21, 2019, https://www.newyorker.com/magazine/2019/10/28 /astrology-in-the-age-of-uncertainty.

45. Ibid.

46. Julie Coleman, "Business Is Booming for NYC Psychics Amid COVID-19 Pandemic," *New York Post*, August 9, 2020, https://nypost.com/2020/08 /09/business-is-booming-for-nyc-psychics-amid-coronavirus-pandemic/.

47. Charlotte Ward and David Voas, "The Emergence of Conspirituality," *Journal of Contemporary Religion* 26, no. 1 (January 2011): 103–21.

48. LaFrance, "The Prophecies of Q."

49. Hugh B. Urban, *Zorba the Buddha: Sex, Spirituality, and Capitalism in the Global Osho Movement* (Berkeley: University of California Press, 2016), 182.

50. Terry Eagleton, *Ideology: An Introduction* (New York: Verso Books, 1991), xiv.

51. Joseph E. Uscinski, quoted in Joe Pinsker, "If Someone Shares the 'Plandemic' Video, How Should You Respond?" *Atlantic*, May 9, 2020,

https://www.theatlantic.com/family/archive/2020/05/plandemic-video
-what-to-say-conspiracy/611464.

52. M. R. X. Dentith, "Debunking Conspiracy Theories," *Synthese*, May 14, 2020, https://doi.org/10.1007/s11229-020-02694-0.

53. Emmet Penney, "Lectureporn: The Vulgar Art of Liberal Narcissism," *Paste*, June 26, 2017, https://www.pastemagazine.com/politics/liberals/lectureporn-the-vulgar-art-of-liberal-narcissism.

54. Kaleigh Rogers, "Why It's So Hard To Gauge Support for QAnon," FiveThirtyEight.com, June 11, 2021, https://fivethirtyeight.com/features/why-its-so-hard-to-gauge-support-for-qanon.

55. Arnaud Gagneur and Karin Tamerius, "Your Friend Doesn't Want the Vaccine. What do You Say?" *New York Times*, May 20, 2021, https://www.nytimes.com/interactive/2021/05/20/opinion/covid-19-vaccine-chatbot.html.

56. Daniel J. Clark, director, *Behind the Curve*, Delta-v Productions, 2018, https://www.netflix.com/title/81015076..

57. Kevin Roose, "The Making of a YouTube Radical," *New York Times*, June 8, 2019, https://www.nytimes.com/interactive/2019/06/08/technology/youtube-radical.html.

58. Kevin Roose, "Three: Mirror Image," *Rabbit Hole*, podcast audio, April 30, 2020, https://www.nytimes.com/2020/04/30/podcasts/rabbit-hole-internet-youtube-virus.html.

59. Ibid.

60. Joshua Citarella, "Marxist Memes for TikTok Teens: Can the Internet Radicalize Teenagers for the Left?" *Guardian*, September 12, 2020, https://www.theguardian.com/commentisfree/2020/sep/12/marxist-memes-tiktok-teens-radical-left.

61. Joshua Citarella, "Mimetic Tactics: The Slow Red Pill," Do Not Research, July 14, 2021, https://donotresearch.net/posts/memetic-tactics-the-slow-red-pill.

62. Following the January 6 Capitol attack, the *New York Times* ran a feature on Lenka Perron, a suburban Detroit woman who became an ardent QAnon supporter. Perron had started out as a Bernie Sanders supporter in 2016, and found the Pizzagate conspiracy through the WikiLeaks dump of Clinton's emails. "She felt that the news media was barely covering [Sanders]. Then he lost the 2016 primary. When she began reading through leaked emails that fall, it looked to her like the party establishment had conspired to block him." What is galling about this framing ("she felt that . . .") is that even the *Times's* own public editor (and much independent research) said that the *Times* treated Sanders in an unfair way, when it covered him at all, quite rightly suggesting to his supporters that there was a media conspiracy to marginalize him (even as fringe candidate Donald Trump received truly massive coverage at the other margin): "The tone of some stories is regrettably dismissive, even mocking at times. Some of that is focused on

the candidate's age, appearance and style, rather than what he has to say."
See Sabrina Tavernise, "'Trump Just Used Us and Our Fear': One Woman's
Journey Out of QAnon," *New York Times*, January 29, 2021, https://www
.nytimes.com/2021/01/29/us/leaving-qanon-conspiracy.html; and Marga-
ret Sullivan, "Has The Times Dismissed Bernie Sanders?" *New York Times*,
September 9, 2015, https://publiceditor.blogs.nytimes.com/2015/09/09
/has-the-times-dismissed-bernie-sanders.

63. Kevin Roose, "The Making of a YouTube Radical."
64. In the very different world of religion, Cornell West long ago pointed out
how, in their relationship to Black liberation theology, even progressive,
non-Stalinist Marxists' belief that they had the scientific theory that made
social change possible inhibited them from forming the kind of alliances
that could actually make social change possible: "The primary aim of this
encounter is to change the world, not each others' faith." Cornell West,
Prophecy Deliverance!: An Afro-American Revolutionary Christianity (Louis-
ville: Westminster John Knox Press, 2002), 107.

Chapter 8: Art and Ecotopia

1. Bill McKibben, "What the Warming World Needs Now Is Art, Sweet Art,"
Grist.com, April 22, 2005, https://grist.org/article/mckibben-imagine.
2. Rugilė Barzdžiukaitė, Vaiva Grainytė, and Lina Lapelytė, "3D Sister's
Song" lyrics, posted at Bandcamp.com, released April 30, 2019,
https://sunandsea.bandcamp.com/track/3d-sisters-song.
3. I've argued that you can see a buried thread linking the advent of contem-
porary art itself, as a genre, and intensifying environmental stress. Scholars
usually date the latter in the United States to the publication of Rachel
Carson's exposé on the effects of pesticides, *Silent Spring*, in 1962. The
same year is a particularly transformative one for US art, when both Andy
Warhol and Robert Rauschenberg began incorporating photos directly
into their compositions, marking the breakdown of traditional categories
of art and media. The insurgent styles of pop art, minimalism, and concep-
tual art all coalesced into a new mainstream over the course of the decade.
Viewing these movements in retrospect against the concerns of early en-
vironmentalism, you can think of these bedrock "contemporary art" styles
as side effects of the newly unavoidable preponderance of the artificial
world: pop art aestheticized the overwhelming presence of advertising and
consumer culture; minimalism the industrial and the machine-made; con-
ceptualism the new insinuation of information and media into everyday
life. See Ben Davis, "Art and the Ecological," *Miami Rail* (Summer 2015),
https://miamirail.org/summer-2015/art-and-the-ecological.
4. Xavier Cordada, "Re-purpose Your Campaign Signs to Make a Politi-
cal Statement about Sea Level Rise," *Miami Herald*, November 6, 2018,

 https://www.miamiherald.com/opinion/op-ed/article221222205.html.
5. Katey Burak and Rob Higgs, "Act Now – Our House Is Flooding," Ex-
 tinctionRebellion.uk, November 10, 2019, https://extinctionrebellion
 .uk/2019/11/10/act-now-our-house-is-flooding.
6. Shore Club (@shoreclubsouthbeach), "About. Last. Night . . . ," Decem-
 ber 3, 2019, https://www.instagram.com/p/B5nuq4QA40t/.
7. See Saffron O'Neill and Sophie Nicholson-Cole, "'Fear Won't Do It': Pro-
 moting Positive Engagement with Climate Change Through Visual and Icon-
 ic Representations," *Science Communication* 30, no. 3 (January 2009): 355–79.
8. Elizabeth Straughan and Harriet Hawkins, *Geographical Aesthetics: Imagin-
 ing Space, Staging Encounters* (New York: Routledge, 2015), 207.
9. Francis Anderton, quoted in Carolina A. Miranda, "'Sink or Swim': L.A.
 photo show looks at how design responds to disaster," *Los Angeles Times*,
 April 7, 2015, https://www.latimes.com/entertainment/arts/miranda/la
 -et-cam-sink-or-swim-la-photo-show-20150406-column.html.
10. Anand Giridharadas, *Winners Take All: The Elite Charade of Changing the
 World* (New York: Vintage, 2019), 87–128.
11. "Summary for Policymakers of IPCC Special Report on Global Warming
 of 1.5°C Approved by Governments," Intergovernmental Panel on Climate
 Change, October 8, 2018, https://www.ipcc.ch/2018/10/08/summary-for
 -policymakers-of-ipcc-special-report-on-global-warming-of-1-5c
 -approved-by-governments.
12. Naomi Klein, *This Changes Everything: Capitalism vs. the Climate* (New
 York: Simon & Schuster, 2014), 59.
13. Sarah Resnick, "A Note on the Long Tomorrow," Triple Canopy, May 14,
 2015, https://www.canopycanopycanopy.com/contents/a-note-on-the
 -long-tomorrow.
14. Adam Jewell, quoted in David Ingram, "A Good Time to Live on the
 Ocean? 'Seasteaders' Double Down during Pandemic," NBC News, June
 17, 2020, https://www.nbcnews.com/tech/tech-news/good-time-live
 -ocean-seasteaders-double-down-during-pandemic-n1231293.
15. Karl Marx and Friedrich Engels, *Manifesto of the Communist Party*, trans.
 Samuel Moore (Moscow: Progress Publishers, 1969), https://www.marxists
 .org/archive/marx/works/1848/communist-manifesto/ch03.htm.
16. E. P. Thompson, *William Morris: Romantic to Revolutionary* (Oakland: PM
 Press, 2011), 790.
17. Helen Harrison and Newton Harrison, "Peninsula Europe IV," Center for
 the Study of the Force Majeure, http://www.centerforforcemajeure.org
 /peninsula-europe.
18. Kodwo Eshun, "Further Considerations on Afrofuturism," *CR: The New
 Centennial Review* 3, no. 2 (Summer 2003): 295.
19. See Nellie Payton, "Future or Fantasy? Senegal Questions 'Akon City,'"
 Reuters, December 14, 2020, https://news.trust.org/item
 /20201214051133-ojymr.

20. Martine Syms, "The Mundane Afrofuturist Manifesto," Rhizome.org, December 17, 2013, https://rhizome.org/editorial/2013/dec/17/mundane-afrofuturist-manifesto.

21. Kate Aronoff, Alyssa Battistoni, Daniel Aldana Cohen, and Thea Riofrancos, *A Planet to Win: Why We Need a Green New Deal* (New York: Verso Books, 2019), 7.

22. Ibid., 173.

23. W. E. B. Du Bois, "The Comet," *Darkwater: Voices from Within the Veil* (Cambridge: Harcourt, Brace, and Howe), 253–73.

24. "Our great ethical question today is, therefore, how may we justly distribute the world's goods to satisfy the necessary wants of the mass of men. What hinders the answer to this question? Dislikes, jealousies, hatreds—undoubtedly like the race hatred in East St. Louis; the jealousy of English and German; the dislike of the Jew and the Gentile. But these are, after all, surface disturbances, sprung from ancient habit more than from present reason. They persist and are encouraged because of deeper, mightier currents. If the white workingmen of East St. Louis felt sure that Negro workers would not and could not take the bread and cake from their mouths, their race hatred would never have been translated into murder. If the black workingmen of the South could earn a decent living under decent circumstances at home, they would not be compelled to underbid their white fellows. Thus the shadow of hunger, in a world which never needs to be hungry, drives us to war and murder and hate. But why does hunger shadow so vast a mass of men? Manifestly because in the great organizing of men for work a few of the participants come out with more wealth than they can possibly use, while a vast number emerge with less than can decently support life." W. E. B. Du Bois, "Of Work and Wealth."

25. Karl Marx, *Capital: Volume 1*, trans. Edward B. Aveling, Ernest Untermann, Samuel Moore (Chicago: Charles H. Kerr & Company, 1915), 21.

26. Indigenous Action, "Rethinking the Apocalypse: An Indigenous Anti-Futurist Manifesto," IndigenousAction.org, March 19, 2020, https://indigenousaction.org/wp-content/uploads/rethinking-the-apocalypse-read.pdf.

27. China Miéville, "The Limits of Utopia," Salvage 1, no. 1 (August 2015), https://salvage.zone/in-print/the-limits-of-utopia/.

28. Ernst Bloch, "The Meaning of Utopia," *Marxism and Art: Essays Classic and Contemporary*, ed. Maynard Solomon, trans. John Cumming (New York: Alfred A. Knopf, 1973), 578.

29. Ibid., 580.

30. Aronoff et al., *A Planet to Win*, 3.

Index

261

About Haymarket Books

Haymarket Books is a radical, independent, nonprofit book publisher based in Chicago. Our mission is to publish books that contribute to struggles for social and economic justice. We strive to make our books a vibrant and organic part of social movements and the education and development of a critical, engaged, international left.

We take inspiration and courage from our namesakes, the Haymarket martyrs, who gave their lives fighting for a better world. Their 1886 struggle for the eight-hour day—which gave us May Day, the international workers' holiday—reminds workers around the world that ordinary people can organize and struggle for their own liberation. These struggles continue today across the globe—struggles against oppression, exploitation, poverty, and war.

Since our founding in 2001, Haymarket Books has published more than five hundred titles. Radically independent, we seek to drive a wedge into the risk-averse world of corporate book publishing. Our authors include Noam Chomsky, Arundhati Roy, Rebecca Solnit, Angela Y. Davis, Howard Zinn, Amy Goodman, Wallace Shawn, Mike Davis, Winona LaDuke, Ilan Pappé, Richard Wolff, Dave Zirin, Keeanga-Yamahtta Taylor, Nick Turse, Dahr Jamail, David Barsamian, Elizabeth Laird, Amira Hass, Mark Steel, Avi Lewis, Naomi Klein, and Neil Davidson. We are also the trade publishers of the acclaimed Historical Materialism Book Series and of Dispatch Books.

Also Available from Haymarket Books

9.5 Theses on Art and Class | Ben Davis

Mama Phife Represents: A Memoir | Cheryl Boyce-Taylor

Revolution Today | Susan Buck-Morss

Too Much Midnight | Krista Franklin

About the Author

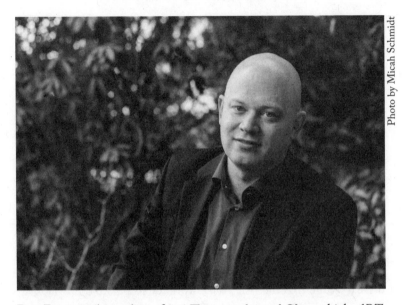

Ben Davis is the author of *9.5 Theses on Art and Class*, which *ART-news* named one of the best art books of the decade in 2019. He has been *Artnet News*'s National Art Critic since 2016. His writings have also been featured in the *New York Times*, *New York Magazine*, the *Baffler*, *Jacobin*, *Slate*, *Salvage*, *e-Flux Journal*, *Frieze*, and many other venues. In 2019, Harvard's Nieman Journalism Lab reported that he was one of the five most influential art critics in the United States. He lives in Brooklyn.